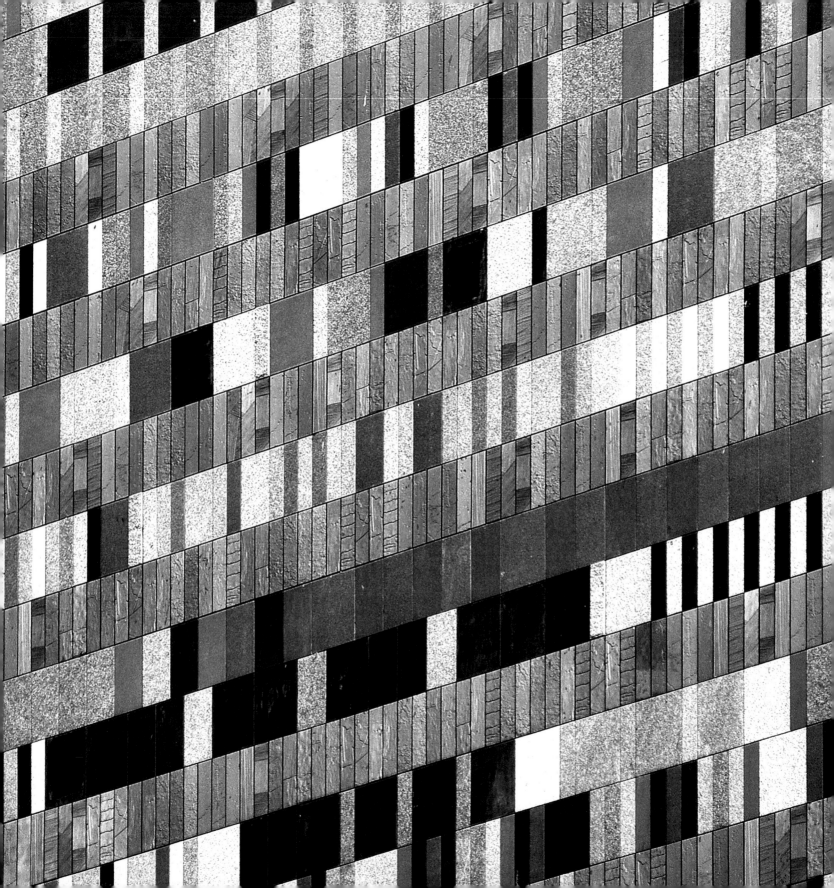

ARCHITECTURE OF

KRIS YAO | ARTECH

姚仁喜 建築師

images
Publishing

PUBLISHED IN AUSTRALIA IN 2011 BY
THE IMAGES PUBLISHING GROUP PTY LTD.
ABN 89 059 734 431
6 BASTOW PLACE, MULGRAVE, VICTORIA 3170, AUSTRALIA
TEL: +61 3 9561 5544 FAX: +61 3 9561 4860
BOOKS@IMAGESPUBLISHING.COM
WWW.IMAGESPUBLISHING.COM

COPYRIGHT © THE IMAGES PUBLISHING GROUP PTY LTD 2011
THE IMAGES PUBLISHING GROUP REFERENCE NUMBER: 851

NATIONAL LIBRARY OF AUSTRALIA CATALOGUING-IN-PUBLICATION DATA

ARCHITECTURE OF KRIS YAO / ARTECH

ISBN 9781864702194 (hbk.)

YAO, KRIS.
ARTECH (FIRM).
ARCHITECTURE - 20TH CENTURY - TAIWAN.

728.092

DESIGN & PRODUCTION BY EN AVANT CREATIVE , TAIPEI / TAIWAN
WWW.ENAVANTCREATIVE.COM

PRE-PUBLISHING SERVICES BY UNITED GRAPHIC PTE LTD, SINGAPORE
PRINTED ON 150 GSM QUATRO SILK MATT BY EVERBEST PRINTING CO. LTD., IN HONG KONG

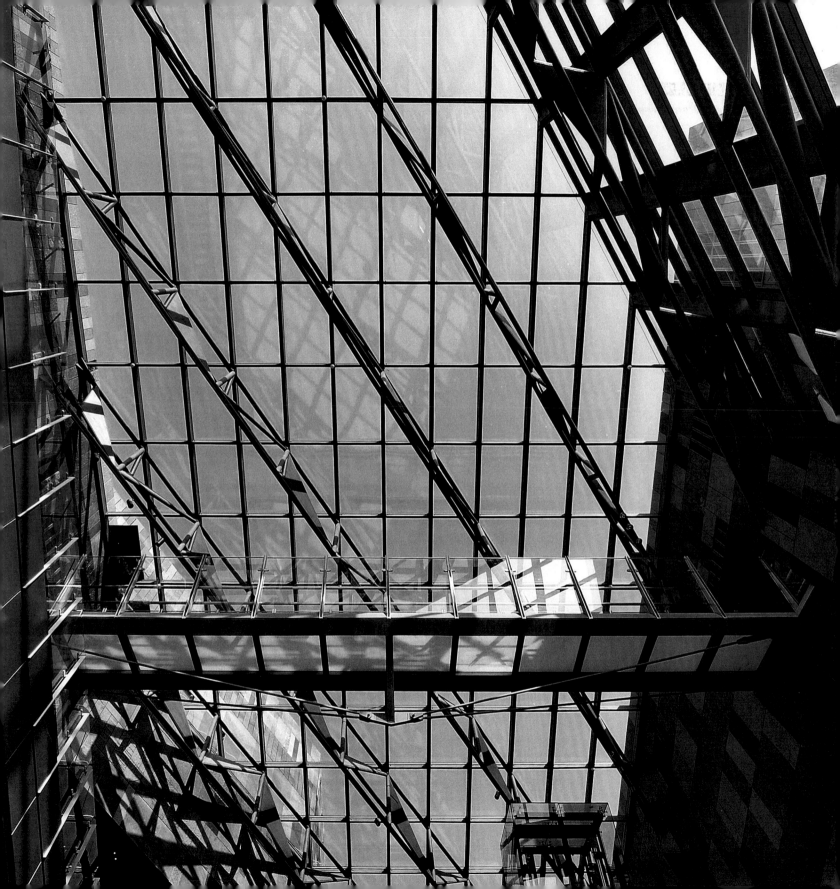

CONTENTS

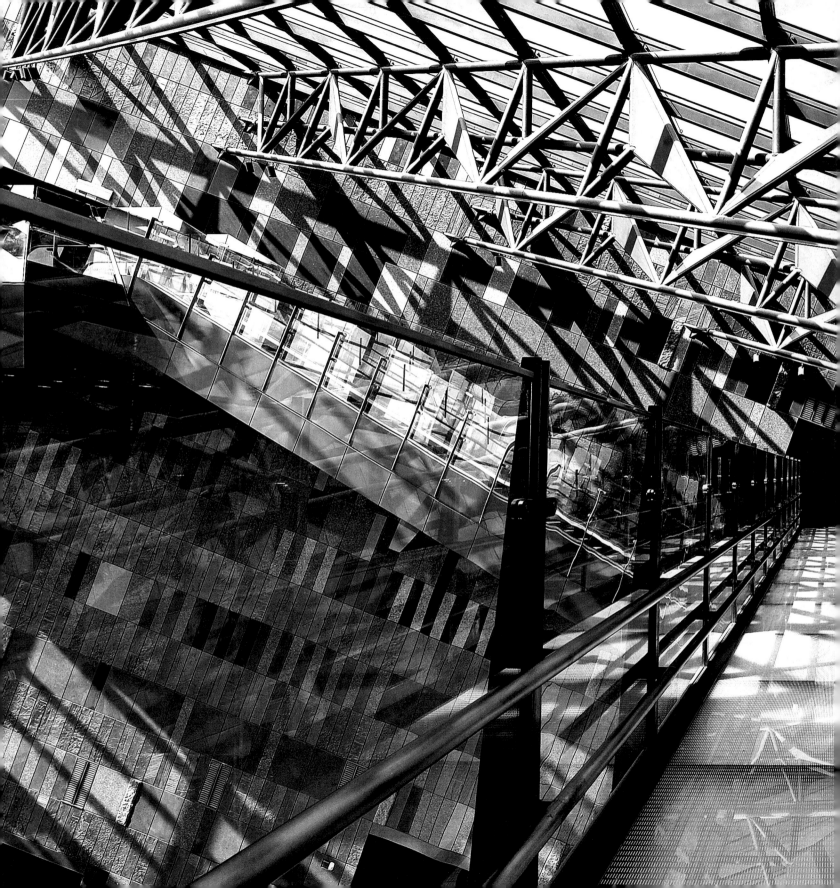

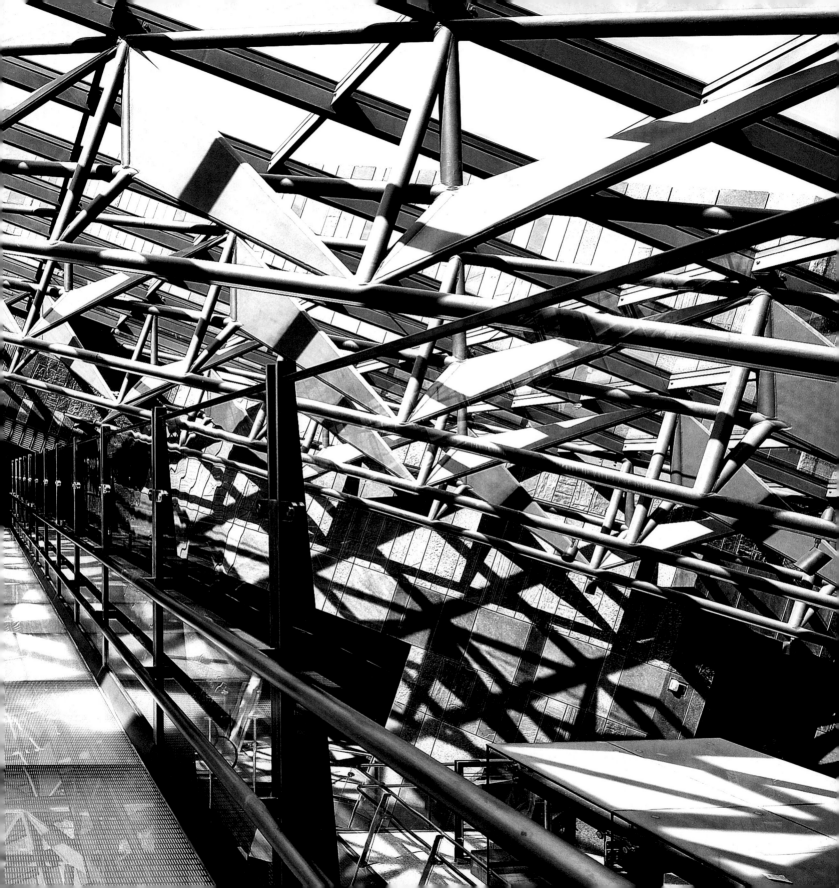

FOREWORD

BY CUI KAI

It was around 10 years ago that I first heard of Mr. Kris Yao. At that time there were already cross-strait professional exchanges occuring, but they were mainly between senior architects, and not many opportunities existed for the younger generations to meet. Of course, through magazines and books, I had some knowledge of Taiwan's architecture scene. Among the main Taiwanese architectural works of the time, Kris Yao's Yuan-Ze University Library project made a profound impression on me—it was concise, bold, and vigorous.

In 2004, through the recommendation of Professor Yung Ho Chang, I participated in the exhibition "Ten Chinese Architects: Dream of the Red Chamber", which was held in the Museum of Contemporary Art, Taipei. That was my first trip to Taiwan. One of the exhibition curators, Ms. Yu-Chien Ann, invited me to be a guest critique at the Shih Chien University where she taught. When I arrived, I found the College of Design building very attractive. The architectural concrete and metal louver building has a strong sense of design and furthermore, I was especially impressed by its successful integration into the existing campus. I later discovered that the building was also the work of Mr. Yao.

In August 2007, I was a jury member for the Far Eastern Architecture Award and was to review selected projects in Shanghai and Taiwan. The Taiwan High Speed Rail Hsinchu Station designed by Mr. Yao was one of them. When we arrived at the station site in a tour bus, Mr. Yao was already waiting at the plaza in front of the station. With his long hair flowing in the wind and a plain dark suit, his presence radiated the bearing of a master. Right in front of this giant steel structure, Mr. Yao casually took out a name card from his pocket and folded it into an arch to explain the concepts of his design: from Hsinchu's local traditional culture to the high-tech developments in the area; from passenger flows to the forming of the architectural space; and from the technical challenges of installing the large steel structure down to the very details of the column bases. As he walked, he told the story of this building eloquently, demonstrating a delicate and logical reasoning, an ability to master the techniques employed, and a quality of excellence. Mr. Yao said that he wanted the

Taiwanese people to have a public project that they could be proud of. I saw him being confident and aspirational, and believed that he had earned the right to do so.

In early 2008, while Mr. Yao was on a trip to Beijing, I invited him to give a lecture in our design institute to allow the young architects a better understanding of architectural developments in Taiwan. Mr. Yao gladly accepted the invitation in spite of his busy schedule. During his lecture, however, I was surprised that he only talked briefly about his dynamic architectural works and focused the main part of his talk on his study of film. He showed us a film clip that he had made for the Venice Biennale. The scene showed a dimly-lit, busy station—in the midst of rushing travelers, a woman stood quietly, waiting either for the train or for a loved one, her expression showing a hint of loneliness. In the exhibition, the model for the station was made of plexiglass; the building mass had already disappeared, and the components were deconstructed. Under the light and shadow cast by the dimly lit glass floor, a fictitious world was presented. Mr. Yao said he wanted to present more than a piece of architecture; instead, he wanted to create a station for the soul and mind. I was quite touched and inspired by his idea. When we indulge in the joy of our own architectural creations, do we think about the emotions of the users? Or should we engage in a heart-felt dialogue with the future users of the architecture we design?

In the summer of 2008, I returned to Taiwan again as one the jurors for another architecture award. While there, I paid a visit to Mr. Yao's office. On that Saturday evening, the large office was empty; nonetheless, stacks of drawings and piles of models at the studio tables revealing the intensity of creative works taking place in the office. These working tables, however, stood in stark contrast to the spotlessness of Mr. Yao's office table. He told me that he didn't like to pile his table up with things, because it affects his concentration while working. On one wall of his office stood a large bookshelf, where I noticed a row of light blue books. Mr. Yao drew one of them out for me and asked, "Are you interested? This is my translation of my teacher's book on Tibetan Buddhism."

To my surprise, I learned that Mr. Yao is a devout Buddhist. In mainland China, few people of our generation hold religious beliefs, and even fewer have knowledge of different spiritual practices. But in recent years, I have occasionally caught sight of monks walking in cities in China, and I also have friends who have seemed to benefit much from encountering Buddhism, sparking my curiosity about this spiritual path. Accordingly, I asked for a copy to read. From the book, I not only discovered Mr. Yao's articulate and poetic translations but also truly sensed his devotion to Buddhism. This reminded me that many of his recent works do emit a special Zen-like quality of emptiness and a touch of spirituality.

I have benefited much from getting to know Mr. Yao personally, and his works professionally. I admire his personal ethics and conduct. His devotion to his work and commitment to architectural quality are highly respected in Taiwan and are also well-regarded by the architectural community on the mainland. In recent years, ARTECH has opened a Shanghai office and has won several design competitions. This has created a positive effect in facilitating architectural culture exchange across the strait. By virtue of both places being culturally Chinese despite their different political and economic systems, mainland China and Taiwan share many similarities in terms of cultural identity and dialectic reasoning. Many developments in architecture in mainland China today resemble what Taiwan has witnessed over the past few decades. The past experiences and current approaches from our colleagues in Taiwan are important references and are of great value to our mainland colleagues. I strongly feel it necessary to strengthen the interactions and collaborations between the two sides.

Earlier this year, I invited Mr. Yao to participate in the design for the Financial Center at the New Tianjin Ocean District, with the intention of bringing more opportunities for cross-strait interaction and cooperation. One day in the early spring, Mr. Yao came to my studio for a coordination meeting; I presented my newly published book *Regionalism in Design* for his comments. Mr. Yao caught me off guard by pulling out a thick first draft of his new monograph, and asking me if I would write a foreword. Though I was very much flattered by his sincerity and accepted the work

with honor, I pondered for a long time, not quite knowing how to put my thoughts into words. Over and over I looked through the pages and enjoyed each exquisite picture, and felt that I should learn from it rather then comment on it. After careful consideration, I decided to recollect some of my personal encounters with Mr. Yao, as vignettes of the architectural exchanges across the strait. I do not know whether it should be titled as a foreword, but instead take it as an opportunity to congratulate the publication of ARTECH's selected works. Being busy with my own work and clumsy with my pen, I started writing in the last lingering cold days of early spring and have finally finished when the peach trees have already blossomed. May this beautiful warm spring bring us auspiciousness!

Cui Kai 崔愷
National Design Master
Beijing Vice President and Chief Architect.
China Architecture Design & Research Group

INTRODUCTION

BY CHING-YUE ROAN

In the early 1990s in Taiwan, a new architectural movement departing from over-commercialized postmodernism was being developed. Based in Taipei City, it marked a rapid divergence with the style and thinking of the past decade. The main characteristic of the movement was the revival of modernism, and it signified an important turning point in the history of contemporary Taiwanese architecture. Architect Kris Yao was one the main proponents for this phenomenon, along with other contemporaries such as Xue-Yi Jian and Su Chang.

In the late 1980s and early 1990s, the political and economic environments in Taiwan were going through momentous changes, including the termination of the ban on free press in January 1988; the lifting of martial law in July the same year; the rights to organize political parties in 1989; and the approval to establish 15 private banks in 1991. These significant events laid down the foundations for the new movement to surface.

During the same period, the real estate market in Taiwan was at its peak and the New Taiwan Dollar was at its historical height, while in contrast the United States economy was very low. The gap between the Gross National Product (GNP) of Taiwan and developed countries was also sharply reduced—in fact, Taiwan was ranked number 18 in the world for GNP in 1995. Under theses circumstances, a large number of professionals who had previously studied and were living in the United States began a trend of "re-immigration" back to Taiwan. Soon, many of them became the leading elites in Taipei. Under an ideal political and economic situation, with the unprecedented strength from numerous returning professionals, the 1990s saw a flood of new waves in aesthetics, style, material, and theories in architecture and design. These new waves fostered a taste in the newly-created metro-bourgeoisie for a new architectural/spatial aesthetic that was urban, refined, middle-class, and humane. This new movement in architectural aesthetics can be traced back to the dual revolutions (French Revolution and Industrial Revolution), and resulted in a global effort to embrace the values of modern architecture, where modulation, standardization and precision based on rationalism were essential.

The postmodern trend in Taiwanese architecture in the 1980s, although briefly popular, never truly rooted itself in the local culture. One of the reasons for this was that it was a short-lived movement globally anyway, due to its rapid shift to commercialism; the more critical reason may be the fact that previously, modernity in Taiwanese architecture had never been fully developed in order for postmodernism to ensue; although undertaken with the earlier efforts of architects such as Da-Hong Wang, Pao-Teh Han, Tseng-Jung Wu and others, the mission had never been truly accomplished. As a result, apart from its contribution to a new visual aesthetic, postmodernism seemed vague and lacked a solid theoretical grounding, and was therefore was unable to establish a dialogue with, or in opposition to, modernism.

Therefore, the modernist revival lead by Kris Yao and others in the 1990s can be viewed as a replenishing act of the "modernization" that was lacking in the contemporary Taiwanese architecture. In fact, by examining the architecture of Kris Yao, who is a key exemplar of this period, and analyzing the differences and evolutions of his earlier and more recent works, we can even begin to project what influences modernism may have on the future development of Taiwanese architecture.

In the earlier works of Yao such as the Continental Engineering Corporation Headquarters (1994), Fubon Insurance Headquarters (1994), and Shi Chien University College of Design (1999), we can clearly see his open-hearted and optimistic willfulness to dialogue with the globalization issue, which was generating fervent debate at the time. The architectural style and language of these works demonstrated his relinquishment of any connections with vernacular motifs or elements, and affirmed his strong intentions to connect with the international mainstream and his adherence to the original modernist ideals. It was due to his unequivocal persistence in exploring these ideals that Yao's works continuously investigated new boundaries in materials and technology, which are modernisms core values. His efforts in these areas elevated Taiwanese architecture's level of sophistication, especially regarding aspects of modern technology, which it had previously lacked. Moreover, Kris Yao's

aspiration for perfection in his works provided a distinct sense of order, delicacy and elegance rarely seen in the prevalently unrefined built environment of Taiwan.

Yao's architecture during this period demonstrated a very clear character— his works were un-dominating and un-competitive towards the context and people, they manifested visible qualities of gentleness (though they were somewhat adamant and uncompromising) and friendliness, and they were exceedingly calm. The exterior forms of his architecture, although they successfully achieved a subdued demeanor through their unadorned disposition and harmonious massing, showed quiet solitude without any invasive aggression towards their neighbors; there was a self-restrained silent aloofness, and a high quest for cleanliness and delicacy in details. Therefore, his architecture was always slightly removed from establishing an intimate relationship with the imperfect reality.

While debates about globalization and localization have not ceased, and doubts and hesitations towards globalization have been in the minds of many later Taiwanese architects, Yao has remained unperturbed. His relatively strong faith in embracing the trend, and his firm belief in his architecture graced his earlier works with solid and consistent style and quality. These works have also contributed an honest balancing force to help prevent Taiwanese architecture from being submerged in populist faux-localization.

Regarding Yao's seemingly total approval of globalization in his works during this period, I see no conflicts or objections in him with the then rising thoughts of localism. The key question is: What is "localism" truly referring to? For this part of the discussion, we can look to Yao's later works, such as the Taiwan High Speed Rail Hsinchu Station (1999), which marked a transition in his career. In this project, apart from the clear modernist approach, Yao proactively incorporated the regional quality of "Hsinchu winds" in a symbolic and abstract architectural language, achieving a dialogue between architecture and its physical context. Later, in the Lanyang Museum (2000), Yao chose the local "cuesta rock" as the inspiration for its form. These examples demonstrate the apparent signs of Yao's shifting of directions. At this stage, Yao's desire to create dialogues with physical and geographic environments (i.e. climate, landform, terrain and landscape) was quite evident. The subjectivity of architecture started to recede, and objectivity was made more apparent and emphasised.

This direction became more visible in several of Yao's later design competition projects. In the National Art Museum of China, Beijing competition (2005), spatial concepts of the Dunhuang Mogaoku Caves were the main inspiration for the overall design. Similarly, in the Jiangsu Provincal Art Museum competition (2006), the use of "cloud" and "rock" to represent the classic approaches of "depicting abstraction"[1] and "making realism"[2] in traditional Chinese art clearly intended to bridge the abstract and reality. In the National Palace Museum Southern Branch competition (2004), Yao employed the image of a piece of half-hidden jade circlet found in the sand to narrate the ancient idea of "ksana", the instant. Or as in the Weiwuying Performing Arts Center competition (2006), with the extension of this "hidden" and "revealed" concept, Yao transformed the brush stokes in Chinese calligraphy into archetypes for architecture. In all these projects, one sees explicit and implicit cultural themes become bases for Yao, establishing a dialogue between his architecture and the origins of his ideas.

In other words, one clearly sees in these projects an abundance of cultural symbols being thoughtfully invoked, and the codes of humanity and history as a core being widely applied. Yet for Yao, a basic belief in the modernist approaches still prevails and has never shifted. It may be said that the current transformation of Yao's works can be viewed as his internal dialogue with modernism, and that further development in his architecture is to be much anticipated. Nonetheless, the division of Yao's architecture before and after the year 1999 reflects the current status of contemporary Taiwanese architecture; or we may say that after the completion of certain stages in architectural developments, Taiwanese architecture has to begin a new era of true "localism" dialectics.

INTRODUCTION

Currently, there are still multiple directions in Yao's approach to architecture. Observing his recent competition projects, we can anticipate his further endeavors in establishing the dialogues of modern architecture with culture and humanity. Here I will discuss the "modernity" and "humanity" dialectic relationship, and the "modernism" and "humanism" dialogues derived from them, as a point of observation and interpretation to Yao's recent architecture and to the development of contemporary Taiwanese architecture as a whole.

Kris Yao's work overall epitomizes our dialogue with our own time. He has entered "modernity" from a rational perspective, and firmly proved that contemporary Taiwanese architecture is capable of speaking out from the foundations of modernity. Consequently, he continues to engage in the delicate inner dialectics, touching the various issues "modernity" inevitably has to face, and properly and precisely reflecting the positioning of contemporary Taiwanese architecture in its time. On this path that Yao has taken, or is just beginning to take, we can sense his intention to shift his focus from a rational world to the world of "the others" through dialogues with physical environment, land formation, or geography; dialogues with the metaphysics; or even dialogues with the spiritual or mystical realm. Whatever and however these dialogues come to be, we should further observe the results and his impact on Taiwanese architecture in the near future.

When discussing Bakhtin's view on "mixing of languages", Scholar Zhengmin Chen asks:

What is the mixing of languages? In his Problems of Dostoyevsky's Art, *Mikhail Bakhtin points out that there were two categories of European novels, one is the traditional monologues in which all the figures were dominated by their authors. The other one is called "Polyphonic novels" that Fyodor Dostoyevsky was the pioneer of this category. In such novels, authors maintain communicating with the figures he created. Bakhtin explained: 'Polyphonic novels are constituted with different voices and independent consciousnesses; they were the basic traits of Dostoyevsky's works. In his novels, the author did not precede stories or develop characters with his consistent will, instead, many equal consciousnesses from their respective worlds clashed but not mixed'. Multiple and equal existence is the reality.*

The architecture of Kris Yao perhaps also demonstrates some kind of "mixing of languages", but what does that imply? Is it a process of compromising with eclecticism? Or is it a way of seeking new possibilities? These questions may well be asked when observing the developments and directions of contemporary Taiwanese architecture.

Modernity may be the necessary route to be taken by contemporary architecture. However, the more important issue is how we continue to forge dialogue and dialectics to connect with it. In other words, how do we maintain the course of the "mainstream", while developing the rich possibilities of "polyphonic" and "mixing" in ideas and language? This is exactly the route and phase that Kris Yao is heading towards. I believe Yao's upcoming investigations and discoveries in the art of architecture will not only be manifestations of his own style, but will also be important evidence in the development of contemporary architecture in Taiwan, and furthermore, an exciting example of the dialectics of localism with modern architecture globally.

Modernism and localism are not conflicting in their inherent essence. Just as Dante in his mesmerizing *Divine Comedy* gracefully and mysteriously portrays to us: angels, can dwell in two places at one time!

Ching-Yue Roan 阮慶岳
Chairman, Associate professor,
Department of Art Creativity and Development, Yuan Ze University

[1] In Chinese, 「寫意」。

[2] In Chinese, 「寫實」。

PREFACE

BY KRIS YAO

In a notebook of visitors' comments, an Iranian film director wrote these heartfelt words for me: "You have brought us to this dream-like space where everything is mystical…" That was back in 2002 at the 8th Architectural Biennale in Venice where I showcased my design of the Hsinchu High Speed Rail Station, then still under construction, at the Taiwan Pavilion.[1] A few months earlier, I had taken a month-long hiatus from the office for an intensive film course in the United States. After that, I felt charged to take a different approach in the Biennale presentation, one that would narrate what I increasingly feel is important in architecture. Rather than emphasizing the technical or architectural aspects of the rail station, visitors to the Biennale were instead introduced to the human emotions present within an architectural setting. The narration focused on the transient and impermanent sentiments and experiences shared by all travelers in the station—two parallel platforms, where two strangers may for a few moments stand across from one another, separated only by the train tracks. Though they are bound in opposite directions and may never meet again, in that brief moment, there is a shared sense of solitude and sympathetic understanding among the travelers. The structure, one of the simplest forms of architecture, helps to facilitate this interaction. Through installations, films, and edited music, I created an exhibition to tell this story, and turned the 16th-century palazzo into an architectural space pregnant with emotions. Many visitors left their comments of appreciation for the exhibition, saying that it touched their hearts. Three Ukrainian architects came up to me one day, and finding no common spoken language among us, they stood straight and put their hands to their hearts. Though no words were exchanged, the sentiments were understood. This exhibition turned a new page in my architecture career.

Since then, I have begun to venture out and explore more daringly the subject of human emotions in architecture whenever possible. I realized that I used to adore using telephoto lenses to observe human activity from a distance, aloof and detached. As an architect, I had been trained to analyze from a distance, not to be involved; to see the bigger picture, rather than delve into specifics. This is a very good method of design until it becomes a tool of abstraction, or a designer's narcissistic game that disregards the people the architecture is intended for. Of course, architecture is never just a scene set for one specific occurrence, but must function as a long-lasting arena for countless events. Yet I have come to see that by embracing human emotions as the main source of inspiration in design rather than some abstract conception or reduction of social theory, architecture becomes alive, fun, apprehensible, and at times even compassionate. In doing this, I am able to envision architectural spaces as they transform from still images to moving film, becoming a steady flow of experiences rather than solitary moments frozen in time. The spaces come vividly alive and burst with emotions, becoming a stage for everyone—everyone at once an audience and an actor, whether the narration is despondent or jubilant, a tragedy or a comedy. I have discovered immense satisfaction and, at times, empathy in trying to embrace common human emotions. Realizing our shared limitations and frustrations as fellow beings has helped me reflect on myself and where my agenda, selfish or otherwise, lies.

In my practice, over the course of the past decade, I have gained a deeper understanding and appreciation for what the great thinker and philosopher Lao Tzu said 2,500 years ago:

> To learn is to increase daily, to make it a Way (Tao) is to decrease daily; decreasing further and further, until you reach non-doing. In non-doing, there is nothing you cannot achieve.[2]

Throughout Eastern history, as testimonies from many artists and spiritual seekers have shown, a mind controlled or fabricated by thoughts and concepts is the single greatest obstacle that prevents creative energy from shining through. It is believed that only through the training of a mind free of inhibition and manipulation can there be the true flow of free will. This is most aptly seen in children's artwork. Uninhibited by fears of judgment or criticism, it is more vibrant with spontaneous, liberated creativity than the artworks of adults who struggle with self-imposed insecurities.

The Sufi poet Jalal al-Din Rumi puts it beautifully in his poem *Chinese Art and Greek Art*:

They make their loving clearer and clearer.
No wantings, no anger. In that purity
They receive and reflect the images of every moment,
from here, from the stars, from the void.

Certainly, to imagine a state so free is unfathomable—nevertheless these spiritual and artistic giants provide great inspiration for me. I have nurtured a new approach to design, perhaps similar to what the ancient Chinese refer to as "direct seeing".[3] This approach is not an analytical method that involves assessments or concepts, but rather a holistic revelation of design that comes with intuition honed over time.

Rare glimpses of such experiences appear in moments when my egotistical agenda is temporarily dissipated. The whole process is more of a discovery than an act of creating a design, because the lack of willfulness is the very element that enables such an experience to unfold. Consequently, since it is neither rational nor linear, architecture may have complex layers of meanings, some even contradicting others. However, our mind manifests paradoxes at all times, and the urge to eliminate these contradictions often results in much of our struggle and suffering. I have discovered that accepting the manifestations as they are is the true art of "direct seeing".

Of course, any measure of true art lies in the work itself. The following pages will demonstrate that there is still a lengthy, perhaps even endless, path for me to travel as I practice "decreasing" and unlearning in the fascinating playing fields of architecture.

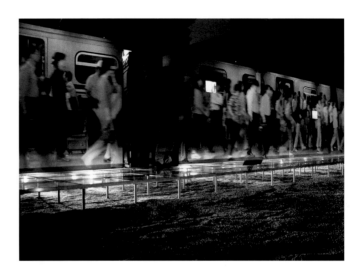

Kris Yao

2009 Architect Registration, Republic Of China
(The National Administration Board Of Architect Registration)
2007 The 11th Annual National Award for Arts in Architecture
2005 Distinguished Alumnus Award, College of Environmental Design, U.C. Berkeley
1997 The 3rd Annual Chinese Outstanding Architect Award, Republic of China

[1] The venue was Palazzo delle Prigioni at San Marcos Square.

[2] 為學日益，為道日損。損之又損，以至於無為。無為而無不為。

[3] In Chinese:"直觀", meaning to see directly without any analytical manipulation.

PROJECTS

Reveal the essentials in building components…
Turning common elements into uncommon composition as an icon for a construction company.

CONTINENTAL ENGINEERING CORPORATION HEADQUARTERS
Duqan Construction Corp.

The Continental Engineering Corporation's company image and culture are reflected through the building design of its headquarters. It has been crafted with sophisticated attention to detail by using the most basic building materials, namely concrete, steel and glass. The building is composed of a transparent glass box, eight reinforced concrete columns, exposed steel bracings at its four corners and a service core at the rear. The exoskeleton element strongly expresses the dynamics of the building structure: the mega-columns and floor trusses support the gravity loadings, and the exterior bracings resolve the lateral system for seismic loading. The technical challenges of the design and construction of the exposed structural system, long-span steel members and pour-in-place architectural concrete were not only overcome collaboratively by the client, contractor and the design team, they were overcome with elegance and grace.

The architecture can be read as a series of transformations as it rises from the ground. The 'base' of the building, from the fourth basement to the second floor, is constructed with reinforced concrete, and completes itself with a thick waffle slab on top of the second floor. On each of the upper floors, a hybrid system is applied: four long-span steel trusses and eight steel reinforced concrete (SRC) columns support the main structure, creating for each floor a 25-meter by 25-meter interior space free of columns for maximum flexibility. At the very top of the building, the steel structure extends from the mega-columns to form a double cross on the roof. The structure is topped by a steel system suspended from the crosses that houses the executive offices at the highest level.

PROJECT DATA

LOCATION
TAIPEI, TAIWAN

FUNCTION
OFFICE BUILDING

DESIGN / COMPLETION
1994 / 1999

SITE AREA
2,114 M²

GROSS FLOOR AREA
17,572 M²

FLOOR LEVELS
13 FLOORS ABOVE GROUND, 4 FLOORS BELOW GROUND

STRUCTURE
STEEL FRAME CONSTRUCTION

MATERIALS
ARCHITECTURAL CONCRETE, ALUMINUM PANELS, GRANITE, GRAY DOUBLE GLAZED UNIT

NOTE
TAIWAN ARCHITECTURE RECOGNITION AWARD 1999

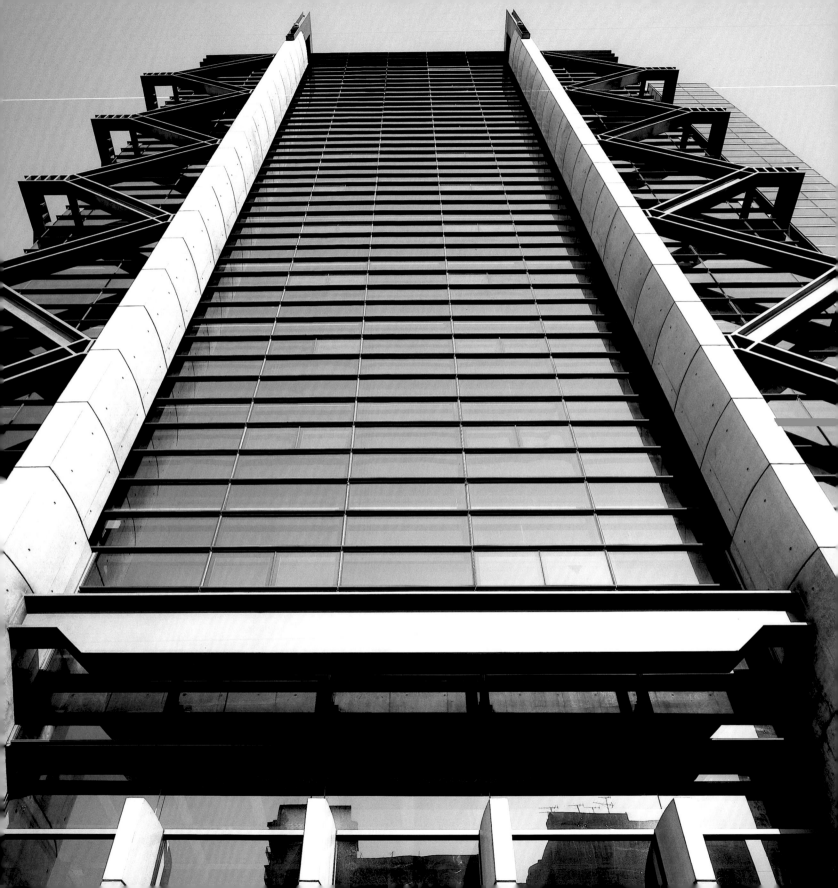

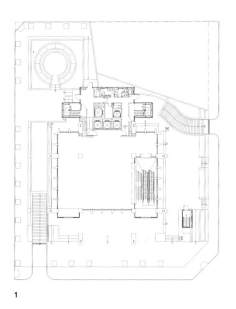

1

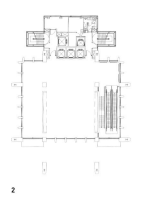

2

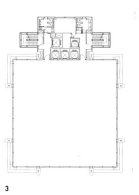

3

1 GROUND FLOOR PLAN
2 SECOND FLOOR PLAN
3 TYPICAL FLOOR PLAN

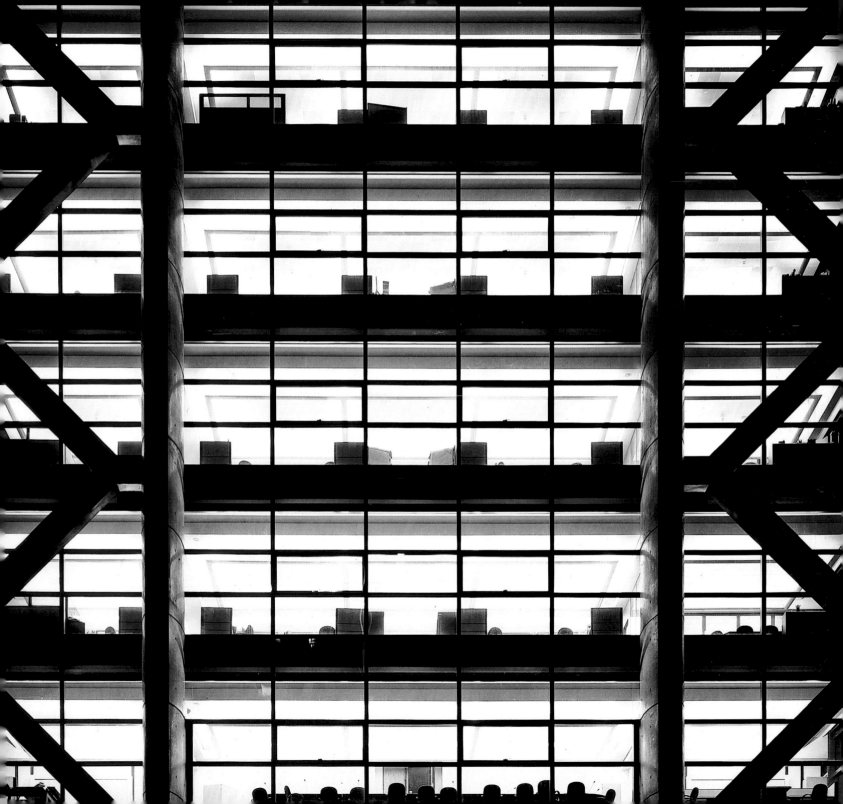

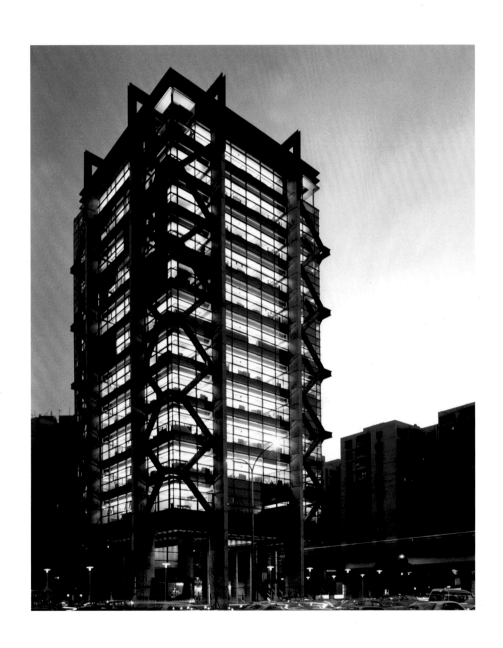

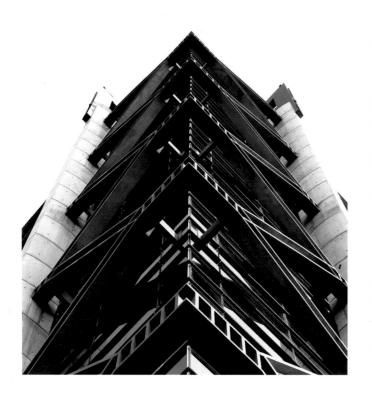
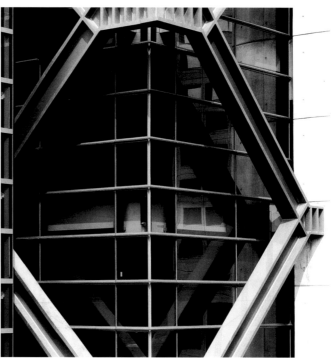

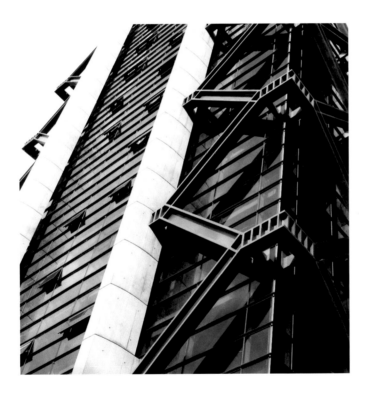

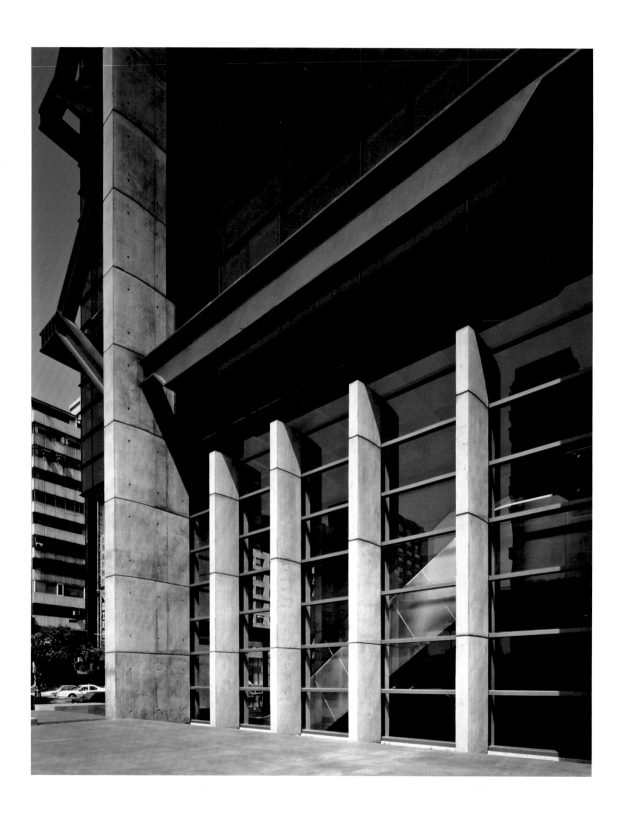

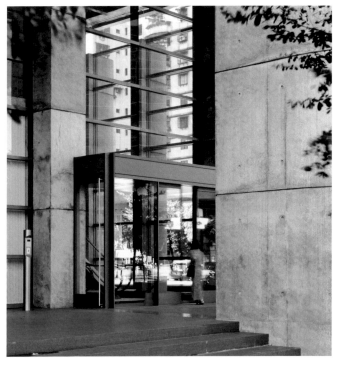
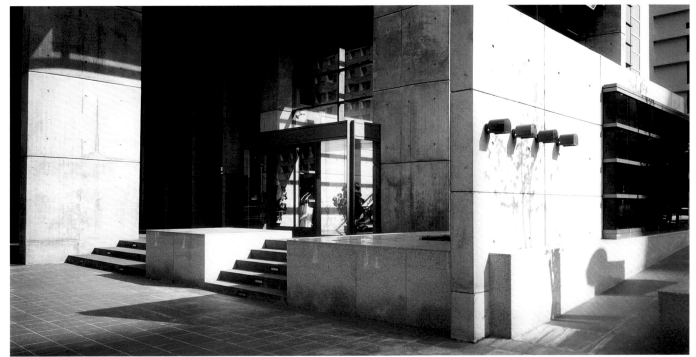

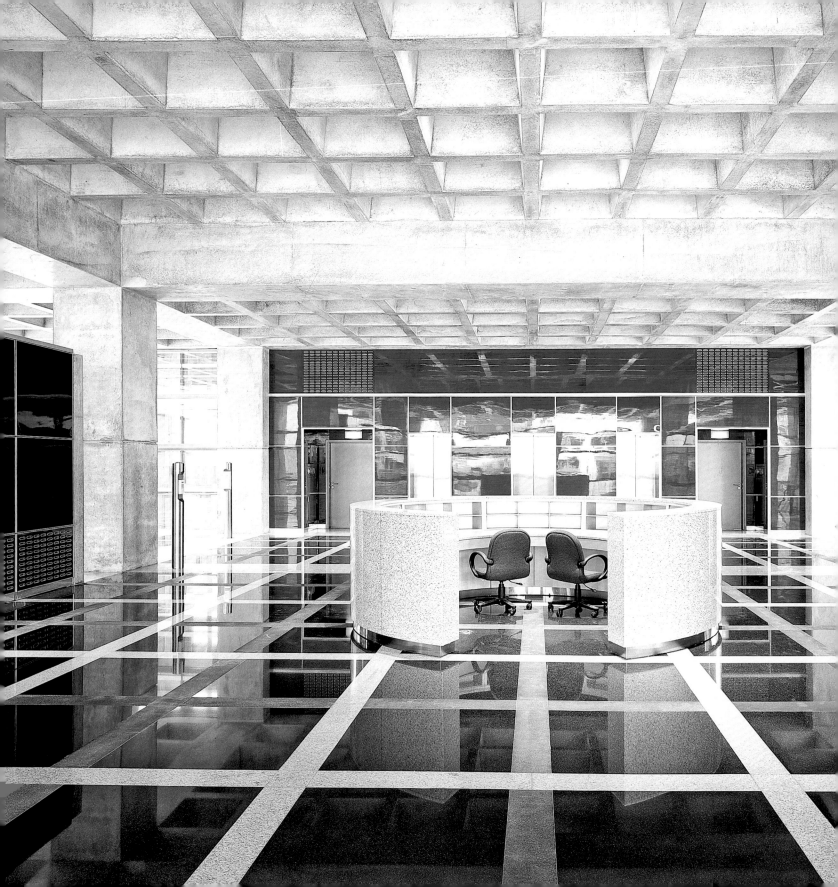

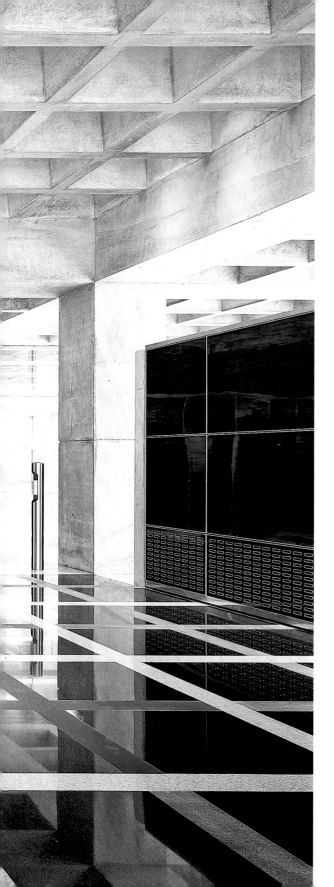

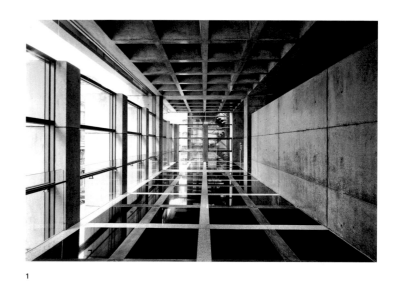

1

1 HALLWAY ON THE SECOND FLOOR
OPPOSITE PAGE ELEVATED LOBBY ON SECOND FLOOR

Quietly rising from the landscaped plinth, the architecture integrates the mountain behind and the river in front.

LITE-ON HEADQUARTERS
Lite-On Electronic Taiwan, Inc.

The owner's aim was to create a friendly environment that was hospitable, timeless and in harmony with nature. The intention was to avoid the impression of a stereotypical high-tech manufacturer, with a cold and sharp-edged showcase building for its products.

The building site is backed by a mountain range that faces a scenic river. In order to circumvent the existing five-meter-tall embankment across the street, the lobby was elevated to the second floor on top of a sloped podium. This podium creates a smooth and natural transition between the river, the mountains, and the architecture. This simultaneously achieves a better feng shui and maximizes the panoramic view of the river. The main tower rises up from the podium with a graceful curve, taking in a commanding view of the river. The sloped rooftop is a series of carefully landscaped gardens with cascading water features, creating a haven of nature and leisure that is removed from the urban pace, accentuating the relationship between the building and its natural surroundings.

The podium, with a number of courtyards acting as light wells, accommodates all public functions of the building, including the auditorium, dining hall, retail shops, gymnasium and daycare center. Energy conservation is a critical feature of the design. Narrow horizontal windows on the south façade minimize heat gain from the sun during the day, and large glazed areas on the north façade offer expansive views of the mountains behind the building.

PROJECT DATA

LOCATION
TAIPEI, TAIWAN

FUNCTION
OFFICE BUILDING

DESIGN / COMPLETION
1997 / 2002

SITE AREA
10,152 M²

GROSS FLOOR AREA
69,816 M²

FLOOR LEVELS
23 FLOORS ABOVE GROUND, 4 FLOORS BELOW GROUND

STRUCTURE
STEEL FRAME CONSTRUCTION

MATERIALS
ALUMINUM PANELS, GRANITE, LOW-E GLASS

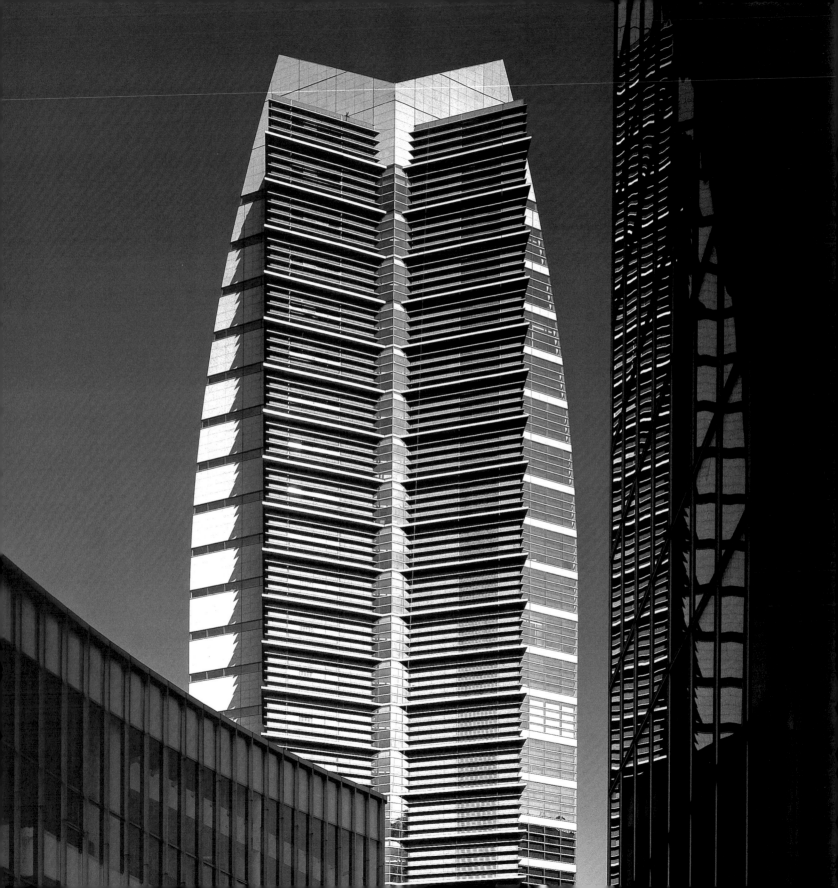

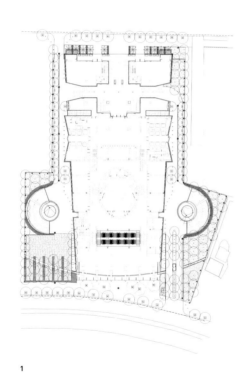

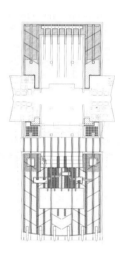

1 GROUND FLOOR PLAN
2 SECOND FLOOR PLAN

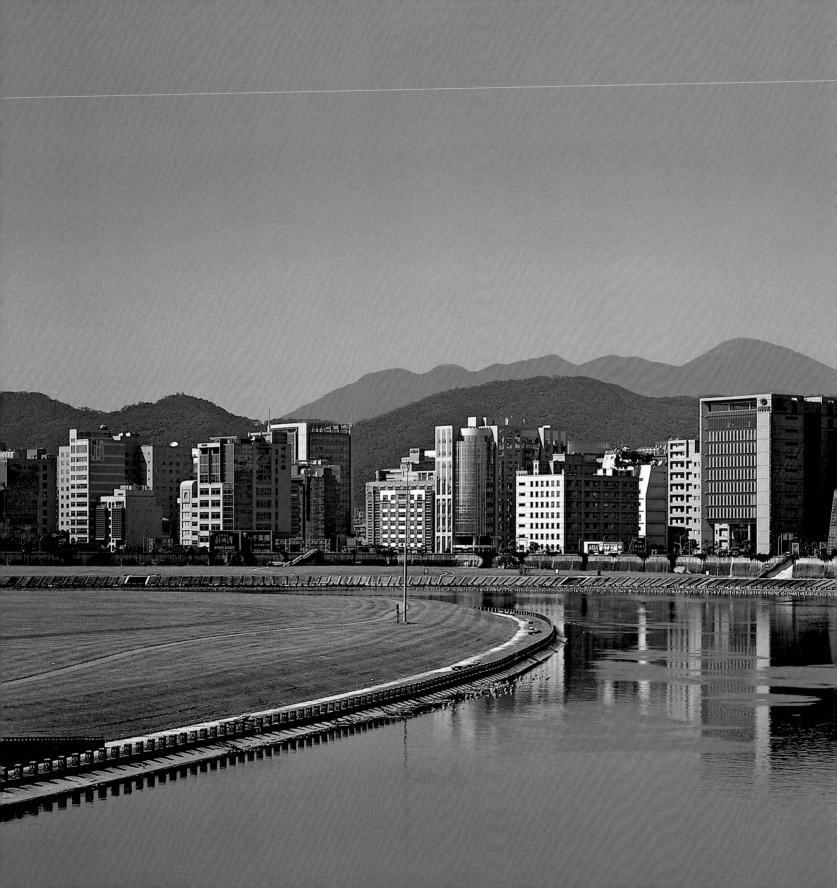

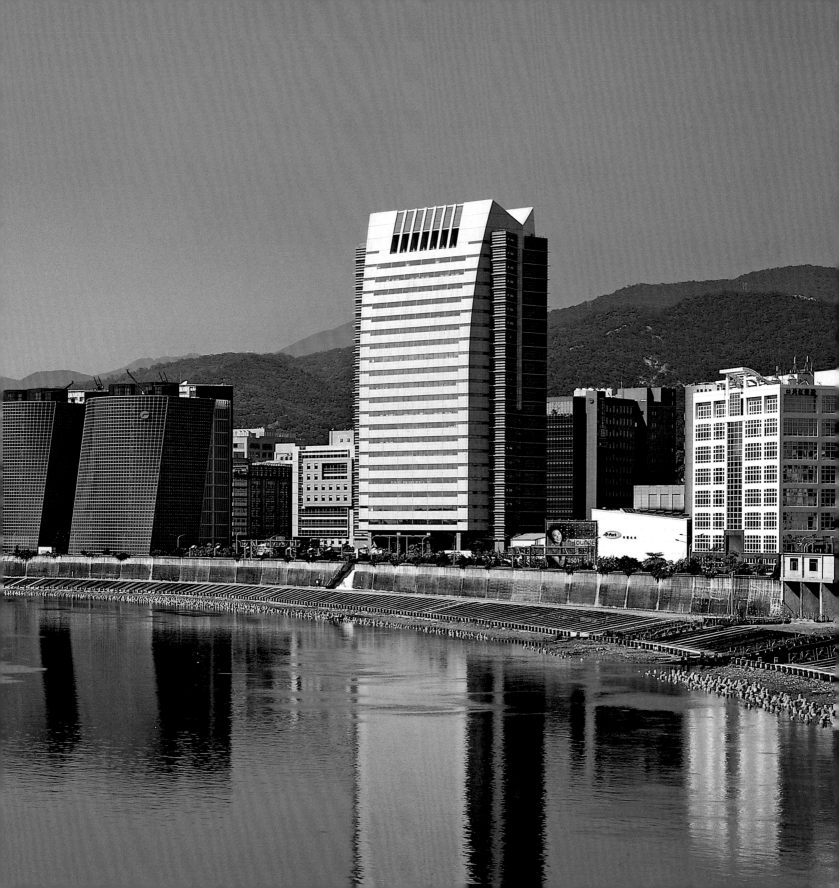

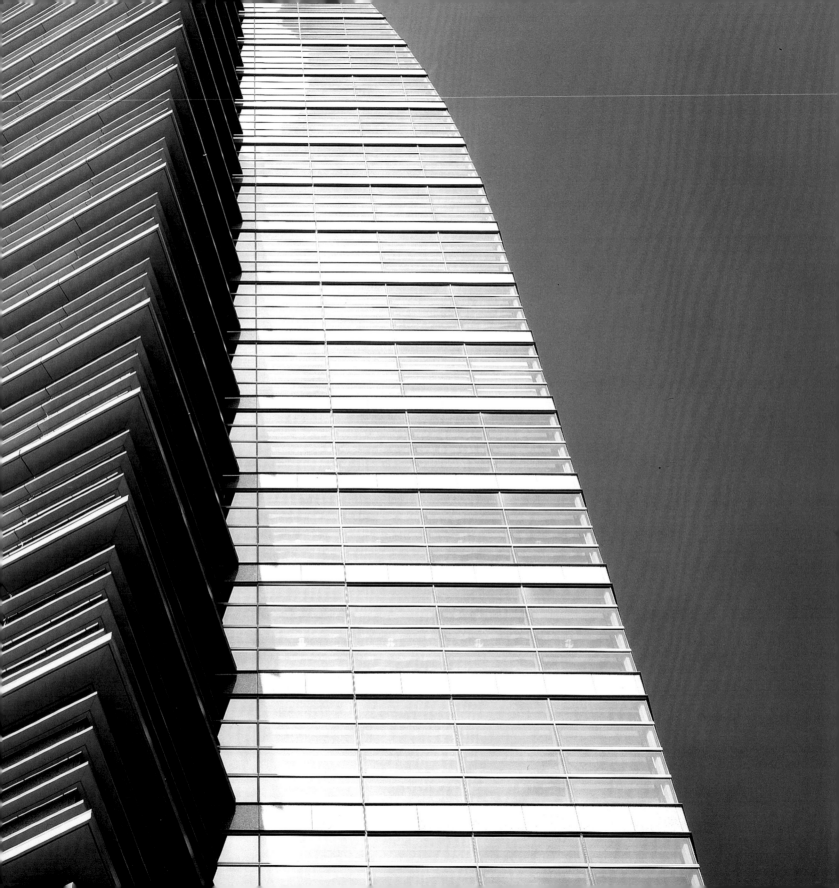

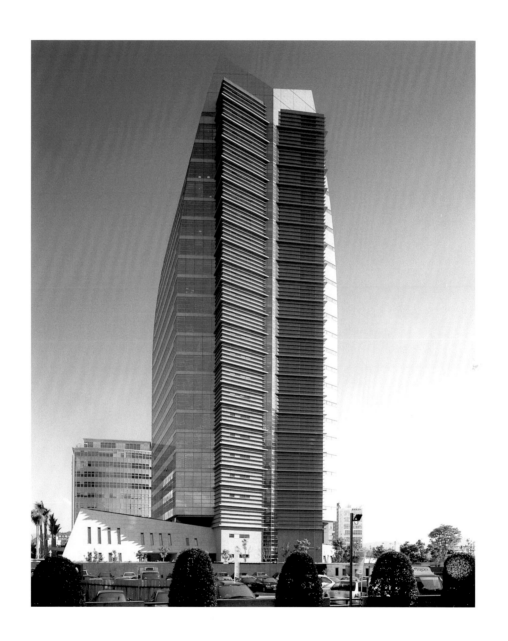

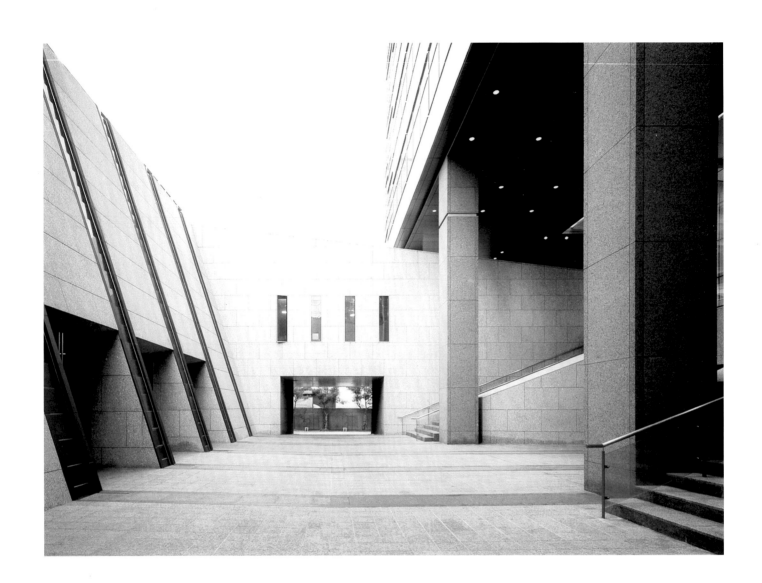

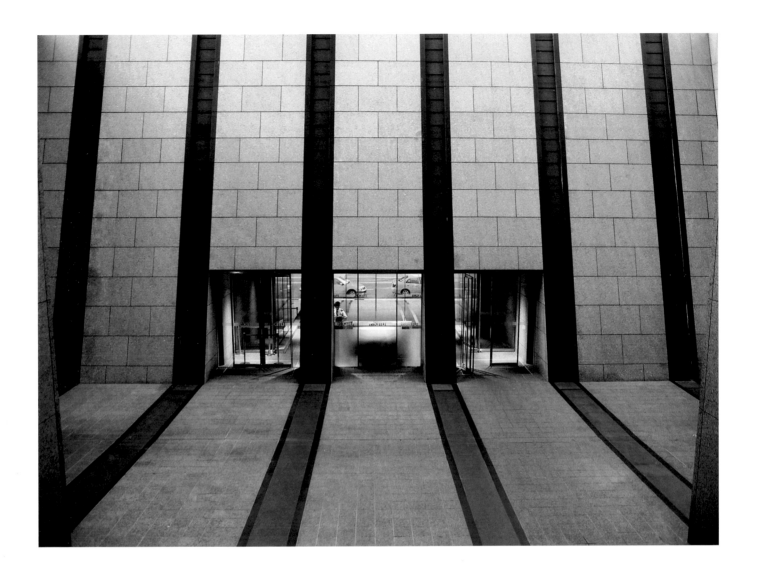

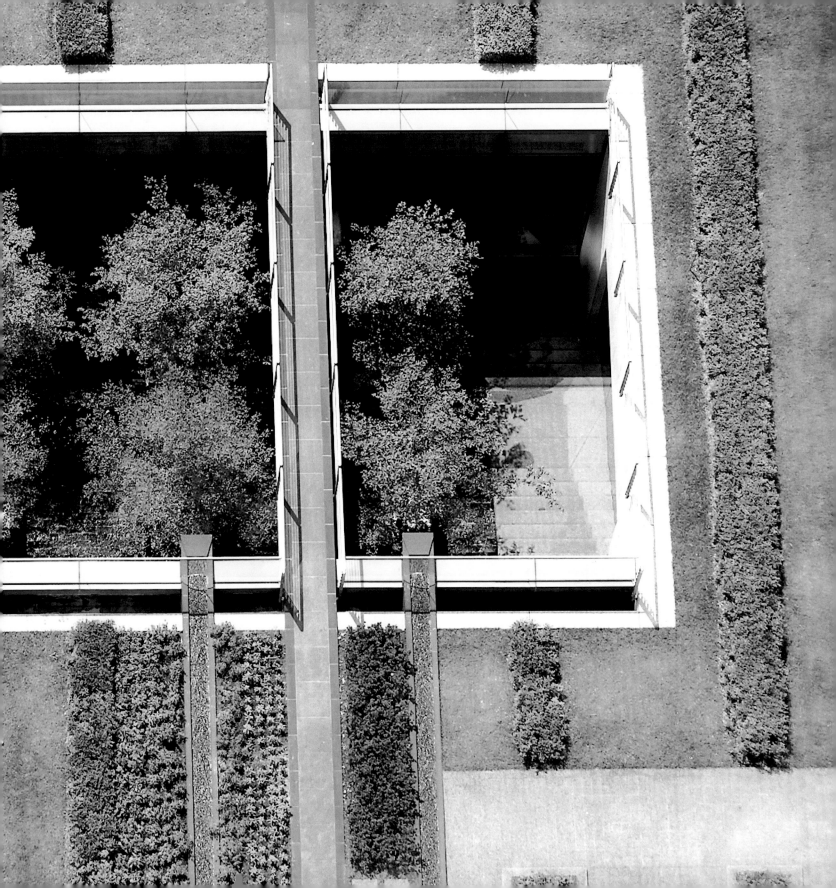

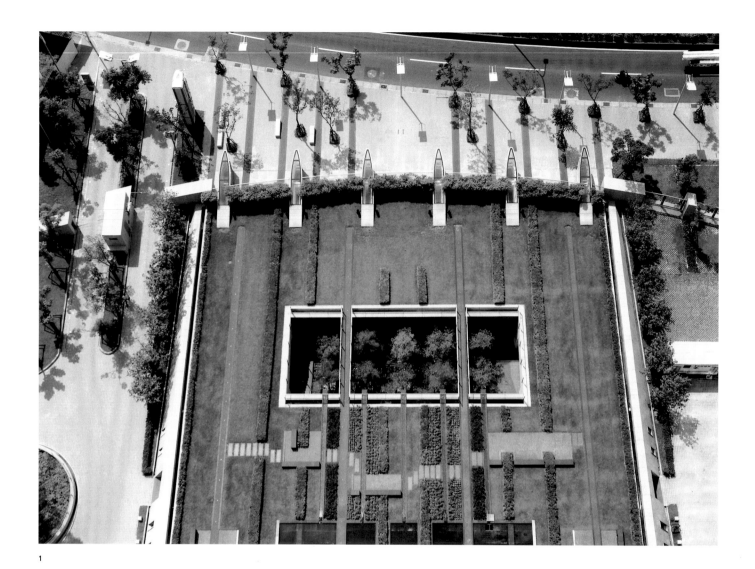

1

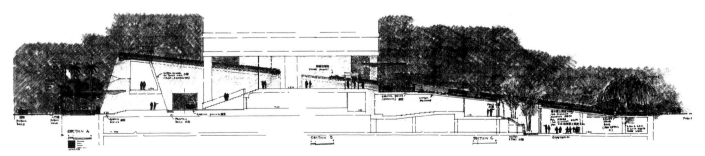

3

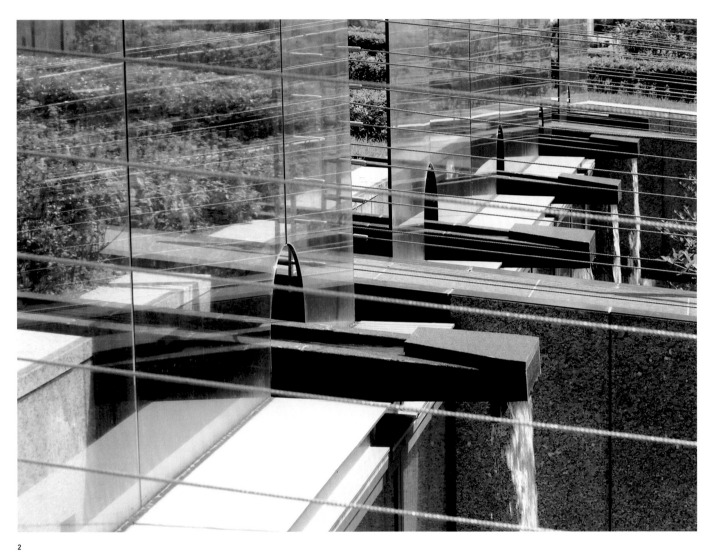

2

1,2 GARDEN ON THE SLOPE AND THE WATER LANDSCAPE IN THE COURTYARD
3 SECTION THROUGH PODIUM

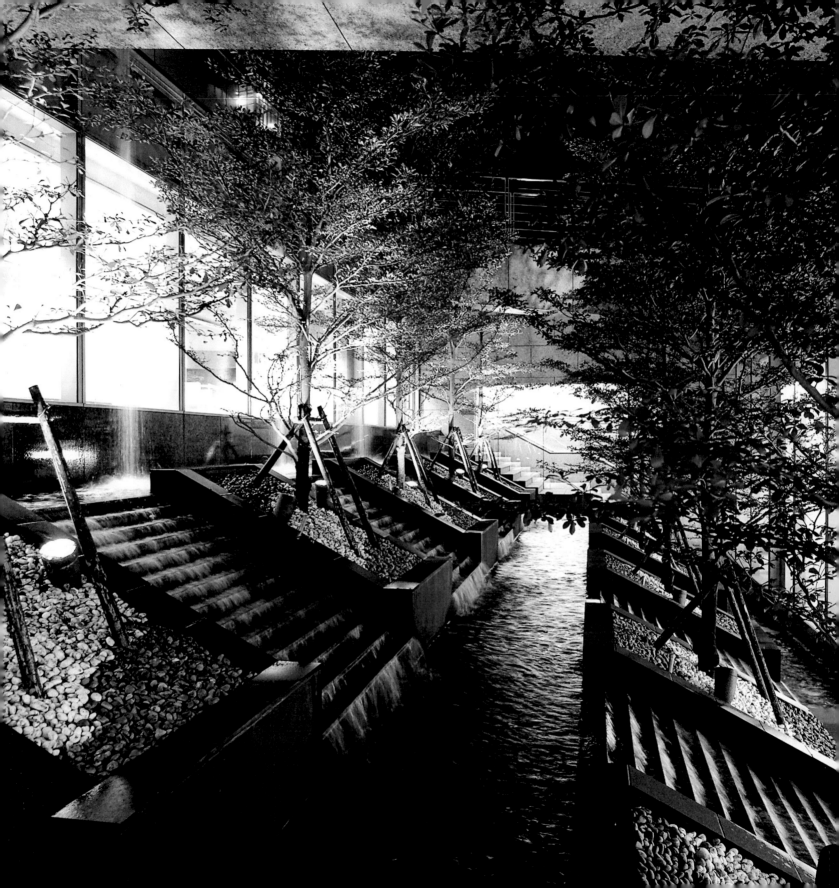

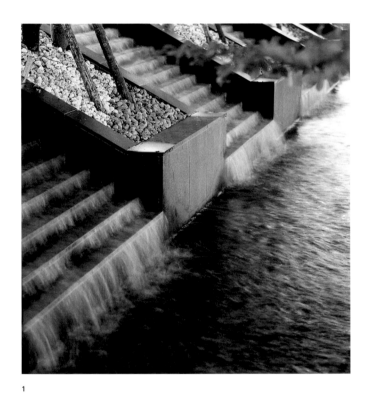

1

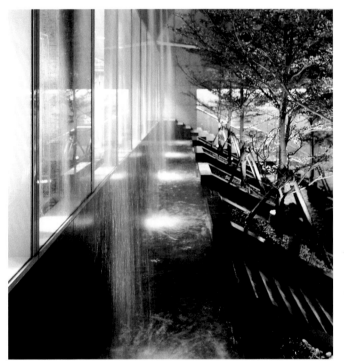

2

1,2 WATER LANDSCAPE IN THE COURTYARD

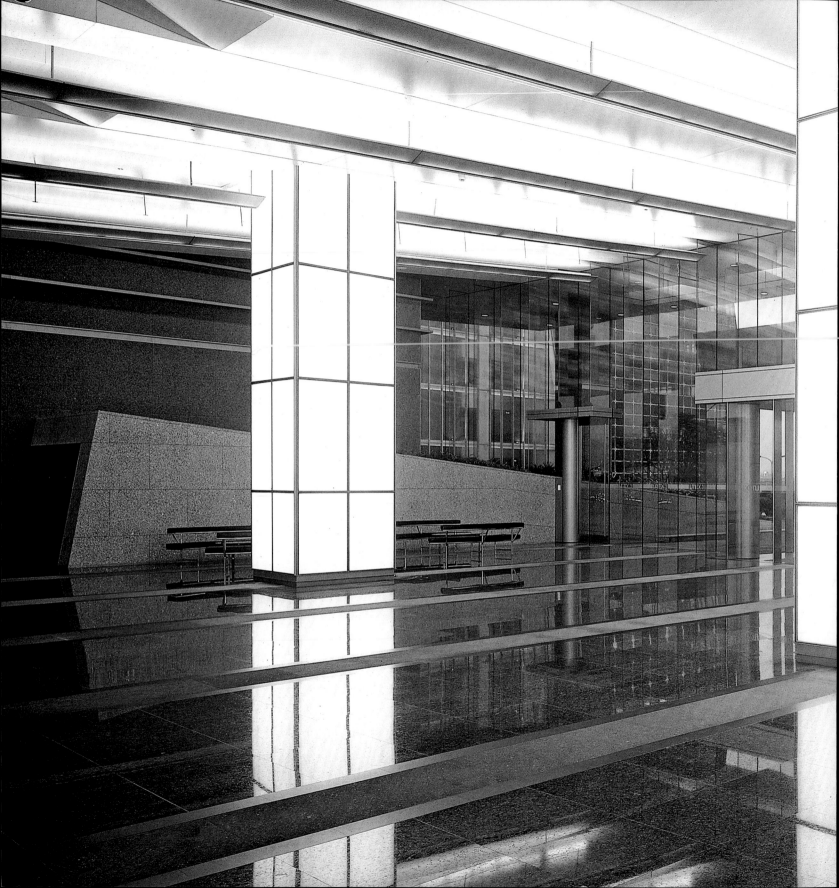

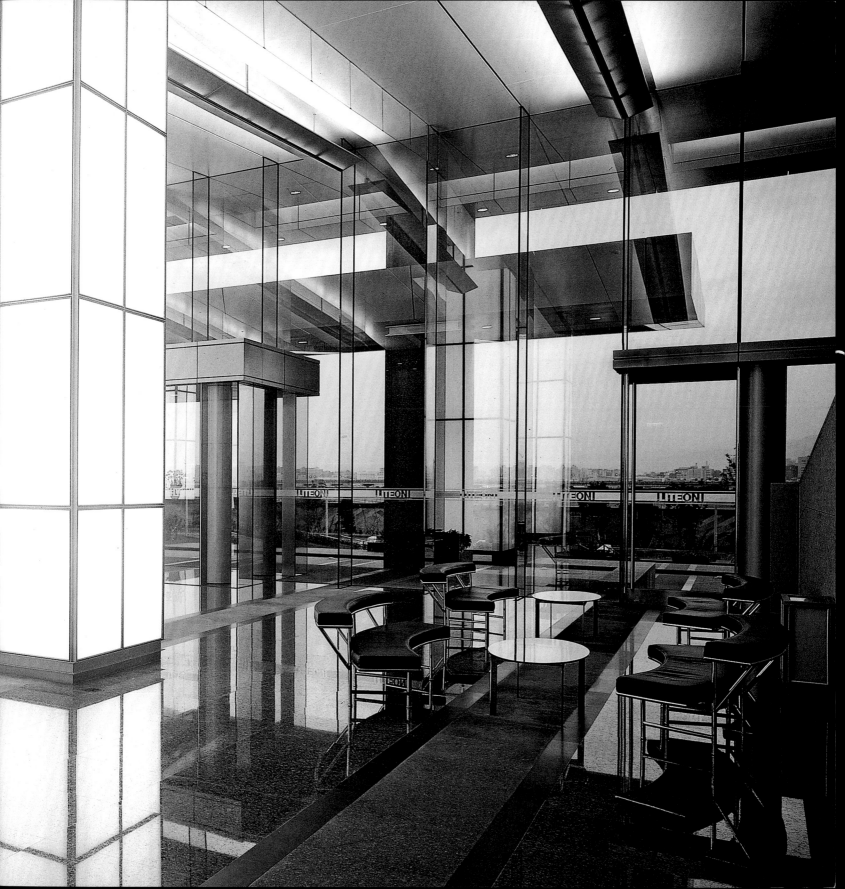

A giant prismatic glass atrium with delicate assembly details reflects and emits a dance of light for this corporation devoted to optical technology.

PREMIER HEADQUARTERS
Premier Technology Co. Ltd.

The Premier Headquarters is located in the corner of a new high-tech park. The sharp 76° angle of the site, with its commanding view of the urban park and the expressway beyond, makes it important to address the corner of the building in this location. A prism-like 56-meter high point-glass atrium alludes to the company's cutting-edge optical technology in camera manufacturing.

The east and south façades of this L-shaped building are adorned with horizontal glass walls, shading louvers, and vertical anodized aluminum panels set with high-tech precision. The main entrance is located at the bottom of the atrium, giving a stunning first impression to visitors. Natural light reflects off the steel trusses in the atrium to create a fluid transparency and a dramatic spatial effect. The building transforms into an illuminated glass box after dark.

The entrance foyer houses an exhibition hall on the first floor, conference rooms on the second floor, and a staff recreational center on the first basement floor. The strategic placement of these main public areas allows the separation of the public spaces from the private offices. The office levels are located between the 3rd and 11th floors. Within the atrium, where steel structures and tension cables dominate the view, a spectacular stairway flanked by wooden louvers extends into the space, balancing the interiors with a warm and friendly atmosphere.

PROJECT DATA

LOCATION
TAIPEI, TAIWAN

FUNCTION
OFFICE BUILDING

DESIGN / COMPLETION
1998 / 2002

SITE AREA
4,950 M²

GROSS FLOOR AREA
35,388 M²

FLOOR LEVELS
13 FLOORS ABOVE GROUND, 3 FLOORS BELOW GROUND

STRUCTURE
STEEL FRAME CONSTRUCTION

MATERIALS
ALUMINUM PANELS, CLEAR FLOAT GLASS, EXTRUDED ALUMINUM LOUVERS, BEECH WOOD

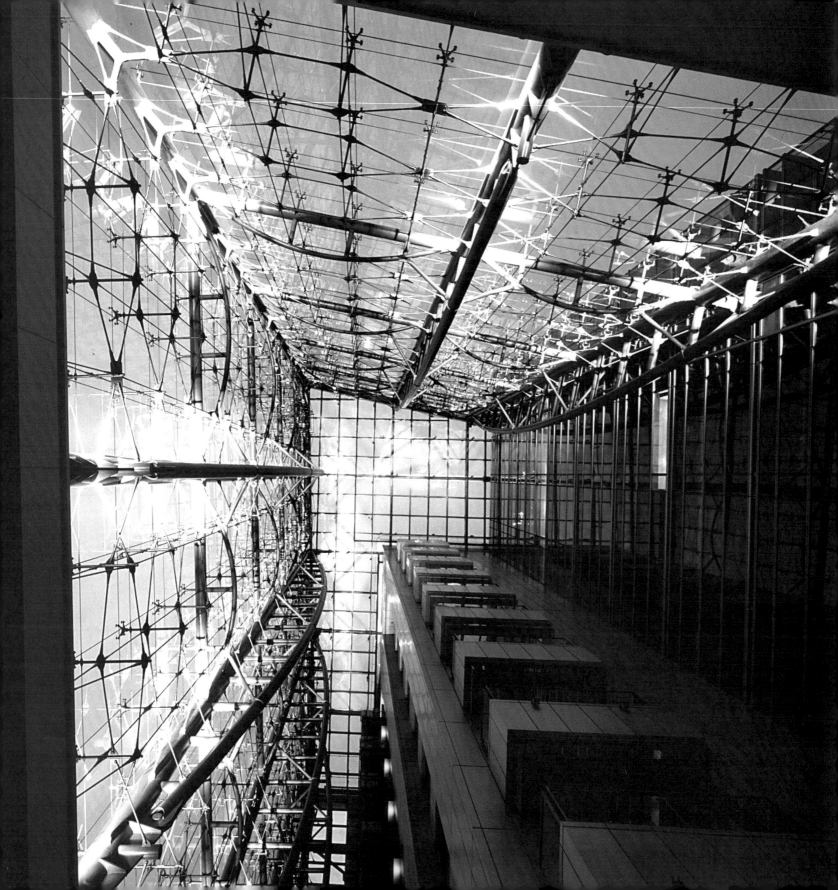

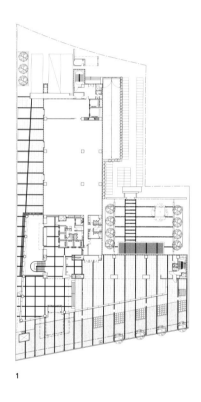

1

2

1 GROUND FLOOR PLAN
2 TYPICAL FLOOR PLAN

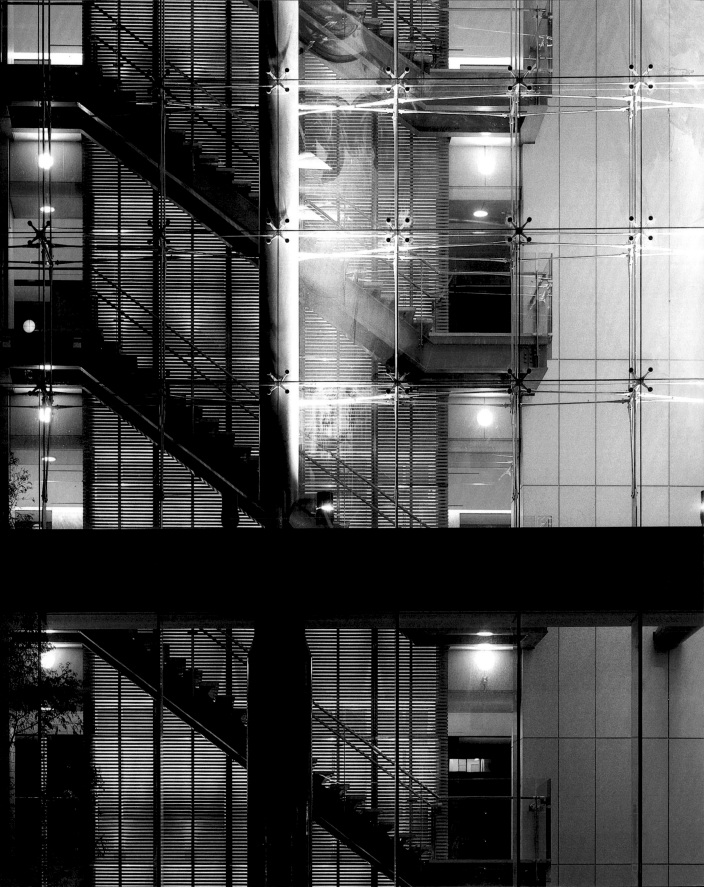

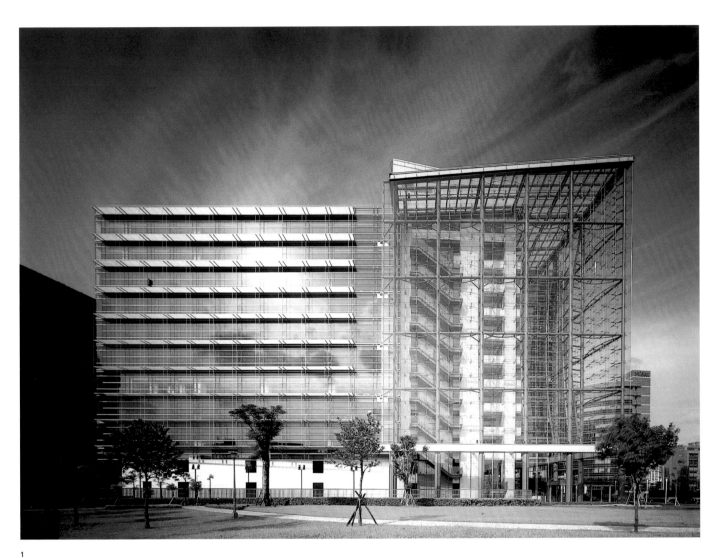

1

2

1 VIEW OF SOUTH ELEVATION
2 SECTION THROUGH ENTRANCE LOBBY

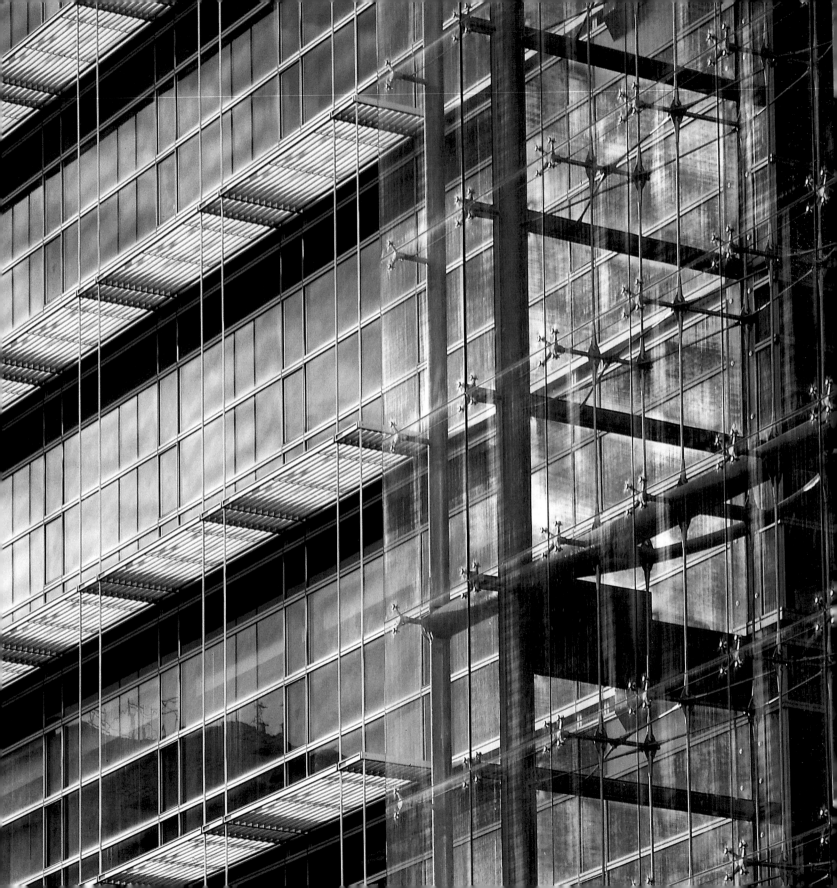

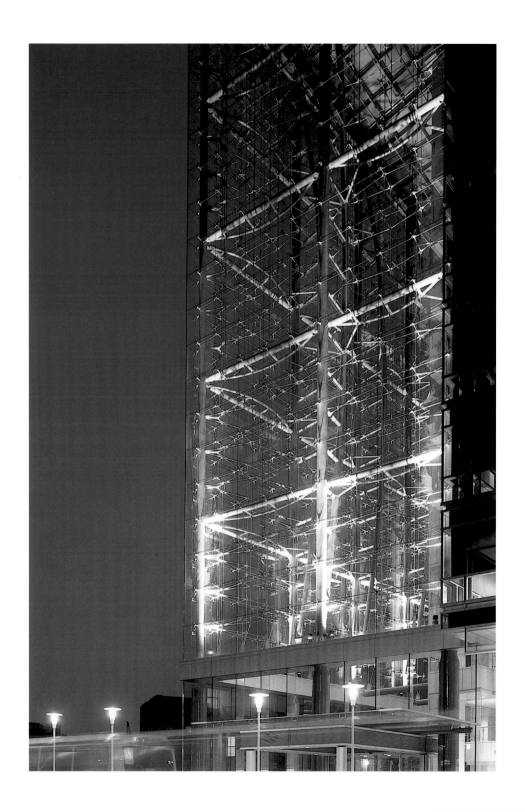

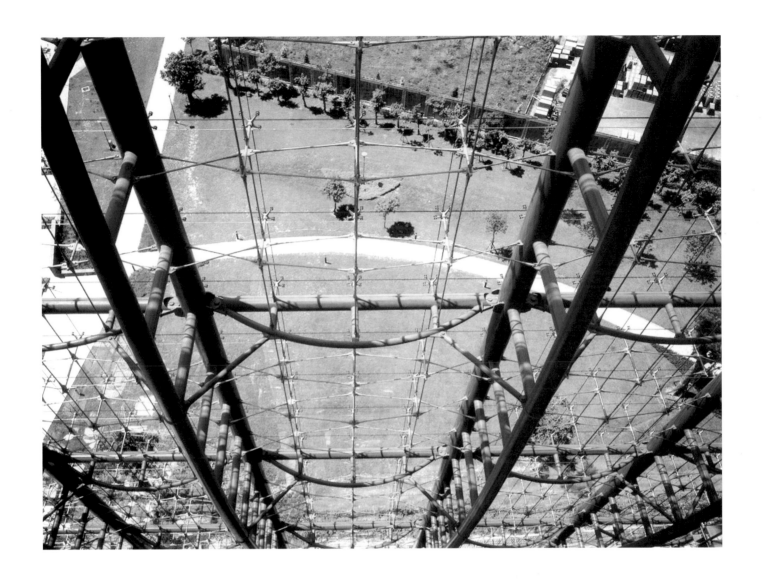

"Inside or outside, workstations or corridors, let every corner in the building turn into stage sets." – the clients' wish.

SET TV HEADQUARTERS
Sanlih Entertainment Television Incorporated

A television headquarters can be seen as analogous to a stage set, where filming, production, editing, and broadcasting take place in the offices and filming studios, and the role of the spectator and the spectacle are fluid and interchangeable. Inspired by the idea of "sets on stage", the design of the building space became a "stage" with a carved form, revealing the presence of actual and artificial walls, layering techniques, and multiple frames created by manipulating the transparent/reflective qualities of glass. The public spaces for social exchange and activities, namely plazas, terraces, outdoor staircases, and protruding balconies, were intentionally designed as "sets".

The floor plan is composed of a long and a short axis. Studios are placed along the long axis and office spaces on the short axis. The exterior façade is a web of zinc panels, glass, and stone. The gradient's low saturated color tone of gray, black, and silver reflects the precision the building design strives to achieve. The client's wish to be modest and simple is conveyed through the use of washed surfaces, matte-finish stone materials, and oxidized zinc panels.

PROJECT DATA

LOCATION
TAIPEI, TAIWAN

FUNCTION
OFFICE BUILDING

DESIGN / COMPLETION
1998 / 2002

SITE AREA
8,243 M^2

GROSS FLOOR AREA
31,941 M^2

FLOOR LEVELS
9 FLOORS ABOVE GROUND, 3 FLOORS BELOW GROUND

STRUCTURE
STEEL FRAME CONSTRUCTION

MATERIALS
ALUMINUM PANELS, BLACK STONE, HEAT STRENGTH-ENED CLEAR FLOAT GLASS, LIMESTONE, WOOD, ZINC PANELS

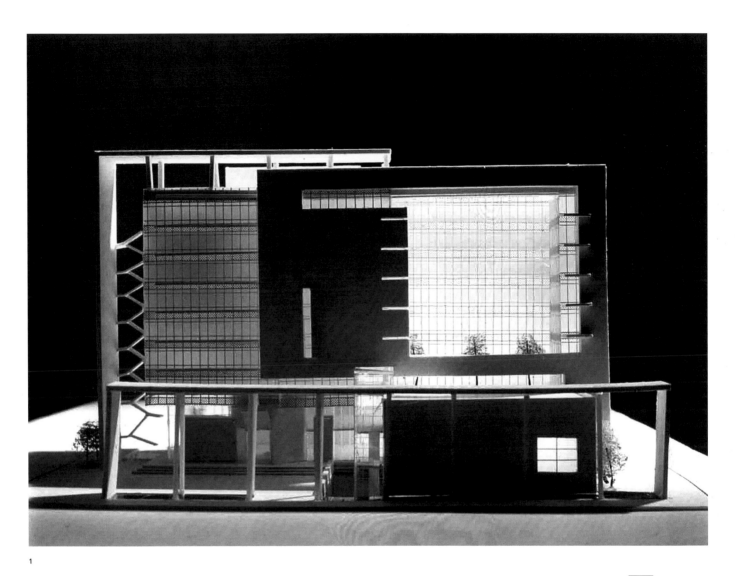

1

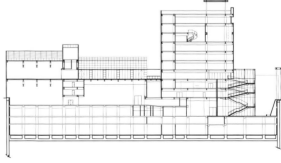

2

1 MODEL, VIEW OF SOUTHWEST ELEVATION
2 LONGITUDINAL SECTION

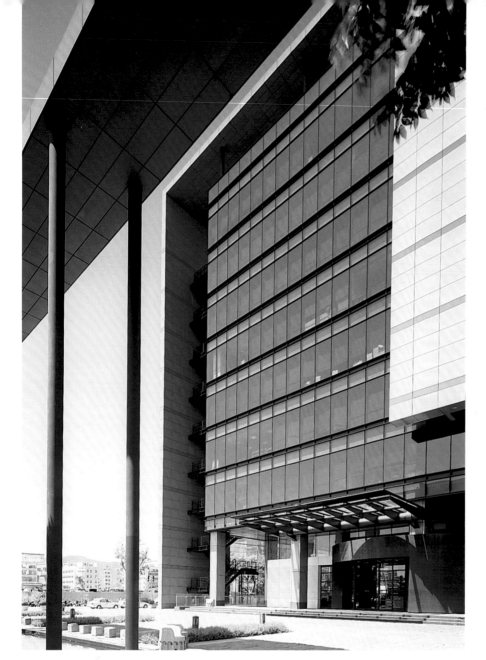
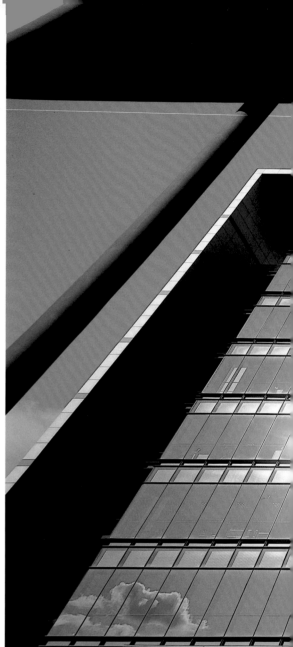

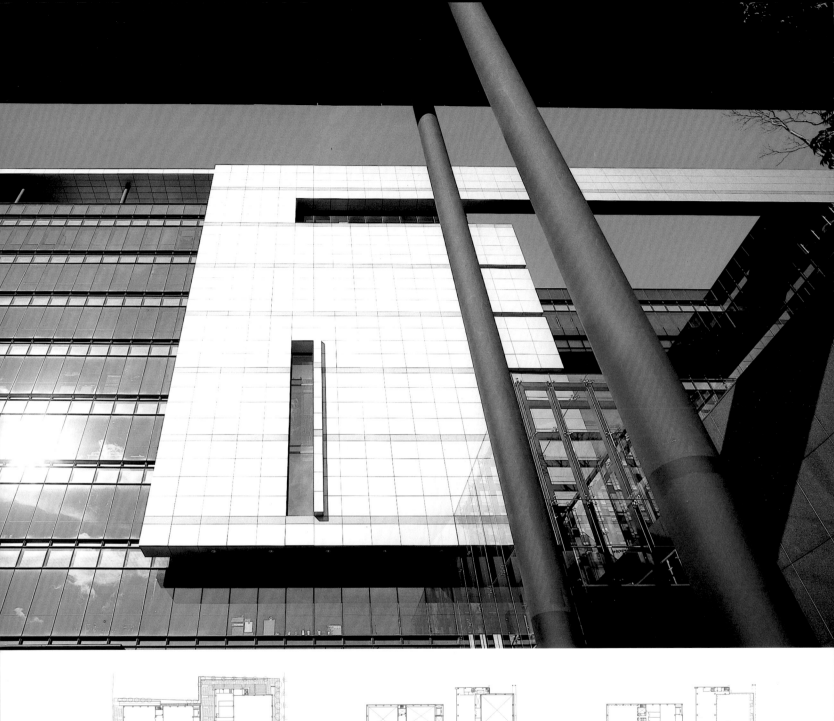

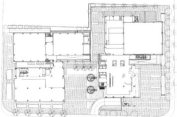

1

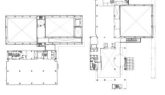

2

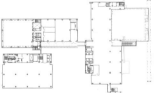

3

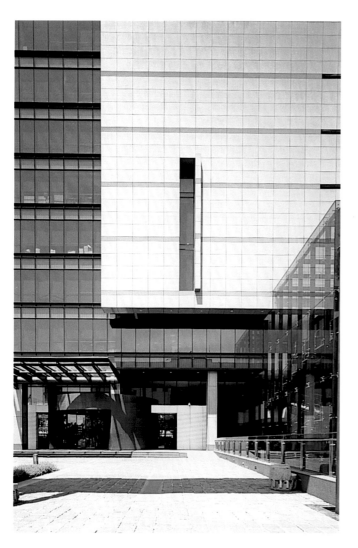
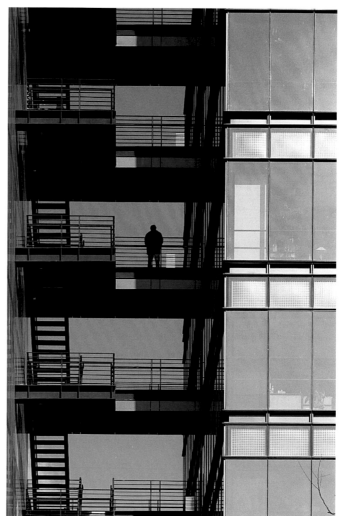

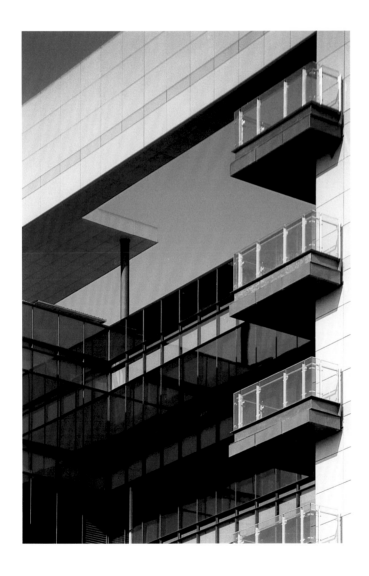

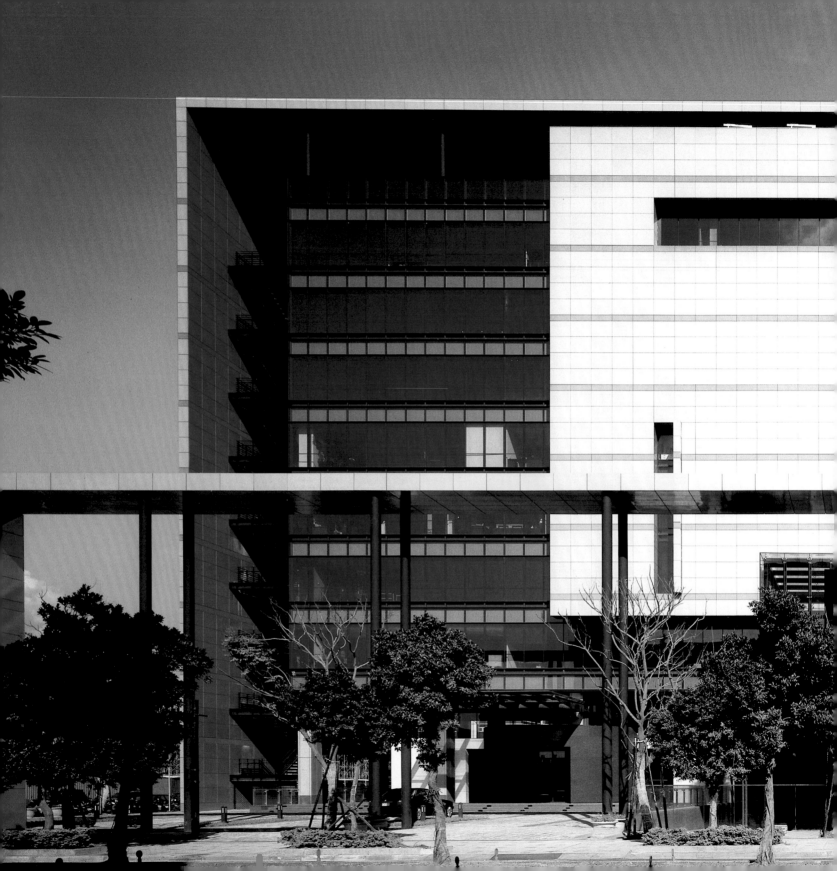

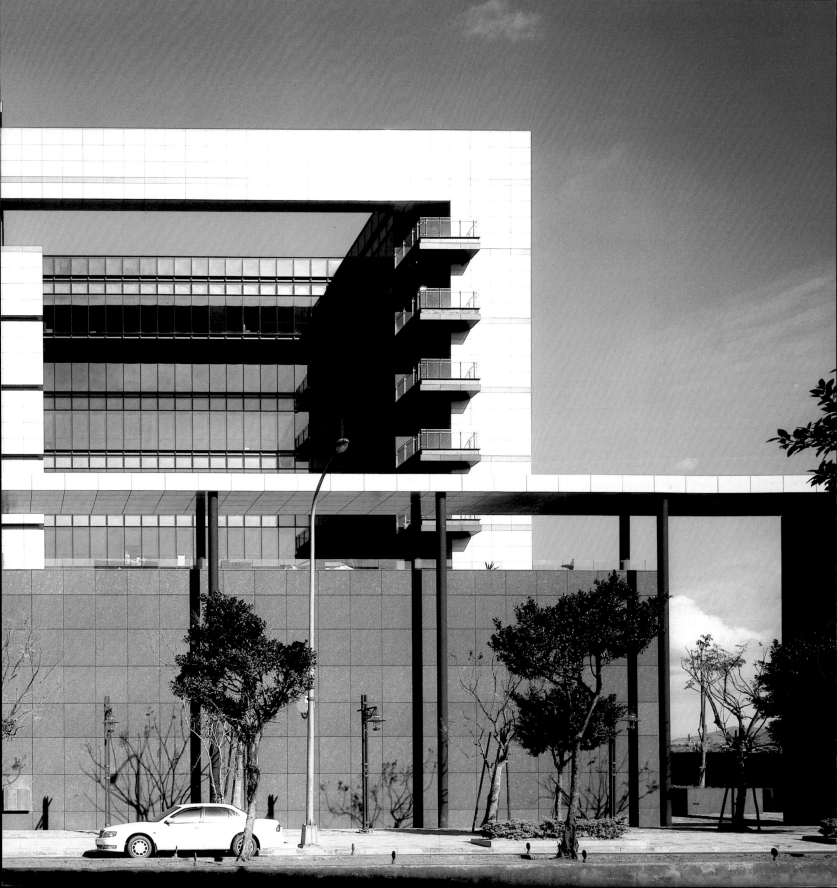

Large-scale serenity: above the grand stairs and under the floating roof, a multi-level courtyard attains its tranquility through disciplined spatial elements.

QUANTA RESEARCH AND DEVELOPMENT CENTER (QRDC)

Quanta Computer Inc.

The Quanta Research and Development Center is a high-tech campus for the humanities and technological research. It provides spaces for health, leisure, and culture. The center is located on a rectangular site with an east–west orientation. Its two interlocking masses resonate with the traditional Chinese ying and yang, leaving open a large central courtyard that serves as the focal point for the complex. In terms of *feng shui*, the courtyard also functions as a container for chi, or energy, while the interaction between the solid building structures and the empty spaces creates an interesting spatial orientation. The courtyard also allows for outdoor activities and exhibitions.

The canopy covering the courtyard is the most prominent element of the center. With its curved shapes and transparent materials, the canopy is made to resemble a white cloud hovering above the plaza. The aerodynamic "Think-Tank" projects outward from the canopy, like a dragon's head soaring above the clouds. The 10-meter transparent, glazed curtainwall in the "Think-Tank" offers an expansive view of the center and the grand canopy below.

To separate the circulation areas of staff members from visitors, public areas such as the conference rooms, training center, restaurant, and café are located on the ground floor. Staff walk up the grand stairs on the south side to access their offices from the central courtyard. On the east, west, and south elevations, the building is adorned with barcode-like aluminum and glass sunshades. The perforated aluminum panels and patterned glass create a visually appealing layered elevation with a high-tech image for the building.

PROJECT DATA

LOCATION
TAOYUAN COUNTY, TAIWAN

FUNCTION
OFFICE BUILDING

DESIGN / COMPLETION
2001 / 2004

SITE AREA
48,311 M²

GROSS FLOOR AREA
212,371 M²

FLOOR LEVELS
7 FLOORS ABOVE GROUND, 3 FLOORS BELOW GROUND

STRUCTURE
STEEL FRAME CONSTRUCTION

MATERIALS
GLASS, GRANITE, PERFORATED ALUMINUM PANELS, TEFLON MEMBRANE, TEMPERED GLASS WITH FRITTED PATTERN

NOTE
HONORABLE MENTION, THE TAIWAN ANNUAL ARCHITECTURE AWARD 2005

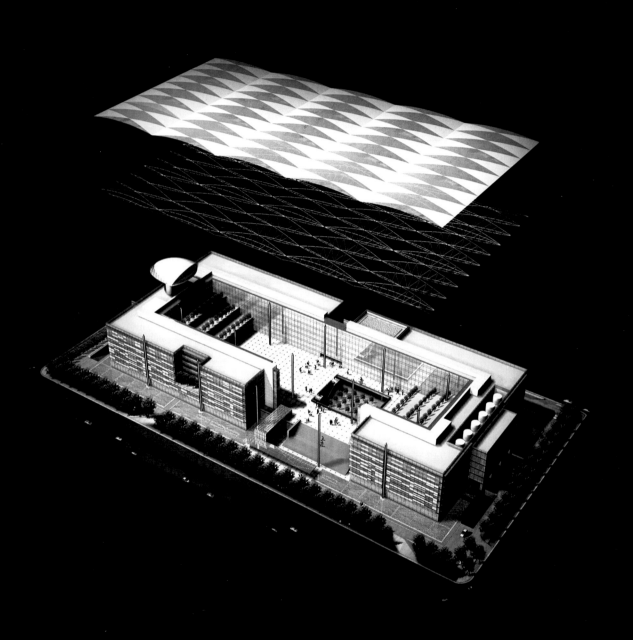

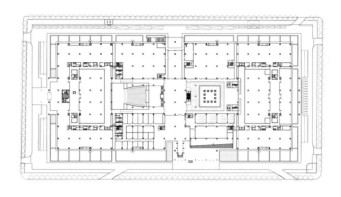

1

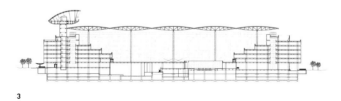

2

3

1 GROUND FLOOR PLAN
2 SECOND FLOOR PLAN
3 LONGITUDINAL SECTION
OPPOSITE PAGE EXPLODED AXON

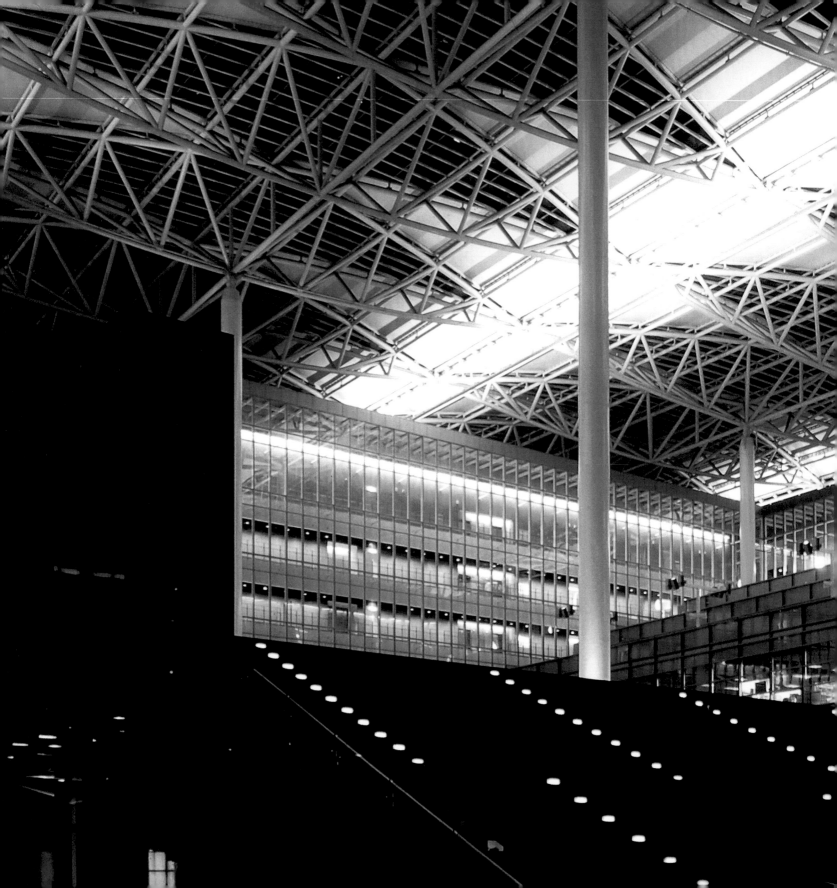

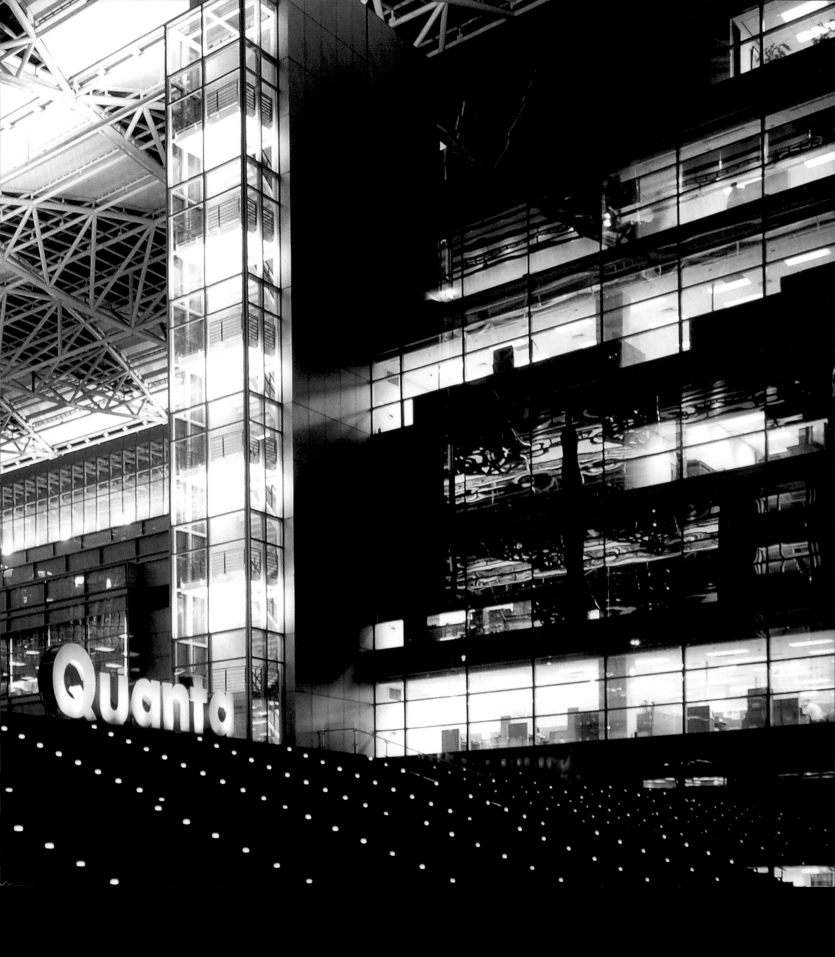

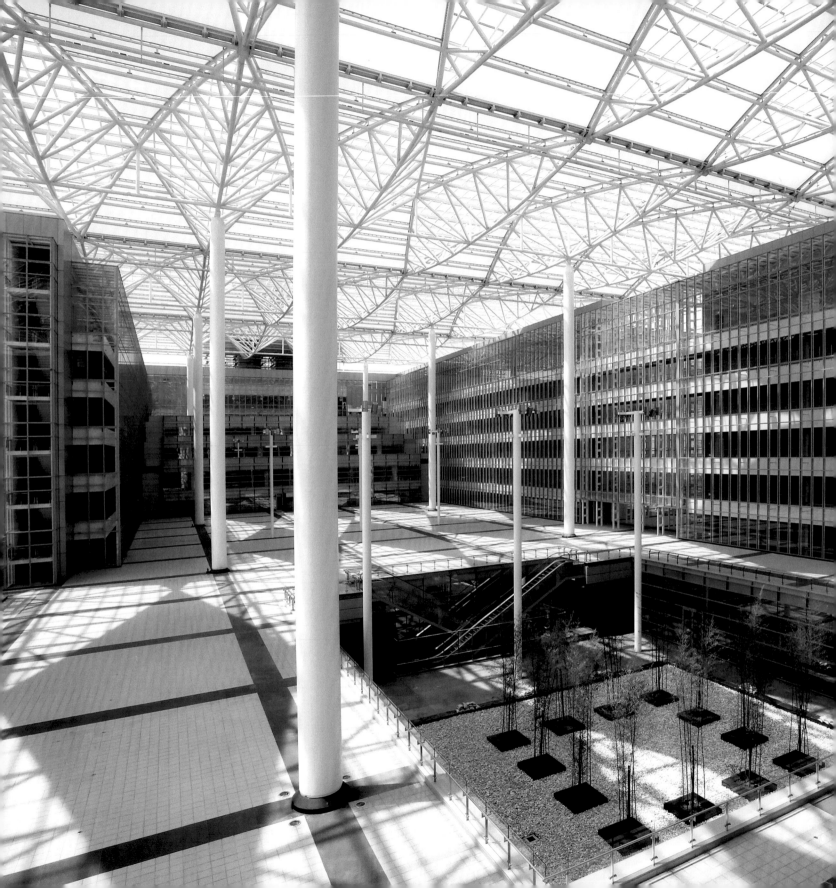

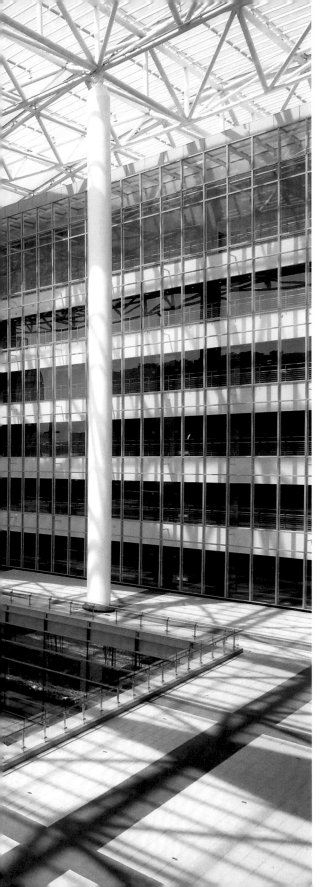

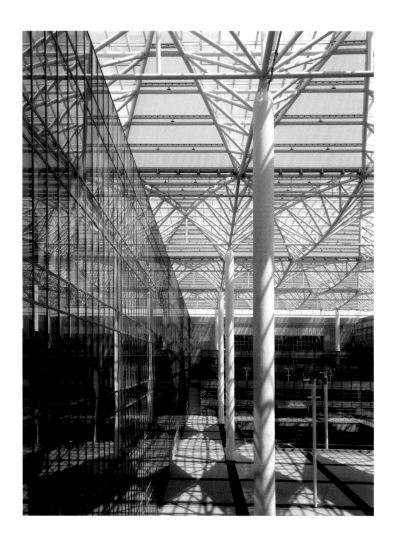

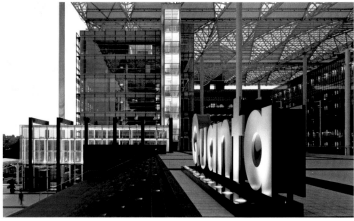

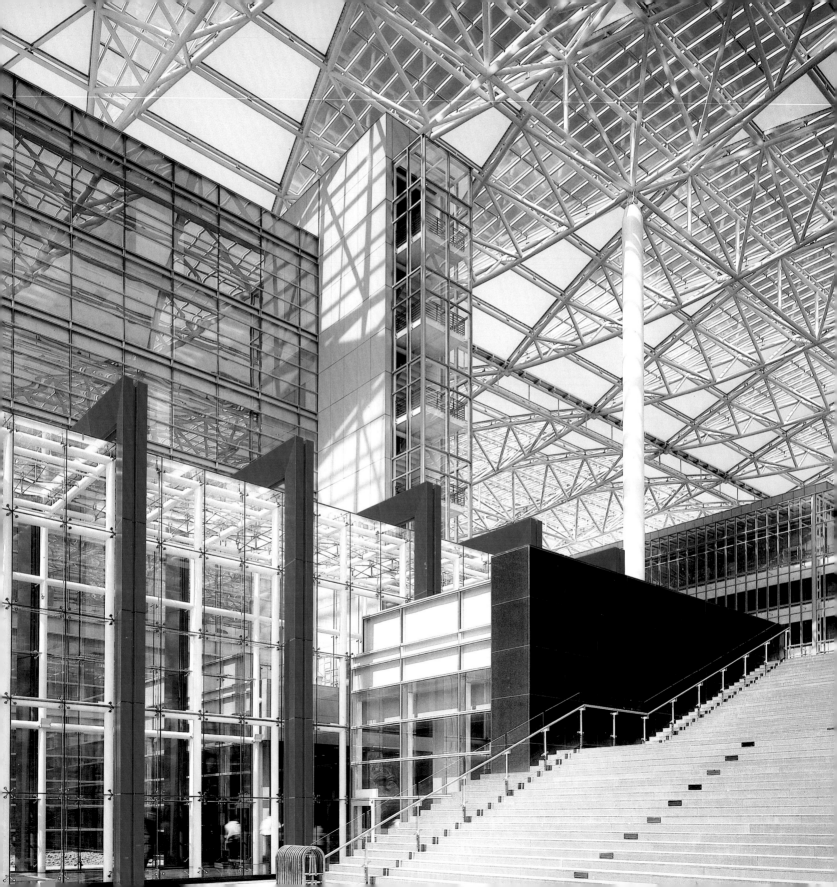

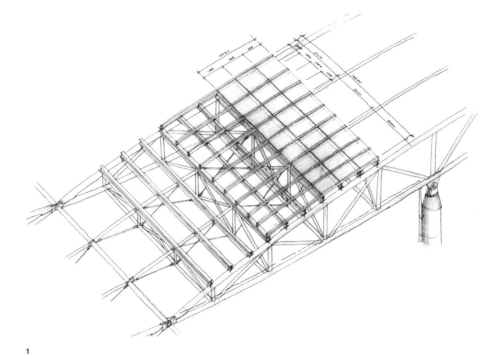

1 GLASS AND MEMBRANE ROOF
OPPOSITE PAGE ENTRANCE OF THE CENTER

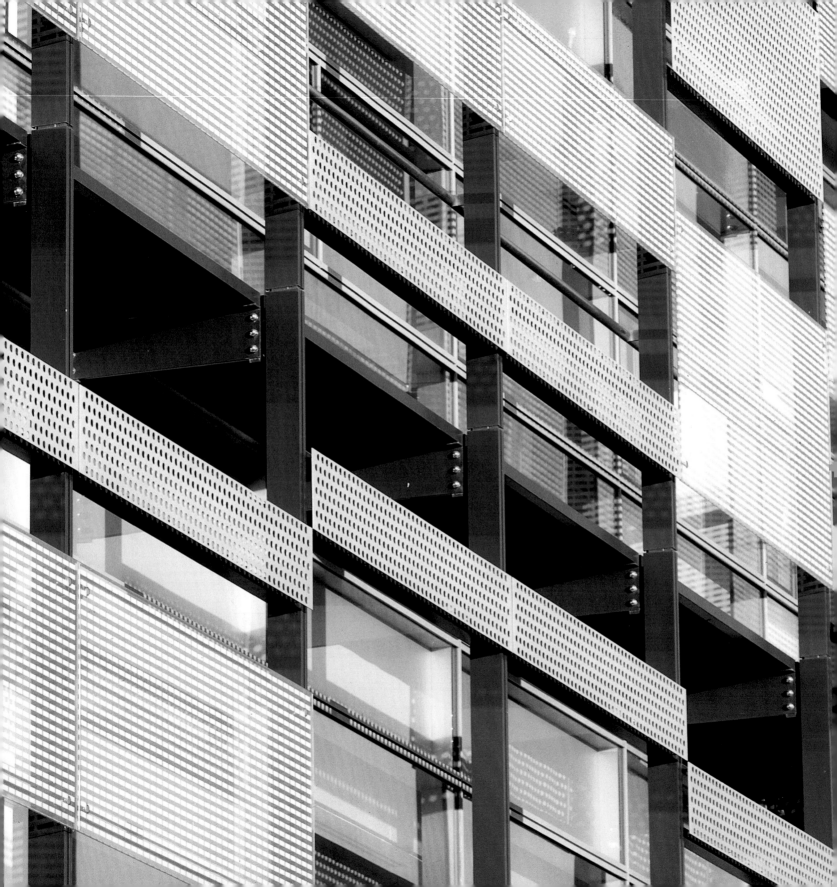

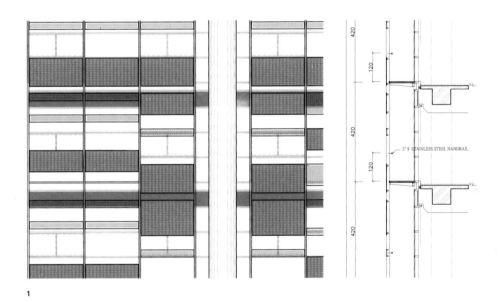

1 DETAIL OF SUNSHADES

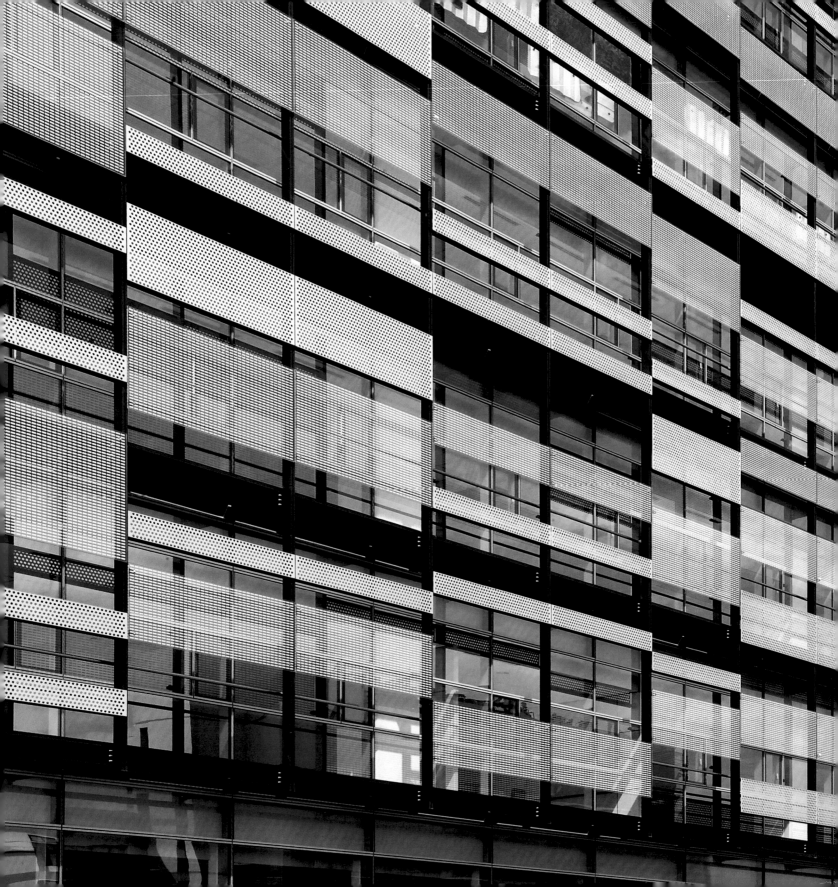

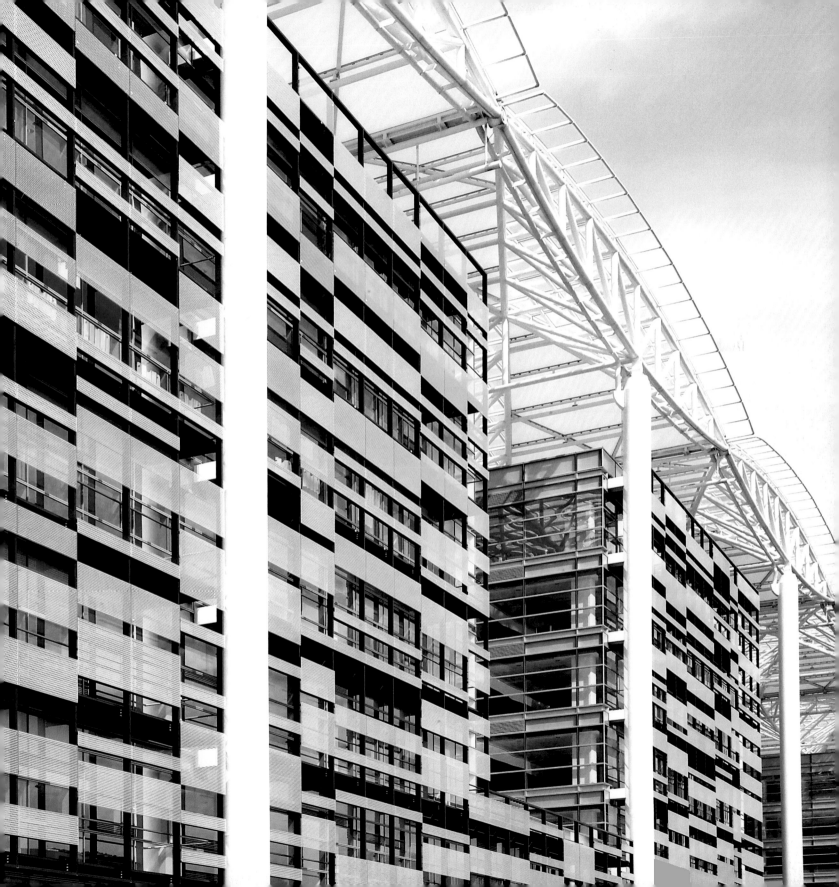

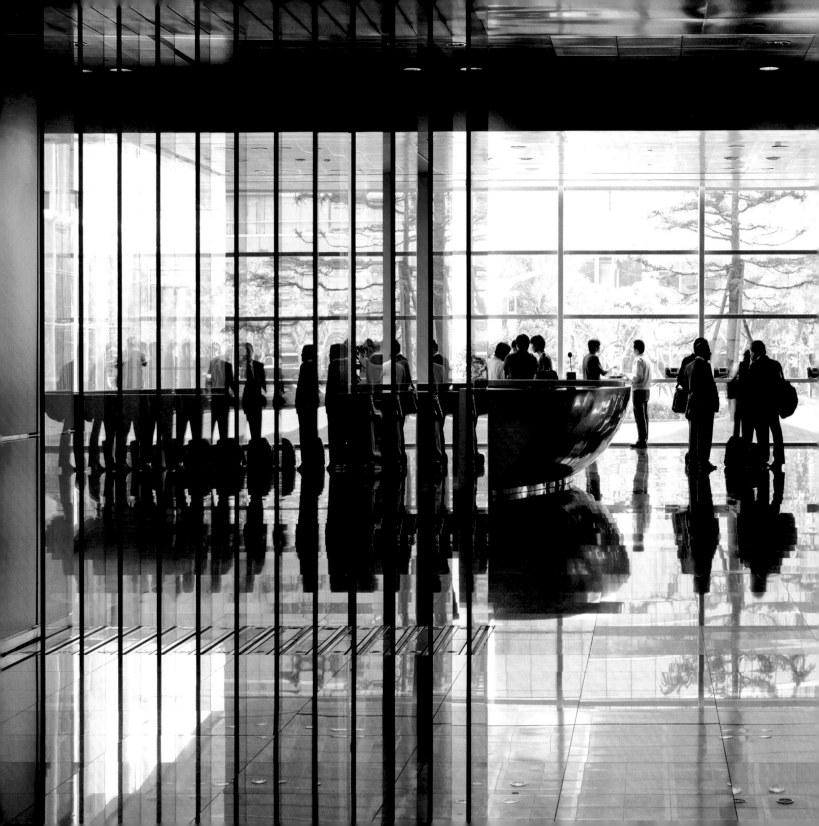

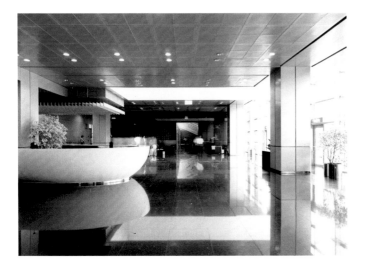

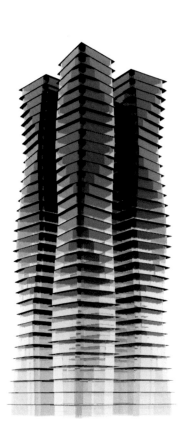

Four multi-faceted square tubes are bundled together to optimize seismic resistance and express the aesthetics of strength in steel.

CHINA STEEL CORPORATION HEADQUARTERS

China Steel Corporation (CSC)

The port city of Kaohsiung, located in southern Taiwan, is transforming itself from an industrial town into a multi-functional business and trading city. The China Steel Corporation Headquarters is located in an area adjacent to the port where the largest urban development in Kaohsiung in recent years is taking place. This area will facilitate functions ranging from transportation, logistics, and trading to culture, recreation, and institution. The headquarters will be an integral element of this new area, and will also become the new landmark for the Kaohsiung Port.

The building is composed of four square tubes bundled together by a shared central core. Each tube is turned 12.5° in increments of eight stories, forming a dynamic geometry. The exterior mega-bracings span every eight stories, with their tiebacks forming terraces at every interval. The diamond-shaped double skin curtain wall allows for optimized natural lighting and ventilation that reduces heat-gain, minimizes energy consumption, and shields traffic noise in this warm urban climate. At the ground level, the square tower sits on a round pond at the center of the site. The remaining site is densely landscaped with trees to provide a comfortable pedestrian environment.

PROJECT DATA

LOCATION
KAOHSIUNG, TAIWAN

FUNCTION
OFFICE BUILDING

DESIGN / COMPLETION
2004 / EXPECTED 2011

SITE AREA
11,126 M²

GROSS FLOOR AREA
69,667 M²

FLOOR LEVELS
29 FLOORS ABOVE GROUND, 3 FLOORS BELOW GROUND

STRUCTURE
STEEL FRAME CONSTRUCTION

MATERIALS
ALUMINUM PANELS, GRANITE, LOW-E GLASS, STAINLESS STEEL

GREEN BUILDING AWARD
TAIWAN EEWH / GOLD

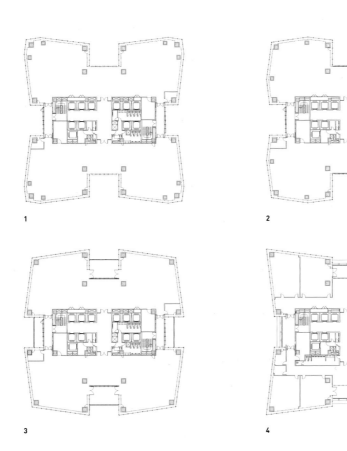

1 SECOND FLOOR PLAN
2 FIFTH FLOOR PLAN
3 EIGHTH FLOOR PLAN
4 SIXTEENTH FLOOR PLAN
5 MODEL, AERIAL VIEW
6 MODEL, VIEW OF NORTHEAST

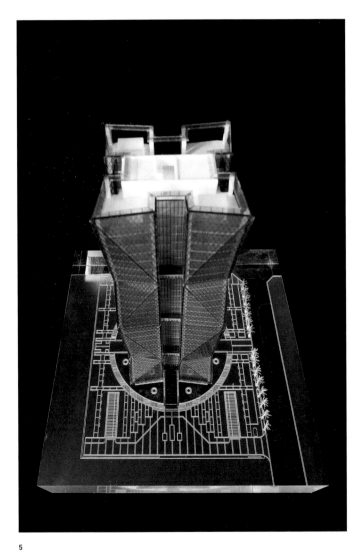

5

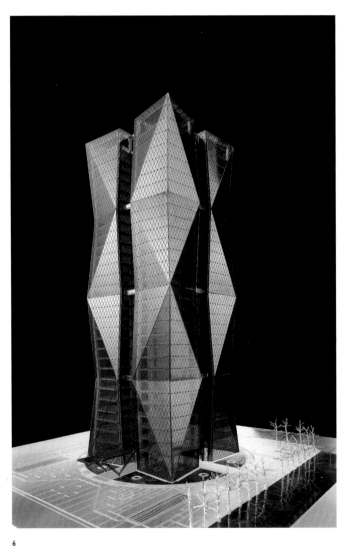

6

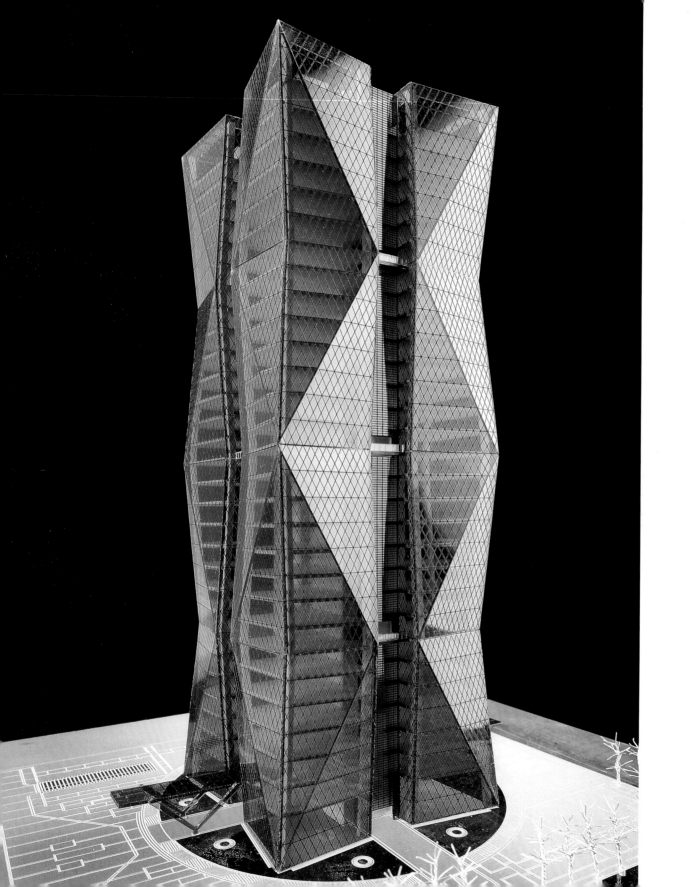

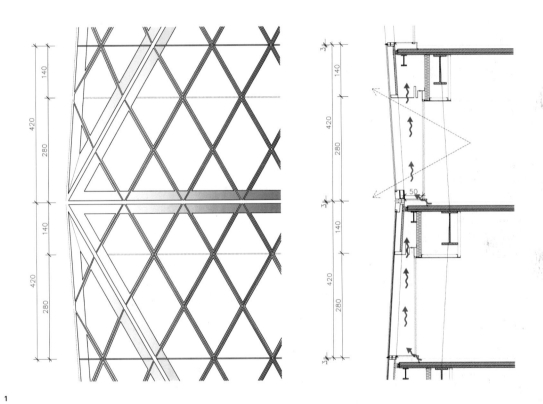

1 DETAIL OF FAÇADE
OPPOSITE PAGE MODEL, VIEW OF NORTHEAST

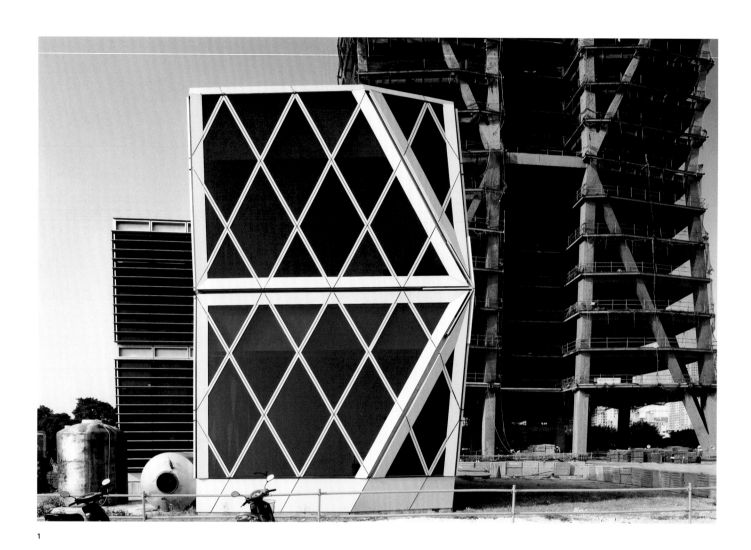

1

1 MOCK-UP
2 CROSS SECTION

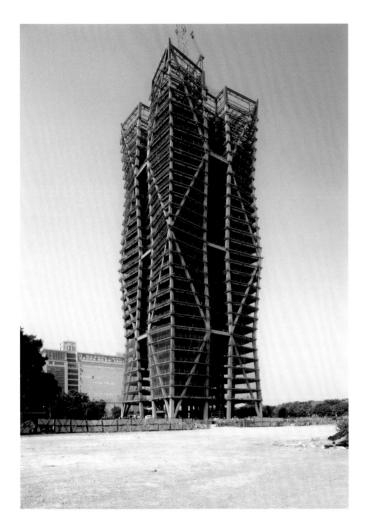

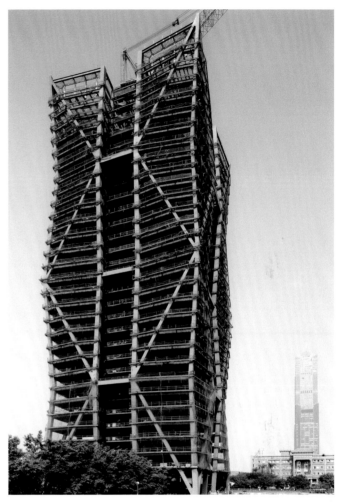

2

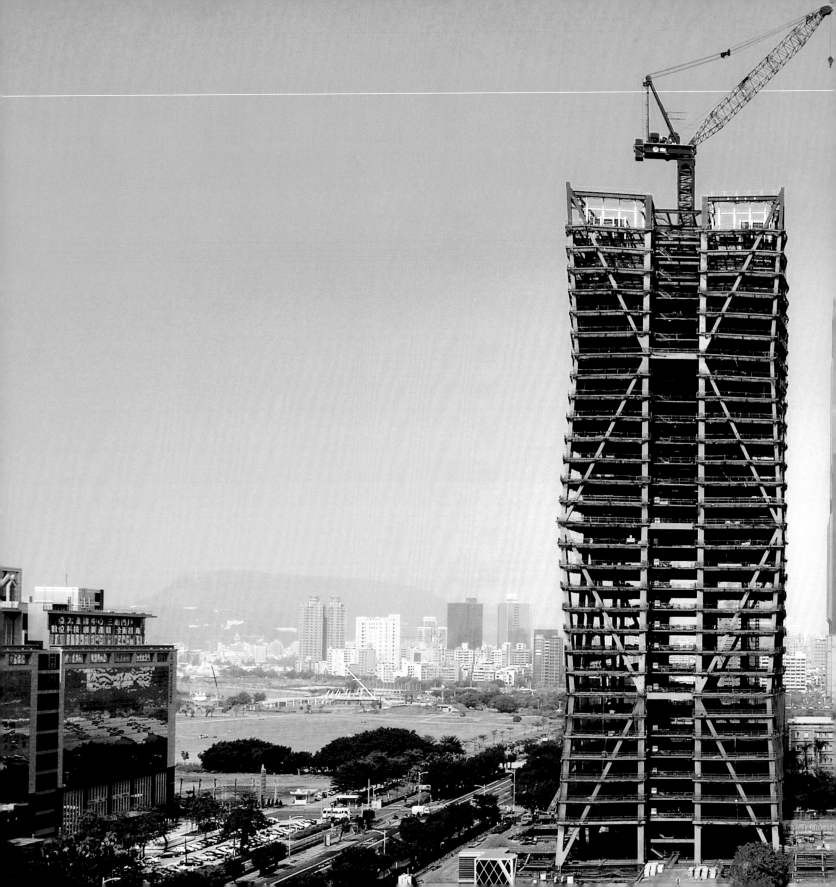

A series of crystal-like volumes packed inside a portal frame, leaving gaps of spaces penetrating the building.

KELTI CENTER
GSharp Corporation.

Located in downtown Taipei, the Kelti Center is a complex that houses corporate offices, an event hall on the top floor, and commercial spaces on the lower levels. Adopting the existing narrow rectangular form of the site with an east–west orientation, the building is set back from the street on the west side—this allows space for a generous open plaza with wide platform stairs.

Two low-rise volumes flanked by service cores on each side and a high-rise structure suspended from the "portal frame" make up the complex. The space between the lower volumes forms the building's entrance. The high-rise structure resembles crystallized rock with alternating dark and light-colored glazing, and is supported by a service core enclosed by a stone façade. It projects an image of trendy elegance and light-hearted tectonics.

The building's lower commercial levels are designated for showrooms and restaurants. The middle section houses corporate offices, and the top floor is a sky-lit, 13.5-meter-high event hall with a spectacular view of the city. Sunlight streams into the restaurants in the basement from the expansive first floor lobby. The service cores are located on the north and south sides to give maximum flexibility for the spaces in between.

PROJECT DATA

LOCATION
TAIPEI, TAIWAN

FUNCTION
COMMERCIAL MIXED USE BUILDING

DESIGN / COMPLETION
2005 / 2009

SITE AREA
5,864 M²

GROSS FLOOR AREA
28,824 M²

FLOOR LEVELS
15 FLOORS ABOVE GROUND, 3 FLOORS BELOW GROUND

STRUCTURE
STEEL FRAME CONSTRUCTION

MATERIALS
ALUMINUM PANELS, GOLD GRANITE, LOW-E GLASS

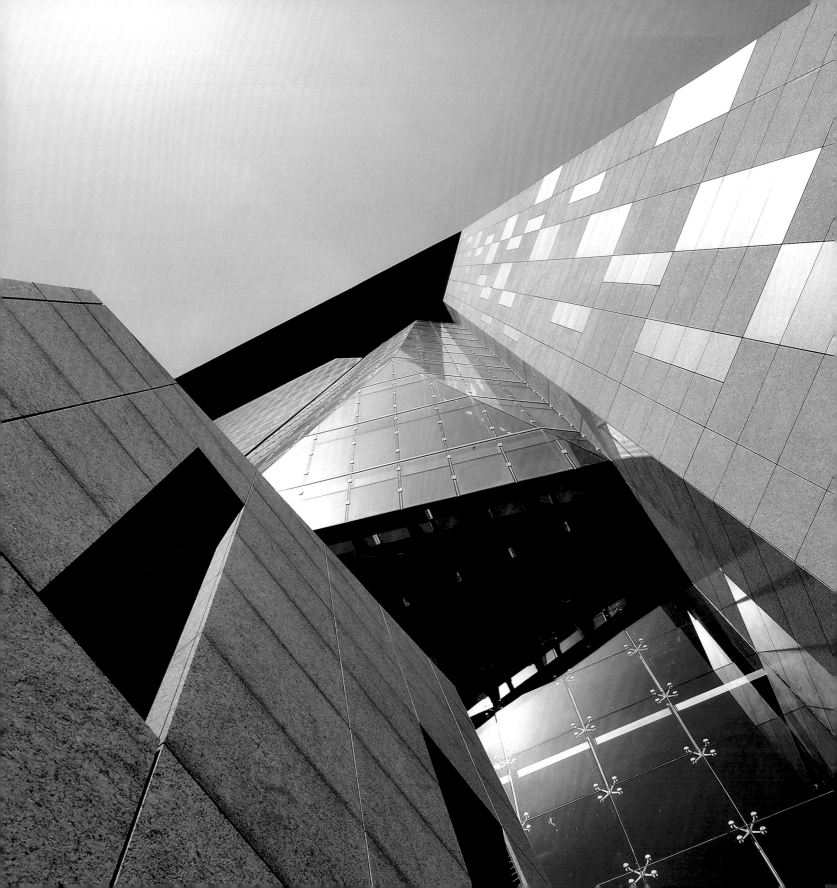

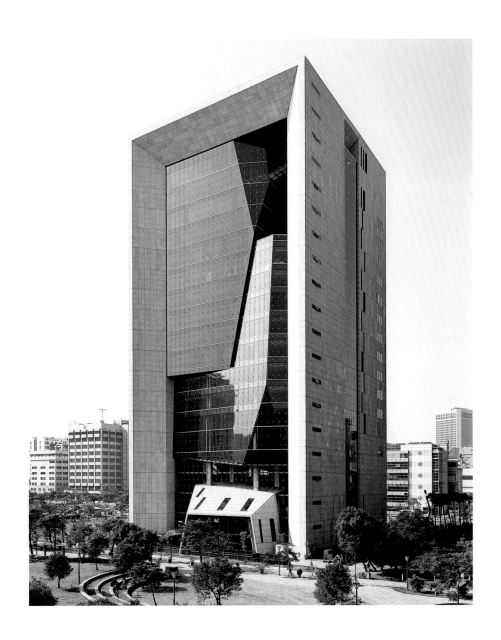

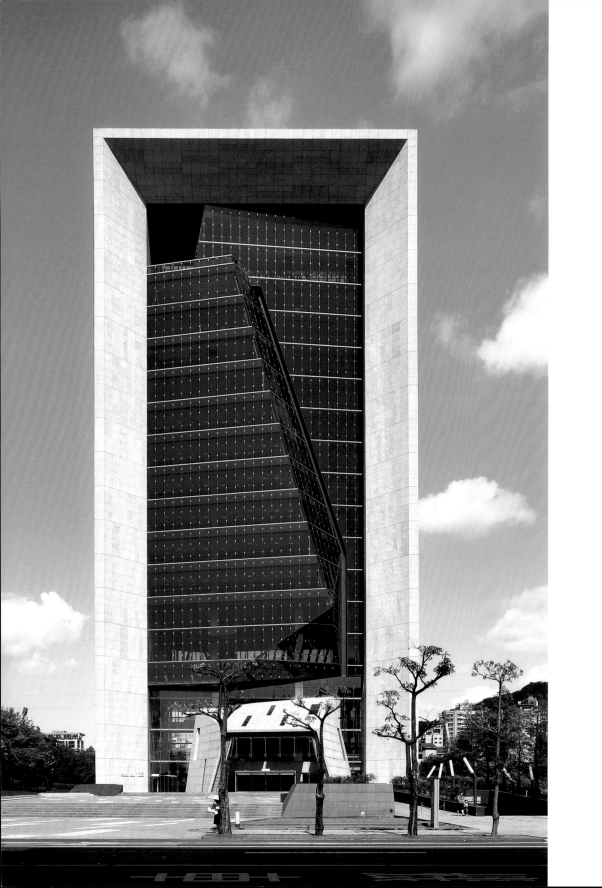

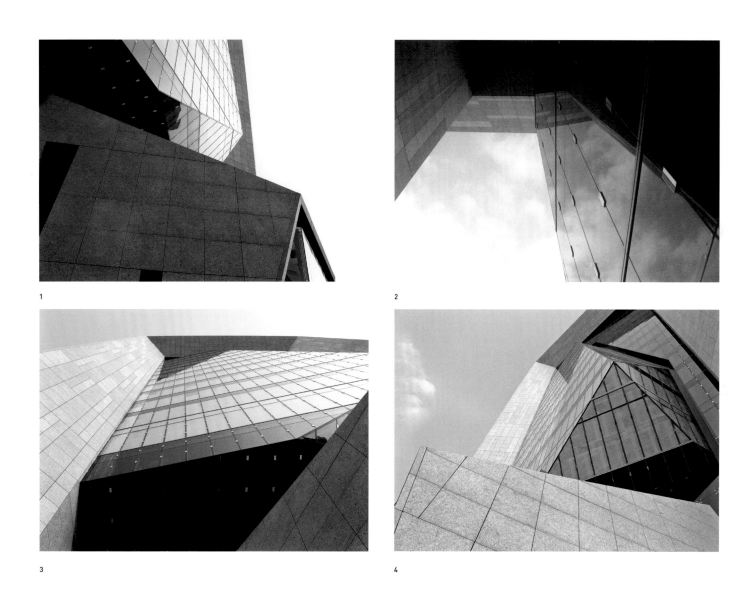

1

2

3

4

1, 2, 3, 4 DETAIL OF FAÇADE

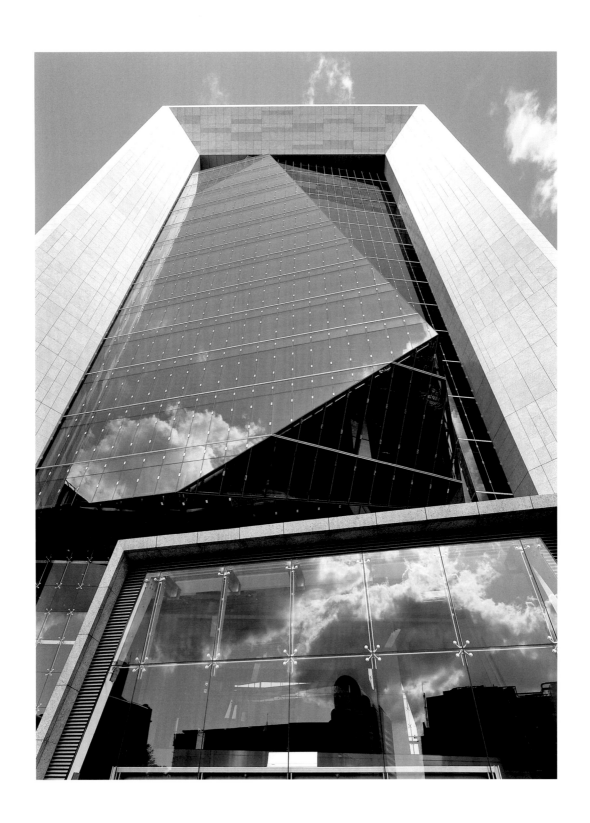

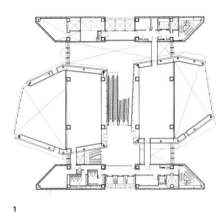

1

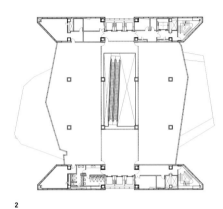

2

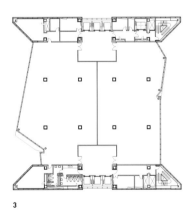

3

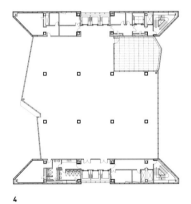

4

1 SECOND FLOOR PLAN
2 THIRD FLOOR PLAN
3 SIXTH FLOOR PLAN
4 ELEVENTH FLOOR PLAN

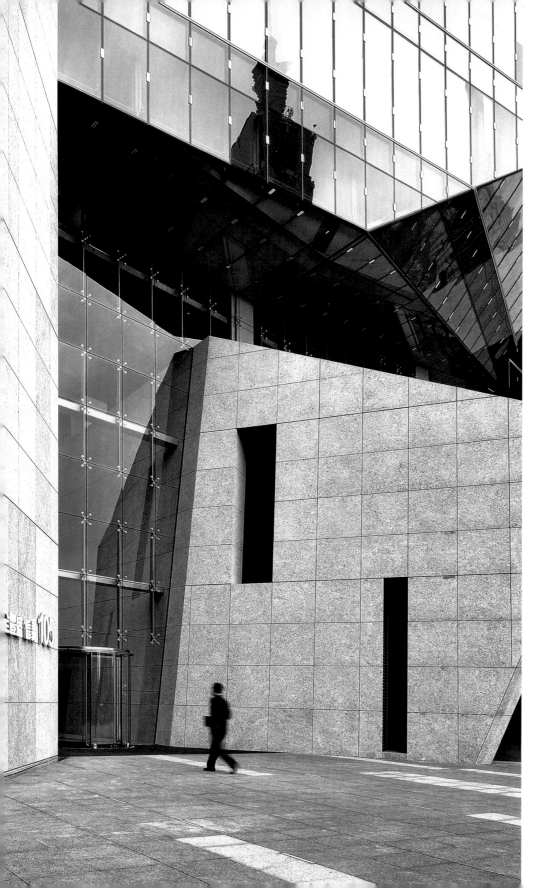

1

1 LONGITUDINAL SECTION
LEFT MAIN ENTRY

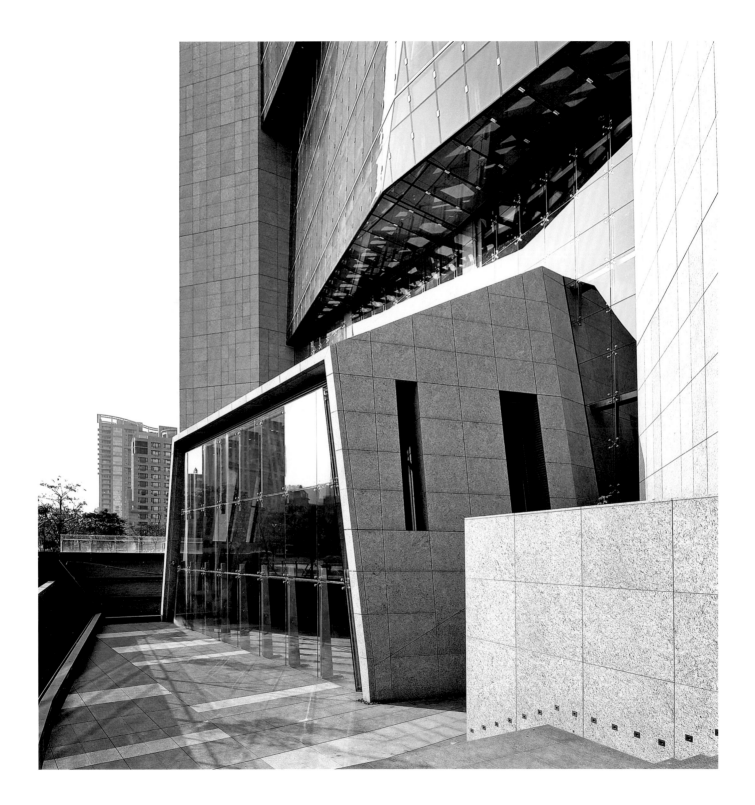

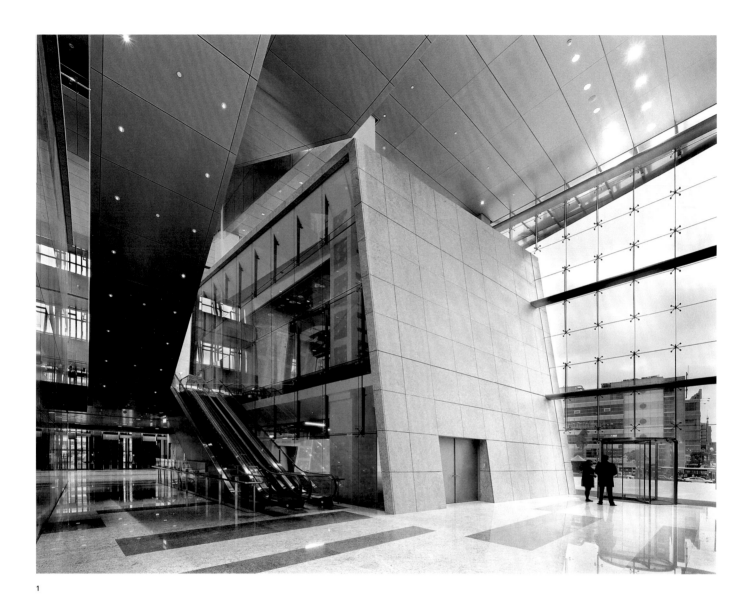

1

1 LOBBY
2 BRIDGE CONNECTING TO RESTAURANT

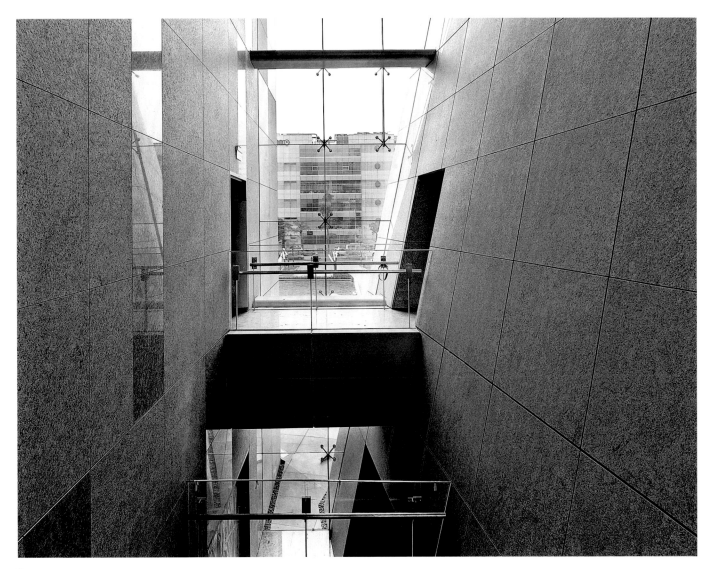

2

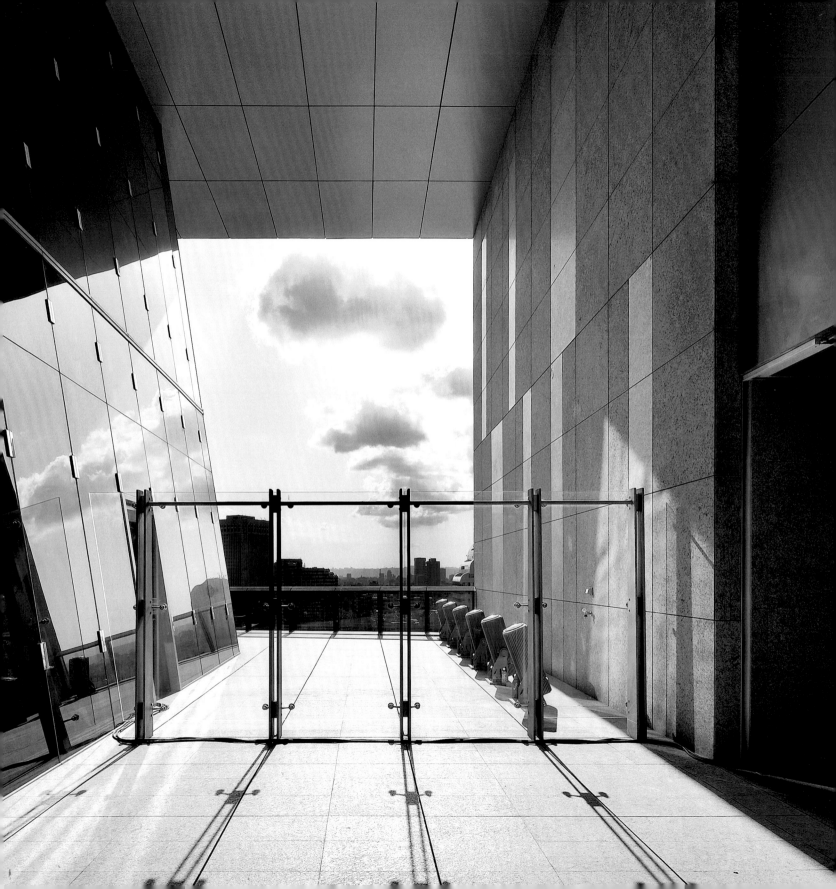

Three void "volumes" are inserted into a solid rectangular cube, allowing the interplay of space and light within.

HTC TAIPEI HEADQUARTERS
HTC Corporation

Large working planes for flexibility, minimum exposure to the outside for security reasons, maximum openness for internal interactions, and a unique spatial experience for the staff—these are the qualities requested by the world-renowned innovative powerhouse, HTC Corporation, in the design of their new headquarters.

The massive and abstract rectangular cube has fewer windows on the outside than a normal office building; however, three void "volumes" were inserted into the cube to bring in natural light and a sense of openness. One of the volumes is transversal on the lower floors, another longitudinal on the top floors, and the last in the middle forms two all-glass levels. These house public facilities for the headquarters such as the dining hall,

café, gym, library, and recreation center. The gaps created by the void spaces help to open up the space and provide visual and physical interactions. Open bridges and stairways crossing over the gaps provide more opportunities for interaction on the otherwise massive floor plan.

Visitors entering the relatively mute façade find themselves in a canyon-like atrium with people walking across on bridges and stairs, a white, media-loaded lobby with bamboo in the middle, and casual seating around for meetings. All these elements provide an unforgettable experience that HTC strives to achieve in their products.

PROJECT DATA

LOCATION
TAIPEI COUNTY, TAIWAN

FUNCTION
OFFICE BUILDING

DESIGN / COMPLETION
2008 / EXPECTED 2011

SITE AREA
8,347 M²

GROSS FLOOR AREA
85,621 M²

FLOOR LEVELS
17 FLOORS ABOVE GROUND, 5 FLOORS BELOW GROUND

STRUCTURE
STEEL FRAME CONSTRUCTION

MATERIALS
ALUMINUM PANELS, CRYSTALLIZED GLASS, LOW-E GLASS

GREEN BUILDING AWARD
TAIWAN EEWH

NOTE
FIRST PRIZE, YULON / HTC SHINDIAN TWIN TOWER COMPETITION

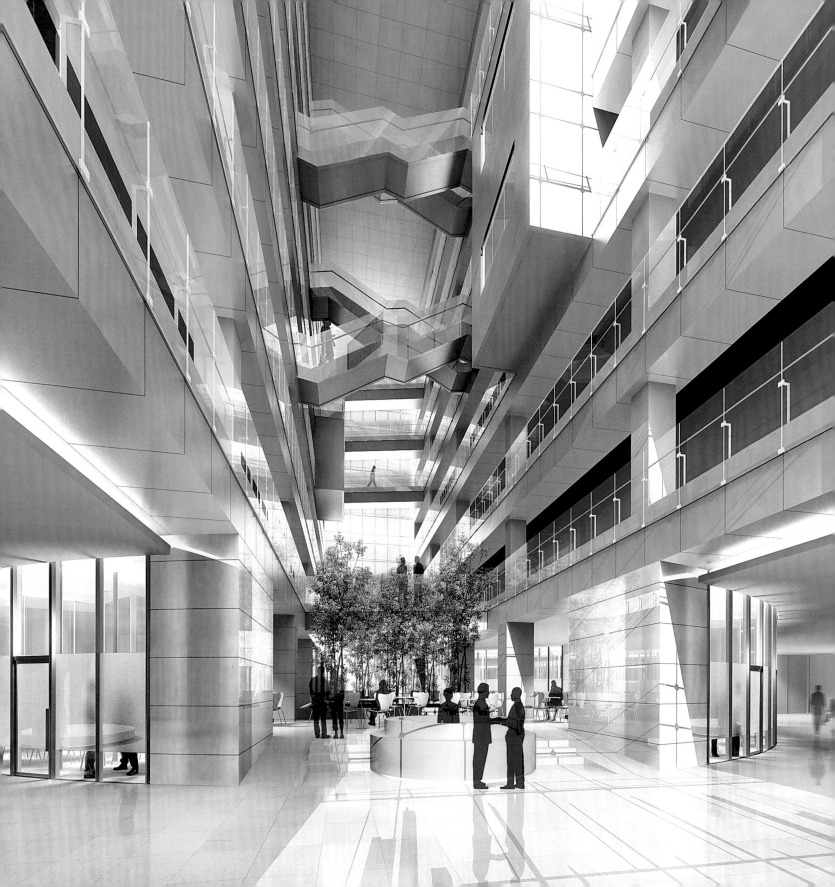

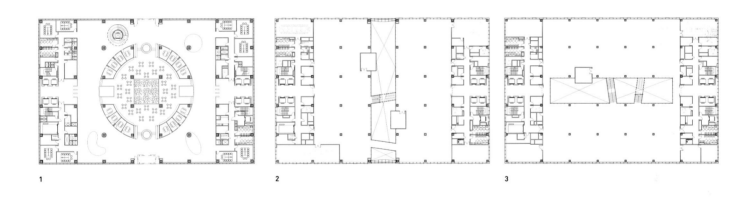

1

2

3

1 FIRST FLOOR PLAN
2 FOURTH FLOOR PLAN
3 ELEVENTH FLOOR PLAN
OPPOSITE PAGE LOBBY

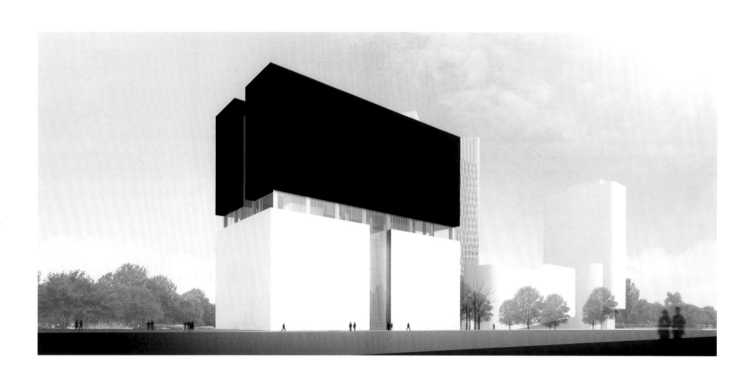

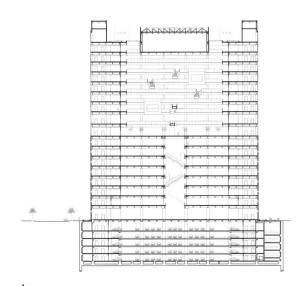

1

An east–west facing building utilizing double-height sky gardens and external structure frames as shading devices to achieve "green".

HUA NAN BANK HEADQUARTERS
Hua Nan Bank

The Hua Nan Bank Headquarters is located in the busy Xinyi District alongside several other financial buildings. Contrary to sustainable design principles, the city planning for this main business district in Taipei has most of its lots facing east and west. In a culture fixated with having significant building façades towards the "front"—east or west in this case—this posed great challenges in designing a green building.

The bank tower rises 154.5 meters from a three-story podium, with the main entrance and long side of the rectilinear plan facing west. Detached from the exterior curtainwall, the peripheral structure is pushed out as an exoskeleton, allowing the spaces in between to be used for balconies. These spaces also act as sun-shading devices to enhance sustainability in the design. This design feature allows the interior space to be column-free with a clean, smooth window line around it for flexibility in space planning. The front center bay of the tower has a series of double-height "sky gardens" that are stacked all the way to the top of the tower. They make for casual meeting and relaxing spaces for the office staff, and serve as buffer zones for reducing heat-gain from the west façade. Over-sized ceiling fans are installed in these spaces to achieve a thermal destratification effect.

With additional energy saving strategies applied throughout the building system, this bank headquarters has acquired a LEED Gold rating in sustainable design.

PROJECT DATA

LOCATION
TAIPEI, TAIWAN

FUNCTION
OFFICE BUILDING

DESIGN / COMPLETION
2008 / EXPECTED 2012

SITE AREA
8,941 M²

GROSS FLOOR AREA
54,179 M²

FLOOR LEVELS
26 FLOORS ABOVE GROUND, 2 FLOORS BELOW GROUND

STRUCTURE
STEEL FRAME CONSTRUCTION

MATERIALS
ALUMINUM PANELS, EXTRUDED ALUMINUM LOUVERS, GOLD GRANITE, LOW-E GLASS, STAINLESS STEEL

GREEN BUILDING AWARD
LEED-NC / GOLD
TAIWAN EEWH / GOLD

NOTE
FIRST PRIZE, HUA NAN BANK HEADQUARTERS COMPETITION.

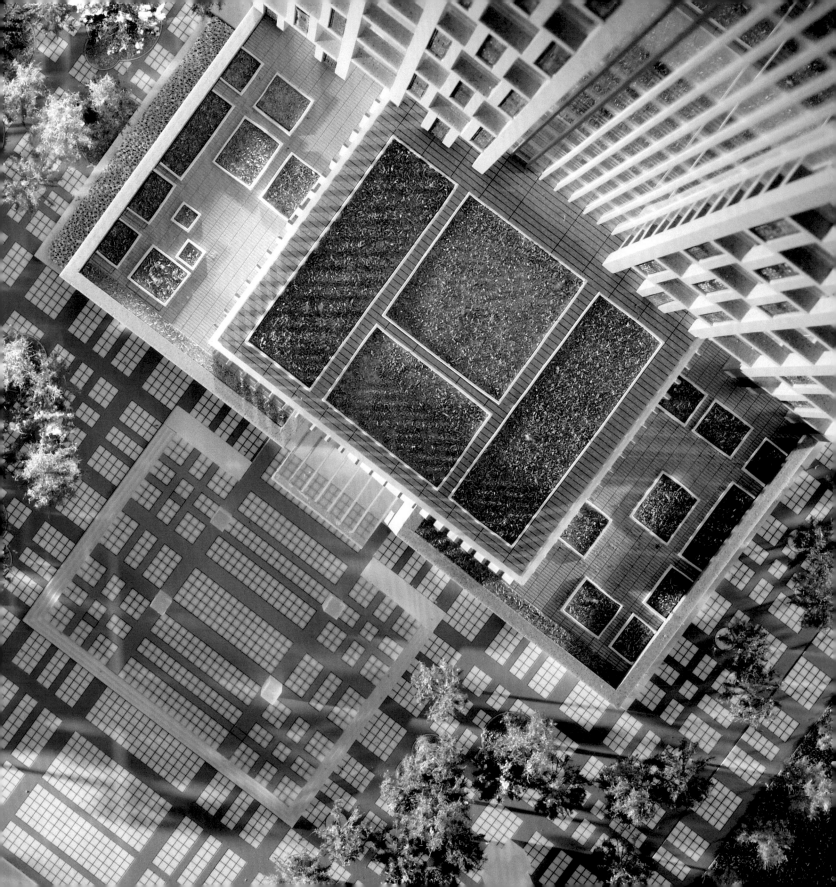

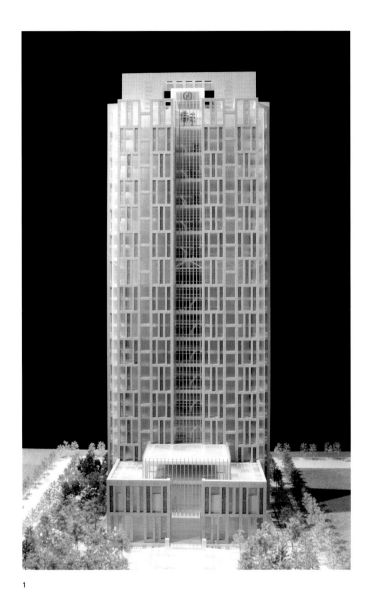

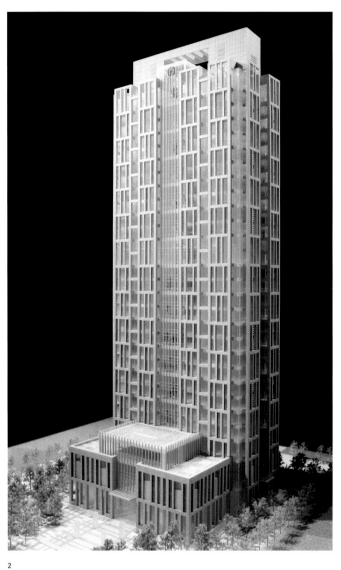

1

2

1 MODEL, VIEW OF WEST ELEVATION
2 MODEL, VIEW OF SOUTHWEST

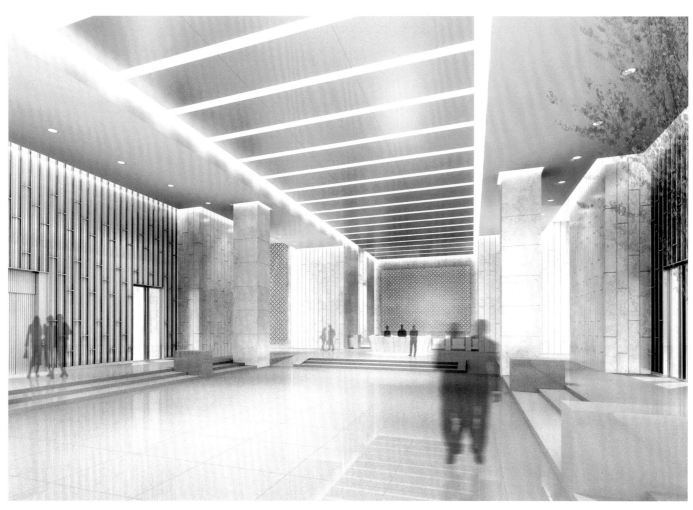

1

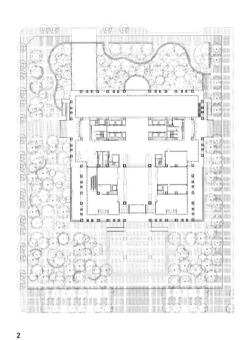

2

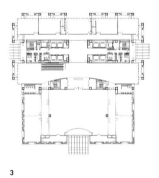

3

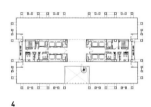

4

1 LOBBY
2 GROUND FLOOR PLAN
3 SECOND FLOOR PLAN
4 TYPICAL FLOOR PLAN

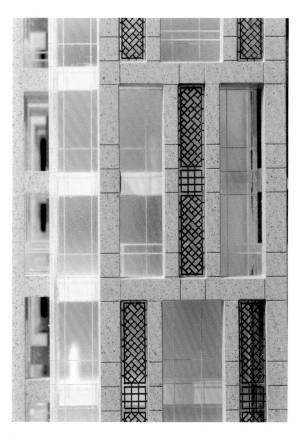

1

2

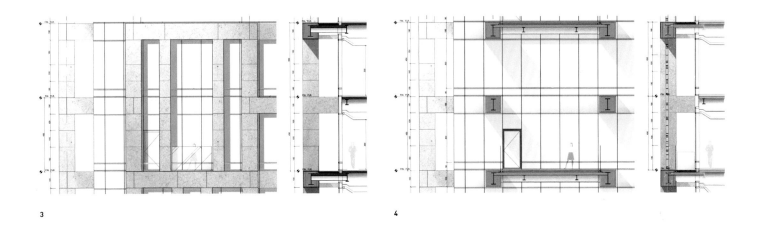

3

4

1 MODEL, DETAIL OF FAÇADE
2 EXPLODED DIAGRAM
3 DETAIL OF FAÇADE
4 DETAIL OF FAÇADE

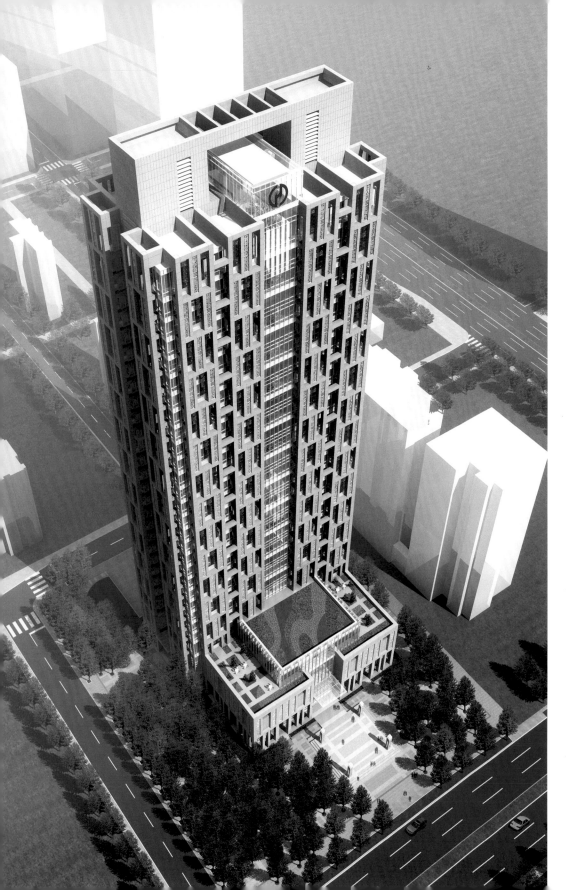

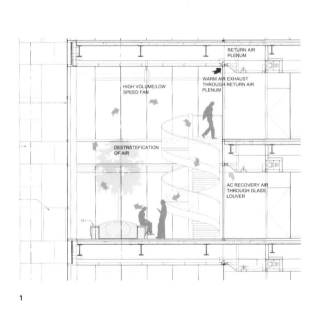

RETURN AIR
PLENUM

HIGH VOLUME/LOW
SPEED FAN

WARM AIR EXHAUST
THROUGH RETURN AIR
PLENUM

DESTRATEFICATION
OF AIR

AC RECOVERY AIR
THROUGH GLASS
LOUVER

ST-1

1

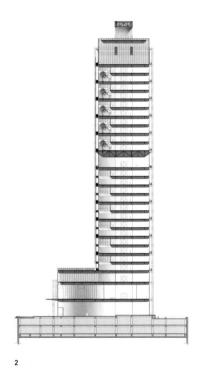

2

1 SKY GARDEN VENTILATION STRATEGY
2 LONGITUDINAL SECTION

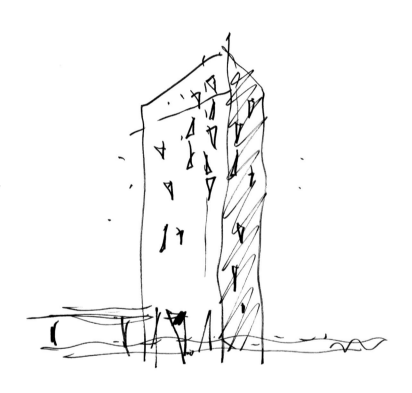

Movements under the building enable glimpses of random reflections from the various triangular prismatic bay windows, creating a dialogue between the public and the architecture through light.

LE OFFICE TOWER

Light Era Development Co. Ltd.

This small, simple office tower located on a corner of a major tree-lined boulevard attains its uniqueness through its façade design.

The four elevations of the building are clad with aluminum panels. Spreading over the façades are floor-to-ceiling triangular window units arranged in a rhythmic fashion. Some of the units are flush with the building elevations, while others are three-dimensional bay windows that face either upwards or downwards. The windows are designed to resemble prisms throughout the elevation to achieve a *chiaroscuro* effect and to create a dynamic, futuristic image. These prism-units will reflect different shades of light, creating an interesting urban dialogue as people pass by the building.

PROJECT DATA

LOCATION
TAIPEI, TAIWAN

FUNCTION
OFFICE BUILDING

DESIGN / COMPLETION
2008 / EXPECTED 2014

SITE AREA
1,169 M²

GROSS FLOOR AREA
14,902 M²

FLOOR LEVELS
21 FLOORS ABOVE GROUND, 4 FLOORS BELOW GROUND

STRUCTURE
STEEL FRAME CONSTRUCTION

MATERIALS
ALUMINUM PANELS, LOW-E GLASS, METAL GRILLE

GREEN BUILDING AWARD
TAIWAN EEWH / GOLD

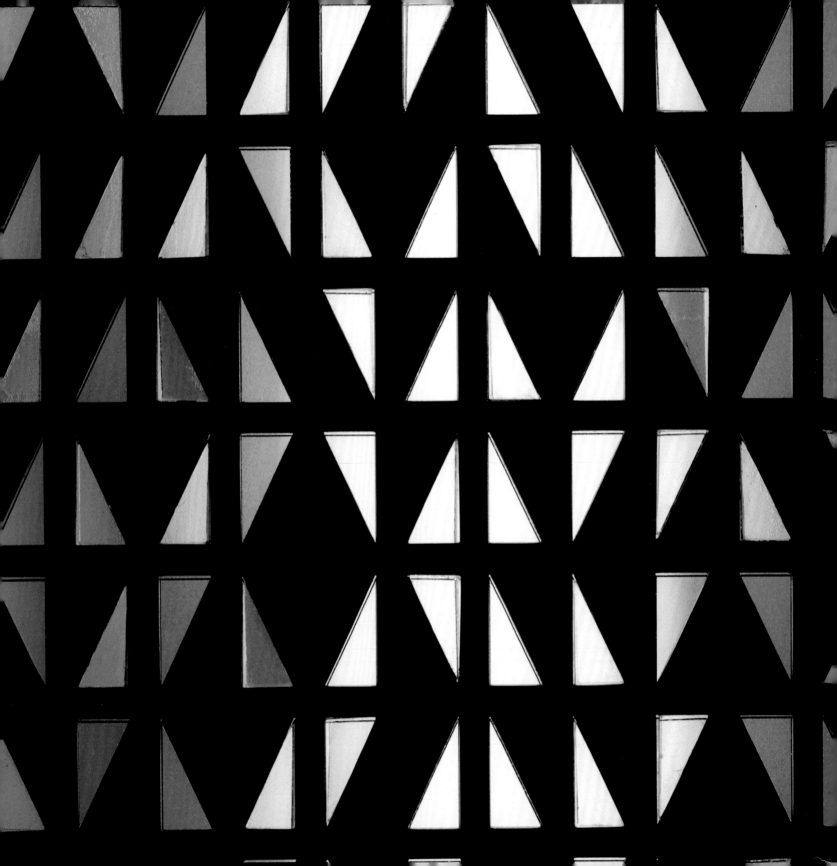

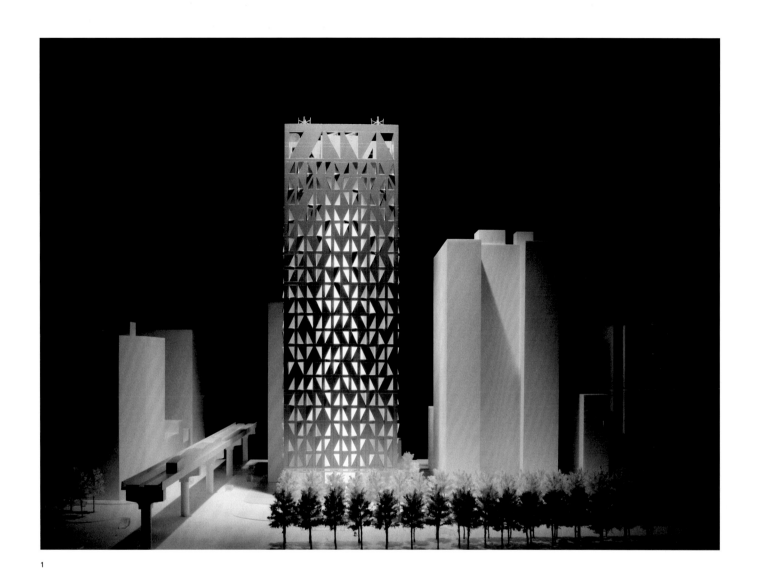

1

1 MODEL, VIEW OF EAST ELEVATION
OPPOSITE PAGE MODEL, RHYTHM OF FAÇADE

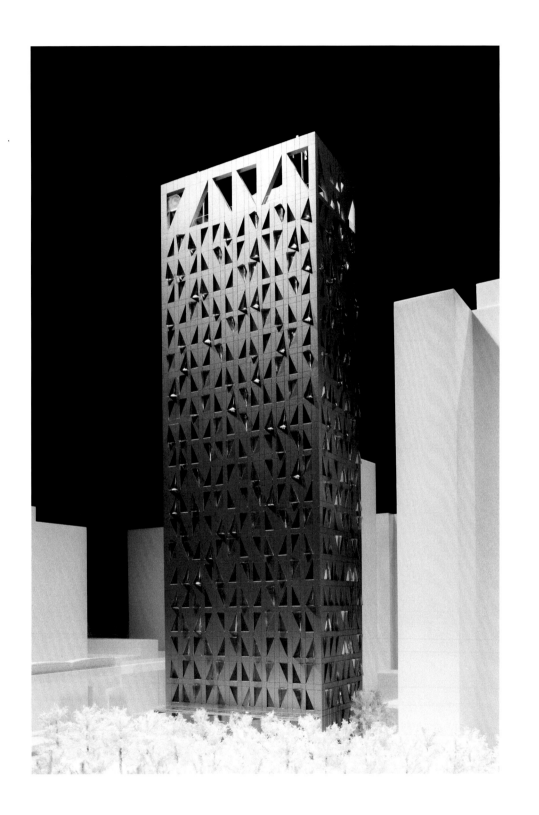

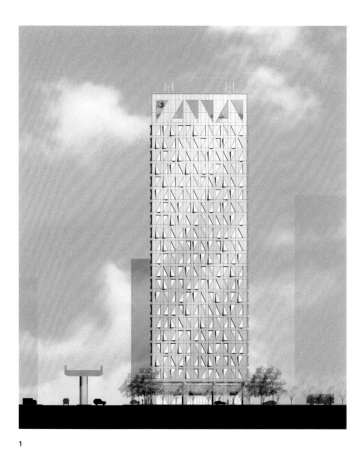

1

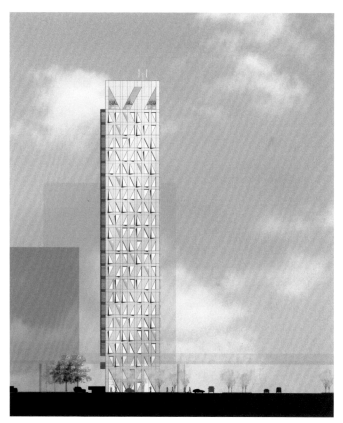

2

1 EAST ELEVATION
2 SOUTH ELEVATION
OPPOSITE PAGE MODEL, VIEW OF NORTHEAST

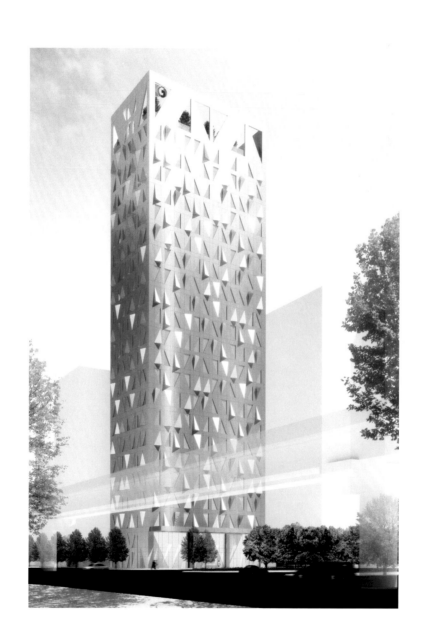

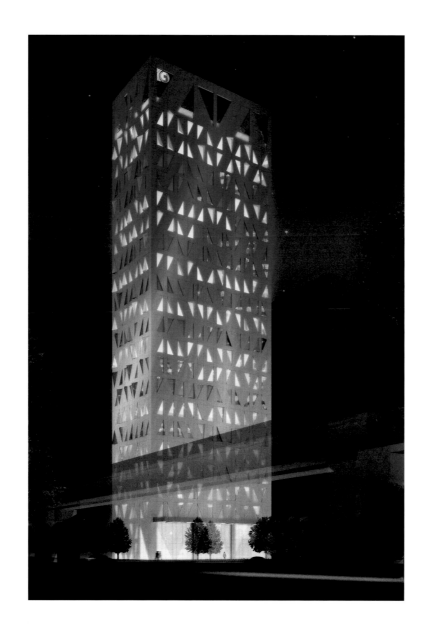

A building invisible in the daytime by reflecting the surroundings, at night it glows like a lantern to reveal the cultural splendor within.

SILKS PALACE, NATIONAL PALACE MUSEUM

NPM Grand Formosa Company Ltd.

Embodying the concept of "inheritance", Silks Palace, the new restaurant facility for the National Palace Museum, blends the colors and materials found in the existing classical architecture with contemporary architectural expressions and techniques. The result is a building that is different from the existing museum buildings, yet blends effortlessly with its surroundings.

Responding to an old Chinese saying, "color weighs more than form", the selection of the color scheme was one of the project's key concerns. The dark brown stone podium extends a visual continuation from the brown tile base of the existing buildings; the yellow ochre roof tile shingles laid on the four cores are transformed, with a slight twist, from the old yellow tiles on the existing walls; and the green hue on the "ice-cracked" sun shades is derived from the existing green glazed roof tiles. The continuation of the colors, namely the rusty brown, yellow ochre, and bronze green, which form the basic palette for the National Palace Museum complex, has contributed to the harmony between old and new.

In contrast to the complexity in the color scheme, the exterior form of the building remains very simple. It is a rectangular glass box suspended and anchored by the four square corners that house the service cores. During the day, the glass volume under sunlight reflects its surroundings and camouflages the building, while at night it transforms into a radiating light box, revealing prominent Chinese flavors within.

PROJECT DATA

LOCATION
TAIPEI, TAIWAN

FUNCTION
RESTAURANT

DESIGN / COMPLETION
2004 / 2008

SITE AREA
167,195 M²

GROSS FLOOR AREA
4,993 M²

FLOOR LEVELS
4 FLOORS ABOVE GROUND, 2 FLOORS BELOW GROUND

STRUCTURE
REINFORCED CONCRETE CONSTRUCTION

MATERIALS
CLEAR FLOAT GLASS, GLAZED CHROME YELLOW ROOF TILE, SANDSTONE, WOODEN GRILLE

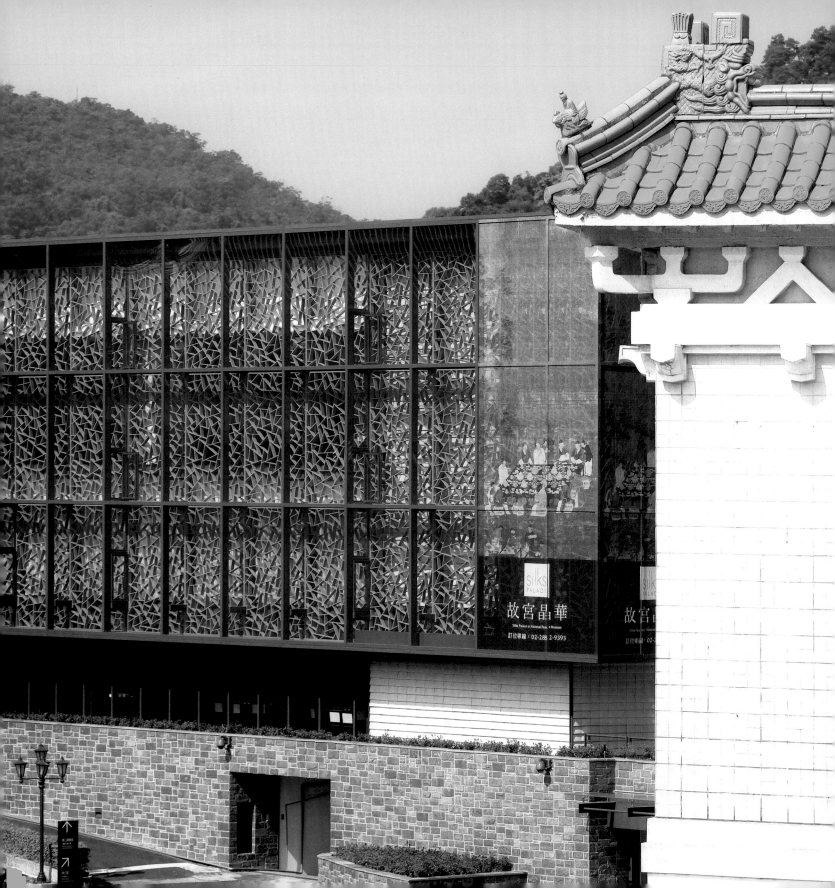

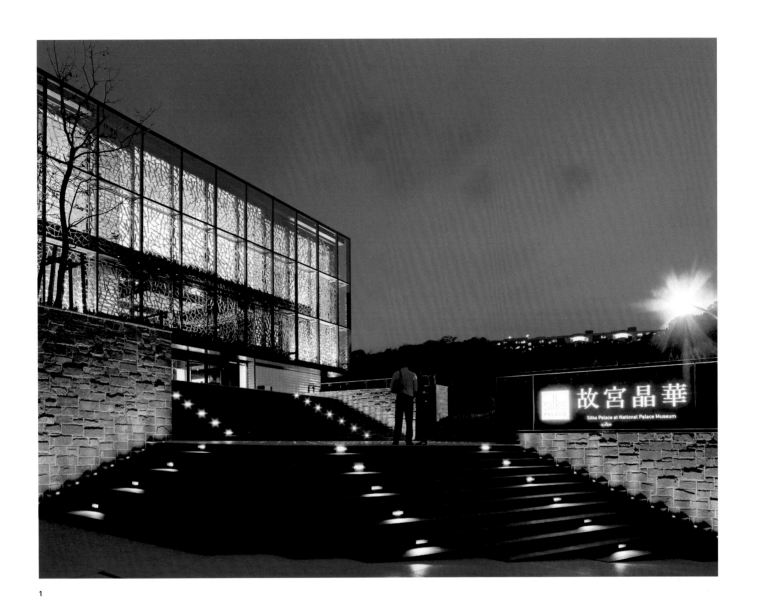

1

1 MAIN ENTRANCE

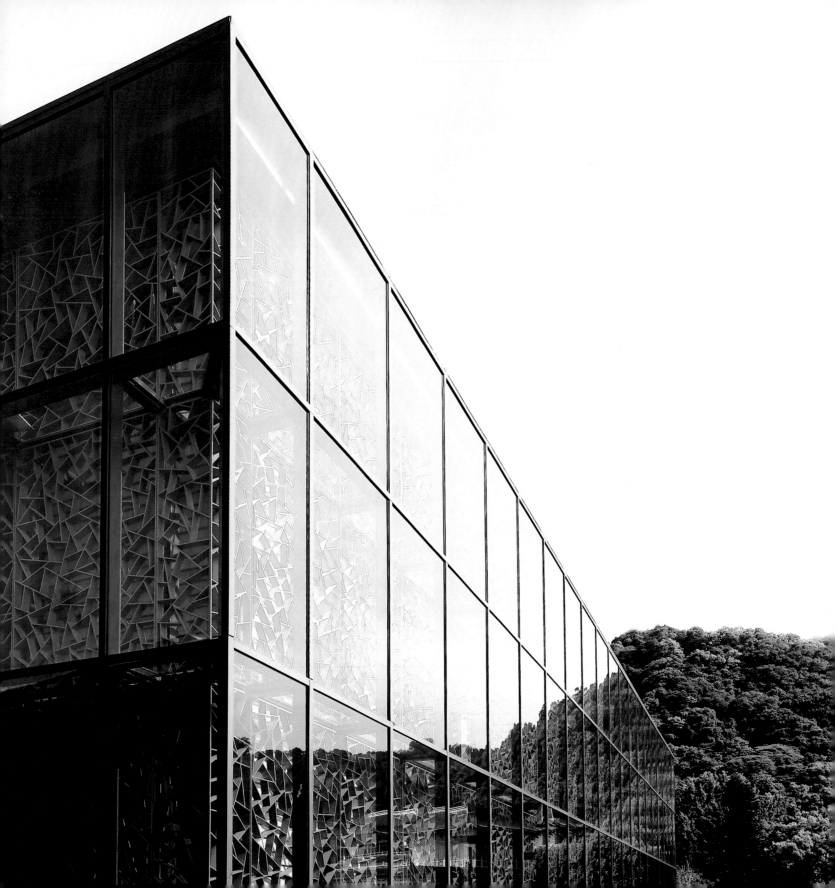

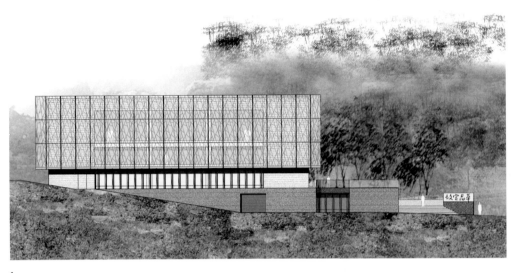

1

2

1 EAST ELEVATION
2 NORTH ELEVATION
OPPOSITE PAGE DETAIL OF DOUBLE SKIN FAÇADE

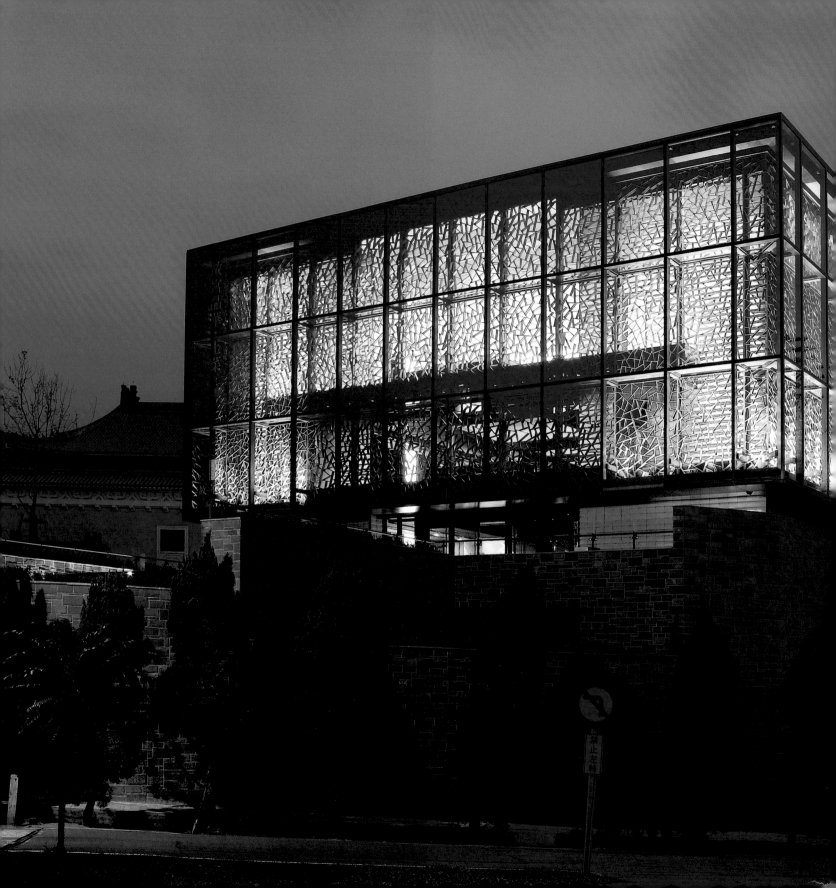

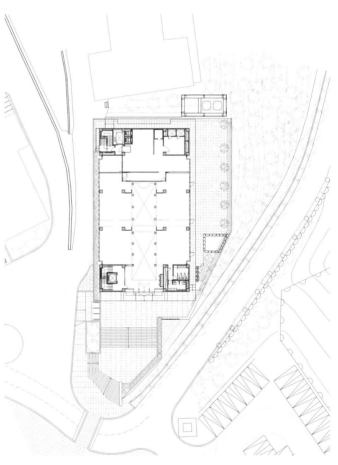

1

1 GROUND FLOOR PLAN

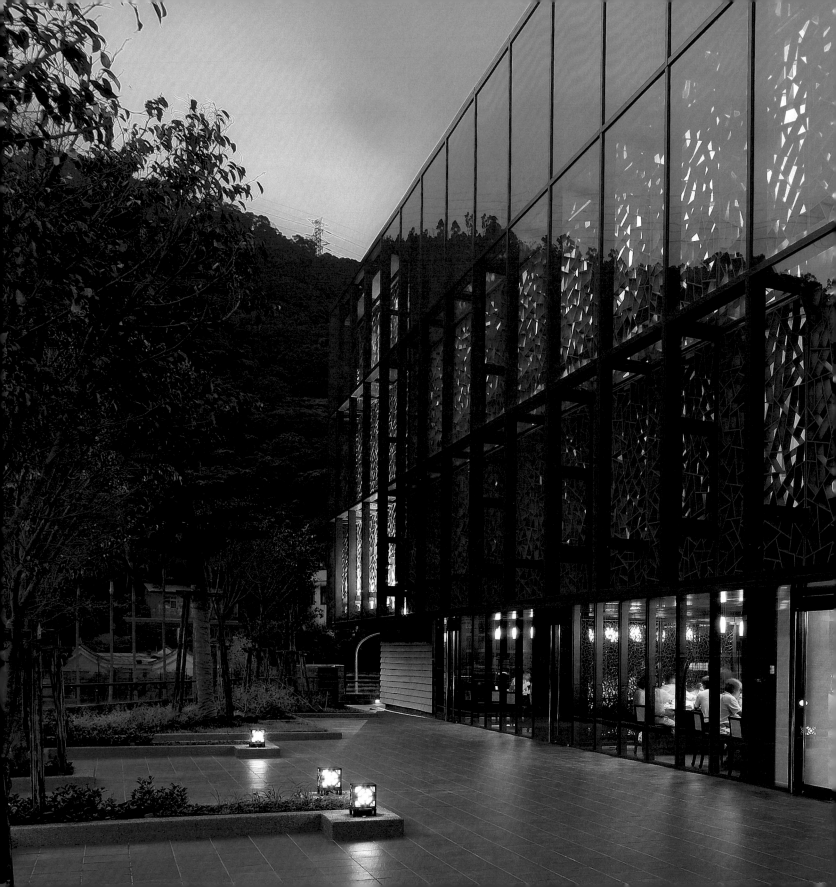

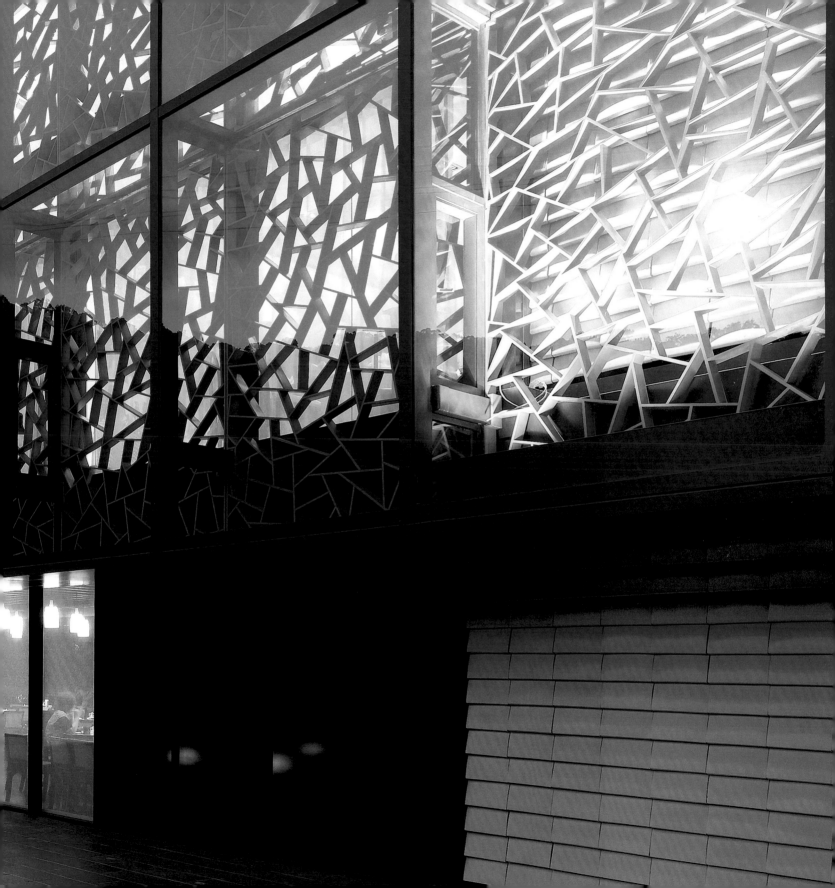

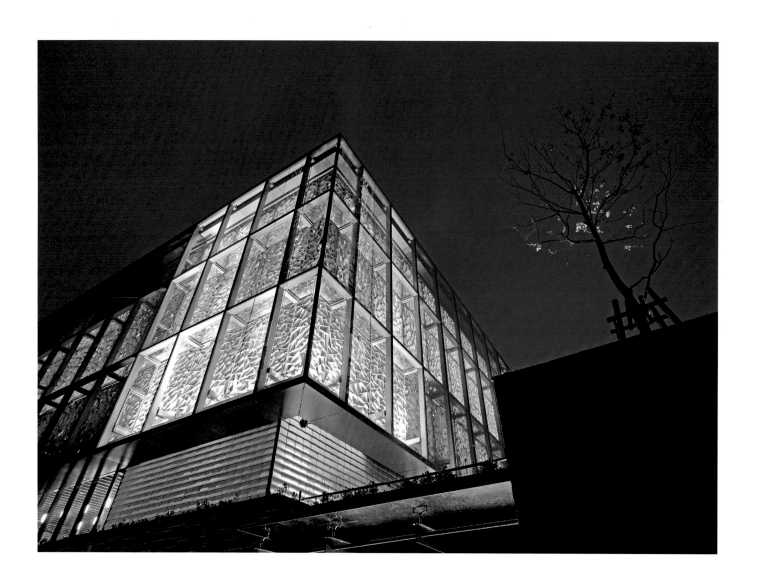

In the old Shanghai city quarter, this unusual yet interesting fan-shaped high-rise office tower is the result of stringent sunlight codes.

1788 NANJING ROAD WEST, SHANGHAI

Progressive Development & Construction Co., Ltd.
Shanghai Century Jing-An Real Estate Development Company Limited

This project is a commercial complex that combines retail shopping, restaurants, and office space in the bustling center of the Jing An Temple business district on Nanjing Road West, Shanghai. In response to the tightly regulated sun-angle guidelines in this area, the building takes on an interesting stepping fan-shaped plan as a solution to the challenge posed by the restrictions.

The office program occupies 29 floors and the retail program spans three floors. A curved atrium, following the fan-shape of the tower, serves as a link for pedestrian traffic from the main boulevard at the front and the park at the rear.

PROJECT DATA

LOCATION
SHANGHAI, CHINA

FUNCTION
COMMERCIAL OFFICE BUILDING

DESIGN / COMPLETION
2007 / EXPECTED 2011

SITE AREA
12,126 M²

GROSS FLOOR AREA
81,438 M²

FLOOR LEVELS
29 FLOORS ABOVE GROUND, 3 FLOORS BELOW GROUND

STRUCTURE
STEEL FRAME CONSTRUCTION

MATERIALS
CLEAR FLOAT GLASS, EXTRUDED ALUMINUM, GRANITE, LOW-E GLASS, METAL GRILLE

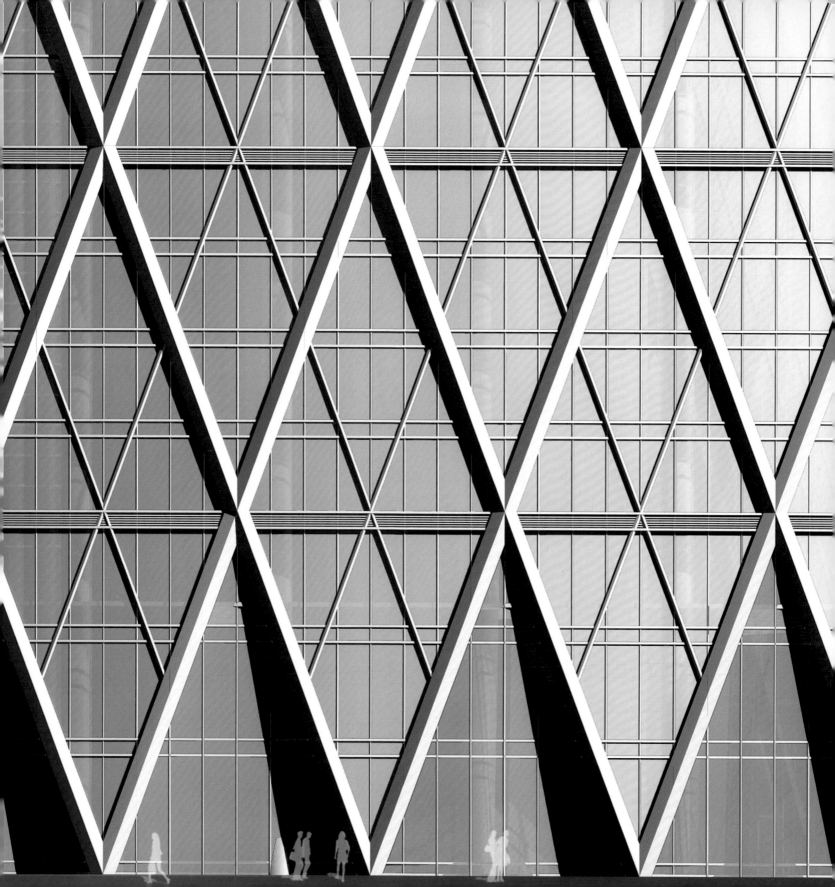

1

1 DETAIL OF FAÇADE

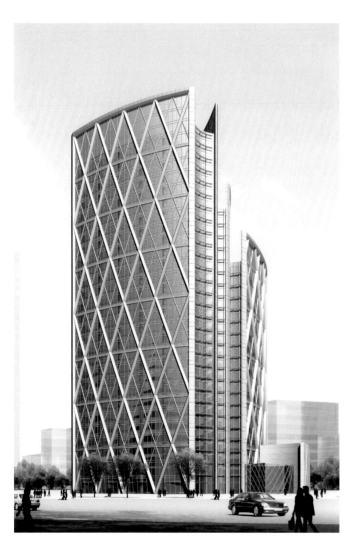
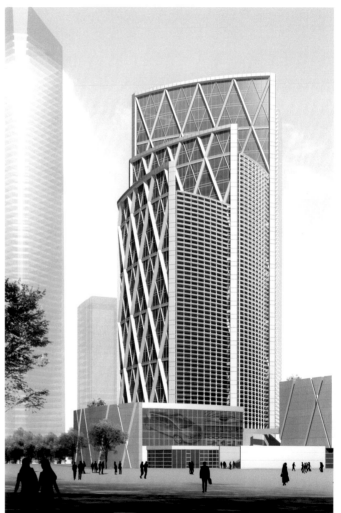

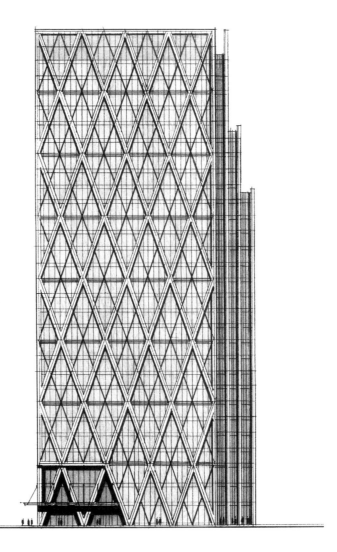

1

Within the 100 meter circular form, visitors are audiences to the drama performed by the ocean and sky from sunrise to sunset.

KENTING RESORT HOTEL

King's Town Group

Facing the ocean with a backdrop of mountains, the Kenting Resort Hotel is built on a beach site with a gentle slope facing west, providing a magnificent view of the sunset. With the C-shaped circular form and the exquisitely landscaped garden in the middle, visitors can enjoy unobstructed views of the ocean and the sky in this resort haven.

The hotel, with an inner diameter of 100 meters, encloses a central landscaped garden that is designed to echo ocean waves and ripples. Along the central axis, a linear cut divides the garden with waterfalls on two sides, guiding one's view

from the arrival lobby directly to the edgeless swimming pool at the far end and further to the ocean beyond, creating a mesmerizing impression in the minds of all visitors.

The individual round villas are designed to be in harmony with the main building. The natural slope of the site and strategically planted vegetation ensure privacy and individual views for each villa.

PROJECT DATA

LOCATION
PINGTUNG COUNTY, TAIWAN

FUNCTION
HOTEL

DESIGN / COMPLETION
2007 / EXPECTED 2012

SITE AREA
34,236 M²

GROSS FLOOR AREA
23,000 M²

FLOOR LEVELS
3 FLOORS ABOVE GROUND, 1 FLOOR BELOW GROUND

STRUCTURE
STEEL FRAME AND REINFORCED CONCRETE CONSTRUCTION

MATERIALS
CLEAR FLOAT GLASS, METAL GRILLE, METAL PANELS, STONE

GREEN BUILDING AWARD
TAIWAN EEWH

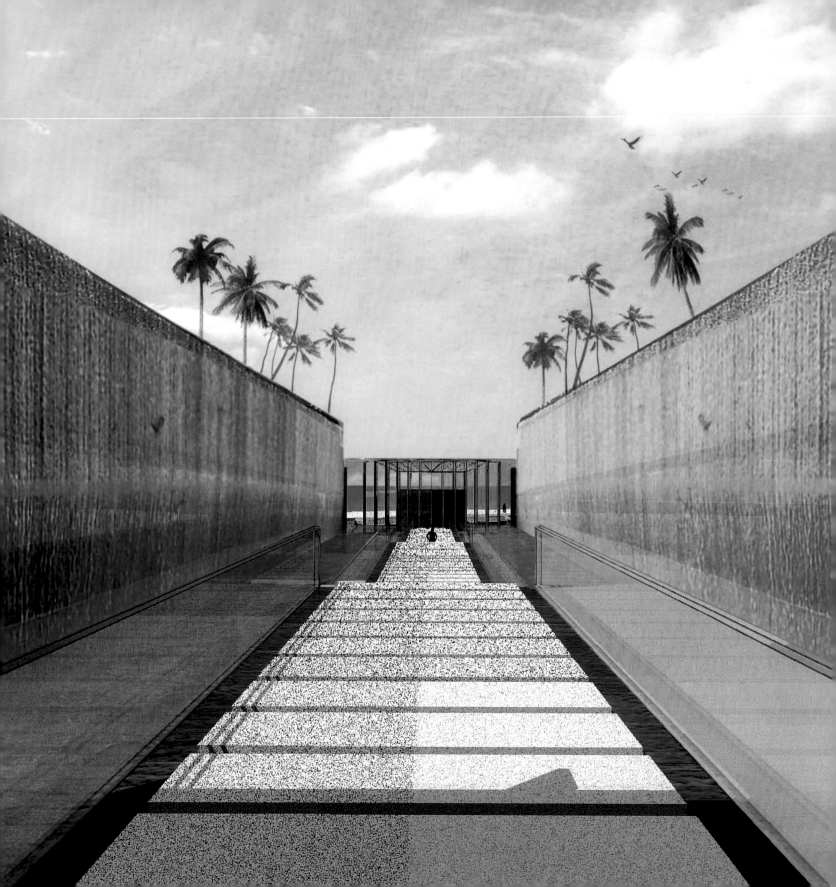

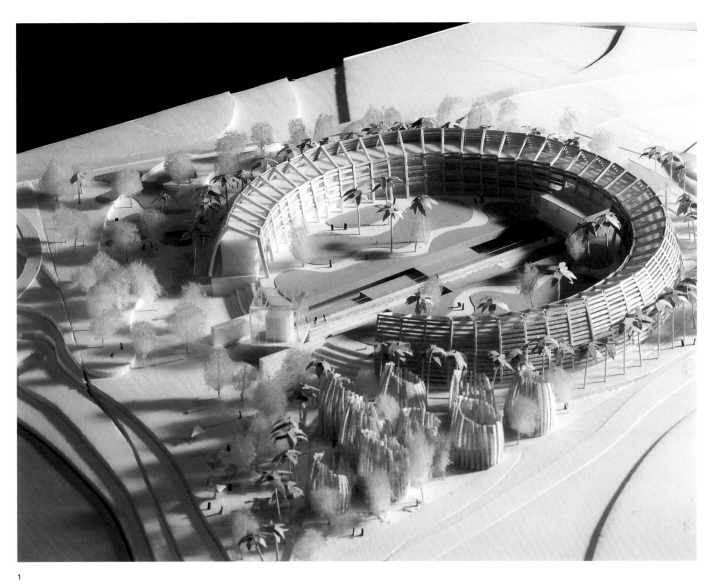

1

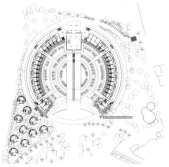

2

1 MODEL, AERIAL VIEW
2 GROUND FLOOR PLAN

With panoramic and commanding views, the curved tower rises and anchors the main city plaza.

FAR EASTERN BANCIAO SKYSCRAPER

Far Eastern Department Store CO., Ltd.
Far Eastern Construction CO., Ltd.

As the second phase of the larger complex that includes retail shops, cinemas, food courts and parking spaces, the Far Eastern Banciao skyscraper is a 50-story, 213-meter tall office tower overlooking the new Banciao Civic Plaza that faces the train station. It will become a landmark building that dominates the New Banciao District when it is completed.

Rising up from a forest of neighboring towers, the skyscraper takes a curved form in order to gain a panoramic view towards the grand civic plaza. On the lower levels, sky bridges are designed to connect the adjacent buildings at multiple levels. The podium is connected to the Phase One retail and parking levels horizontally. On the top of the tower, taking advantage of the building's soaring height, are atrium restaurants with excellent views of the city.

The exterior glazed curtainwall system incorporates principles for energy efficiency in many ways, including the use of deep metal sunshades. Structurally the tower is designed as a tube-in-tube system with bracings attached to the inner tube system for optimal seismic performance.

PROJECT DATA

LOCATION
TAIPEI COUNTY, TAIWAN

FUNCTION
MIXED USE COMMERCIAL BUILDING

DESIGN / COMPLETION
2007 / EXPECTED 2012

SITE AREA
19,432 M^2

GROSS FLOOR AREA
122,906 M^2

FLOOR LEVELS
50 FLOORS ABOVE GROUND, 4 FLOORS BELOW GROUND

STRUCTURE
STEEL FRAME CONSTRUCTION

MATERIALS
ALUMINUM PANELS, LOW-E GLASS, STONE, STAINLESS STEEL

GREEN BUILDING AWARD
TAIWAN EEWH / SILVER

NOTE
MASTER PLAN & PHASE ONE ARCHITECTURE DESIGN BY KISHO KUROKAWA ARCHITECTS & ASSOCIATES

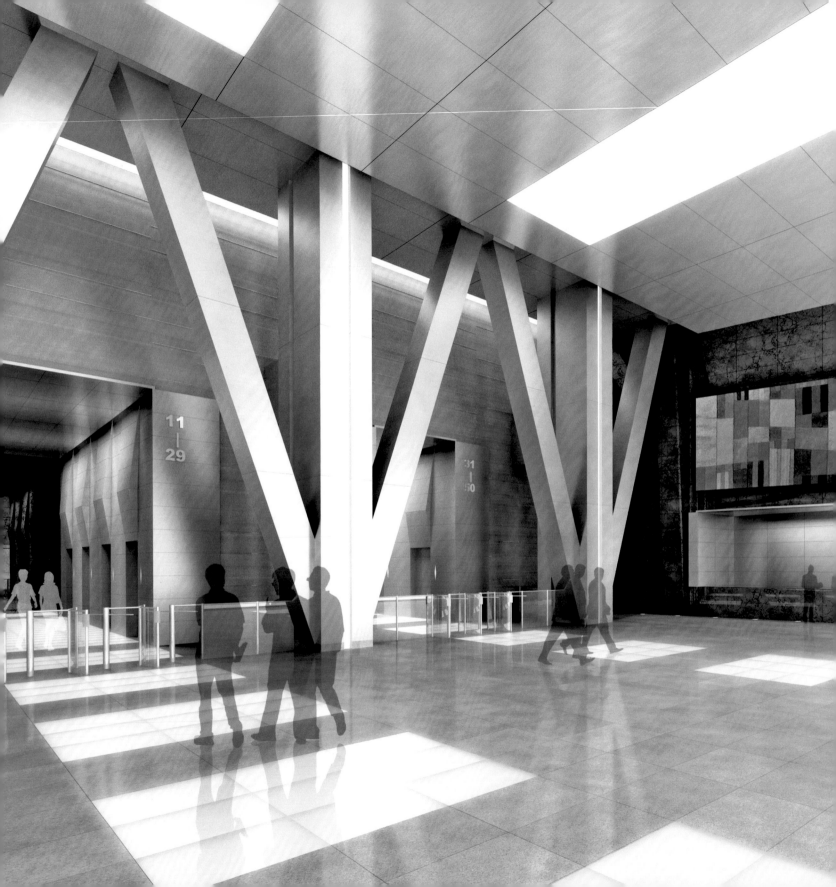

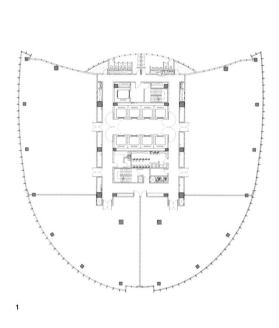

1

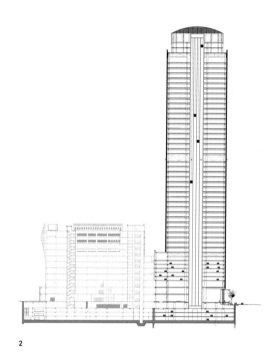

2

1 TYPICAL FLOOR PLAN
2 CROSS SECTION
OPPOSITE PAGE LOBBY

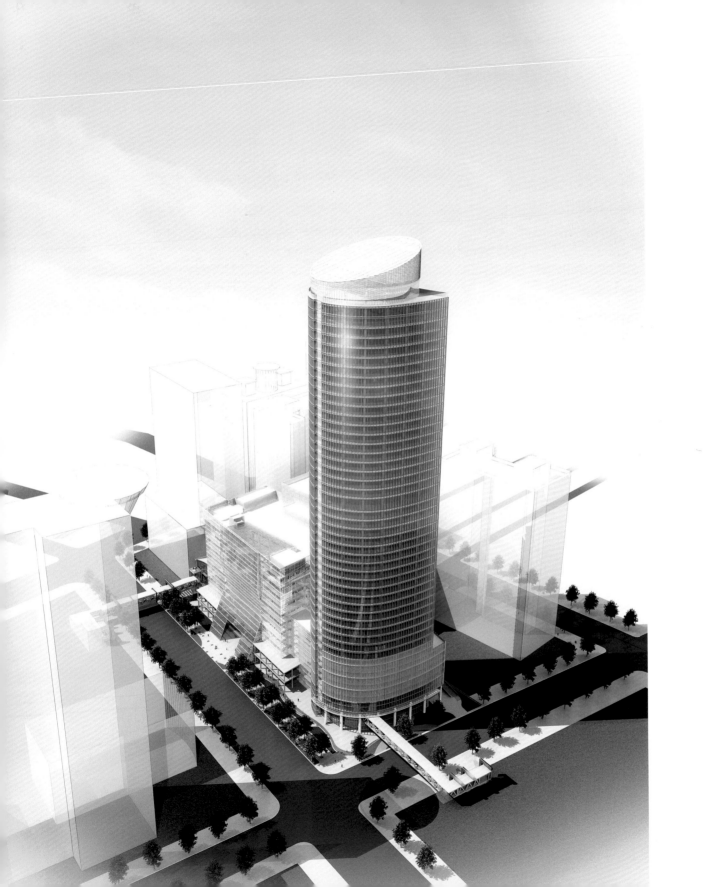

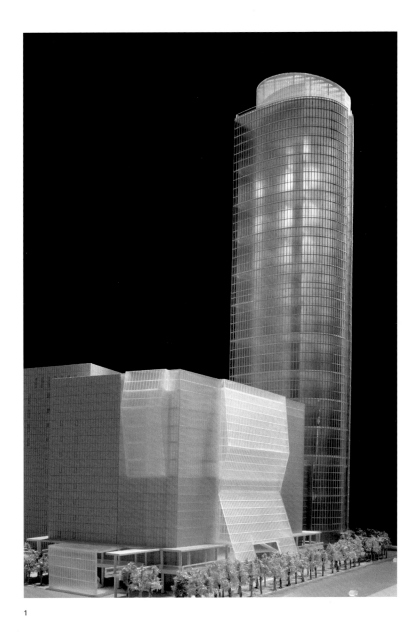

1

1 MODEL, VIEW OF WEST

Exterior sun-shading blades are designed to create optical illusions of circles on the building.

GWANGHUA ROAD SOHO 2, BEIJING

SOHO China Ltd.

This is a proposal for the second phase of a commercial complex mixed with retail areas and offices. The circular theme relates to phase one of the development as desired by the client.

Several proposals were made for the exterior façade of the project, including some that were daring and avant-garde, while others were more gentle and practical. One of the schemes offered a vertical sun-shading façade—different thicknesses of the shading blades revealed circular optical illusions. As one moves along the street, the circles on the façade change and disappear when one is standing directly perpendicular to them, creating an interesting urban dialogue with the people on the street.

PROJECT DATA

LOCATION
BEIJING, CHINA

FUNCTION
MIXED USE COMMERCIAL BUILDING

DESIGN
2007

SITE AREA
25,619 M²

GROSS FLOOR AREA
191,180 M²

FLOOR LEVELS
23 FLOORS ABOVE GROUND, 4 FLOORS BELOW GROUND

STRUCTURE
STEEL FRAME CONSTRUCTION

MATERIALS
ALUMINUM PANELS, LOW-E GLASS, TEMPERED GLASS WITH FRITTED PATTERN

DESIGN COLLABORATION
DADA ARCHITECTURE DESIGN

NOTE
GUANGHUA ROAD SOHO 2 DESIGN COMPETITION

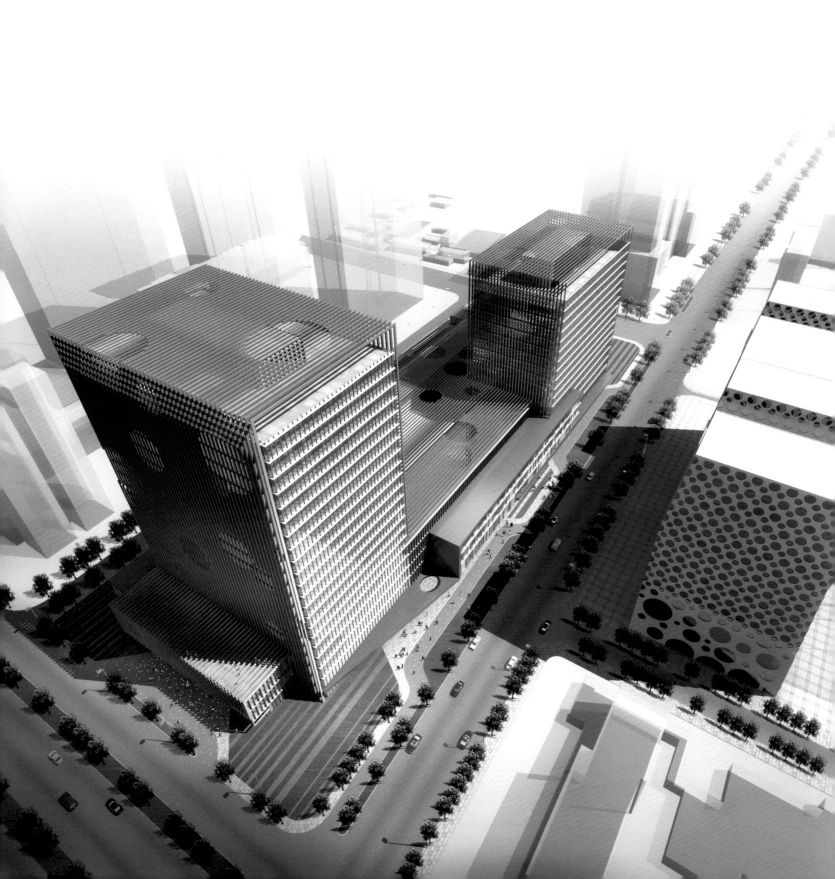

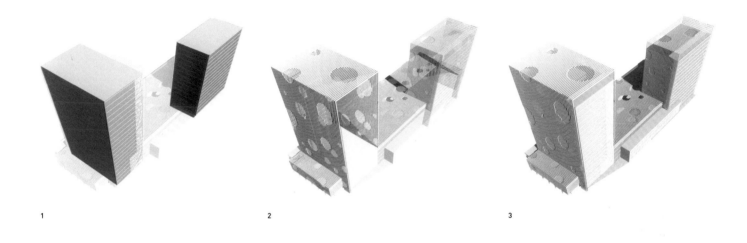

1 2 3

1, 2, 3 VOLUMETRIC CONCEPT

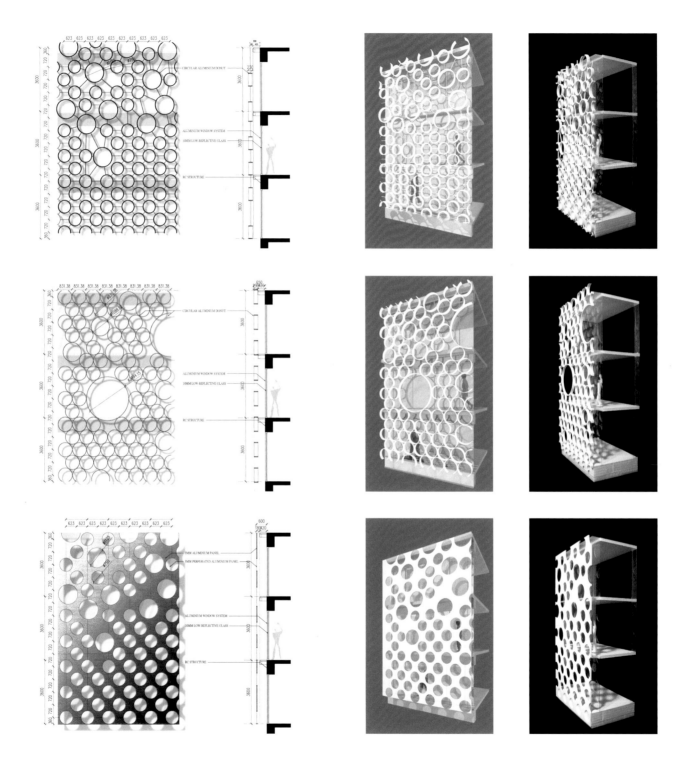

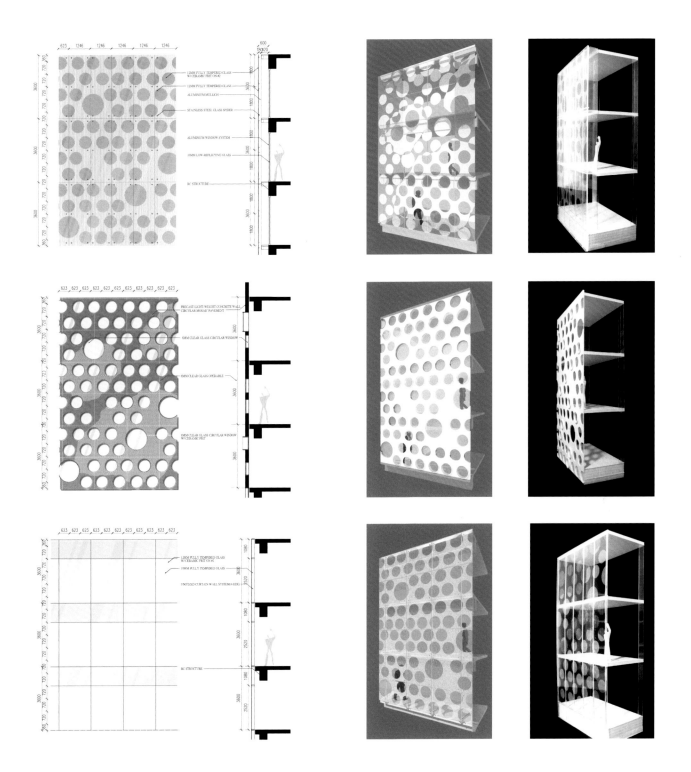

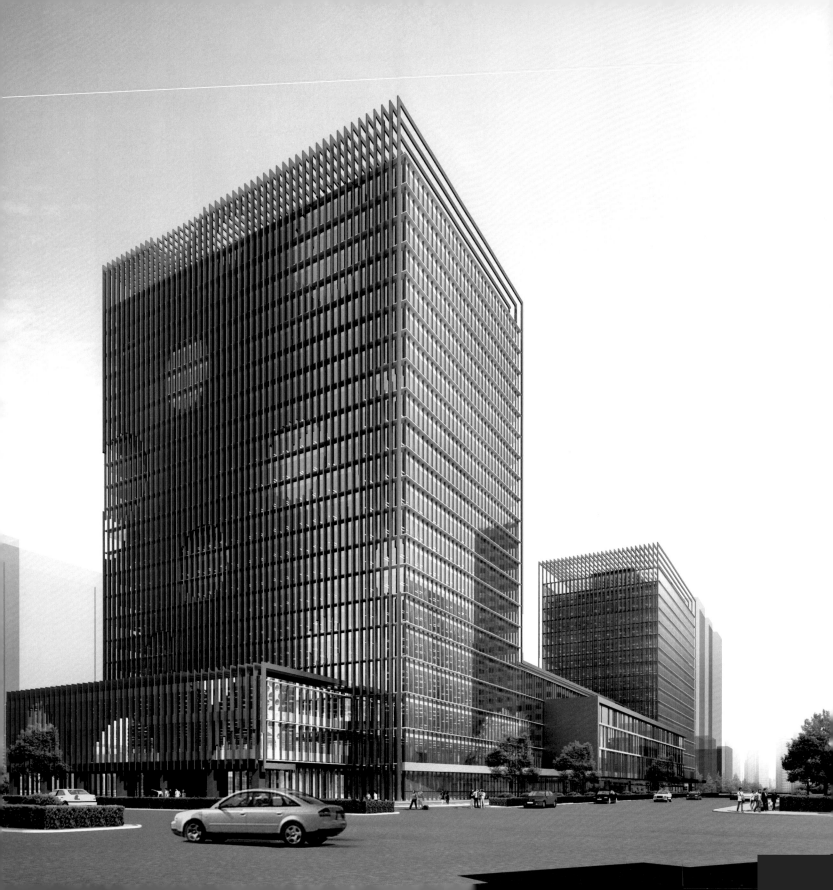

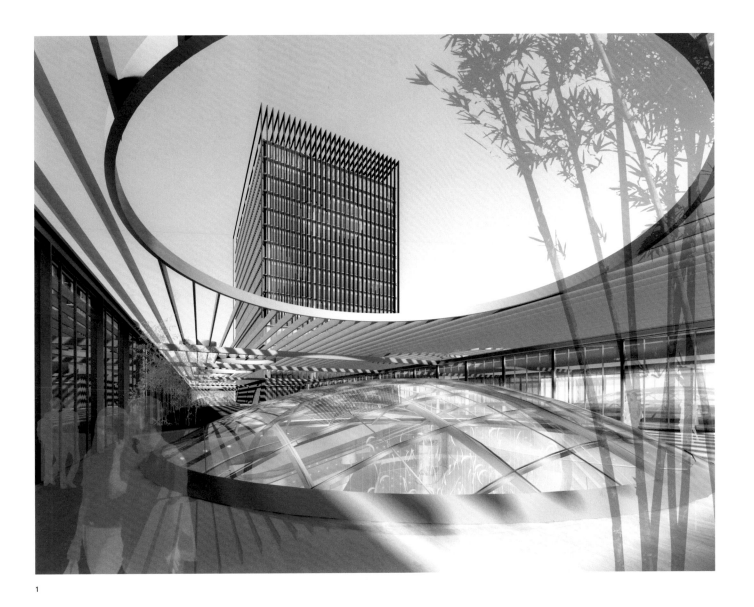

1

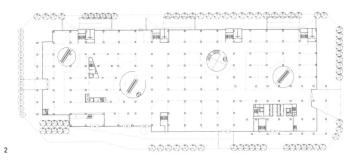

2

1 ROOF GARDEN
2 GROUND FLOOR PLAN

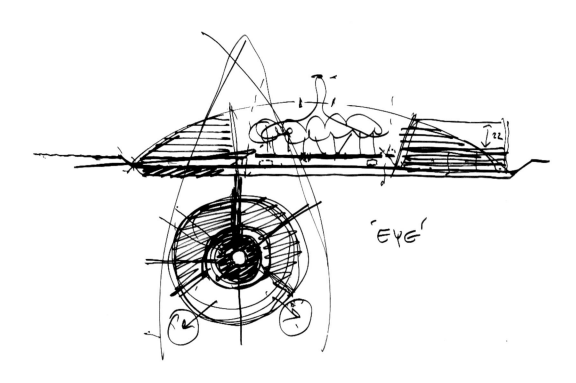

'EYE'

A smooth circular fortress, shielding out the harshness of the site, is hollowed out in the center to create a green oasis for all arrivals.

CHINA AIRLINES COMPLEX COMPETITION
China Airlines

Located at the threshold of the Taoyuan International Airport, which acts as the gateway of Taiwan, the China Airlines Complex will be visitors' first sight when approaching the airport. The complex is to accommodate three major programs: a transit hotel of 500 guestrooms, a headquarter office for the Airlines, and a training school for pilots and stewardesses that includes large simulators.

The site poses some inherent difficulties, namely in its location, circulation, and wedge shape, something that the Chinese *feng shui* deems undesirable if not treated properly. Our proposal attempts to resolve all the negative aspects of the site in one simple gesture, by designing a floating circular, donut-shaped building with entrances to all parts from within. Visitors enter the complex and are immersed in the oasis-like green atrium that serves as the arrival point for the three respective programs. In this central space, the noise from the airport is greatly reduced, the hard surface of massive tarmac is hidden from view, and the undesirable sharp wedge is smoothed out and resolved by the circular shape.

The façade of the building is constructed with fortified metal panels complemented with sun-shade louvers to further minimize noise caused by airplanes and traffic. The entire circular building is raised to create the illusion of being suspended in the air, and the clear glazing at the bottom provides visual transparency while offering natural ventilation in line with green architecture principles. The Airline's cutting-edge image is conveyed through the building's futuristic appearance, with an aerodynamic form made possible through industrial aerospace material.

PROJECT DATA

LOCATION
TAOYUAN COUNTY, TAIWAN

FUNCTION
MIXED USE COMMERCIAL BUILDING

DESIGN
2007

SITE AREA
47,747 M²

GROSS FLOOR AREA
140,561 M²

FLOOR LEVELS
8 FLOORS ABOVE GROUND, 2 FLOORS BELOW GROUND

STRUCTURE
STEEL FRAME AND REINFORCED CONCRETE CONSTRUCTION

MATERIALS
GLASS CURTAINWALL, METAL GRILLE, PAINTED METAL PANELS

NOTE
CHINA AIRLINES COMPLEX DESIGN COMPETITION

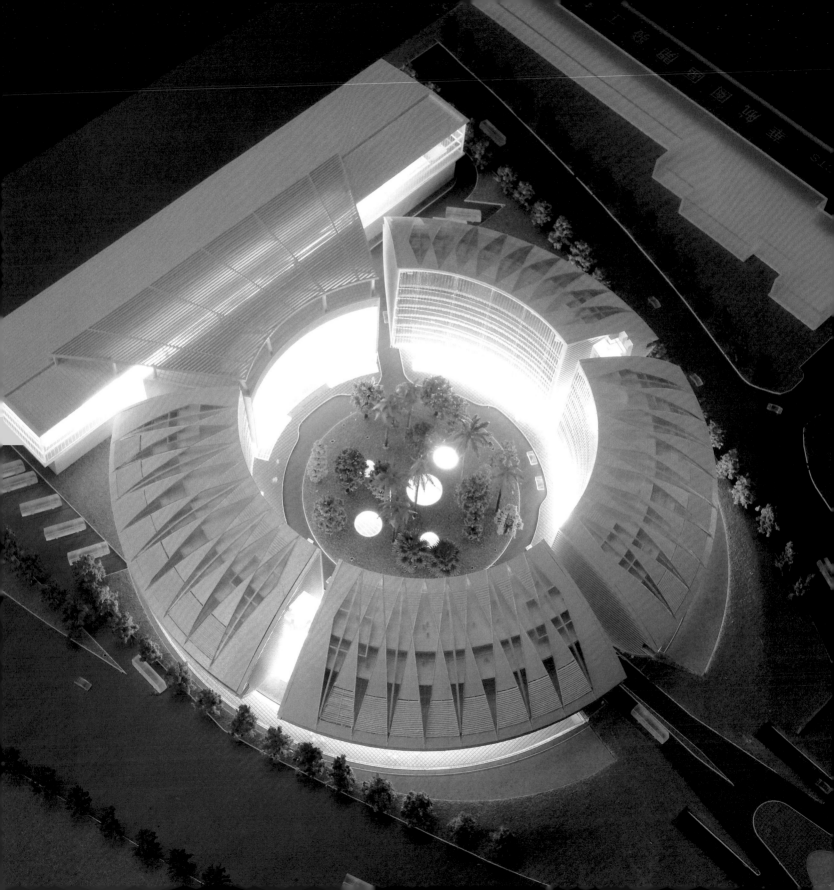

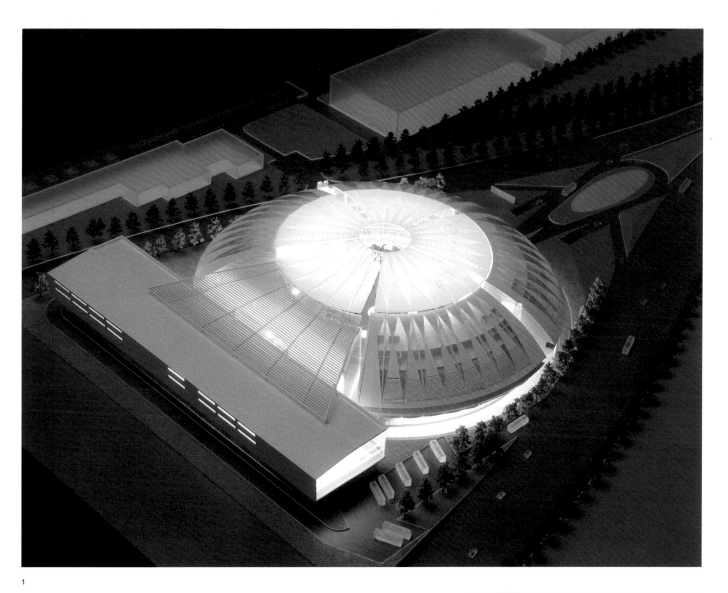

1

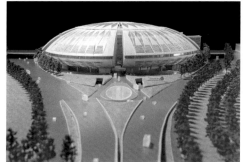

2

1 MODEL, AERIAL VIEW
2 MODEL, VIEW OF EAST

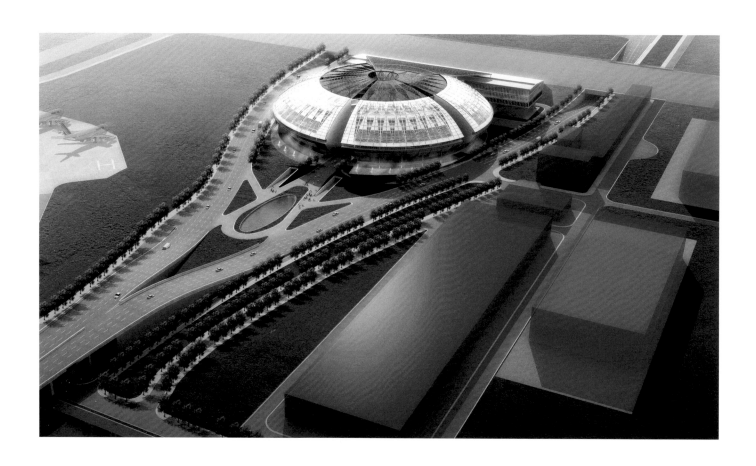

1 LONGITUDINAL SECTION

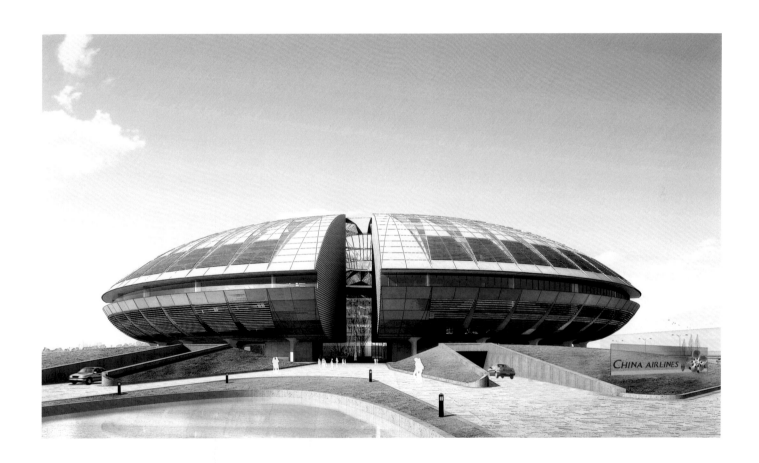

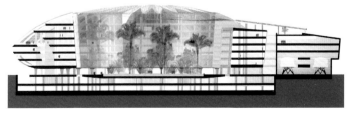

1

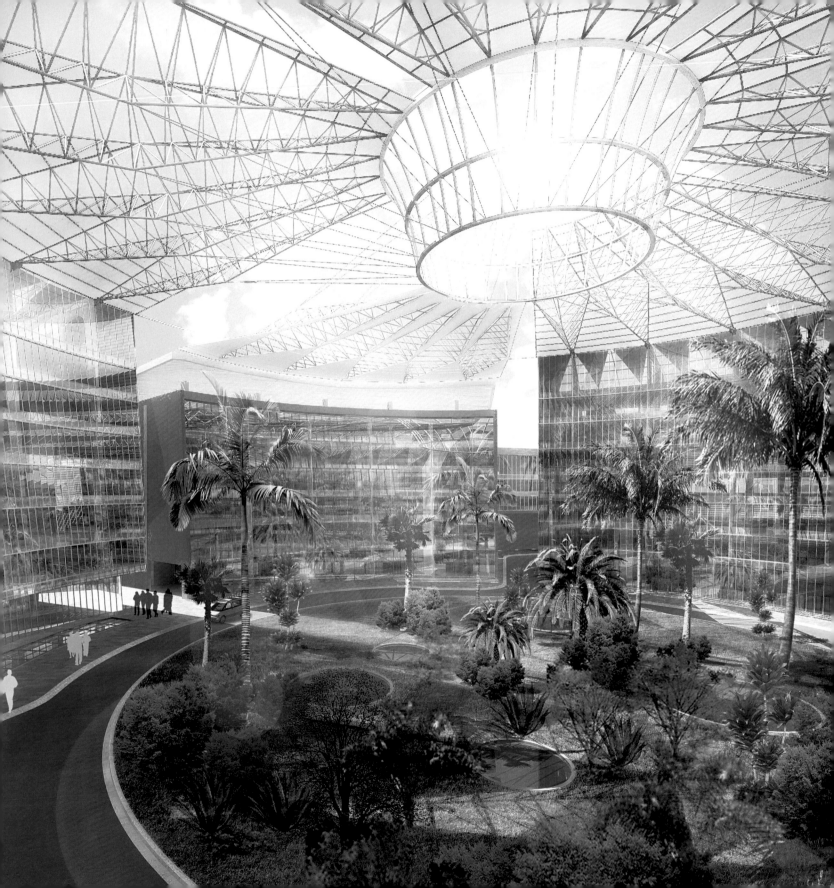

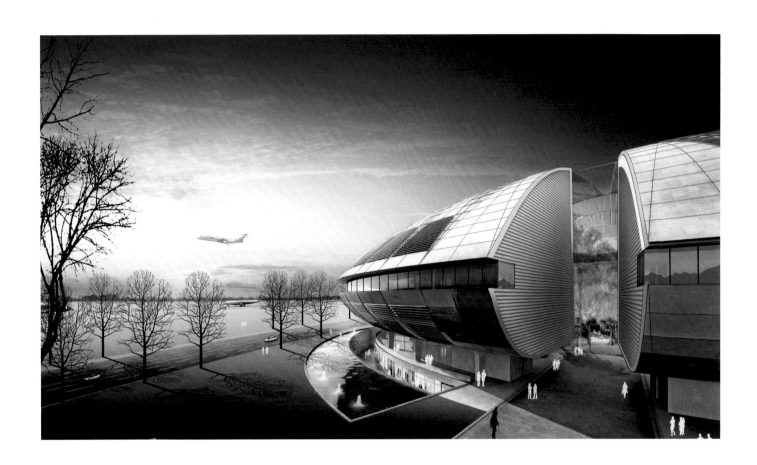

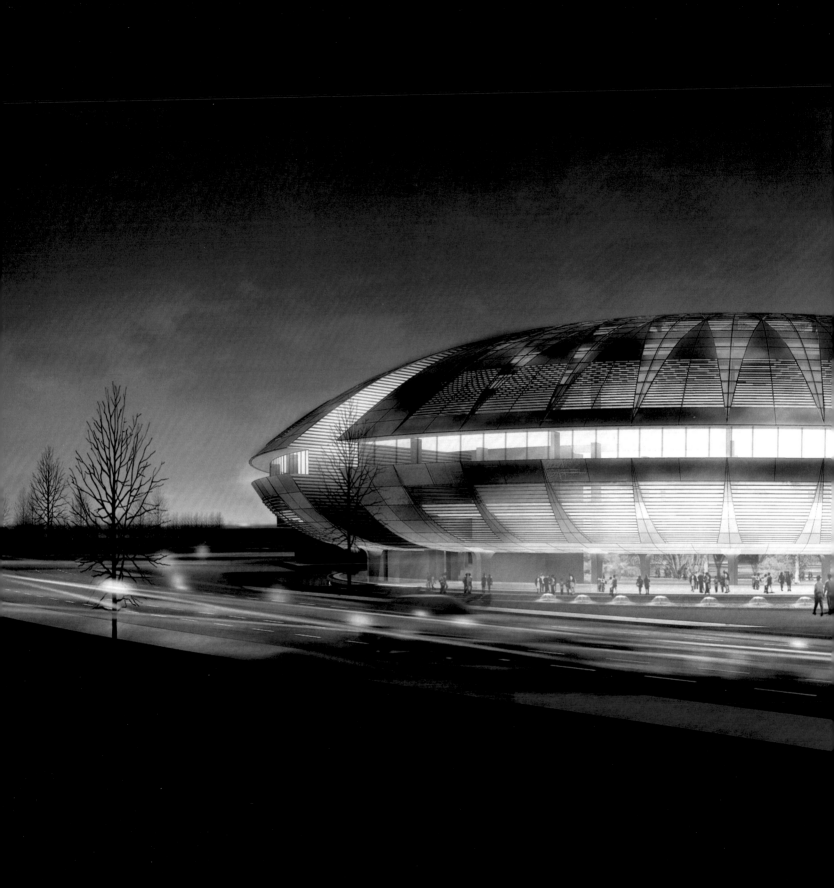

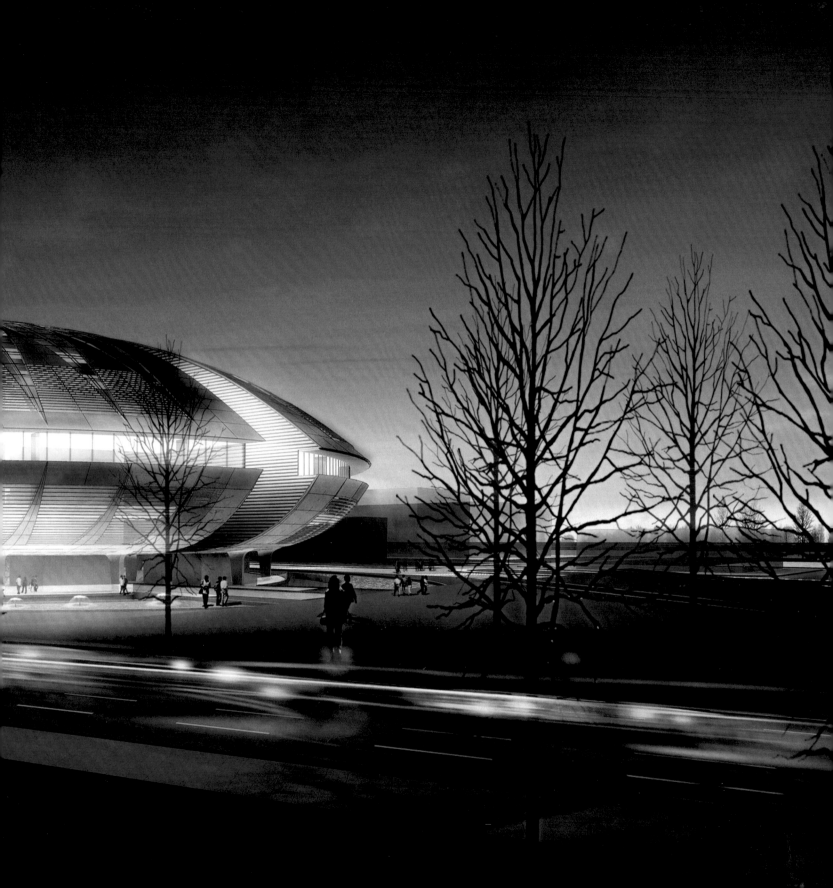

A dynamic composition of forms reflects the diverse content of the building program and vibrant energy of its context.

A-10 HOTEL COMPLEX
Fubon Land Development Co., Ltd.

Located in dense downtown Taipei, where high-rise commercial buildings are bridged by skywalks, the A-10 Hotel Complex sits on one of the last remaining lots in the prominent Xinyi District, making it a key pedestrian hub.

The project has three components: a 250 room business hotel in the main tower, a retail mall housed in the podium, and parking and technical facilities in the third to fifth basement levels. The tower adapts a "windmill" plan to gain maximum views for its relatively small guestroom units. Public venues such as restaurants, the ballroom, conference areas, and a spa and swimming pool are conveniently located right below the guestrooms, occupying the middle portion of the building. On the ground level, the retail mall and the hotel share a sizable plaza designed for passenger drop-off and occasional events.

On the exterior, sharp, triangular bay window units give an interesting rhythmic order to the tower and expand the view for the small rooms. For the podium, various cladding material are applied including curved glass panels, perforated metal screens, and transparent and translucent glass walls, creating a vibrant façade that reflects the varied functions within.

PROJECT DATA

LOCATION
TAIPEI, TAIWAN

FUNCTION
MIXED USE COMMERCIAL BUILDING

DESIGN / COMPLETION
2008 / EXPECTED 2012

SITE AREA
6,373 M²

GROSS FLOOR AREA
55,010 M²

FLOOR LEVELS
22 FLOORS ABOVE GROUND, 5 FLOORS BELOW GROUND

STRUCTURE
STEEL FRAME CONSTRUCTION

MATERIALS
LOW-E GLASS, METAL GRILLE, PERFORATED ALUMINUM PANELS, STONE

GREEN BUILDING AWARD
TAIWAN EEWH

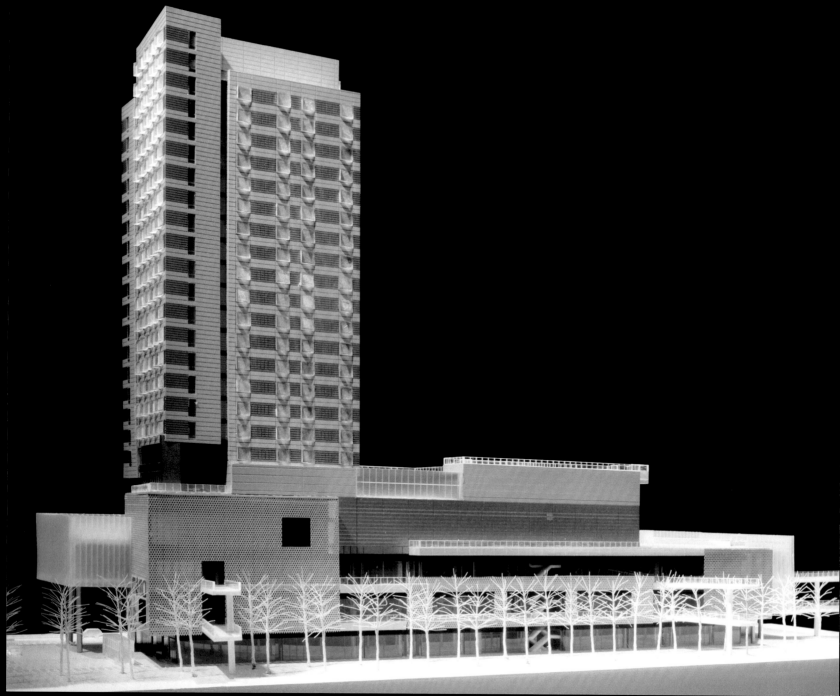

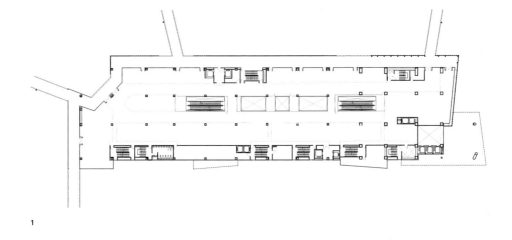

1

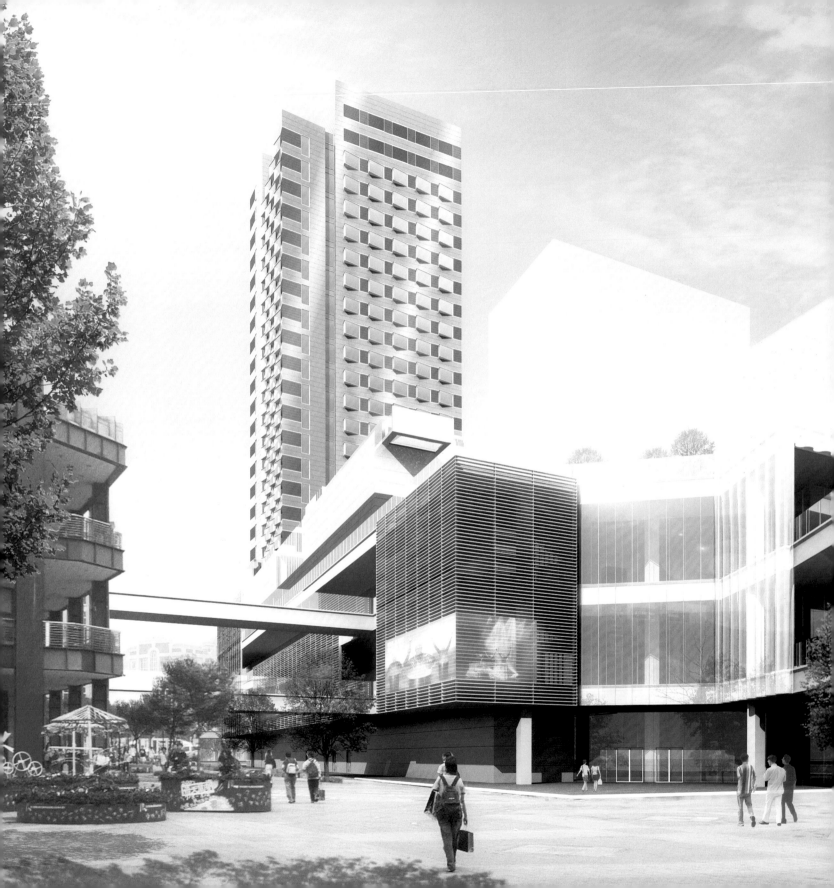

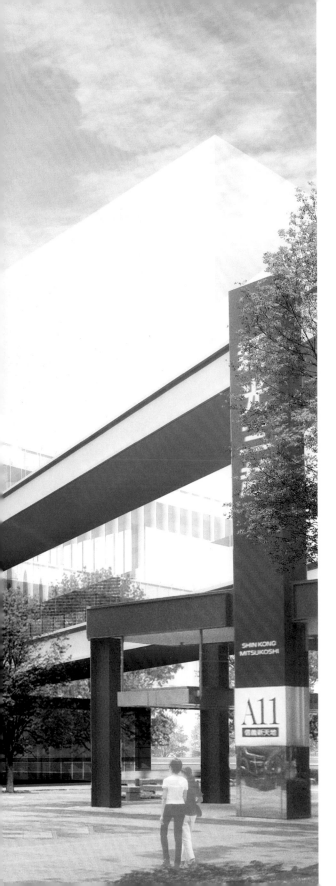

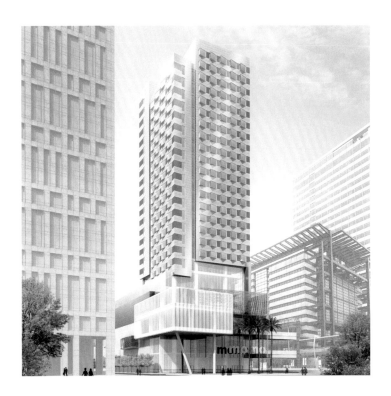

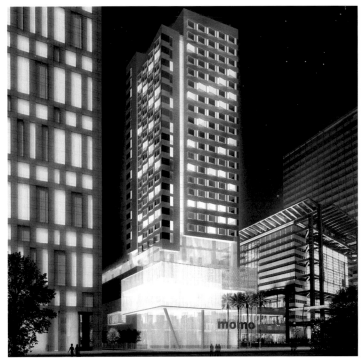

New tectonic in the old French Quarter of Shanghai.

HUASHAN SQUARE

ASE Group, Shanghai Hong Jia Real Estate Development Co., Ltd.

Located in the Jing An Temple district, Huashan Square is a luxury residential tower in the prominent neighborhood of the old French Quarter. This landmark tower soars to a height of 40 stories, pairing up with the Hilton Hotel Tower located next door. The five-story podium bends gracefully along the street housing retail spaces, clubs, restaurants, and a residential entrance lobby at the rear.

The tower is designed as two interlocking C-shapes, with the service core placed in the middle to maximize the view from both wings. The curved glazed curtainwall of the tower resonates with the curvature of the podium below. To increase visual diversity, vertical glass shades are placed in a rhythmic pattern. The double-skin exterior wall helps to save energy, and its full-height glazing provides ample natural light and ventilation, creating a brightly lit and comfortable living environment in this high-density city. The alternating finishes of hand-chiseled and water-jet surface of the El Dorado Gold granite on the podium highlight the verticality and enrich the elevation design.

PROJECT DATA

LOCATION
SHANGHAI, CHINA

FUNCTION
MIXED USE COMMERCIAL AND RESIDENTIAL BUILDING

DESIGN / COMPLETION
2002 / 2008

SITE AREA
5,838 M²

GROSS FLOOR AREA
48,729 M²

FLOOR LEVELS
40 FLOORS ABOVE GROUND, 3 FLOORS BELOW GROUND

STRUCTURE
STEEL FRAME CONSTRUCTION

MATERIALS
CLEAR FLOAT GLASS, EXTRUDED ALUMINUM, GOLD GRANITE, LOW-E GLASS

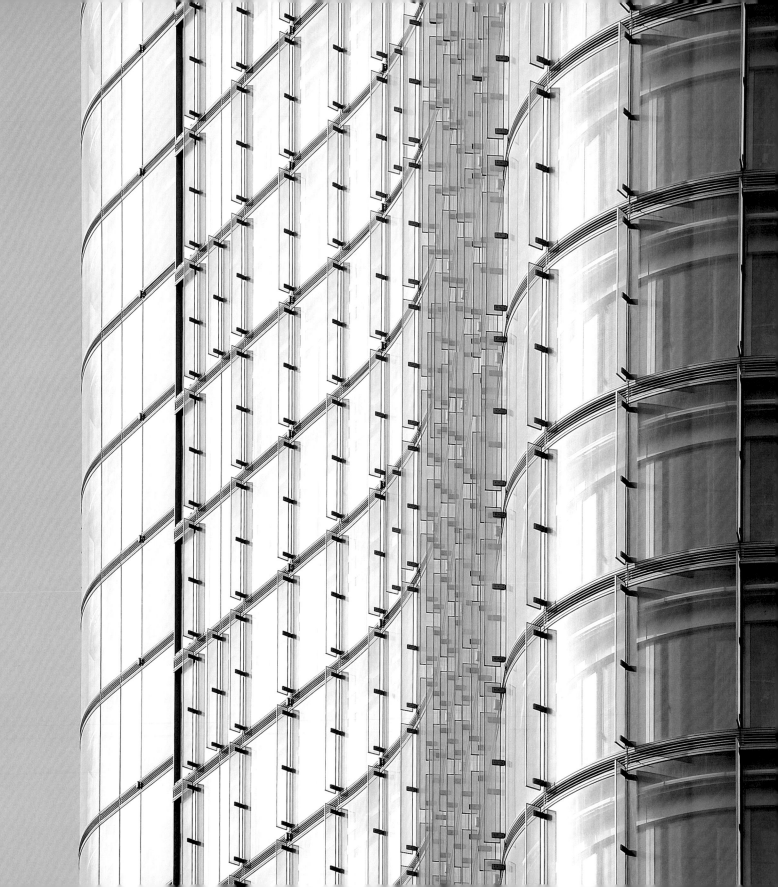

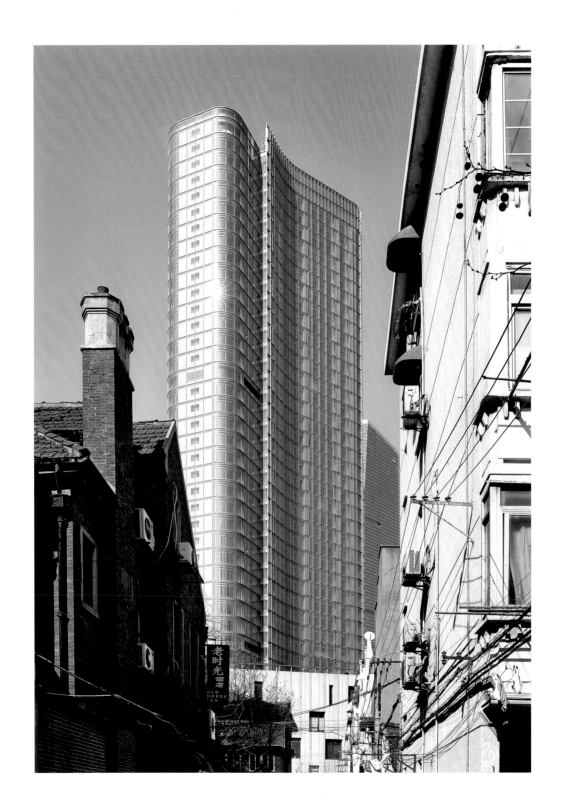

1

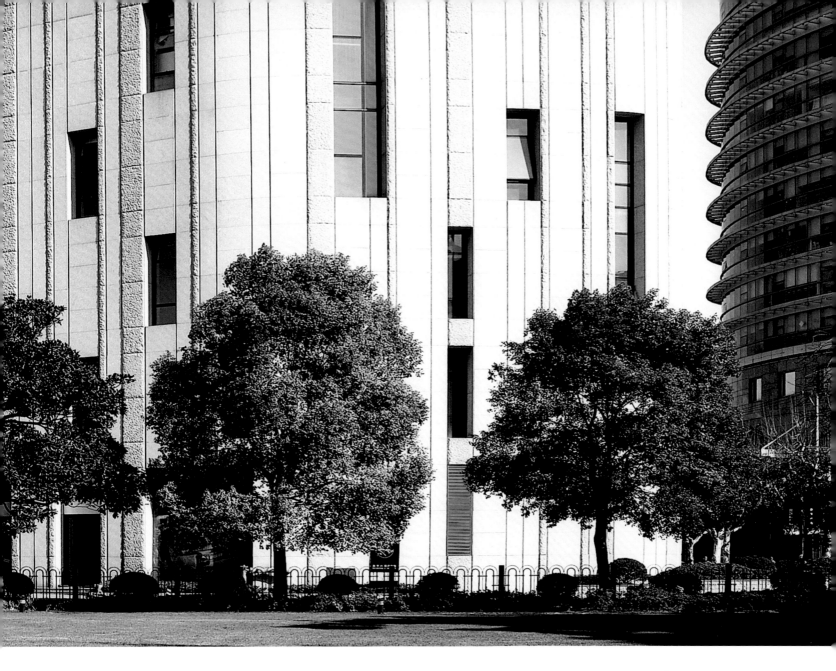

1 STONE PODIUM
2 SECOND FLOOR PLAN

2

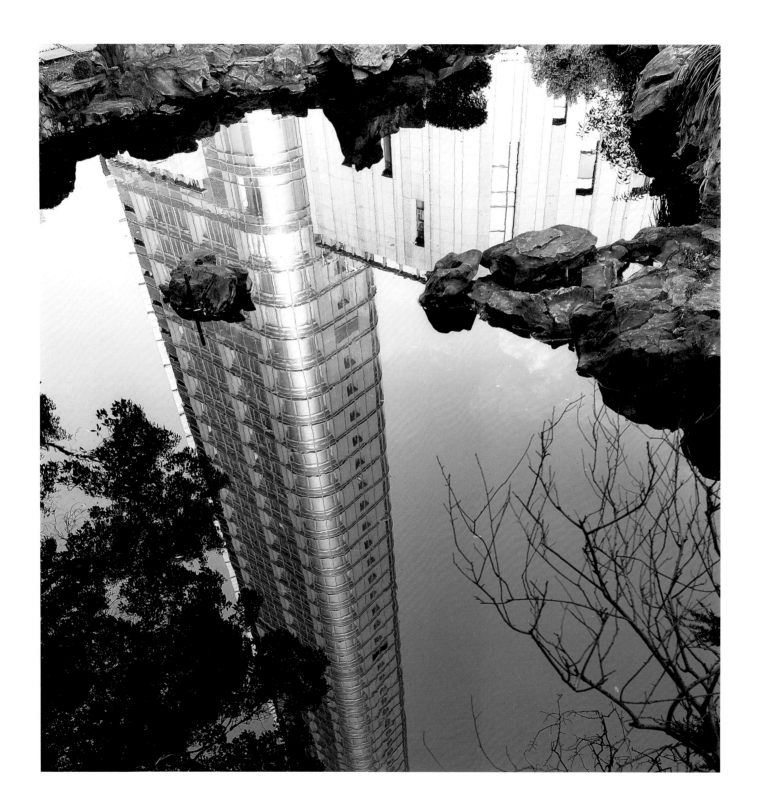

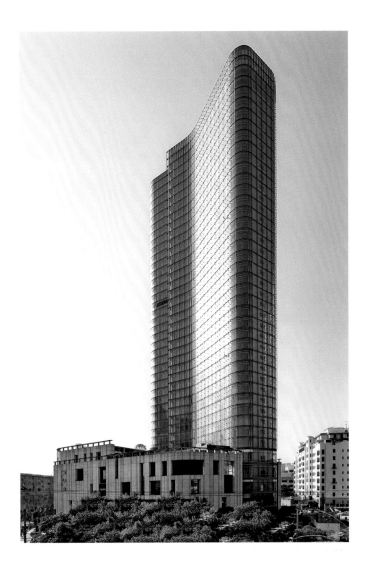
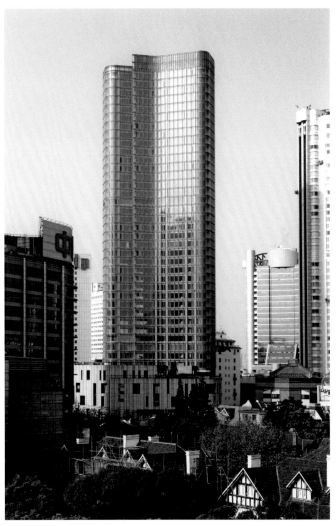

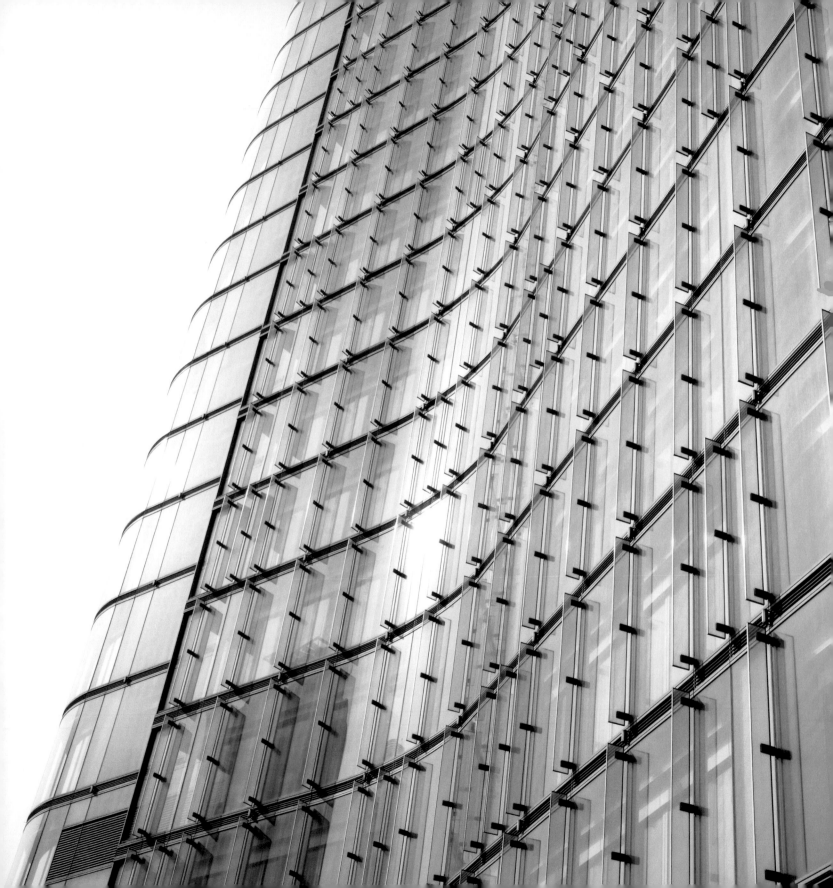

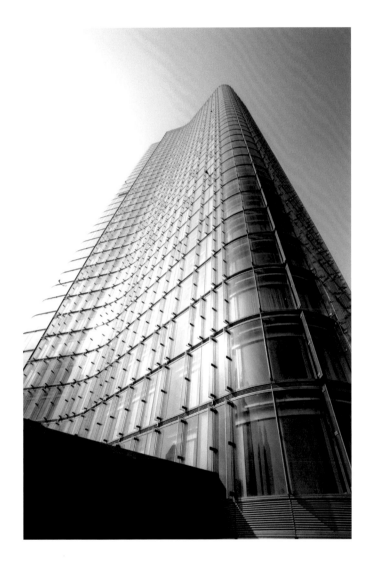

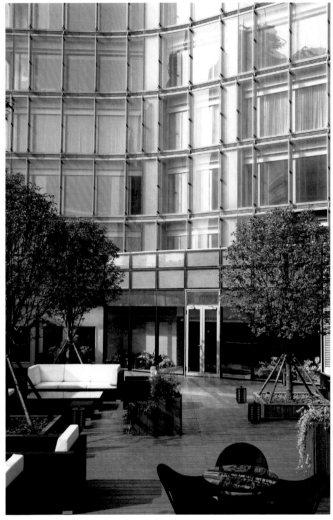

AL IMAGES DETAIL OF FAÇADE

...as the wind blows, the building takes on an indefinite shape...

THE DRAPE HOUSE

Nanjing Foshou Lake Architecture & Art Development Ltd. Co.

Twenty architects from around the world were invited to each design a five-room vacation house on the shore of the Fo Sho Lake in Nanjing, China. The ARTECH team proposed a "House of Drapes" by the lake. Emulating a traditional dyehouse with hanging fabrics, the swaying draperies obscure the frame of the building, creating indefinite forms that are constantly changing as the wind blows.

The estate is not fully visible at first glance. The house slowly reveals itself as the visitor strolls along a winding path, passing a swing, a rusted animal cage, and a juniper-burning stove to finally catch glimpses of the building through the trees. A view of the lake unfolds at the end of the path as the visitor reaches the lakefront house. At the ground floor entrance, five box-shaped wooden structures are suspended in the air like tree houses, held by a steel frame. Maroon drapes are hung on the sides of the boxes. Stairs that are partially visible from the exterior connect these wooden compartments independently. The elongated pool on the ground, reflecting the house, enhances the connection between the structure and the lake, which serves as the axis of this linear structure. The kitchen, dining, and living spaces are hidden from view in the slope of the hill that functions as the basement of the building.

PROJECT DATA

LOCATION
NANJING, CHINA

FUNCTION
VACATION HOUSE

DESIGN / COMPLETION
2003 / EXPECTED 2012

SITE AREA
10,152 M²

GROSS FLOOR AREA
638 M²

FLOOR LEVELS
2 FLOORS ABOVE GROUND, 1 FLOOR BELOW GROUND

STRUCTURE
STEEL FRAME CONSTRUCTION

MATERIALS
FABRIC, TEAKWOOD

NOTE
CHINA INTERNATIONAL PRACTICAL EXHIBITION OF ARCHITECTURE-NANJING
THE FIRST INTERNATIONAL ARCHITECTURE BIENNALE BEIJING, 2004

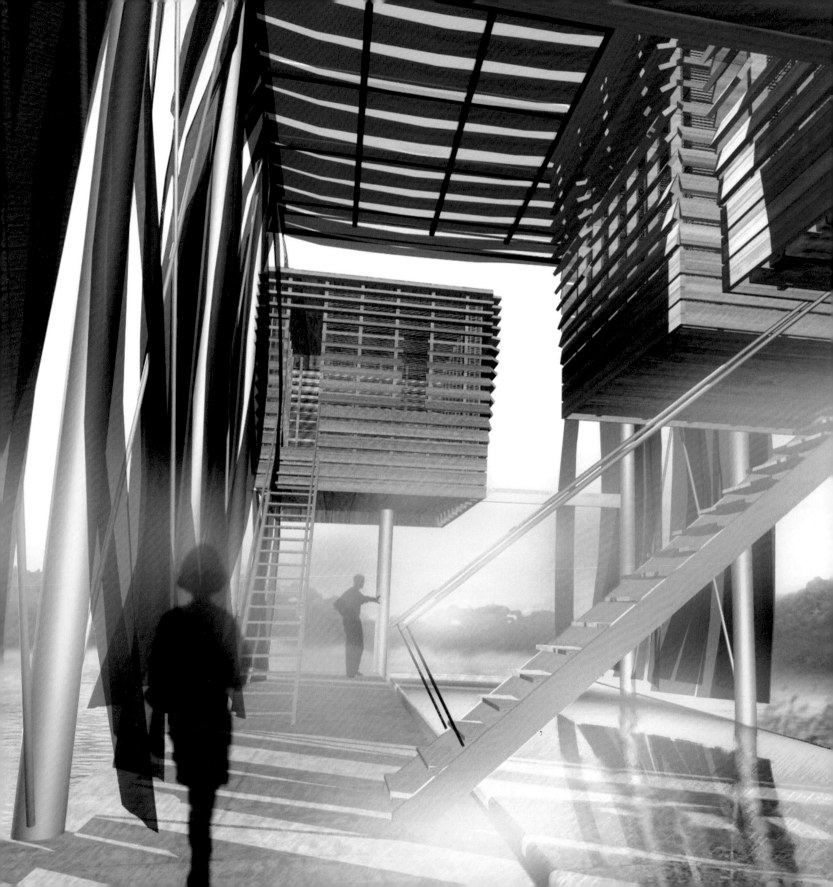

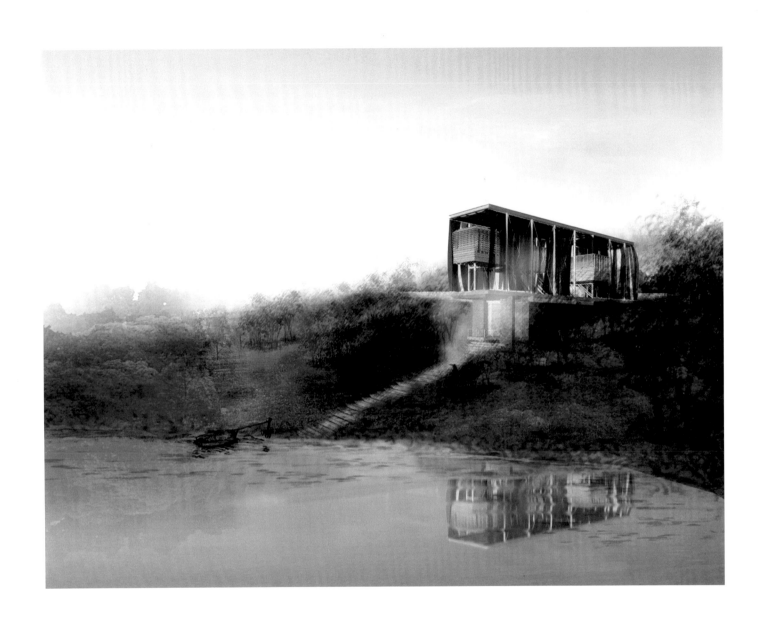

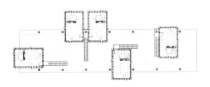

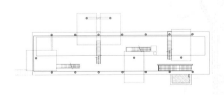

1 SECOND FLOOR PLAN
2 GROUND FLOOR PLAN

1

2

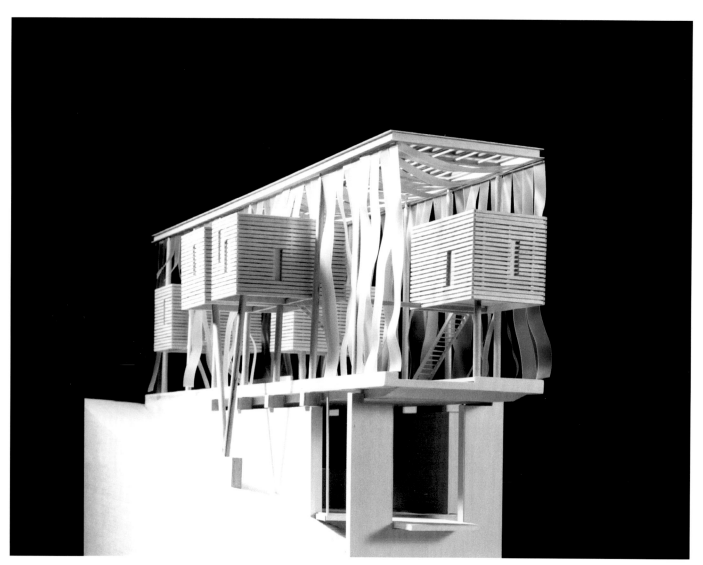

1

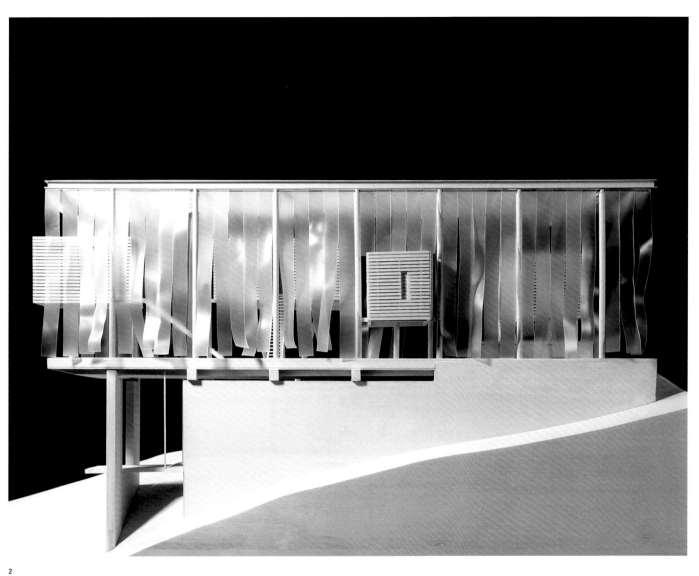

2

A slender building struggles for maximum light exposure.

CHIAOKUO RESIDENTIAL TOWER

Overseas DROS. Co., Ltd.

Sitting in front of an elevated MRT rail, this simple residential tower occupies a site of high visibility. The narrow site gives the building the opportunity to present a slender and sleek façade. The design toys with the alteration of façade elements, despite the identical plans for all the residential units.

In addition to great attention to its material and details, this tower employs interlaced balconies, strategically planned façade components, and punched parapets on its façade, creating a lively and eye-catching building amidst the busy central commercial district.

PROJECT DATA

LOCATION
TAIPEI, TAIWAN

FUNCTION
CONDOMINIUM

DESIGN / COMPLETION
2006 / 2010

SITE AREA
685 M²

GROSS FLOOR AREA
6,163 M²

FLOOR LEVELS
14 FLOORS ABOVE GROUND, 3 FLOORS BELOW GROUND

STRUCTURE
REINFORCED CONCRETE CONSTRUCTION

MATERIALS
ALUMINUM PANELS, BLACK GRANITE, LOW-E GLASS

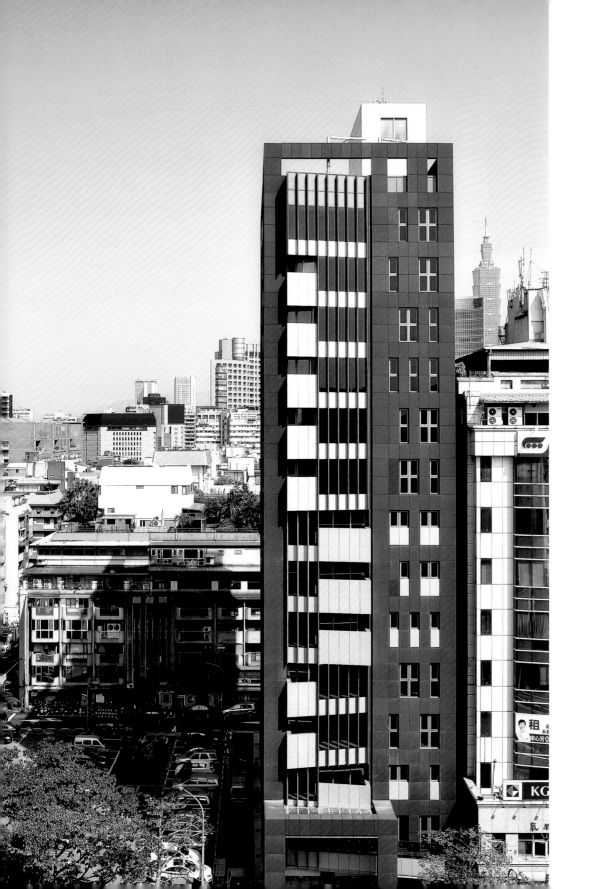

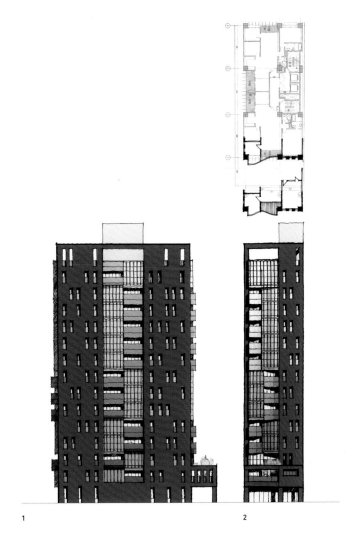

1 NORTH ELEVATION
2 EAST ELEVATION
OPPOSITE PAGE VIEW OF EAST ELEVATION

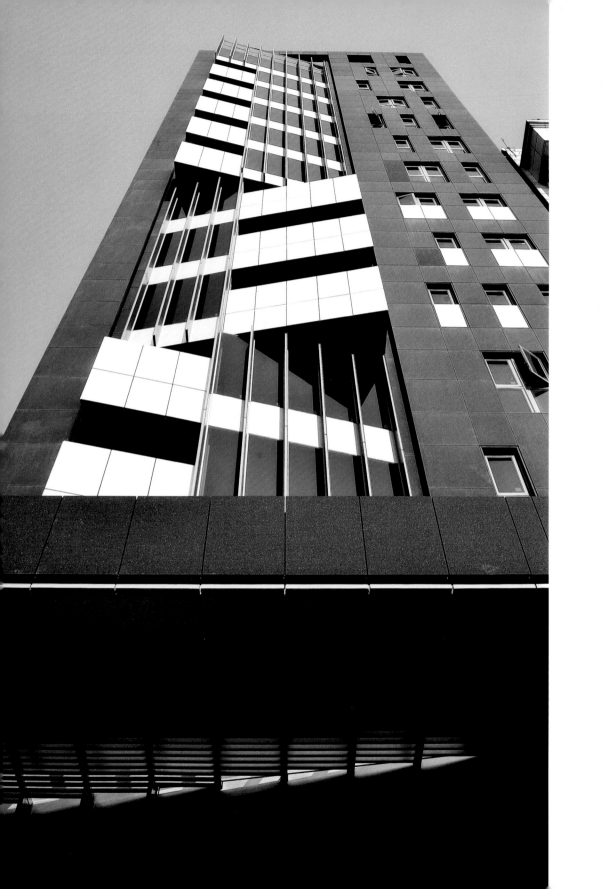

1

2

1,2 COVERED SIDEWALK

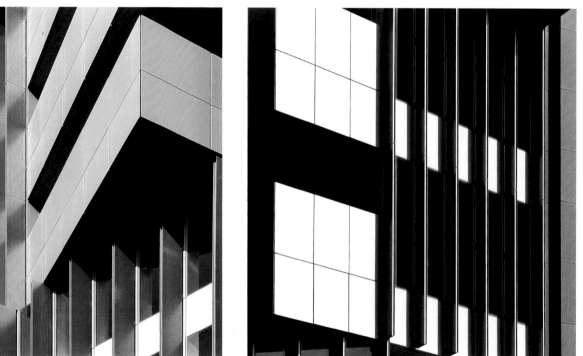

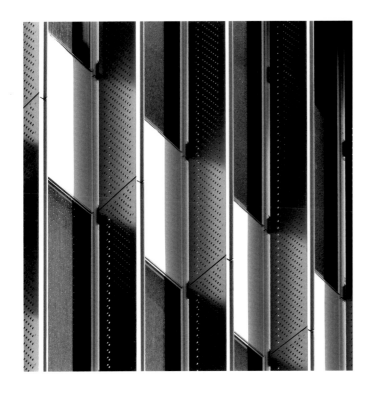

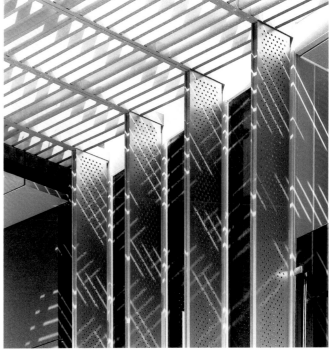

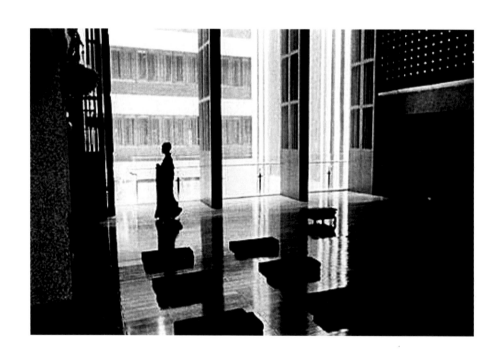

An introspective space for meditation in a bustling urban environment…
A silent exterior with an opulent interior space.

LUMINARY BUDDHIST CENTER

Luminary Buddhist Society

The Luminary Buddhist Center is a modern, urban Buddhist temple, with spaces for Buddhist ceremonies, teachings, gatherings, and residences for nuns. Since its completion in 1998, the center has become an archetype for new spiritual centers in Taiwan and draws many interested visitors with its unique architecture.

The center is located on a typical storefront lot (13.5 meters wide and 34 meters deep) with buildings surrounding it on three sides. It is designed with an introspective focus to create a tranquil place for meditation. The project transforms the traditional horizontal courtyard sequence of a temple into a vertical one through a central atrium that provides natural light to the spaces within. Visitors explore the courtyard on multiple paths, just as one would explore a traditional temple. The Grand Hall, unlike the traditional configuration, is located on the third floor. It can be seen directly from the street from the main entrance and courtyard.

Drawing inspiration from Buddhist philosophy, the design seeks to retreat from the surrounding urban chaos through a space conducive to introspection. The heavy, monolithic pebble stone façade blocks out urban distractions while the randomly placed glass-block openings imply the presence of a central courtyard within.

PROJECT DATA

LOCATION
TAICHUNG, TAIWAN

FUNCTION
RELIGIOUS BUILDING

DESIGN / COMPLETION
1995 / 1998

SITE AREA
418 M²

GROSS FLOOR AREA
2,588 M²

FLOOR LEVELS
8 FLOORS ABOVE GROUND, 2 FLOORS BELOW GROUND

STRUCTURE
REINFORCED CONCRETE CONSTRUCTION

MATERIALS
BLACK CAST-IRON, GLASS UNIT MASONRY, MULTI-COLORED PEBBLES WITH STUCCO WASH FINISH IN WHITE CEMENT

NOTE
FIRST PRIZE, THE TAIWAN ANNUAL ARCHITECTURE AWARD 1999

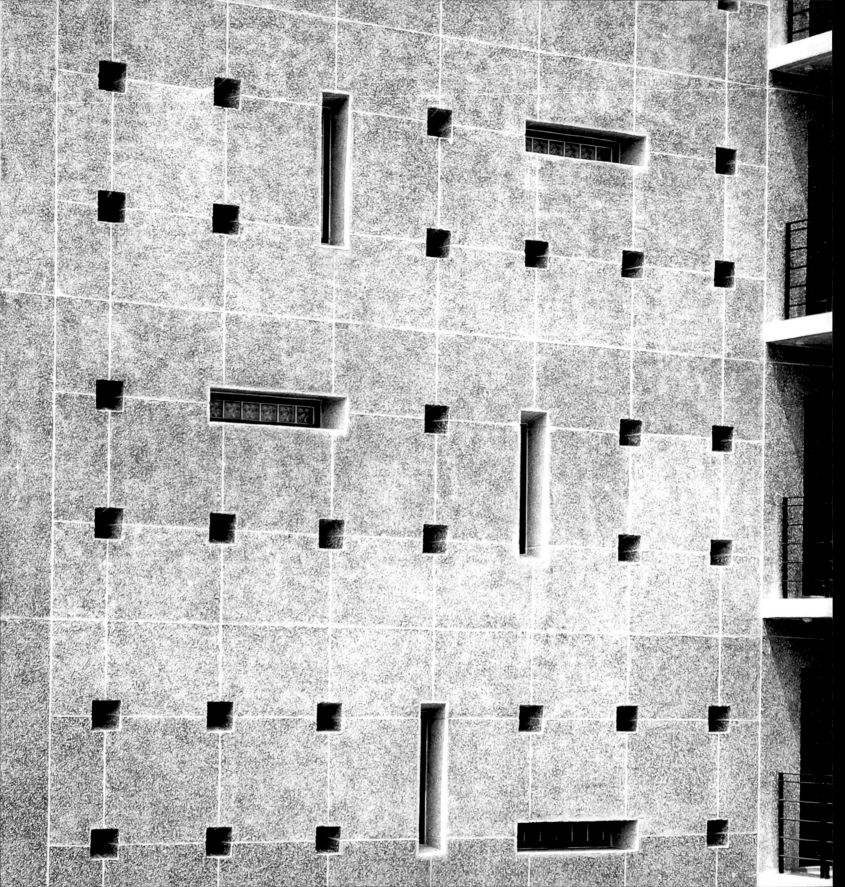

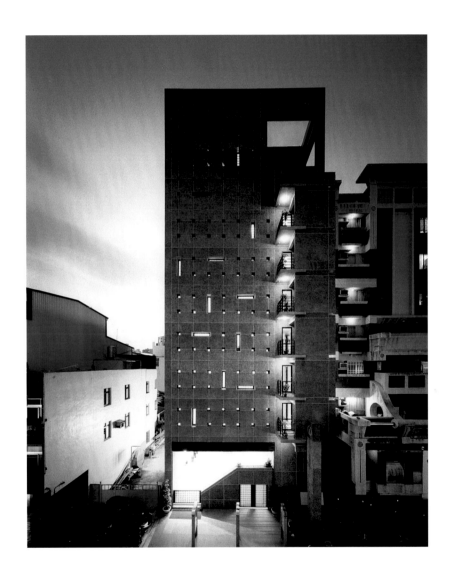

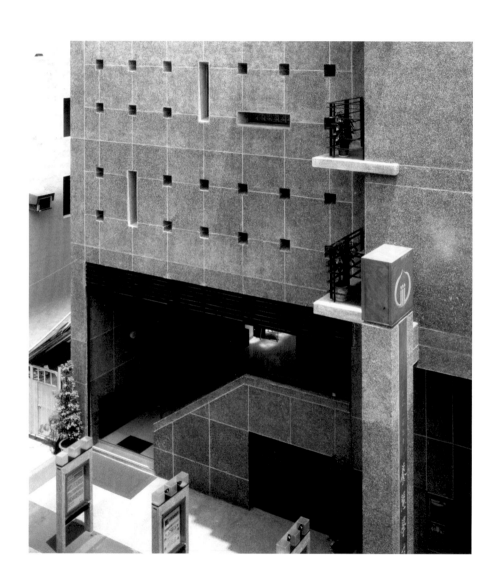

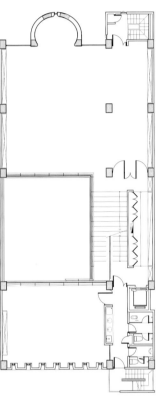

1 FIRST FLOOR PLAN
2 THIRD FLOOR PLAN
OPPOSITE PAGE MAIN ENTRY

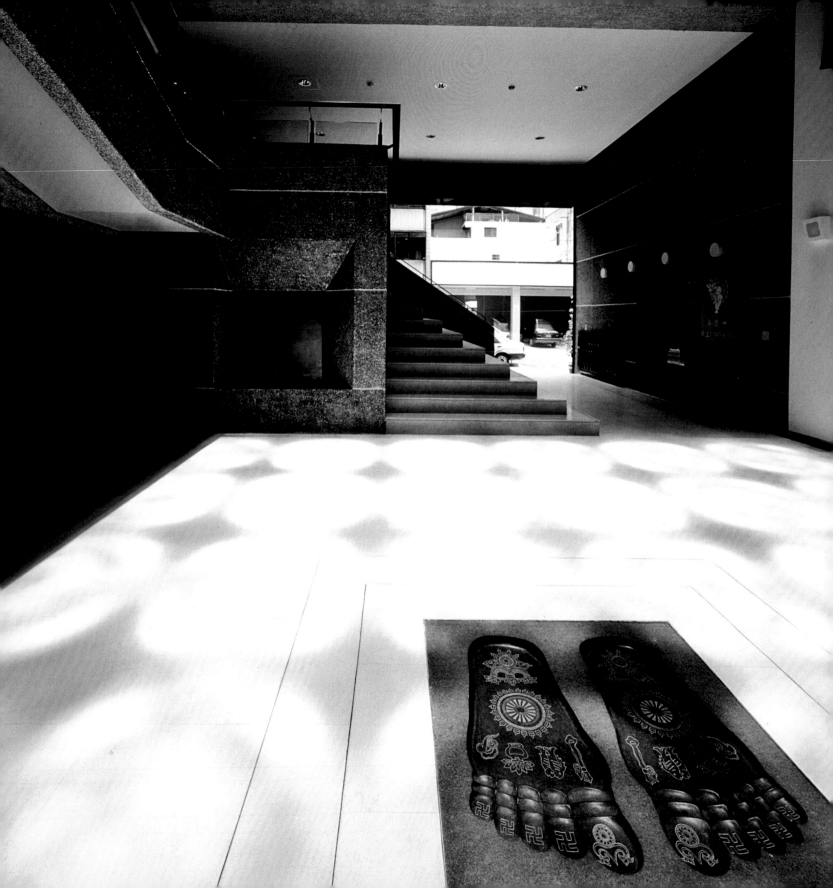

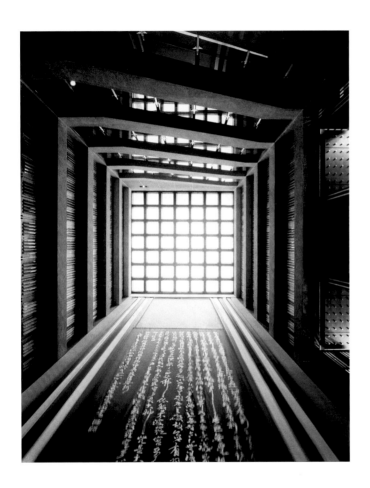
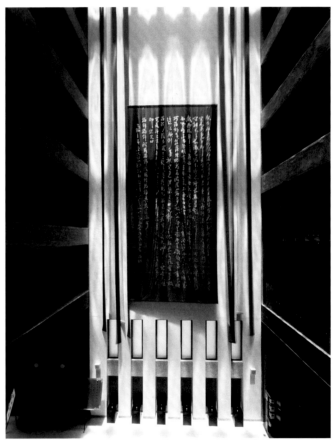

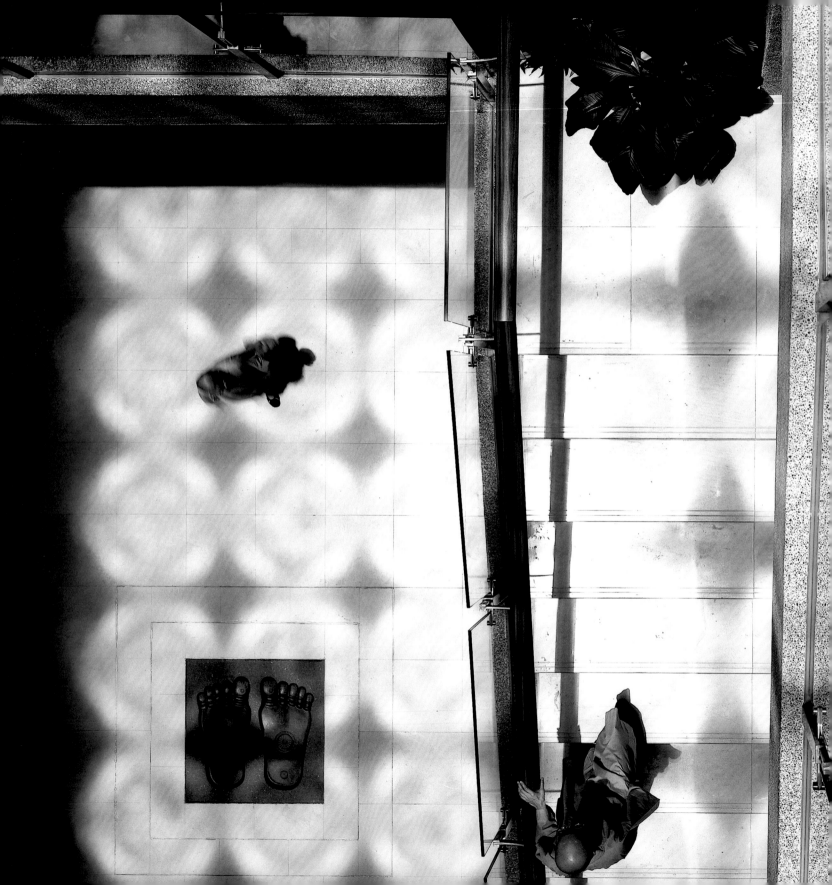

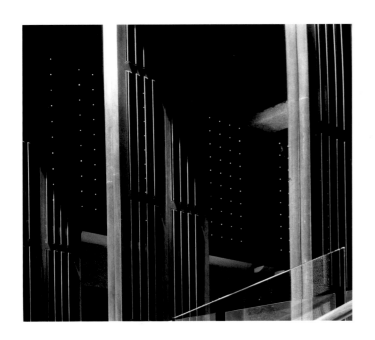
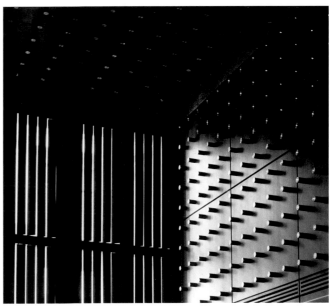

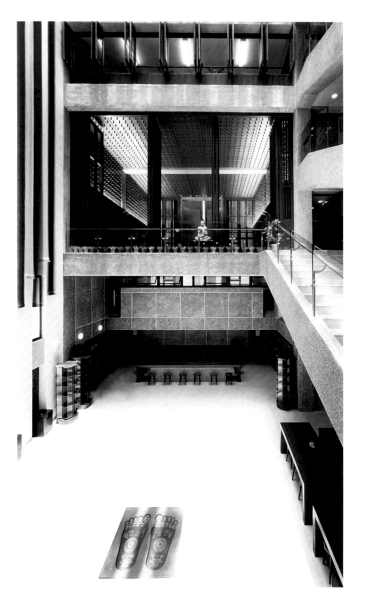
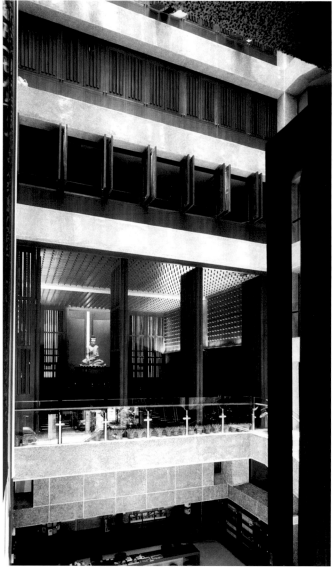

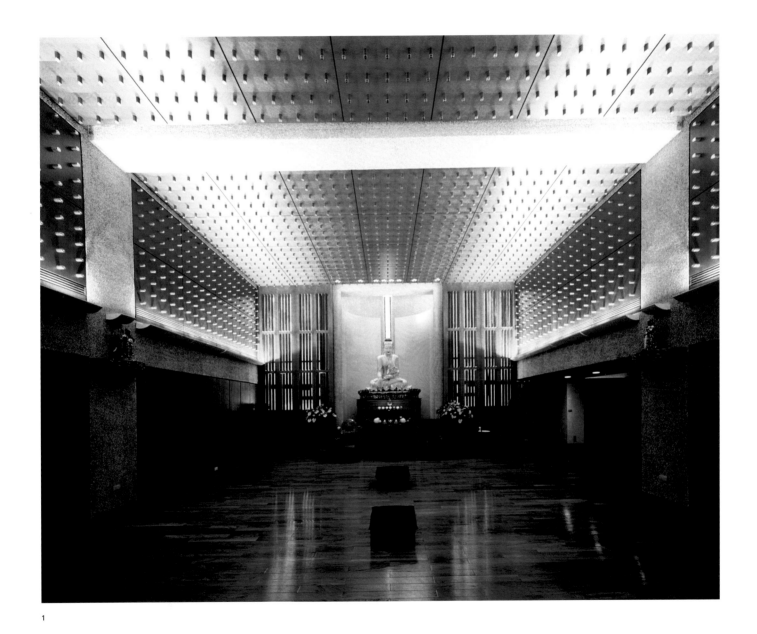

1

1 GRAND HALL

Taking forms from the cuesta rock formation in and around the site, the museum spaces shift in and out of the "rock".

LANYANG MUSEUM
Yilan County Government

This museum is adjacent to the Wushih Port, a once prosperous harbor that is now a wetland. The museum is designed to reflect the unique history, culture, and landscape in Lanyang. In addition to reconstructing the harbor's history, the museum also introduces Yilan's rich wetland ecology as part of an outdoor exhibition.

The volume's dominant geometry is inspired by the natural cuesta rock formation commonly found on the coast. By inserting the triangular mass into the ground at an angle, the minimalist architectural geometry mimics the nearby terrain. The building consists of interlacing solid and glass volumes, where the solid volume is reserved for exhibition and administrative spaces and the glass volume serves as the main lobby and the restaurant area. The gaps between the volumes provide natural lighting and divisions between different functional spaces. The view of the Guishan Island (Turtle Mountain Island) in the distance acts as a reference point for visitors as they experience the alternating inside/outside, solid/void journey through the museum.

A range of granite and cast aluminum panels are used on the building's exterior to represent the reef's natural erosion process while incorporating the image of seasonal changes over the Lanyang plain. These panels of varied texture and size translate into the musical notes and the rhythmic tempos of Vivaldi's *Four Seasons Concerto*.

PROJECT DATA

LOCATION
YILAN COUNTY, TAIWAN

FUNCTION
MUSEUM

DESIGN / COMPLETION
2000 / 2010

SITE AREA
39,070 M²

GROSS FLOOR AREA
12,472 M²

FLOOR LEVELS
4 FLOORS ABOVE GROUND

STRUCTURE
STEEL FRAME AND REINFORCED CONCRETE CONSTRUCTION

MATERIALS
ALUMINUM PANELS, GRANITE, LOW-E GLASS, WOOD

GREEN BUILDING AWARD
TAIWAN EEWH

NOTE
FIRST PRIZE, YILAN LANYANG MUSEUM PHASE ONE DEVELOPMENT PLANNING COMPETITION

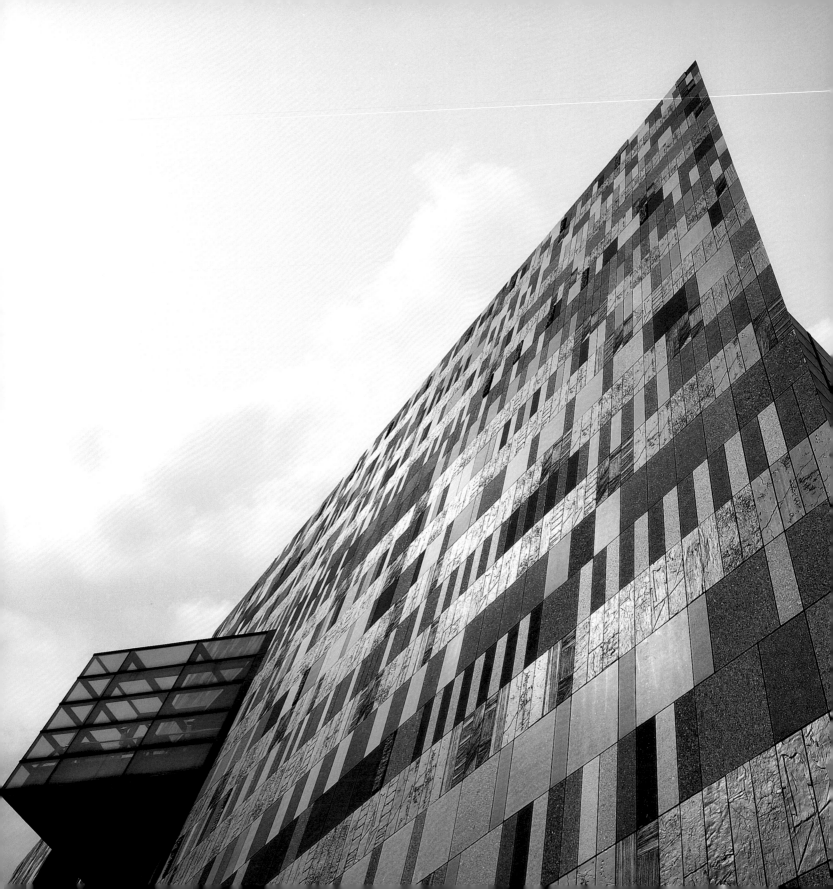

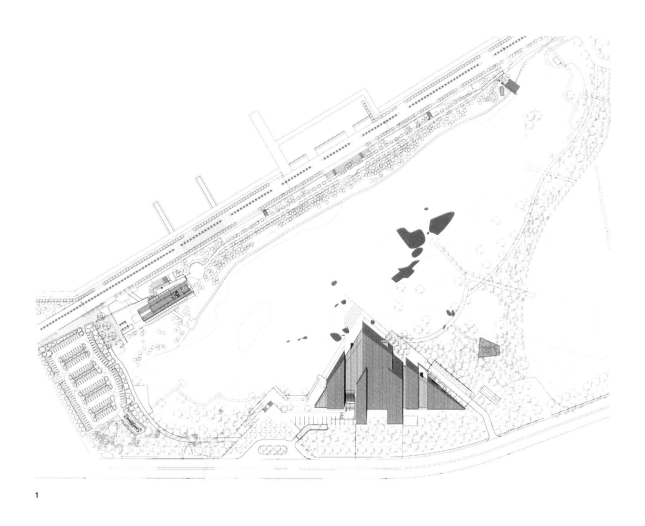

1

1 SITE PLAN

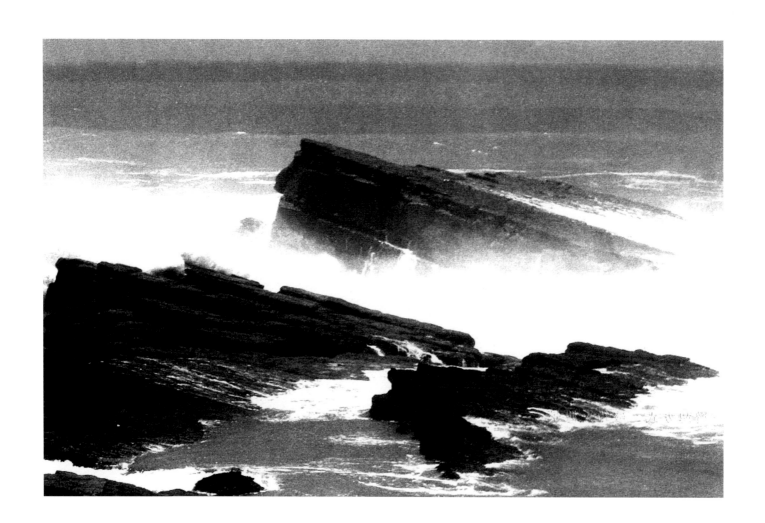

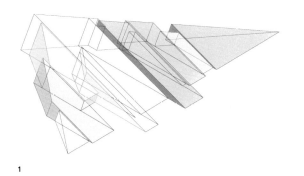

1

2

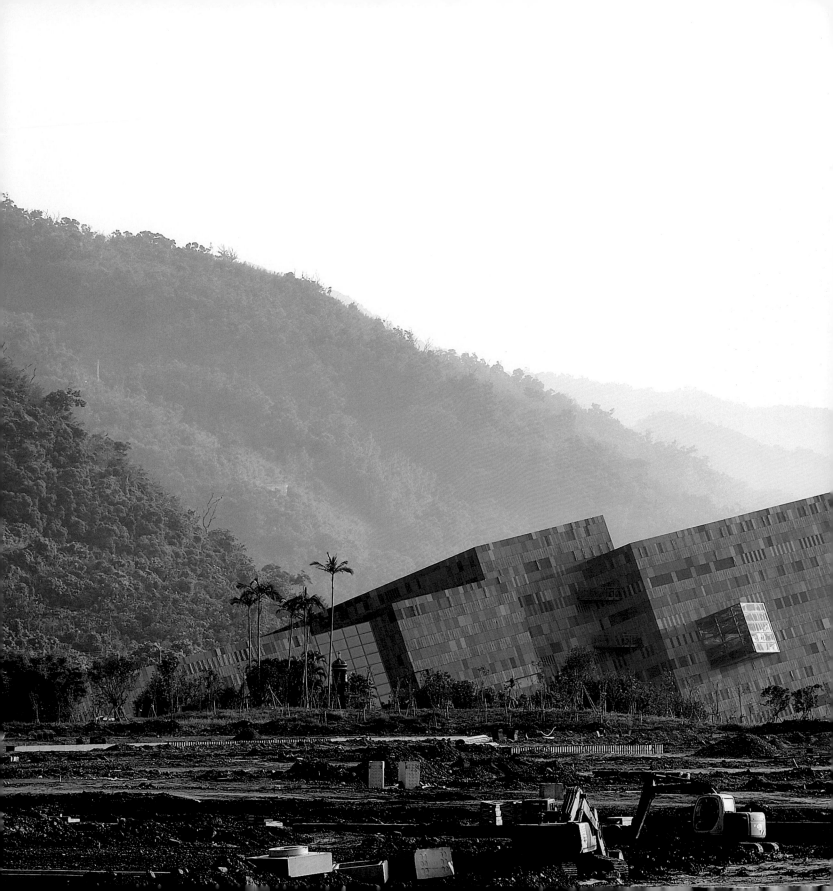

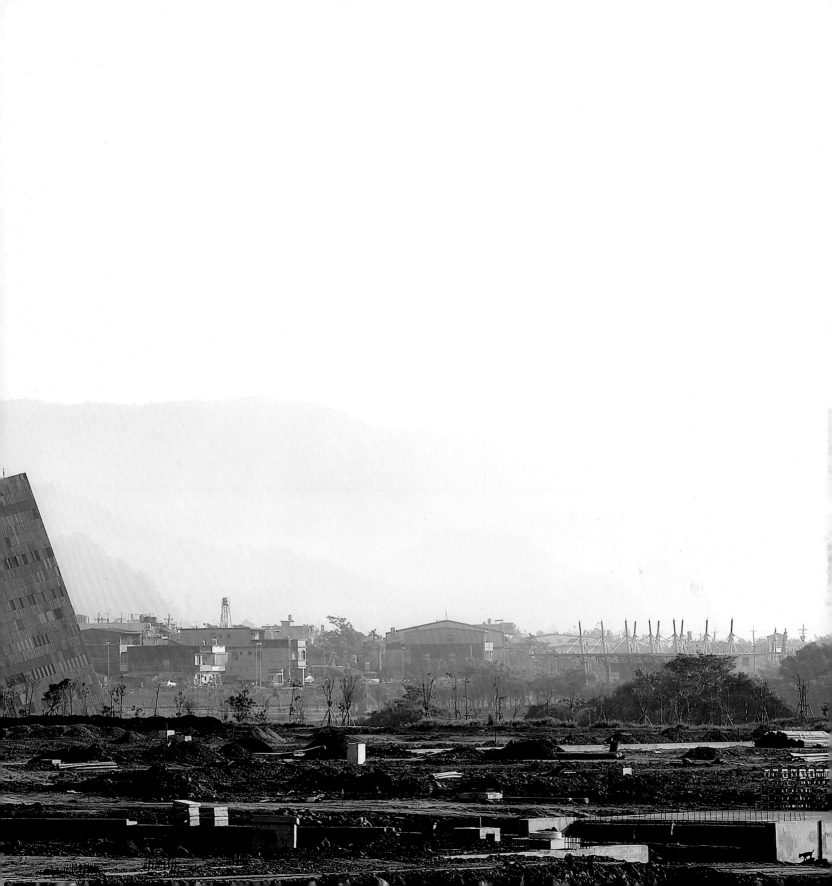

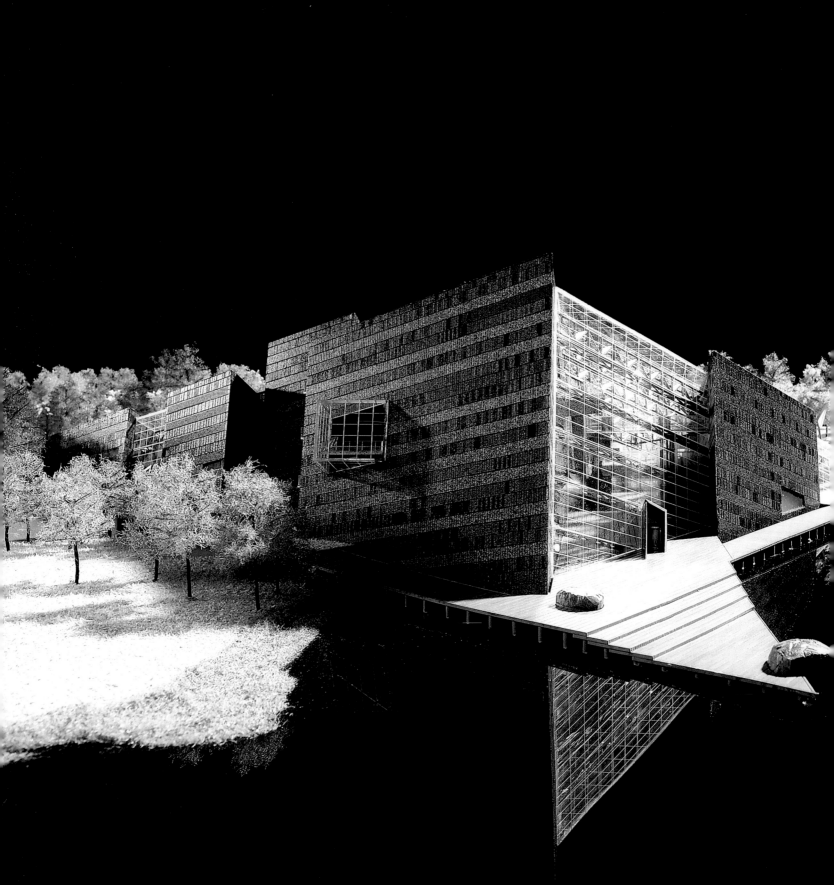

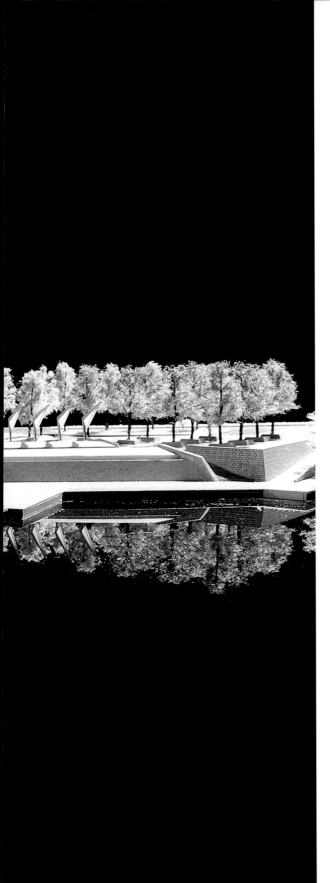

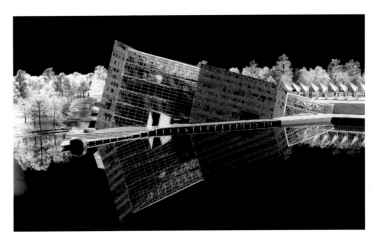

1

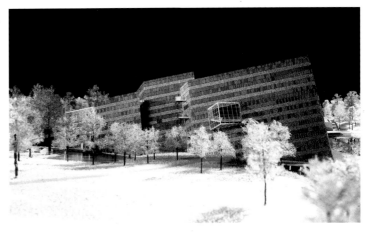

2

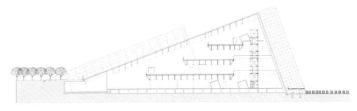

3

1 MODEL, VIEW OF EAST
2 MODEL, VIEW OF SOUTH
3 SECTION THROUGH EXHIBITION HALL
OPPOSITE PAGE MODEL, VIEW OF SOUTHEAST

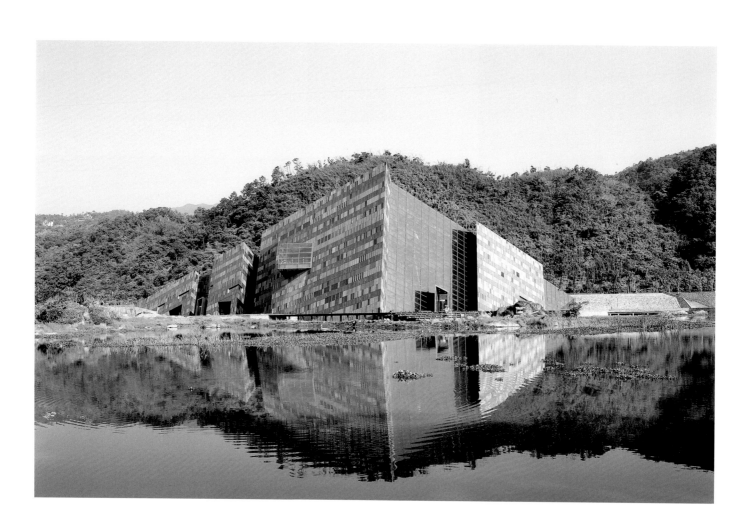

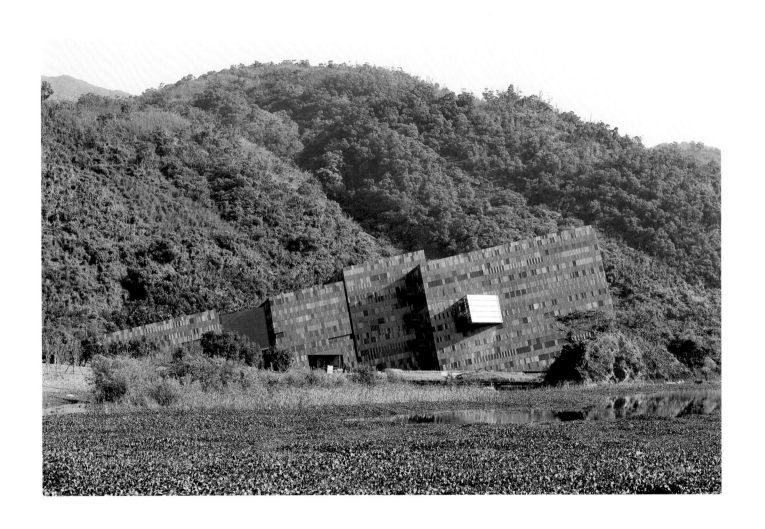

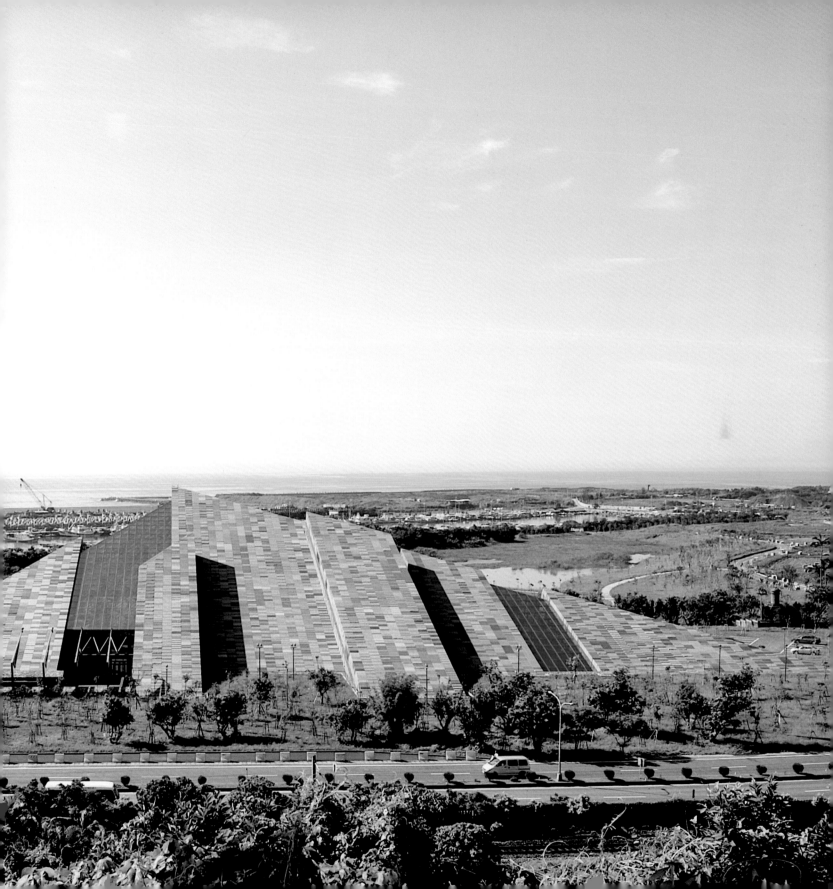

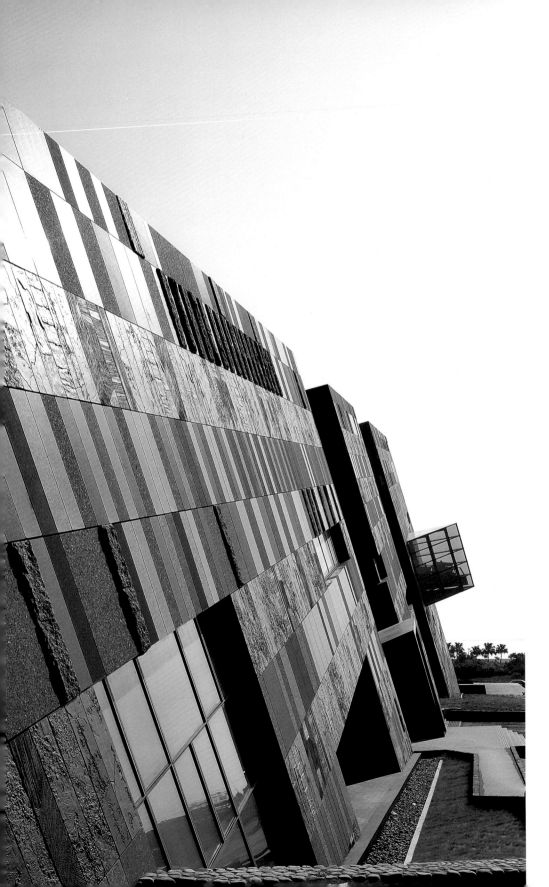

LEFT DETAIL OF FAÇADE

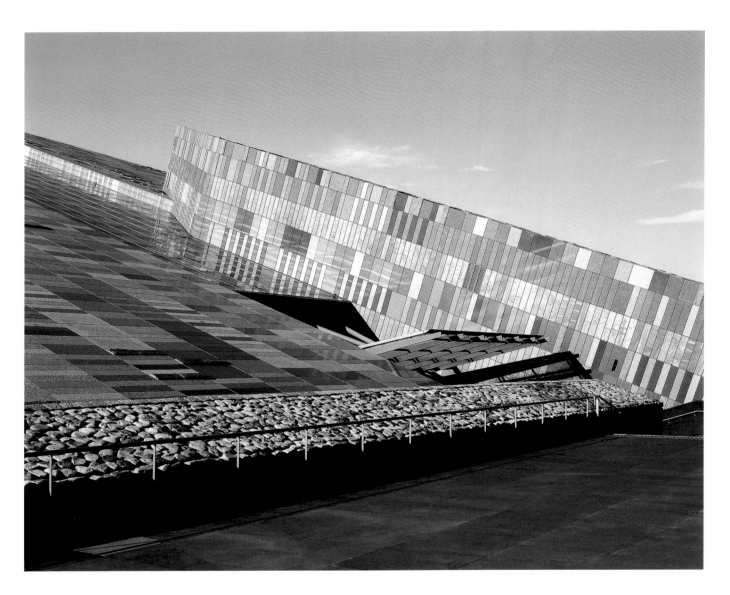

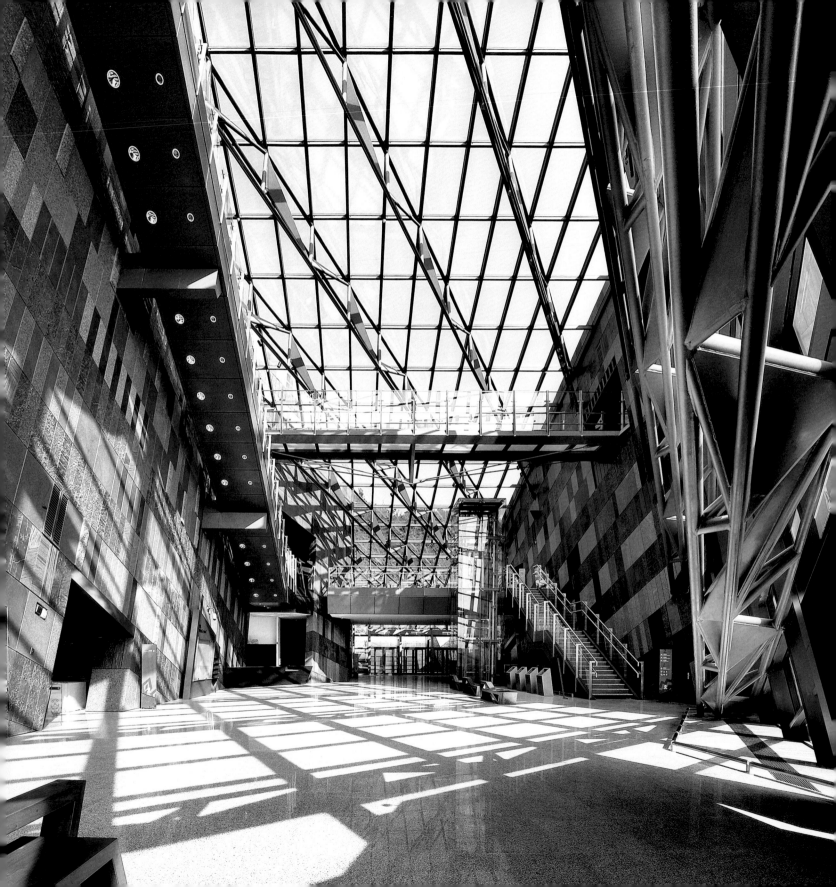

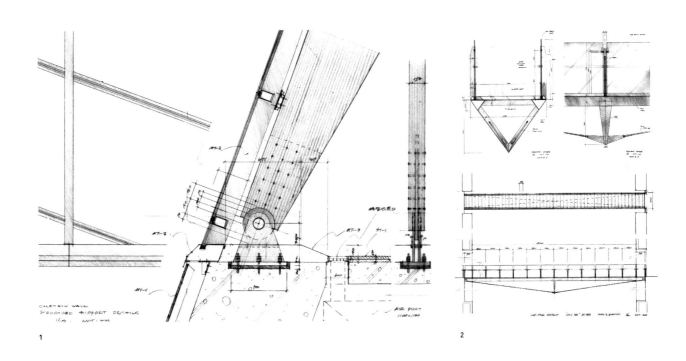

1

2

1 DETAIL OF THE GLAZED CURTAINWALL SYSTEM
2 DETAIL OF MAIN LOBBY'S SKY BRIDGE
OPPOSITE PAGE LOBBY

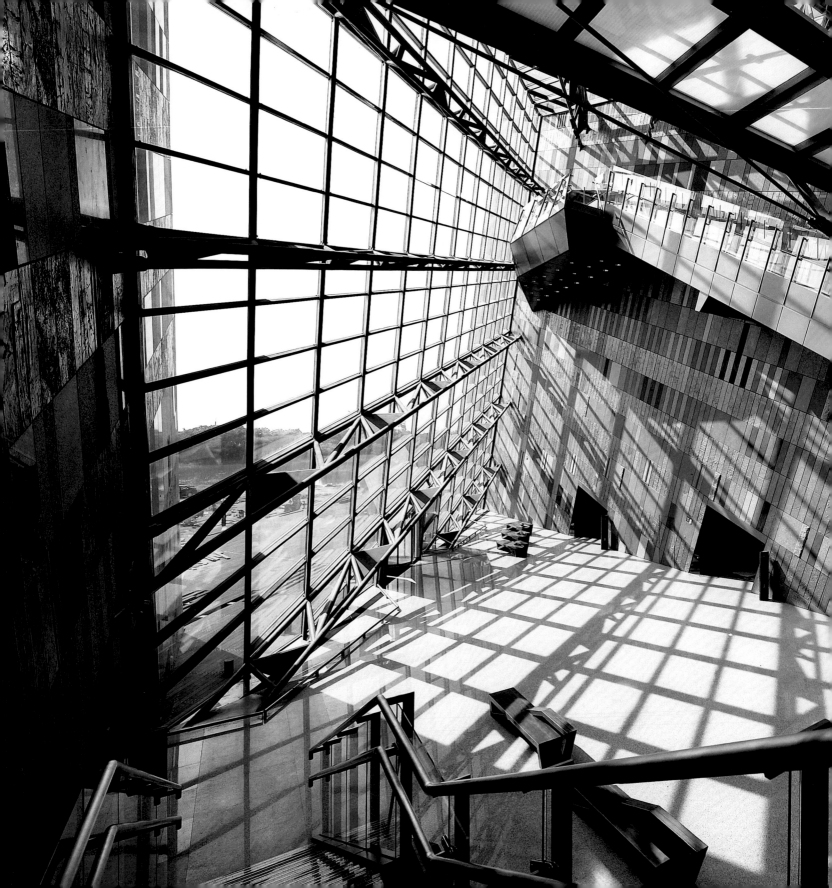

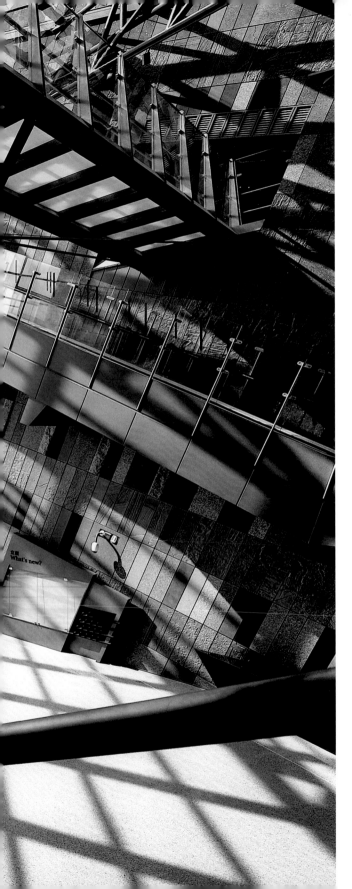

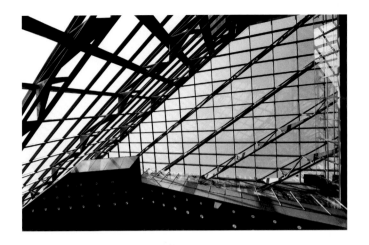

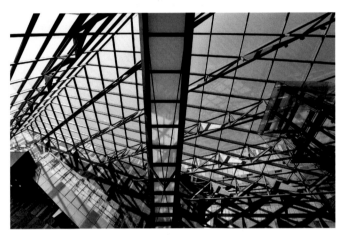

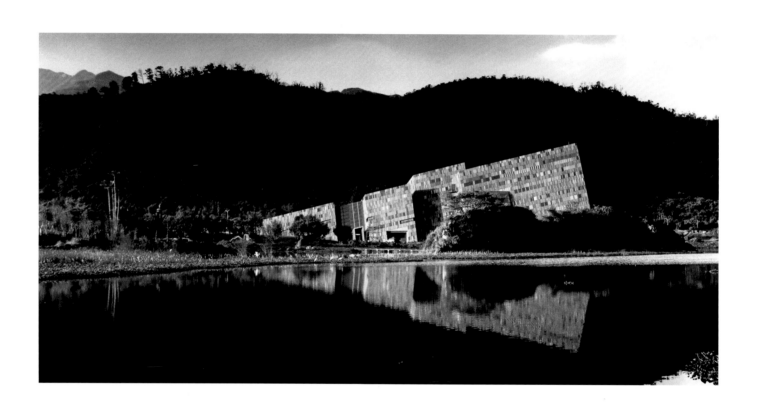

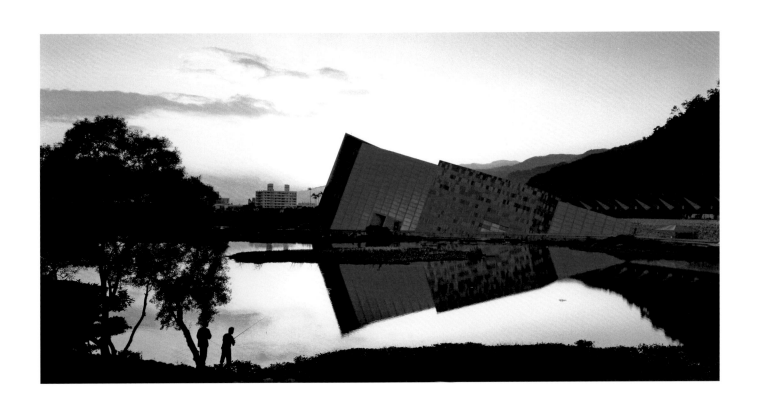

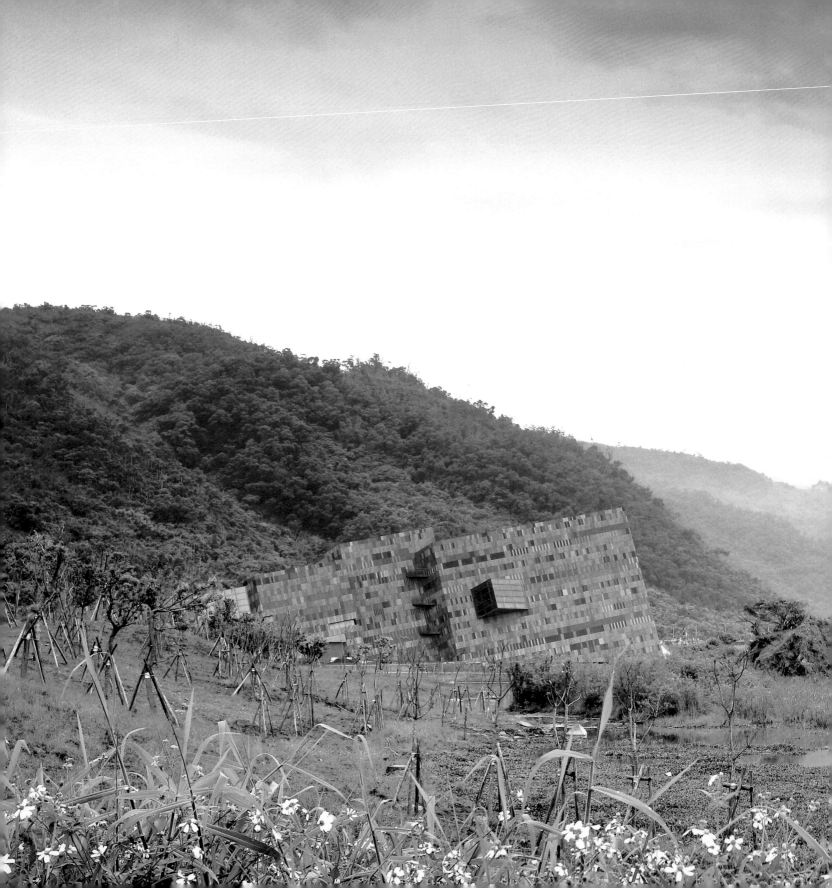

A boundless will to break through the rigid shell…
A tribute to the artist for his spiritual artworks.

TOMOHIRO ART MUSEUM COMPETITION
Tomohiro Museum of Shi-Ga

In line with the competition objective—to establish a museum paying tribute to the Japanese mouth and foot painter, Mr. Hoshino Tomohiro—the design proposal focuses on creating an abstract space that alludes to determination while accentuating the artist's poetry and artwork inspired by nature.

The transparent glass volume portrays the purity of the artist's creative soul and also serves as an exhibition spaces for the art museum. The heavy, opaque wooden box wraps around the glass volume, suggestive of a sense of division and distance between the interior and the outside world.

Set above a quiet pond, a gently sloping pathway leads to the entrance of the art museum. Natural light seeps through thin, cross-shaped openings cut out from the wooden box exterior and shines on the glass walkways of each level. These openings are kept to a minimum to protect the artworks from direct sunlight. The glass volume and the wooden box appear to be floating above the crystalline pond that reflects ever-changing nature— the source of the artist's inspiration— straight into the museum space, as well as into the heart and soul of its visitors.

PROJECT DATA

LOCATION
GUNMA PREFECTURE, JAPAN

FUNCTION
ART MUSEUM

DESIGN
2001

SITE AREA
70,000 M²

GROSS FLOOR AREA
1,000 M²

FLOOR LEVELS
4 FLOORS ABOVE GROUND, 1 FLOOR BELOW GROUND

STRUCTURE
STEEL FRAME CONSTRUCTION

MATERIALS
ARCHITECTURAL CONCRETE, CLEAR FLOAT GLASS, WOOD

NOTE
TOMOHIRO ART MUSEUM INTERNATIONAL DESIGN COMPETITION

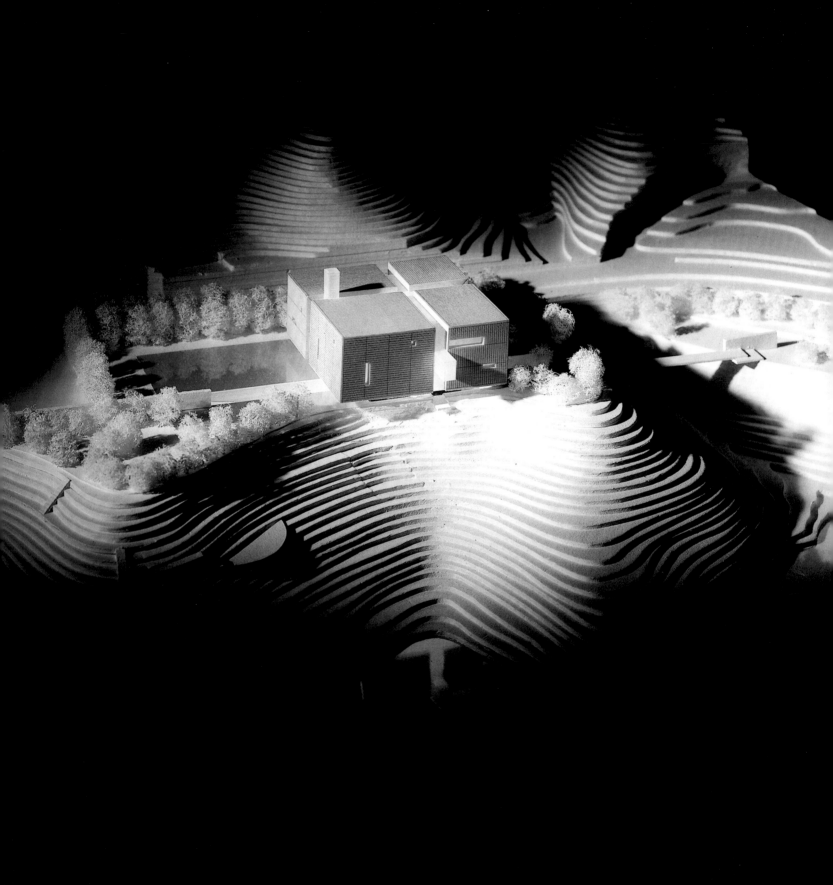

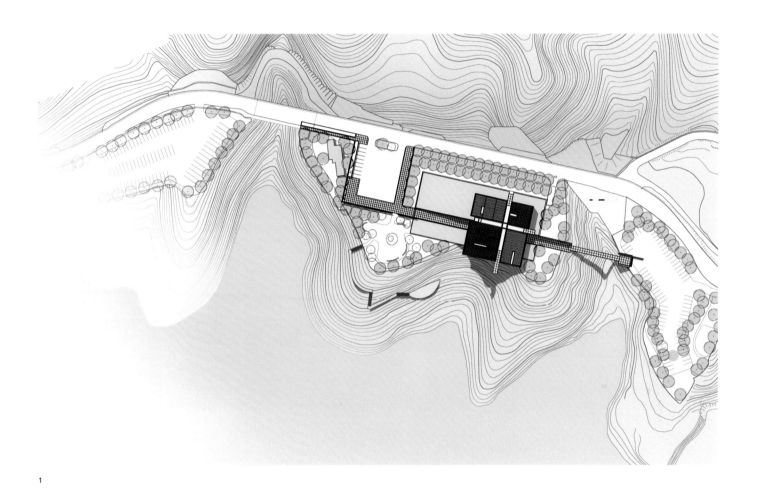

1

1 SITE PLAN
OPPOSITE PAGE MODEL, AERIAL VIEW

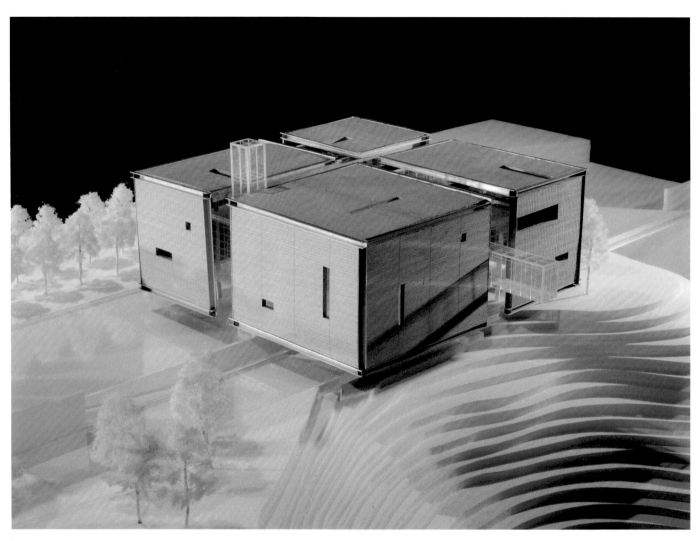

1

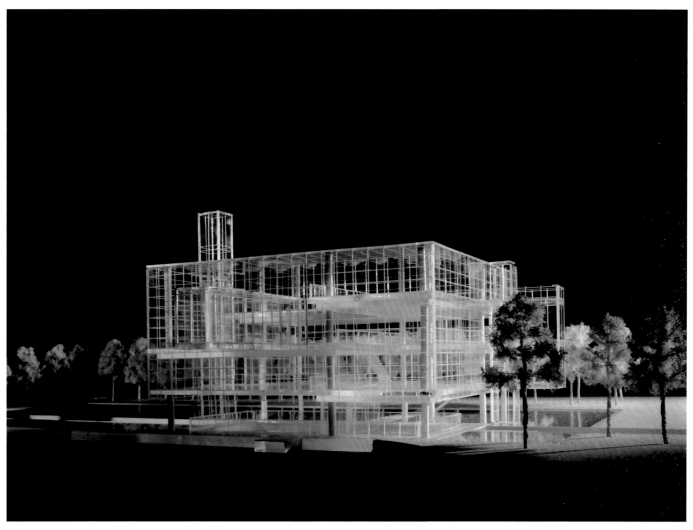

2

1 MODEL, WOODEN BOX OUTSIDE
2 MODEL, TRANSPARENT GLASS VOLUME INSIDE
3 EXPLODED DIAGRAM

3

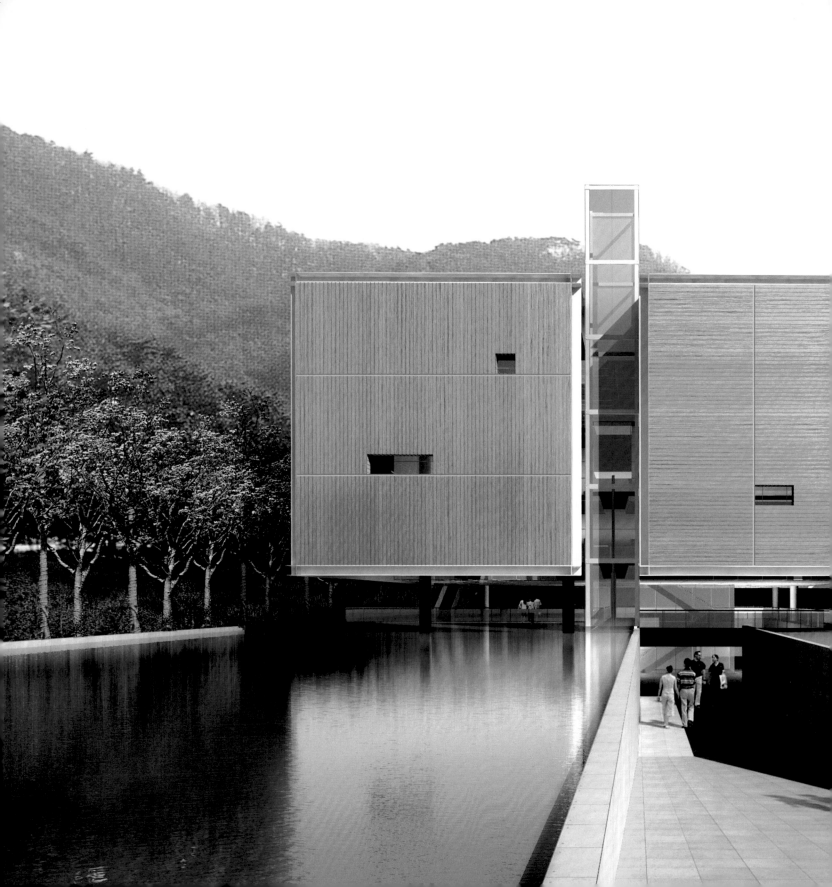

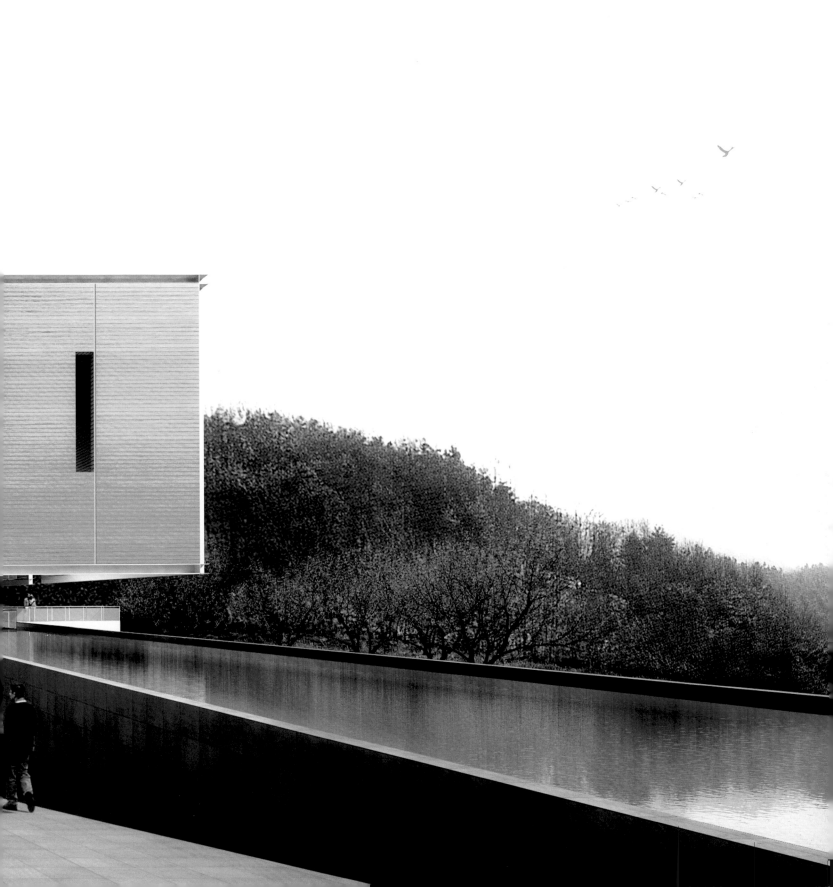

Heavy

light.

Minimizing the building mass into a series of linear slabs with green-covered spaces in between, the architecture redefines the spatial sequence of a traditional temple in a zigzag manner and achieves a "Temple-in-the-Park".

FO GUANG SHAN MONASTERY, BUSSY, FRANCE

Fo Guang Shan Monastery

This Monastery is located in the center of a green park, with a historical castle to the south, in Bussy Saint Georges in the suburbs of Paris. It offers spaces for religious activities, meditation, cultural education, and social gatherings. The design concept emphasizes harmony with the surrounding natural ecology and its history. The use of unadorned materials, modestly sized massing, and abundant green spaces, helps the new building to blend in with its surroundings in a quiet manner.

Three thick horizontal "walls" house the main circulation corridors to all the functions. This provides three layers of spaces with different degrees of privacy for the public zone, ceremonial spaces, and living quarters. The public zone on the outer layer houses general classrooms and social areas, such as the café, art gallery, and bookstore; the second layer

contains a series of religious assembly halls; and the innermost layer accommodates the living quarters for monks and nuns. The ceremonial Main Hall, the Mahakaruna Hall, the Zen Hall, and the Ksitigarbha Hall are linked together by outdoor courtyards or terraces on the east–west (horizontal) axis. The entrance lobby, the central courtyard, and the Zen garden connect on the north–south (vertical) axis. Visitors to the Main Hall ascend the gentle ramp along the outer wall, enter the second floor lobby, then step down the grand stairs to the center courtyard in front of the Main Hall. This zigzag progression preserves the ancient ritual of approaching a temple.

Green roofs are incorporated for sustainability. Vast windows provide natural ventilation, views, and entrances to the gardens and courtyards, allowing people to be immersed in nature's gentle breeze, light, and greenery.

PROJECT DATA

LOCATION
BUSSY SAINT GEORGES, FRANCE

FUNCTION
RELIGIOUS BUILDING

DESIGN / COMPLETION
2004 / EXPECTED 2011

SITE AREA
6,750 M²

GROSS FLOOR AREA
7,300 M²

FLOOR LEVELS
3 FLOORS ABOVE GROUND

STRUCTURE
PRE-CAST REINFORCED CONCRETE CONSTRUCTION

MATERIALS
ARCHITECTURAL CONCRETE, STONE, WOOD

NOTE
ARCHITECT OF RECORD: ATELIER FREDERIC ROLLAND

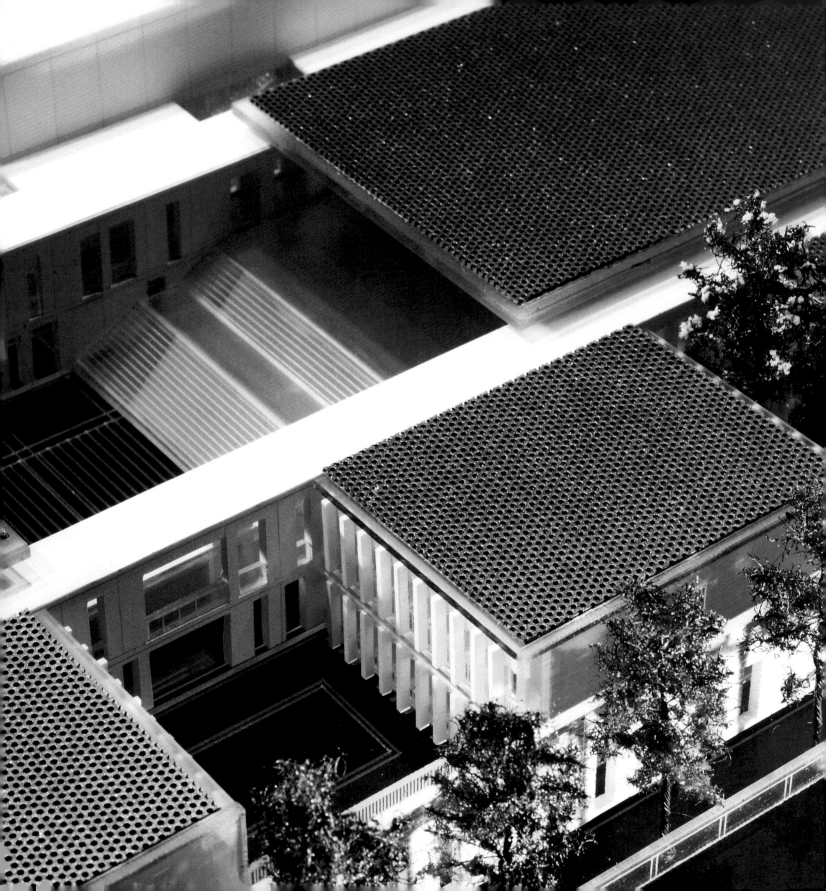

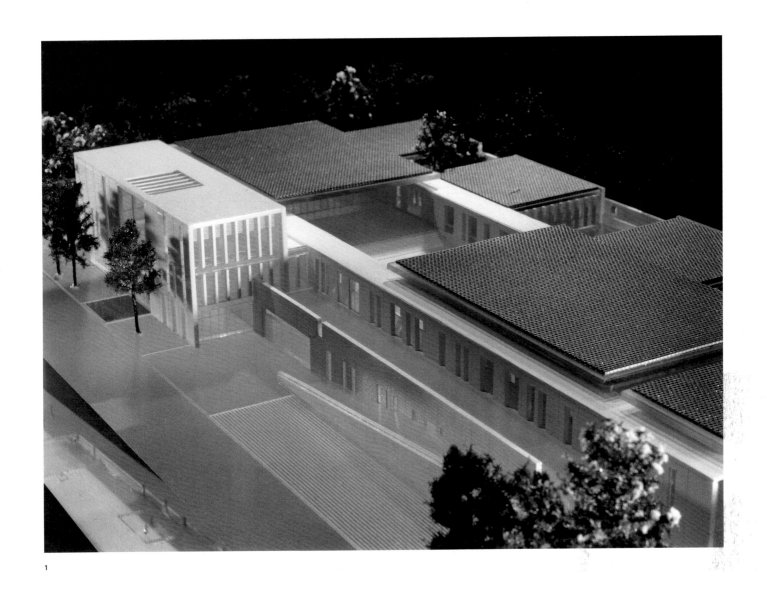

1

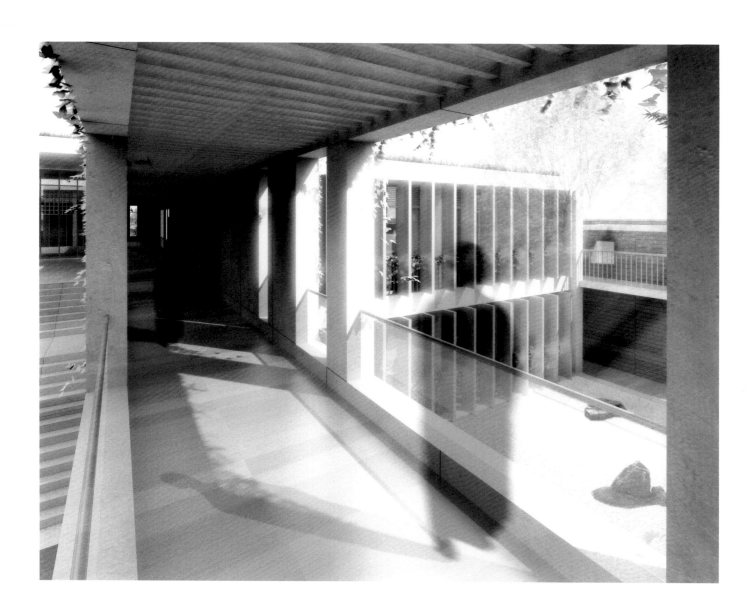

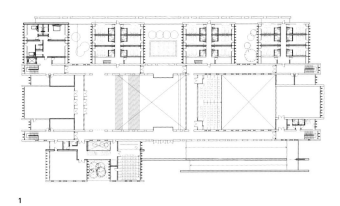

1

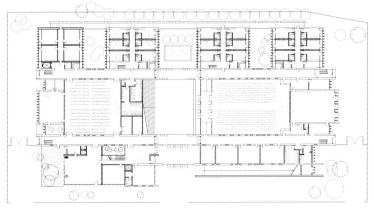

2

1 SECOND FLOOR PLAN
2 GROUND FLOOR PLAN

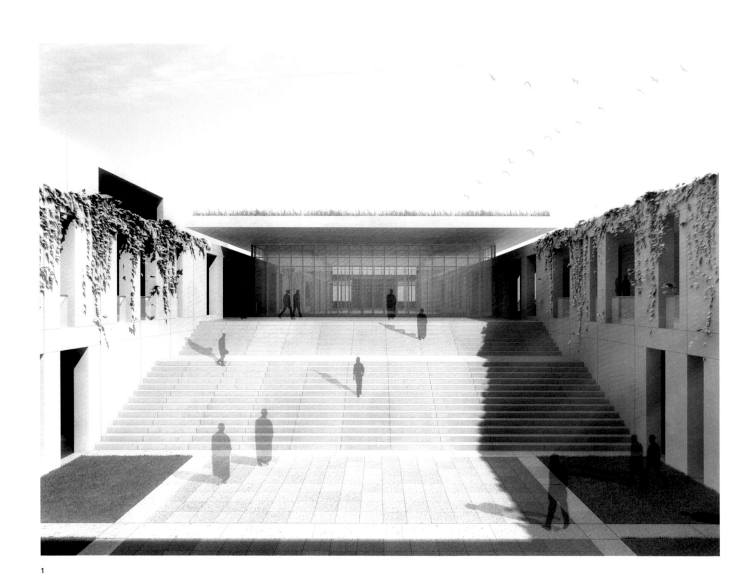

1

1 CENTRAL COURTYARD

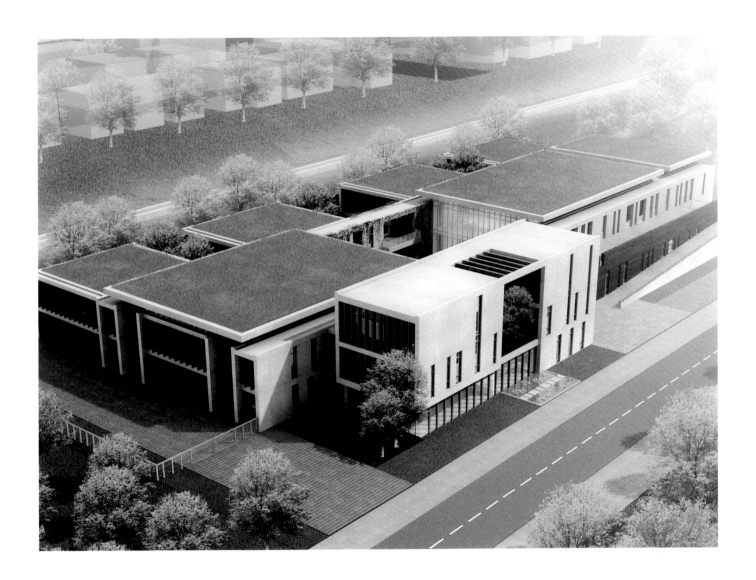

A half-concealed, half-revealed form embraces the emptiness.

NATIONAL PALACE MUSEUM SOUTHERN BRANCH COMPETITION
National Palace Museum

The new branch for the world renowned National Palace Museum was themed to exhibit a broader collection of Asian arts that were influenced by Chinese culture. In response to this theme, our entry for the competition aims to convey a vision of a modern Asian museum through a unique design fused with Chinese cultural characteristics.

The metaphor we chose is that of a piece of ancient jade, found in the split second as it is half revealed and half hidden. The Chinese word for hidden, "tsang", is ripe with multiple meanings: to collect, to hide, to conceal, and to treasure. All of them speak of transcending the superficial and looking deeply within. This concept is transformed into architecture of introspective spaces and modest forms. Furthermore, the notion of "ksana" (the fleeting moment), adapted from India to China, that embodies the moment of power and mystery when the jade is found, is precisely what the museum strives to present.

The architectural design begins with an artificially created hill, with a lake 160 meters in diameter carved out from the center of the hill. Around the lake sits a circular building that is half-concealed by the hill. Upon entering the museum, the visitor is greeted by a diverse range of exhibition spaces. Some of the spaces are located by the lake, facing the island outside; some lead into passages or into open spaces. Guests are then invited to slowly discover the hidden treasures in the museum.

PROJECT DATA

LOCATION
CHIAYI COUNTY, TAIWAN

FUNCTION
MUSEUM

DESIGN
2004

SITE AREA
700,000 M²

GROSS FLOOR AREA
23,400 M²

FLOOR LEVELS
2 FLOORS ABOVE GROUND, 1 FLOOR BELOW GROUND

STRUCTURE
REINFORCED CONCRETE CONSTRUCTION

MATERIALS
ARCHITECTURAL CONCRETE, CLEAR FLOAT GLASS, STONE

NOTE
THIRD PRIZE, TAIWAN NATIONAL PALACE MUSEUM SOUTHERN BRANCH INTERNATIONAL DESIGN COMPETITION

藏

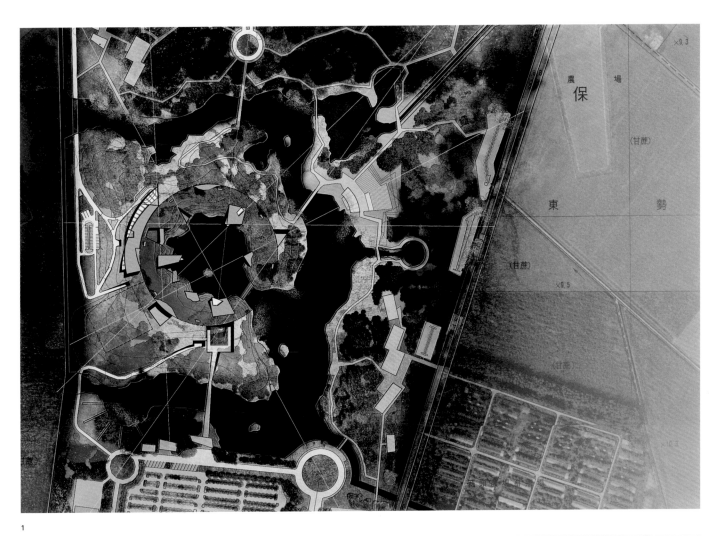

1

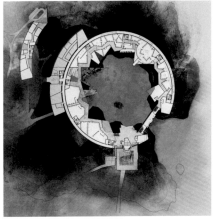

2

1 SITE PLAN
2 BASEMENT FLOOR PLAN

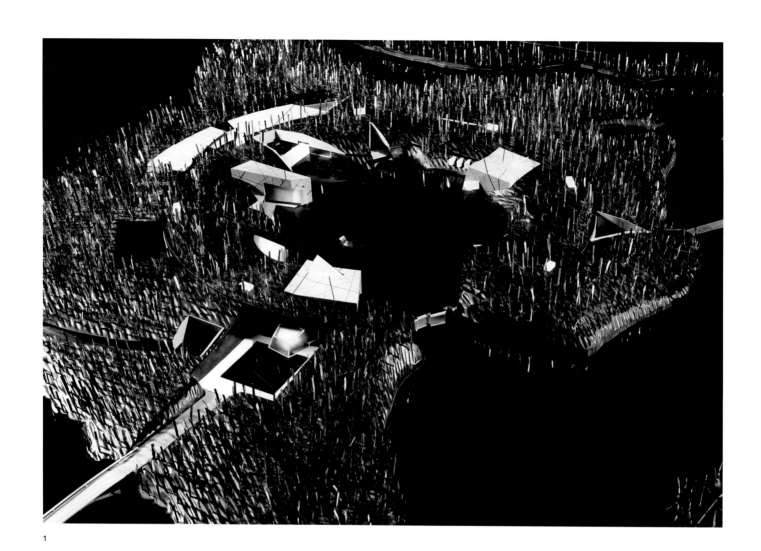

1

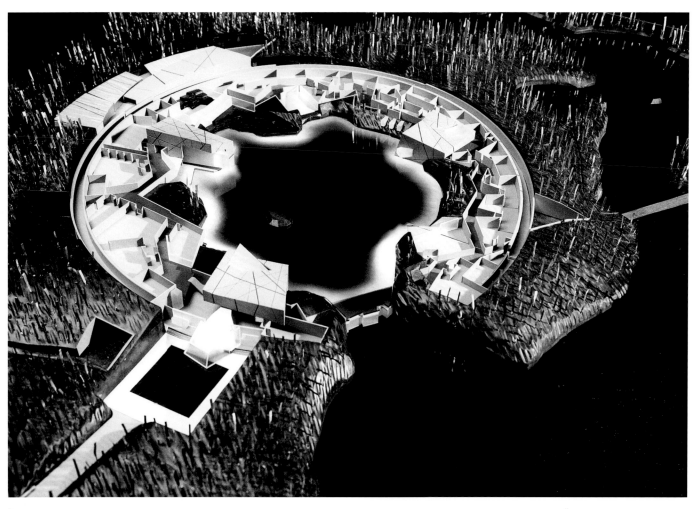

2

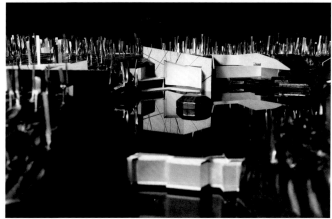

1 MODEL, AERIAL VIEW
2 MODEL, VIEW OF UNDERGROUND FLOOR
3 MODEL, ARCHITECTURE SURROUNDING INNER LAKE

3

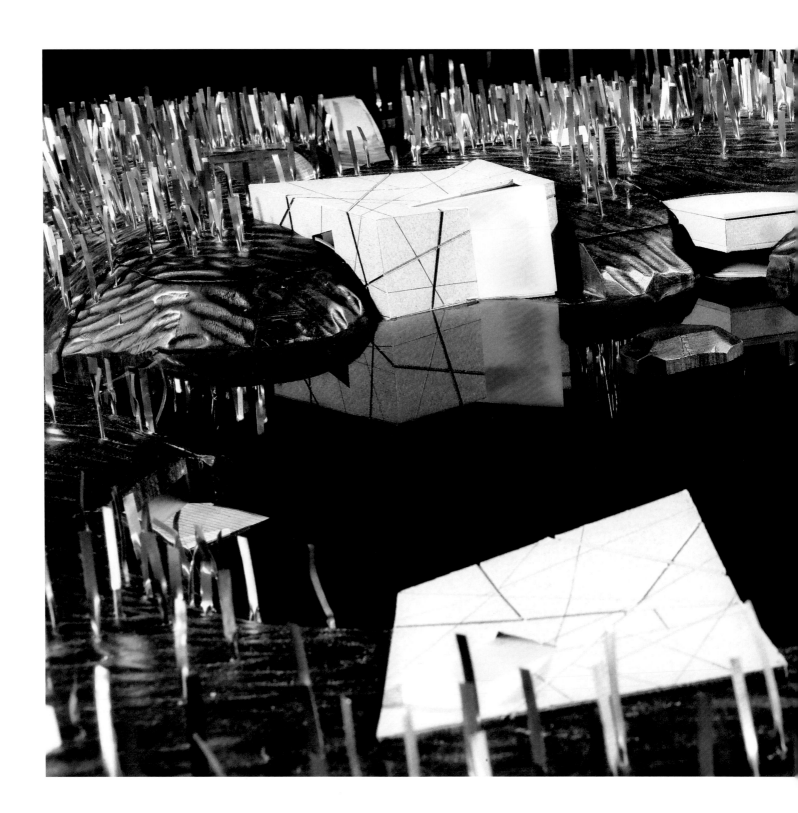

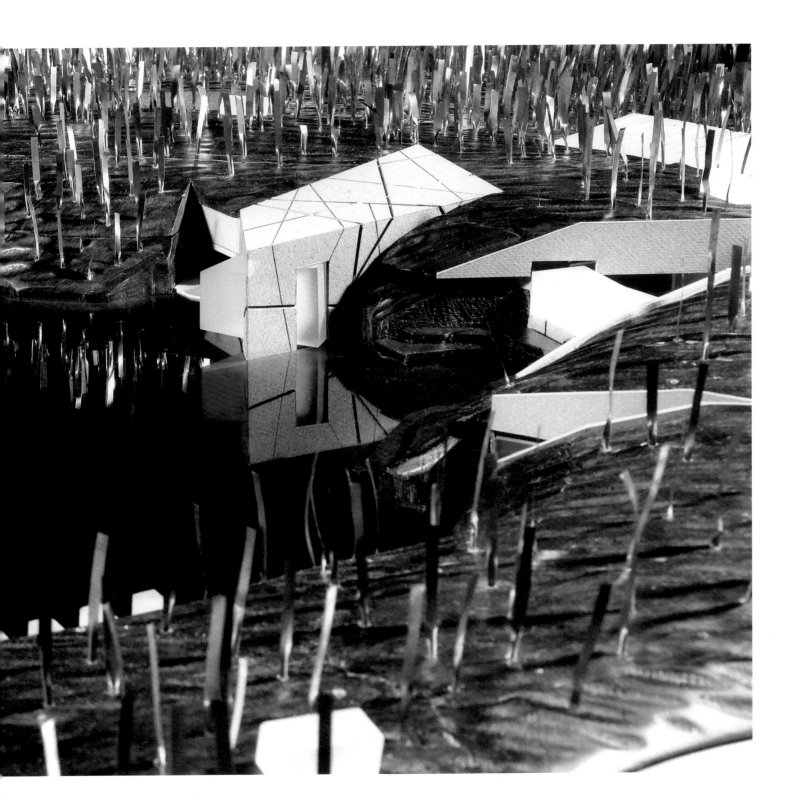

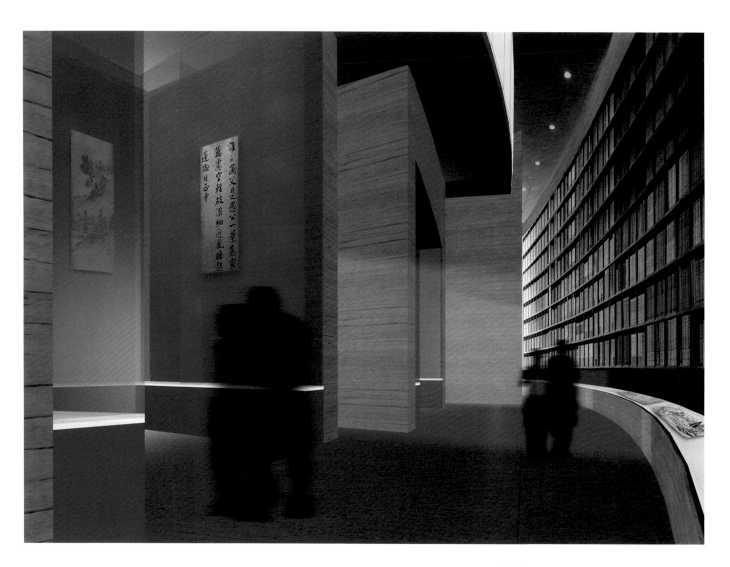

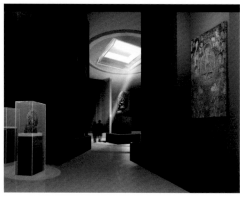

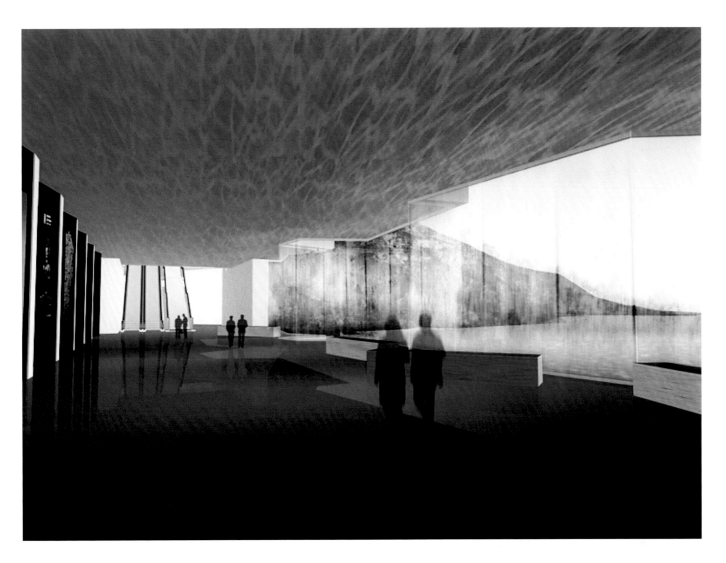

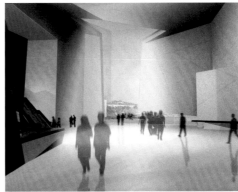

Staggered as a string of treasure boxes, the new annex is designed to echo the existing museum.

NATIONAL ART MUSEUM OF CHINA, BEIJING, COMPETITION

National Art Museum of China

Constructed in 1958 and located to the north of the Forbidden City, the National Art Museum is recognized as one of the most important early modern buildings in Beijing. The original architecture, designed by famous architect Dai Nian-Chi, is inspired by the Mogao Grottoes of Dunhuang, including the pagoda form and its nine layers of cornices. The competition addresses the expansion of the art museum. Over a year, the ARTECH team proposed four design schemes reflecting innovations upon the inheritance of tradition.

The design aims to use modern architectural language to express traditional Chinese spirits, to narrate the museum in the same storyline 50 years later. While the original building used the form of the Mogao Grottoes as its source of inspiration, the new addition echoes the spirit of the space of the Dunhuang caves. Multiple layers of "treasure boxes", as were found in ancient treasure caves, are stacked up in the space for visitors to explore the artworks within. These boxes match the original museum in configuration and size, while the choice of the exterior material resonates with the texture, color, and details of the original building. The use of modern materials, such as transparent stones and glass, attempts to further enhance the spatial fluidity and to introduce natural lighting to the new building.

The proposal opens up the old museum's west elevation, strengthening the east–west axis that responds to the city's grand axis. The beautiful elevation of the old museum can be viewed from the new museum through surfaces of glass, light, and water, in a moment when tradition and modernity coexist in a harmonious and artistic dialogue.

PROJECT DATA

LOCATION
BEIJING, CHINA

FUNCTION
ART MUSEUM

DESIGN
2005

SITE AREA
17,600 M

GROSS FLOOR AREA
39,980 M

FLOOR LEVELS
3 FLOORS ABOVE GROUND, 2 FLOORS BELOW GROUND

STRUCTURE
STEEL FRAME CONSTRUCTION

MATERIALS
ALUMINUM PANELS, LOW-E GLASS, METAL GRILLE

NOTE
THIRD PLACE, NATIONAL ART MUSEUM OF CHINA
SECOND PHASE EXPANDING CONSTRUCTION DESIGN
COMPETITION

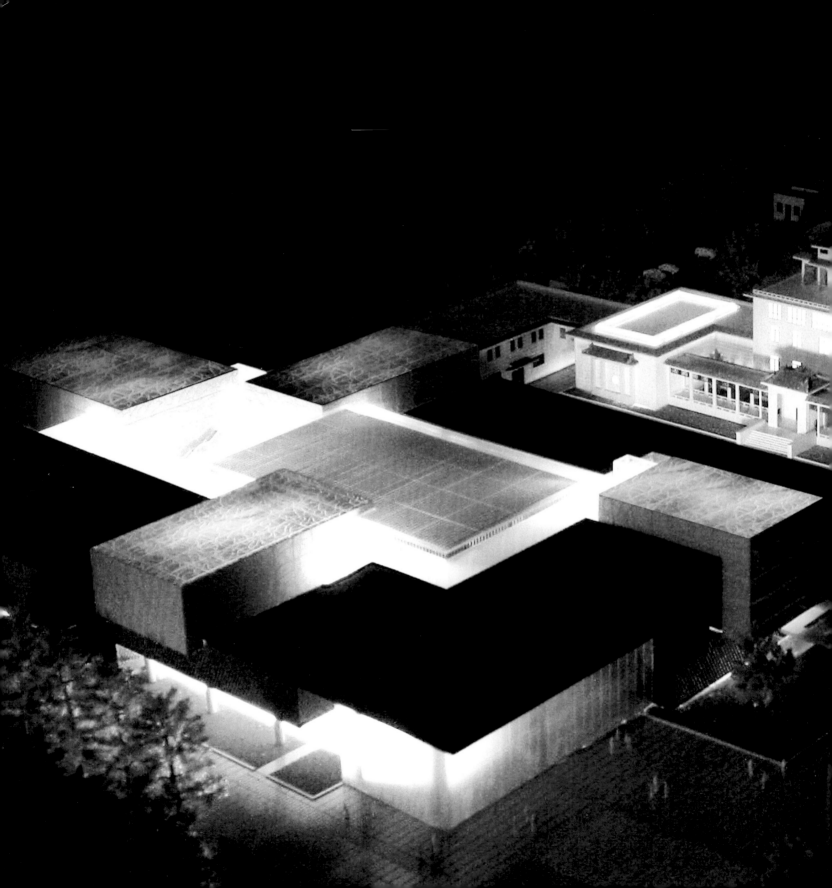

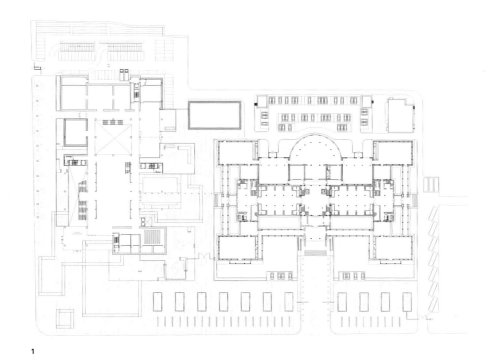

1

1 GROUND FLOOR PLAN
OPPOSITE PAGE MODEL, AERIAL VIEW

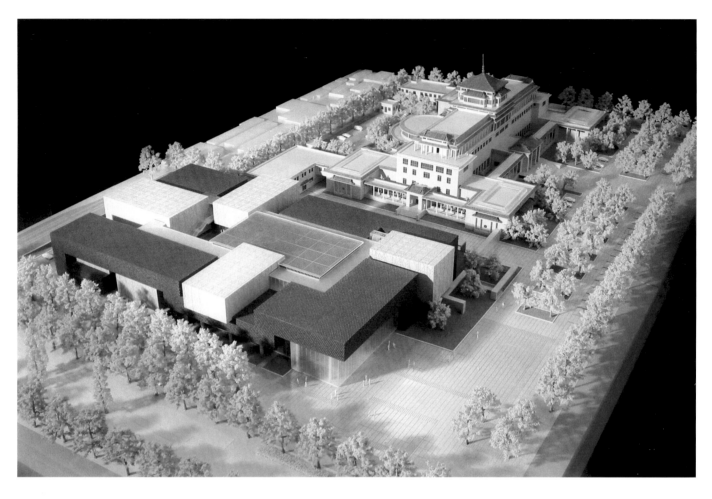

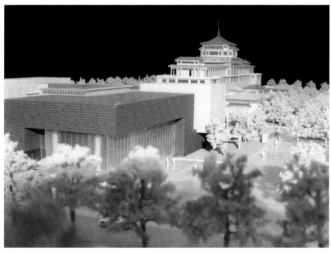

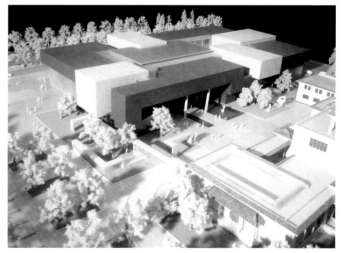

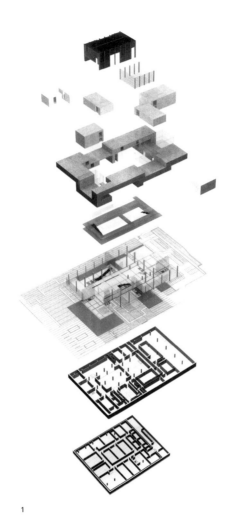

1

1 EXPLODED AXON
OPPOSITE PAGE MODEL, AERIAL VIEW

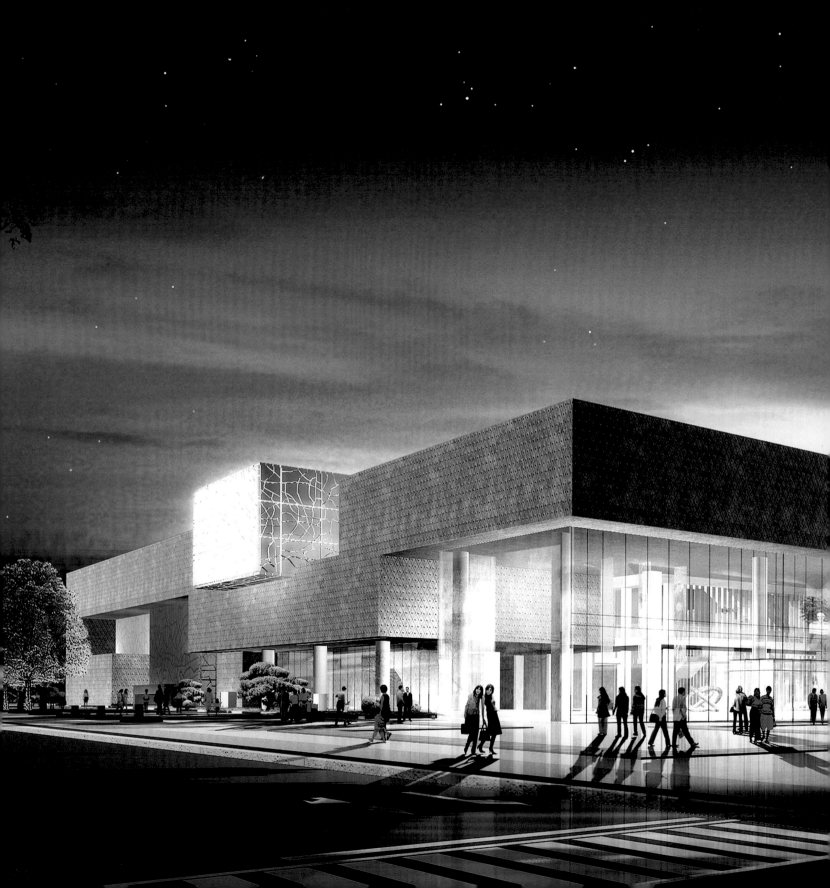

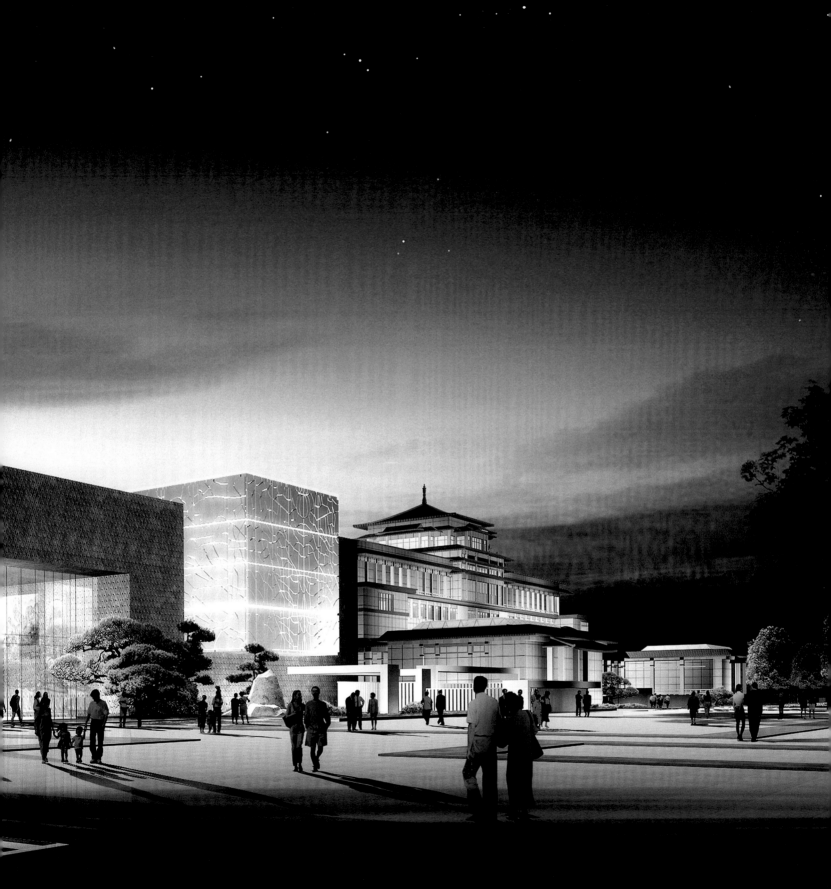

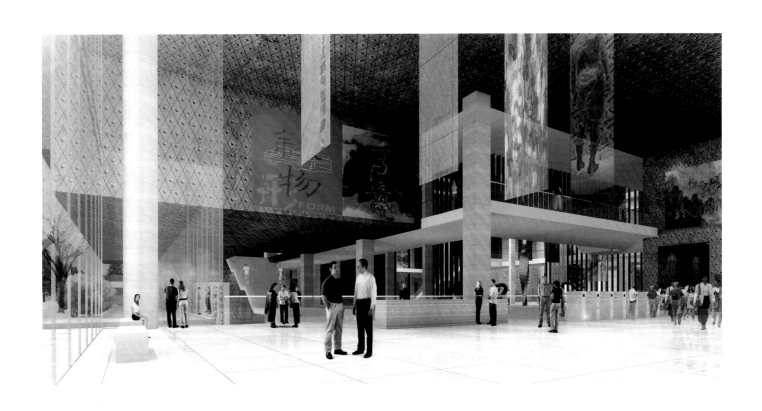

"This monastery shall be 'Flower in space and Moon in water'." – Master Shenyen

WATER-MOON MONASTERY
Dharma Drum Mountain Buddhist Foundation

When asked what his vision for the future temple would be, Master Shenyen, the founder of the Monastery and the Dharma Drum Buddhist Group, answered that he "sees" the temple in his meditation dhyana: "It is a Flower in Space, Moon in Water," he said. "Let's name it the Water-Moon Monastery".

Thus began the Water-Moon Monastery. Situated on the vast Guandu plain, facing the Keelung River and with the Datun Mountain as its backdrop, the design takes advantage of its natural surroundings and strives to build a tranquil, spiritual place.

After passing through two walls of different heights that serve as buffer from the express-way outside, upon entering the temple visitors face the view of the Main Hall that sits at the far end of an 80-meter long lotus pond. The reflections on the pond of the over-sized colonnades and the flowing golden drapes in between create a scene that has an illusory quality. Using architectural concrete as the main material, the design reduces color and form to a minimum, conveying the spirit of Zen Buddhism. The lower part of the Grand Hall is transparent, giving an impression of its upper wooden "box" being suspended in the air.

On the west side of the Grand Hall, a massive wooden wall is carved with the famous "Heart Sutra" in Chinese characters. As the light shines through the carved-out characters, the space is infused with an aura of culture and spirituality. Outside the long corridor, the characters of the "Vajracchedika Prajnaparamita Sutra" are cast void on the prefabricated glass-reinforced concrete (GRC) panels, providing additional religious meaning while functioning as sun-shades. When the scripture is imprinted onto the interior surface by the sunlight, it is as if the Buddha's teaching, in an unspoken manner, is revealed.

PROJECT DATA

LOCATION
TAIPEI, TAIWAN

FUNCTION
TEMPLE

DESIGN / COMPLETION
2006 / EXPECTED 2011

SITE AREA
27,936 M²

GROSS FLOOR AREA
8,702 M²

FLOOR LEVELS
2 FLOORS ABOVE GROUND

STRUCTURE
STEEL FRAME AND REINFORCED CONCRETE CONSTRUCTION

MATERIALS
ARCHITECTURAL CONCRETE, CLEAR FLOAT GLASS, LIMESTONE, TEAKWOOD

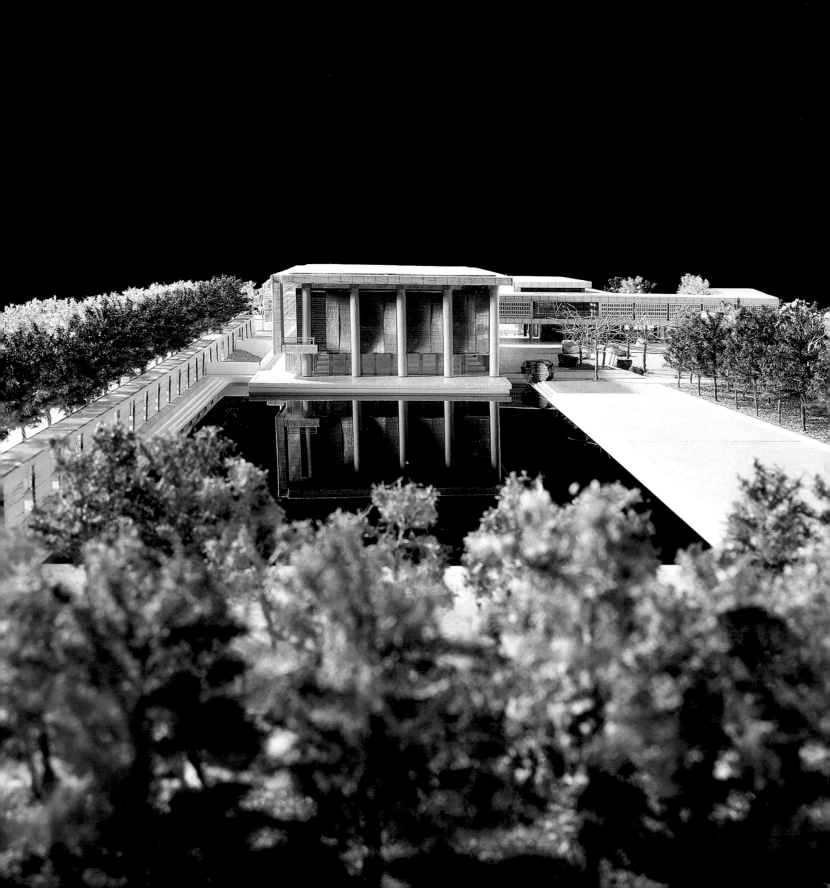

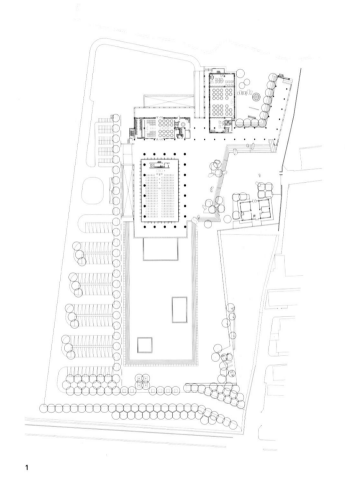

1

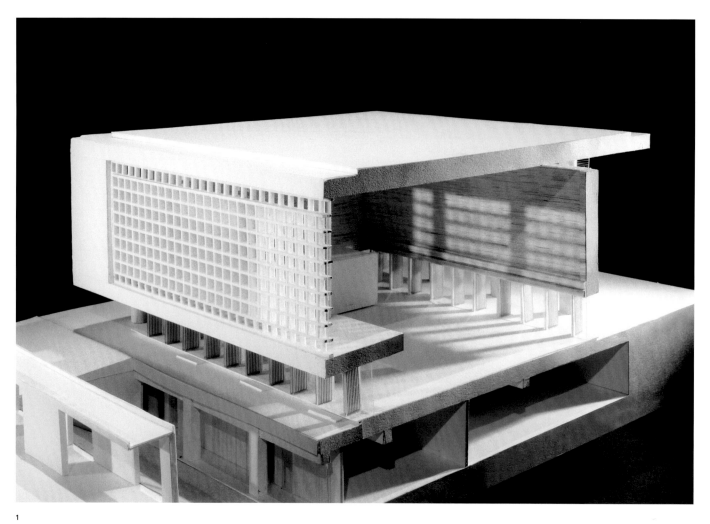

1

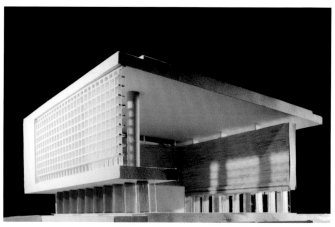

2

3

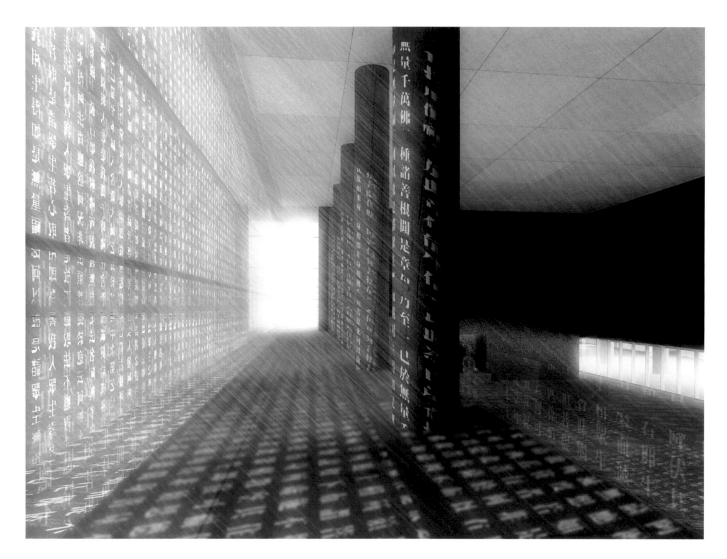
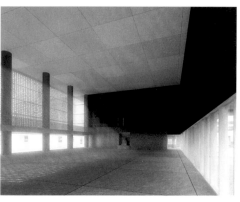

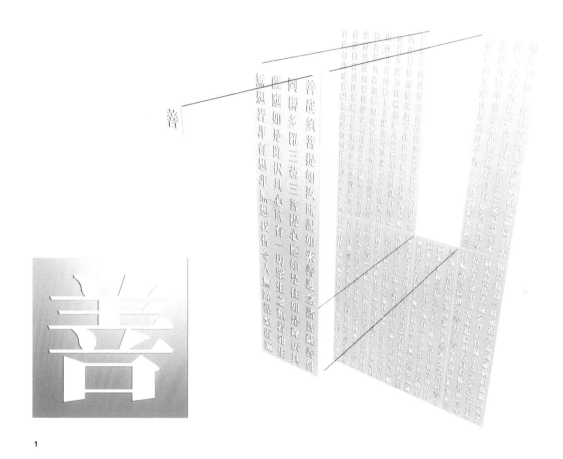

1 DETAIL OF SCRIPTURE WALL

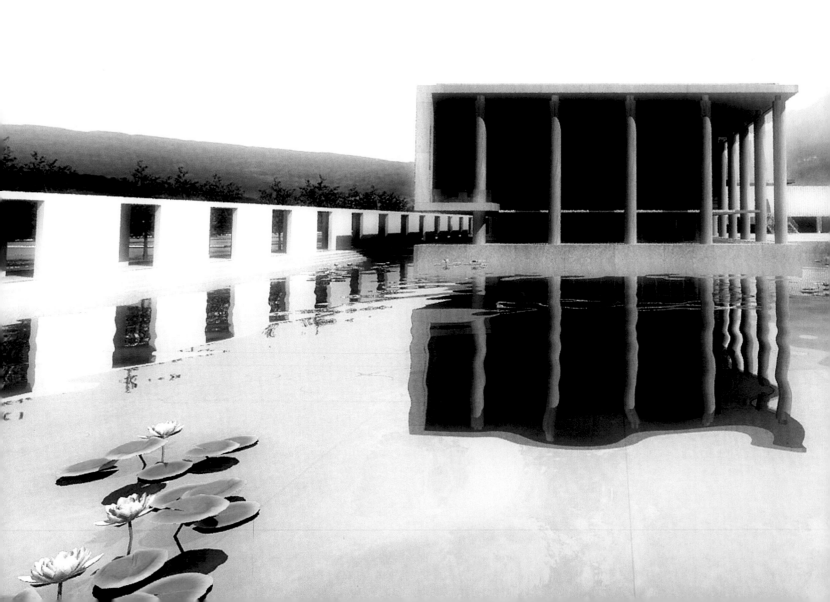

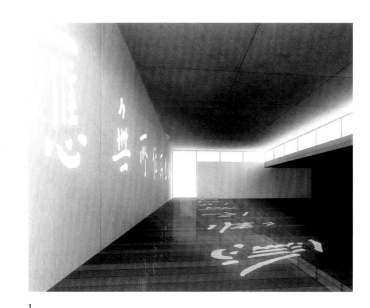

1

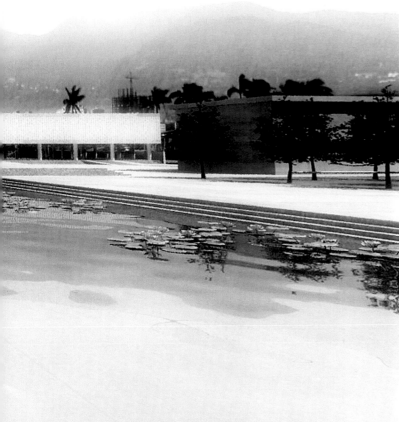

1 MEDITATION HALL

Three brush strokes of Chinese calligraphy: the thick, the dry, and the permeated.

WEIWUYING PERFORMING ARTS CENTER COMPETITION
Council for Cultural Affairs, Executive Yuan

This competition calls for a complex of four venues: a concert hall, a grand theater, a playhouse, and a black box theater. Arts related programs such as classrooms, art stores, restaurant and cafés also needed to be included. Our proposal tries to shape this complex into a truly public place. It is located in a linear stretch of the park. Longitudinally the design provides a covered inner "street" for all the arts-related activities; horizontally it allows the park visitors to pass through freely; and vertically it transports the theater audiences and prevents interference from other functions. The complex becomes an integrated part of the large urban park, both in its form and function.

The design borrows the spirit in three unique brush strokes of Chinese calligraphy: the "thick", the "dry", and the "permeated". The solid and the void inherent in these strokes transform into three types of building masses: the "solid" for the stages, the "semi-solid" for the foyers, and the "transparent" for the general public functions. The four performance venues are distributed within this space where three curvilinear forms interlock. From the outside, the public can view the flow of activity in the buildings through a transparent glass and steel frame structure.

The four auditoria are each part of an egg-shaped volume. The geometry of the egg is deconstructed to these four pieces, each with partial forms of "shell" and "yolk". The remaining smaller masses are then dispersed in the plaza and park, serving as the vertical circulation to the basement or other facilities.

PROJECT DATA

LOCATION
KAOHSIUNG, TAIWAN

FUNCTION
PERFORMING ARTS CENTER

DESIGN
2006

SITE AREA
550,000 M

GROSS FLOOR AREA
12,899 M

FLOOR LEVELS
5 FLOORS ABOVE GROUND, 2 FLOORS BELOW GROUND

STRUCTURE
STEEL FRAME AND REINFORCED CONCRETE CON-
STRUCTION

MATERIALS
ARCHITECTURAL CONCRETE, LOW-E GLASS, STONE,
RUSTED STEEL, WOOD

DESIGN COLLABORATION
CHIEN ARCHITECTS & ASSOCIATES
STONEHENGE ARCHITECTS INTERNATIONAL

NOTE
HONORABLE MENTION, NATIONAL WEIWUYING
PERFORMING ARTS CENTER INTERNATIONAL DESIGN
COMPETITION

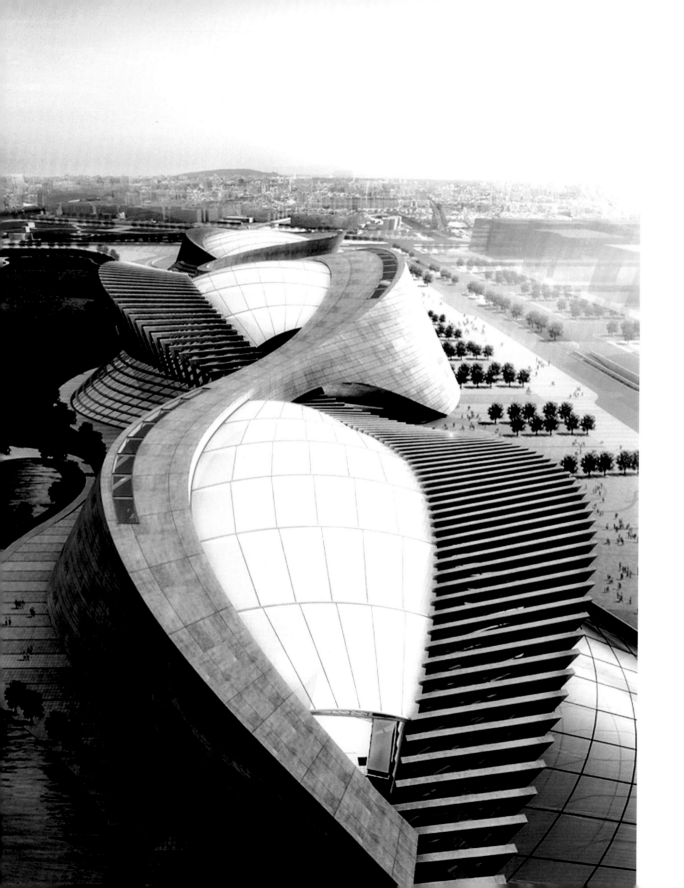

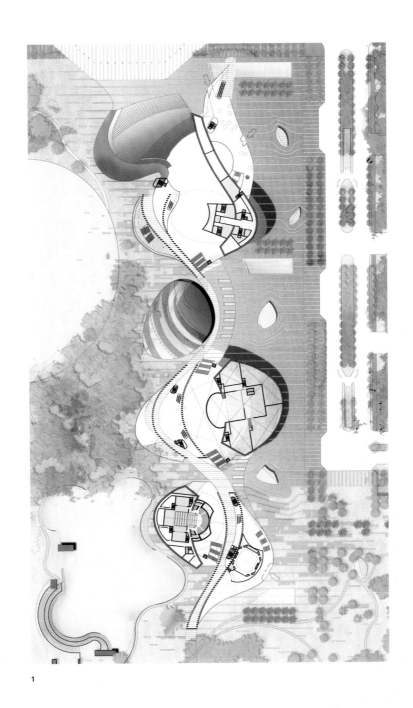

1

1 GROUND FLOOR PLAN

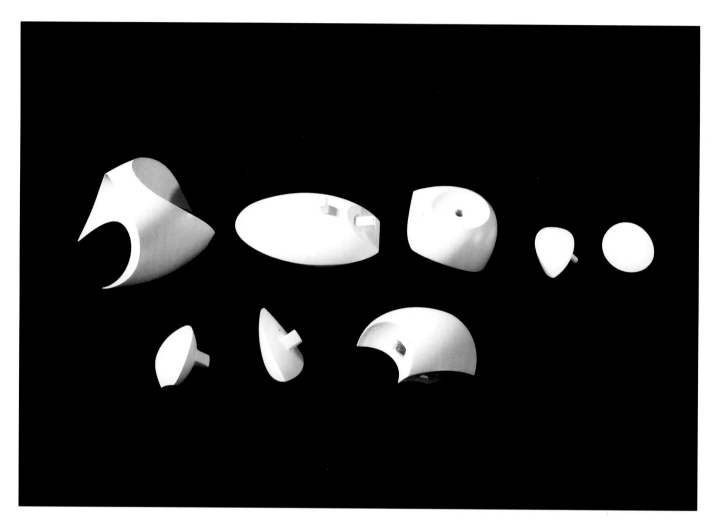

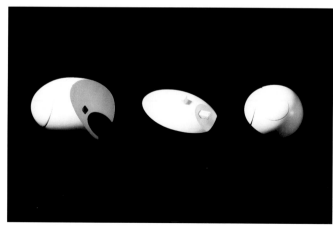

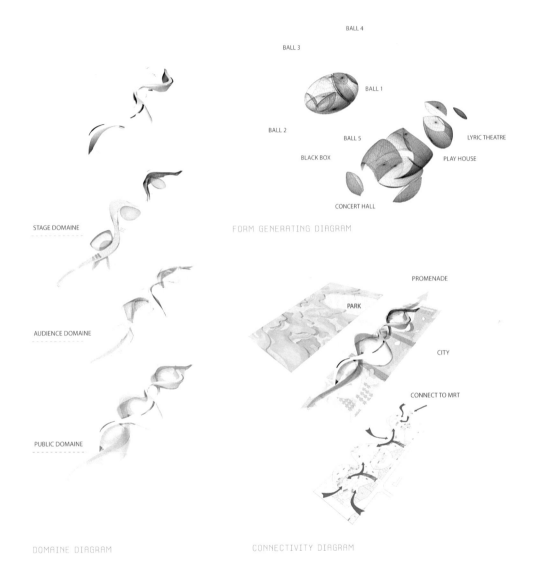

BALL 4

BALL 3

BALL 1

BALL 2

BALL 5

BLACK BOX

LYRIC THEATRE

PLAY HOUSE

CONCERT HALL

FORM GENERATING DIAGRAM

STAGE DOMAINE

AUDIENCE DOMAINE

PUBLIC DOMAINE

DOMAINE DIAGRAM

PROMENADE

PARK

CITY

CONNECT TO MRT

CONNECTIVITY DIAGRAM

ALL IMAGES DECONSTRUCTION PROCESS

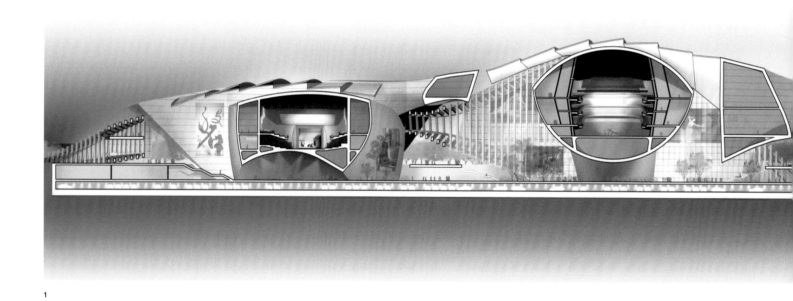

1

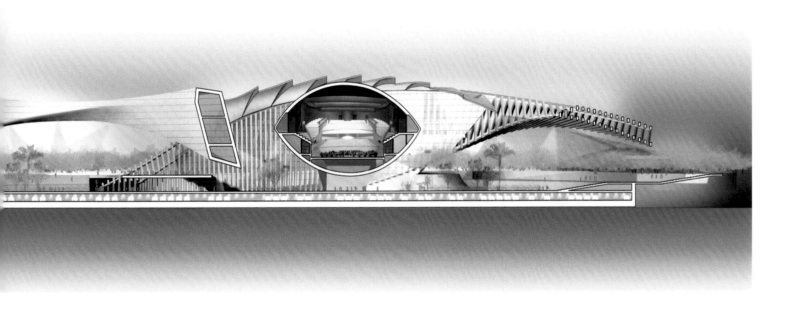

1 LONGITUDINAL SECTION

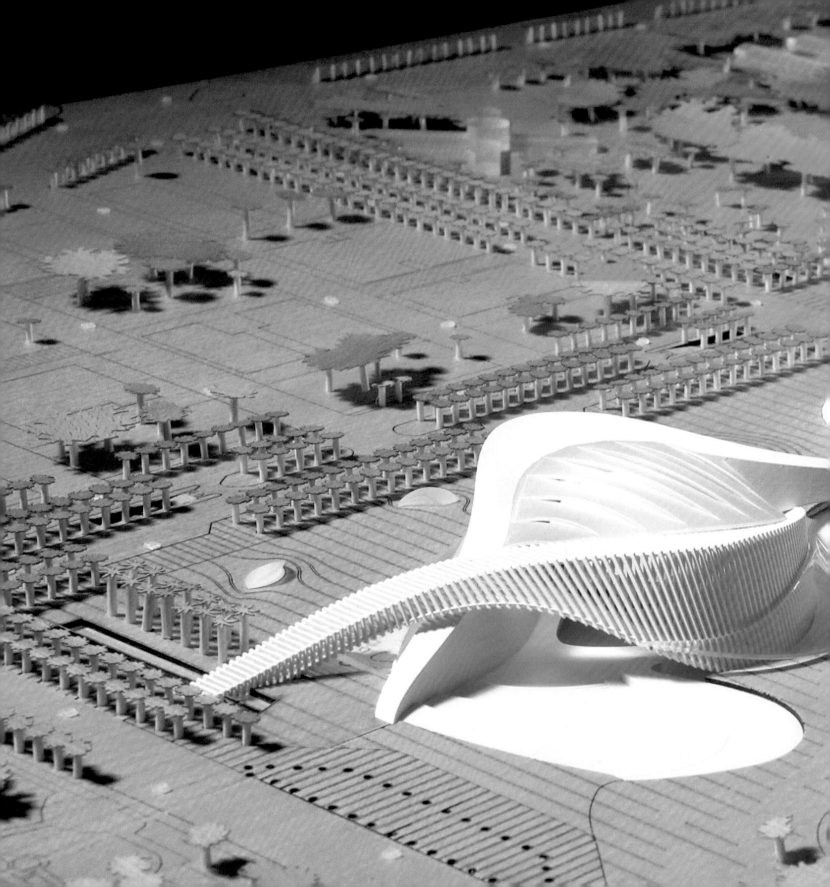

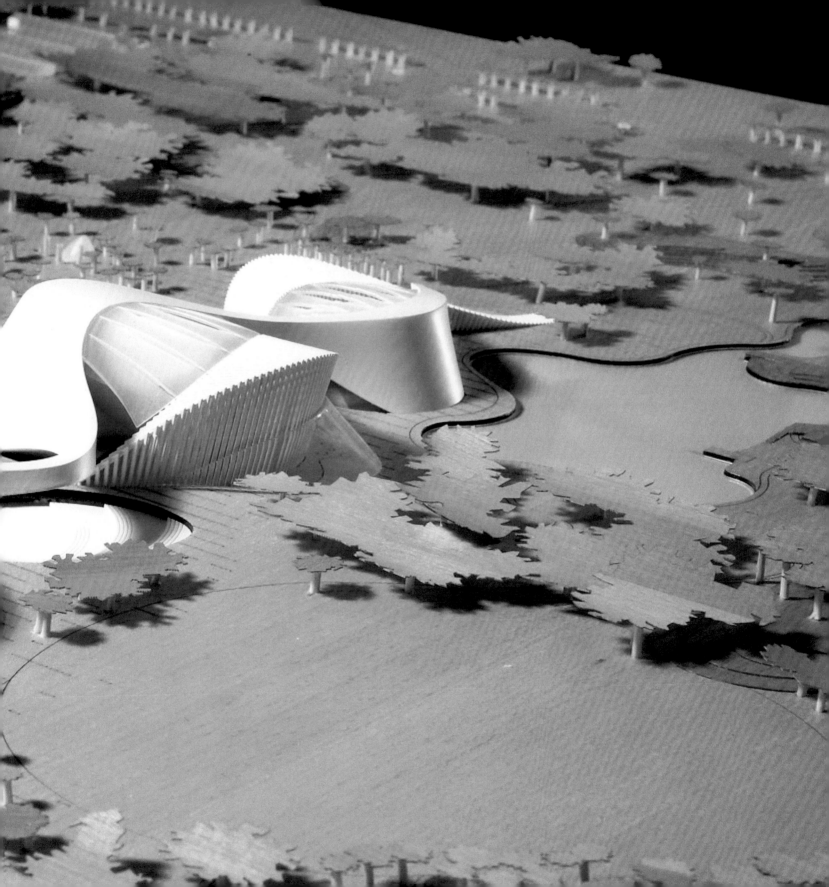

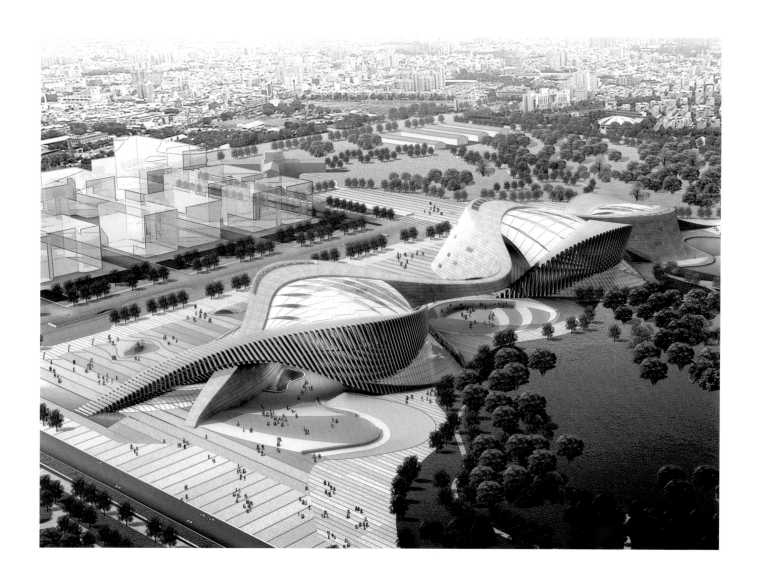

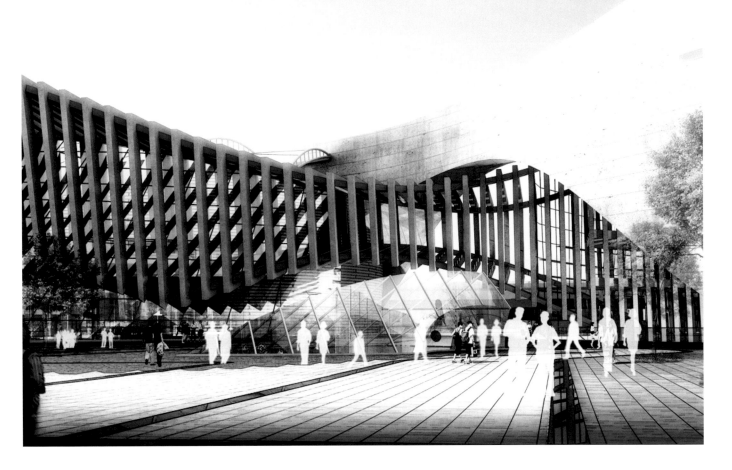

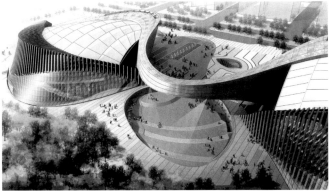

A hall composed of Chinese seals.

QUANTA CONCERT HALL
Quanta Computer Inc.

The Quanta Concert Hall is located in the Quanta Research and Development Center, and serves as a multi-functional performance hall for the staff and general public. Using architectural acoustics as the point of departure, the concert hall stands independent of other functions of the building to ensure that the events taking place in the concert hall are not interfered with by their surroundings.

The three walls around the auditorium are major design elements in the theater, both in terms of visual and acoustic effects. Aesthetically, the use of wooden blocks on these walls creates a strong image for the hall by taking forms from Chinese seals, replicated from the owner's private collection of precious Chinese art. The various sizes and depths of the wooden blocks give the hall its fine acoustic quality.

PROJECT DATA

LOCATION
TAOYUAN COUNTY, TAIWAN

FUNCTION
MUSIC HALL

DESIGN / COMPLETION
2006 / 2009

GROSS FLOOR AREA
1,843 M²

FLOOR LEVELS
2 FLOORS ABOVE GROUND

MATERIALS
STAINLESS STEEL, WOOD

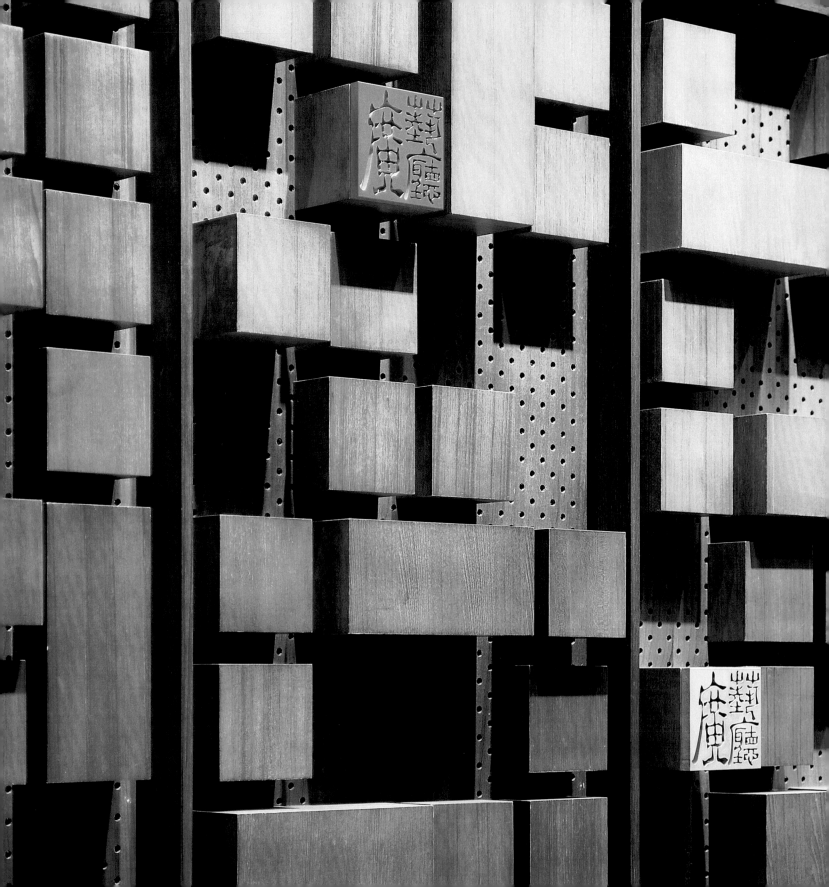

1

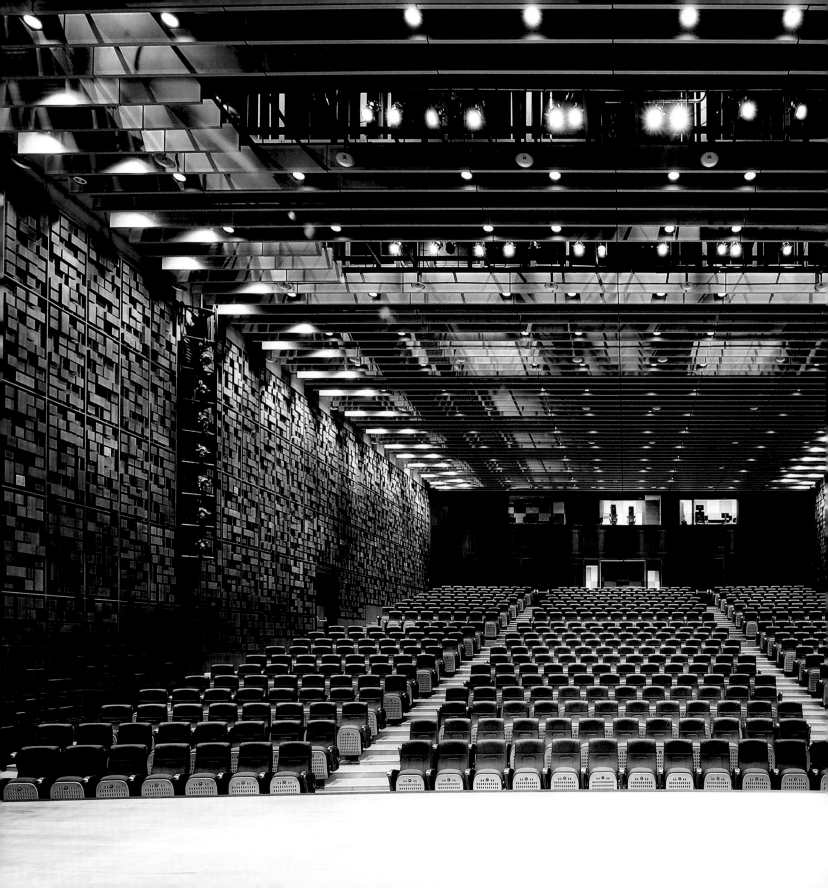

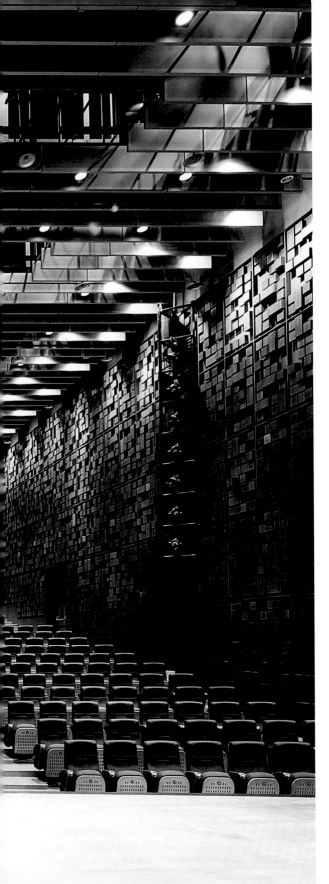

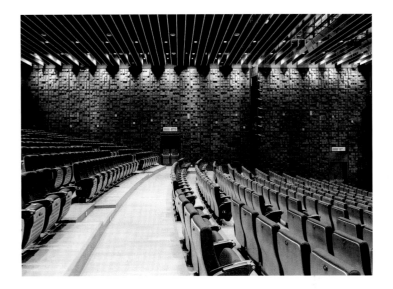

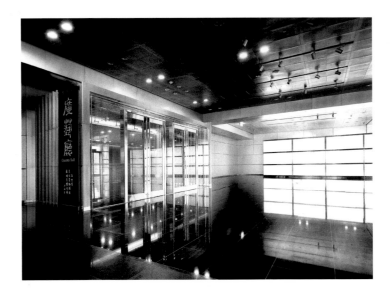

Two curves formed by a series of leaning posts embrace the public plaza between the two theatres, creating a "place" for the local community.

PINGTUNG PERFORMING ARTS CENTER

Pingtung County Government

The growing self-awareness of identity in local communities around Taiwan has helped to shape this project. Although there have been spurts of modernization around Taiwan, the remote sub-tropical Pingtung where this Center is located is still a place that maintains a tightly-knit social fabric with an old-time, relaxed charm. The Performing Arts Center is designed to reflect this local character by making it truly a place for the local people, rather than a sophisticated performing venue reserved for high culture. In this design, many "back-of-house" facilities are brought to the front, enabling intimate interactions between the performer and the audience—it allows grandparents to watch their grandchildren rehearse and scene production to be viewed by the public. The central plaza can conveniently accommodate festival events, outdoor films, or even political rallies. The concert hall of 1,200 seats, a multiform black box theater with 200 seats, and a series of low-rise structures in blocks for auxiliary functions are placed strategically to form indoor and outdoor spaces that are visible and easily accessible to the public.

Two sets of portal frames with dancing angles where the concert hall and the black box are housed define the overall form of the building and the plaza. A terrace on the second level wraps around the plaza, with grand stairs connecting it to the ground level, encouraging the public to use the outdoor amphitheater. The deep portal frames on the east and west provide sun shading, and on the north and south sides protruding solid boxes reduce exposure to the sun. Above the plaza, a large movable awning system provides additional shade from the summer sun.

PROJECT DATA

LOCATION
PINGTUNG COUNTY, TAIWAN

FUNCTION
MUSIC HALL

DESIGN / COMPLETION
2009 / EXPECTED 2012

SITE AREA
5,865 M

GROSS FLOOR AREA
17,250 M

FLOOR LEVELS
4 FLOORS ABOVE GROUND, 1 FLOOR BELOW GROUND

STRUCTURE
STEEL FRAME AND CONCRETE CONSTRUCTION

MATERIALS
ALUMINUM PANELS, LOW-E GLASS, RED BRICK, STAINLESS STEEL

GREEN BUILDING AWARD
TAIWAN EEWH

NOTE
FIRST PRIZE, PINGTUNG PERFORMING ARTS CENTER COMPETITION

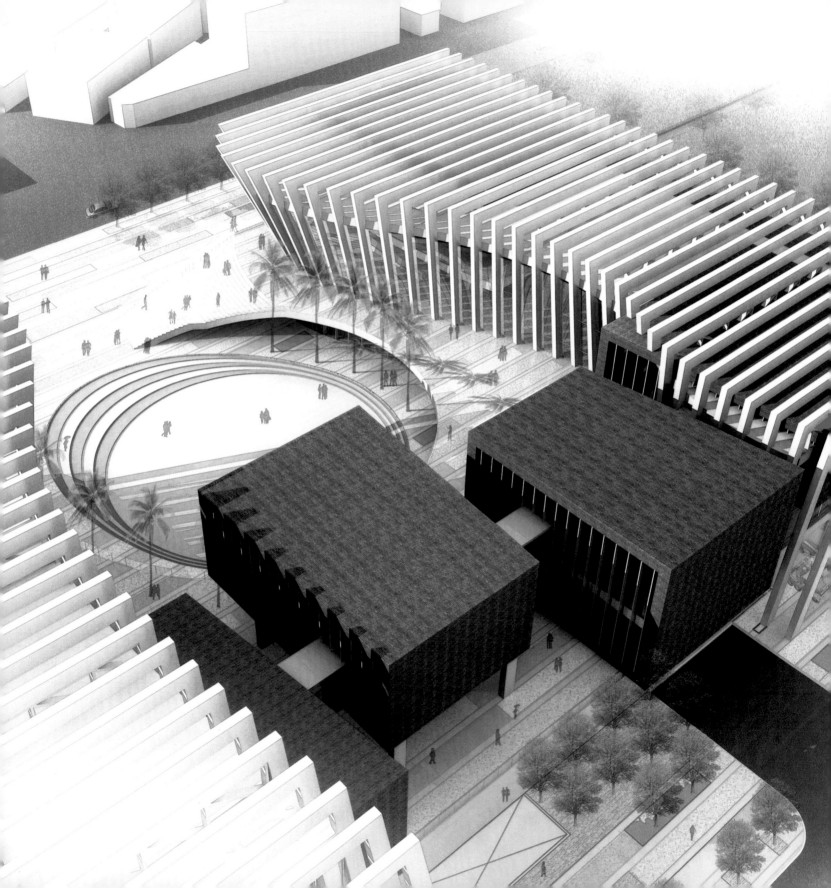

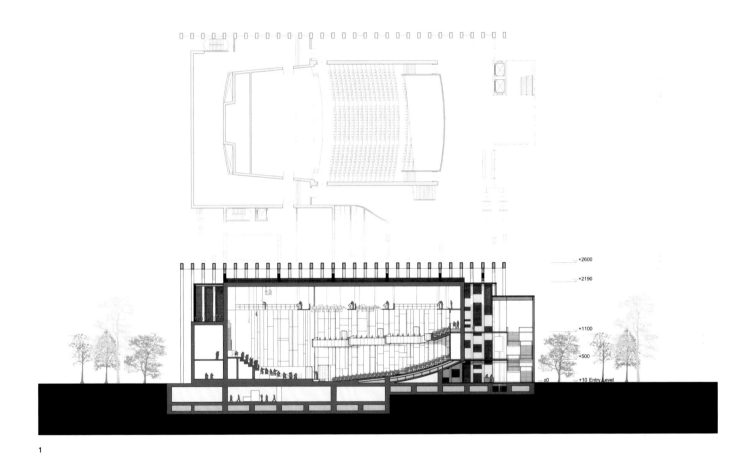

+2600
+2190

+1100

+500

+10 Entry Level
±0

1

1 SECTION THROUGH MAIN HALL

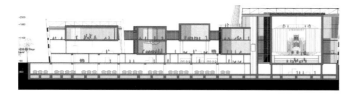

1

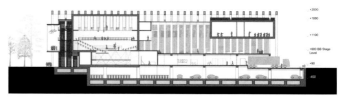

2

3

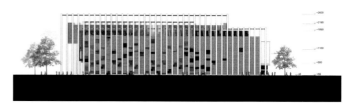

4

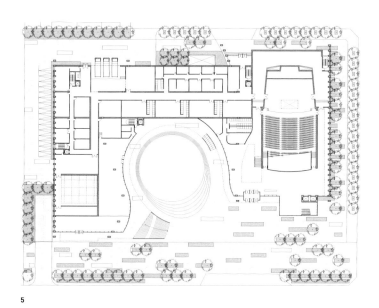

5

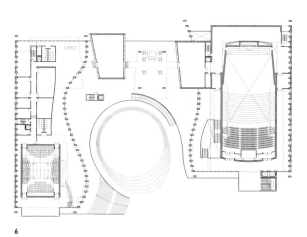

6

1 LONGITUDINAL SECTION
2 CROSS SECTION
3 SOUTH ELEVATION
4 WEST ELEVATION
5 GROUND FLOOR PLAN
6 SECOND FLOOR PLAN

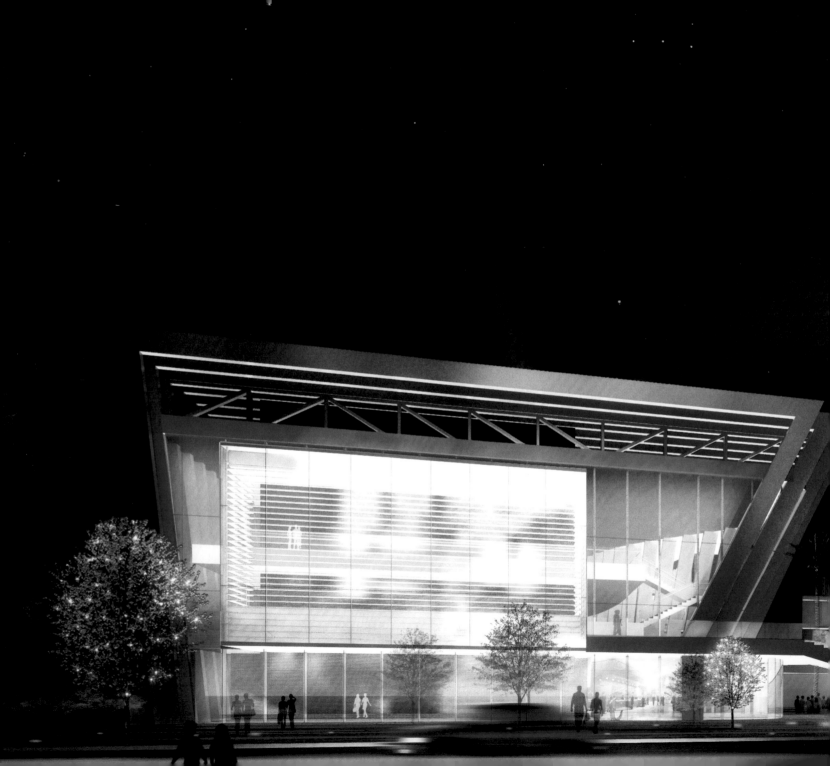

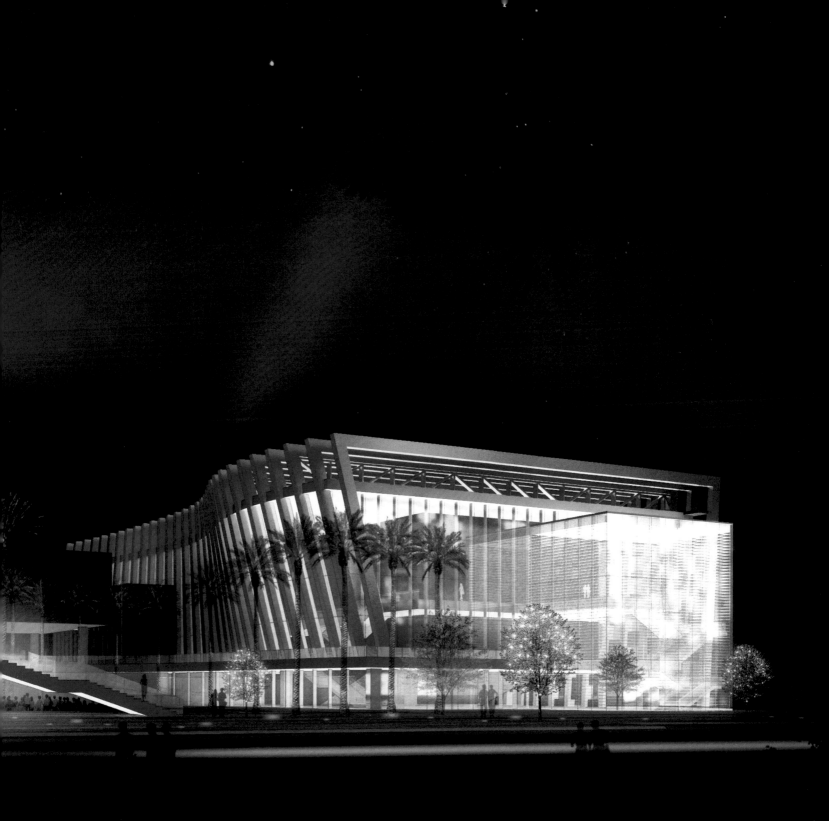

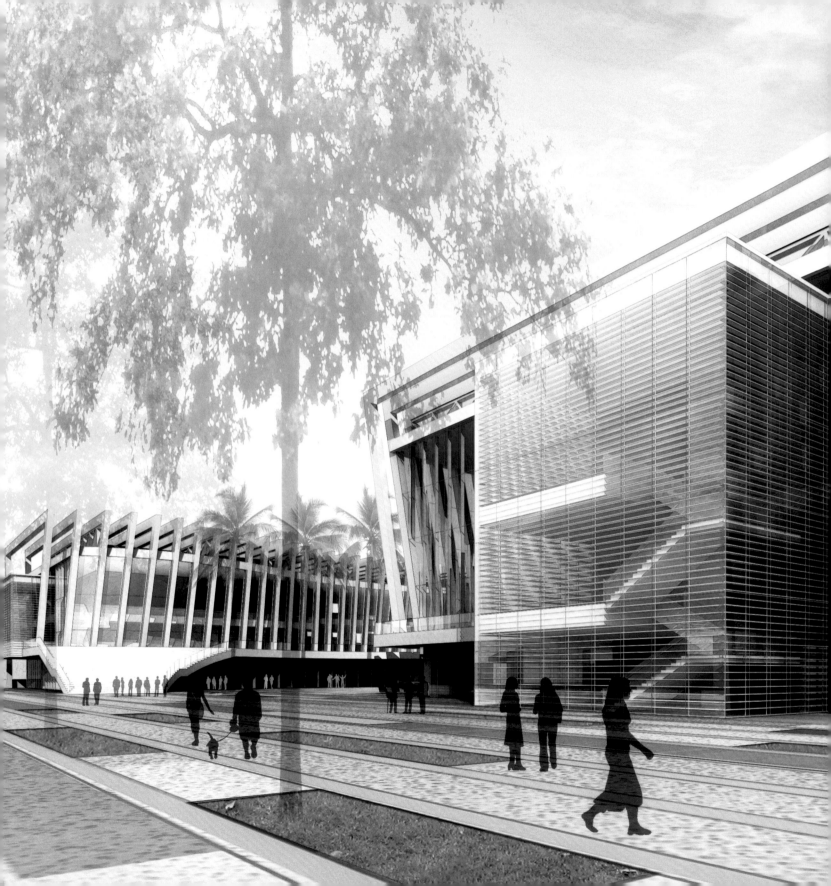

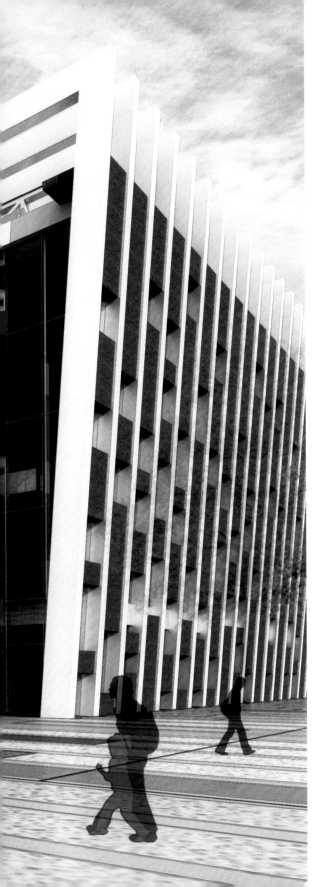

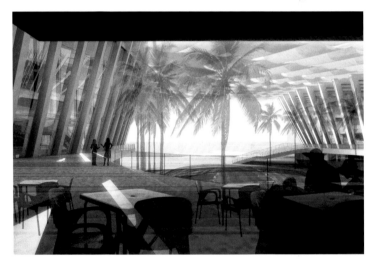

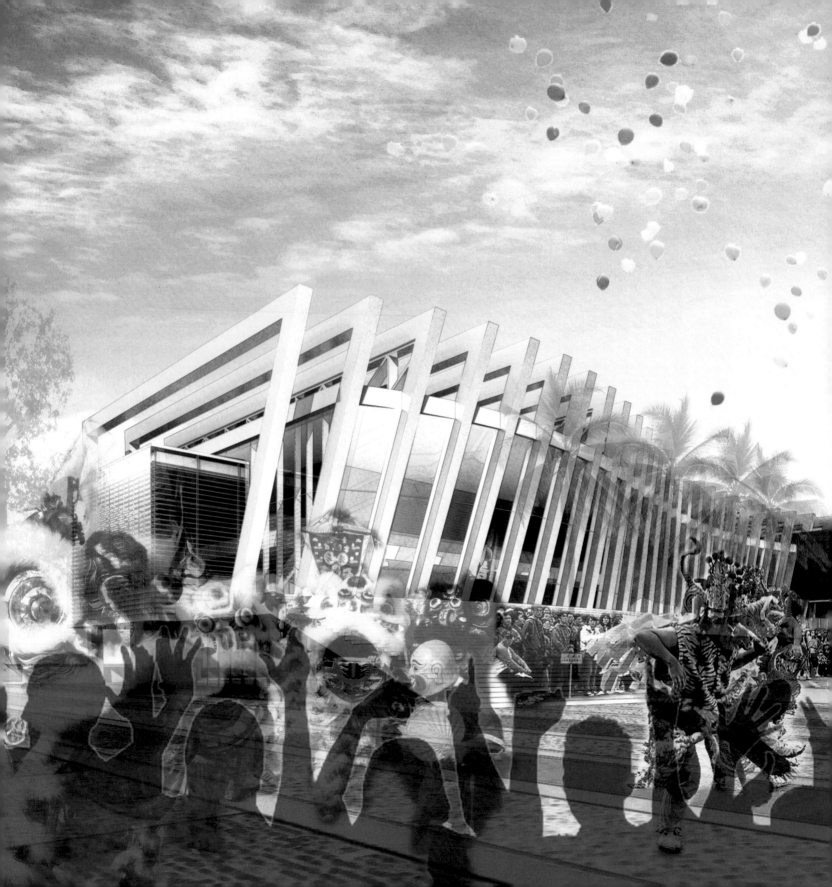

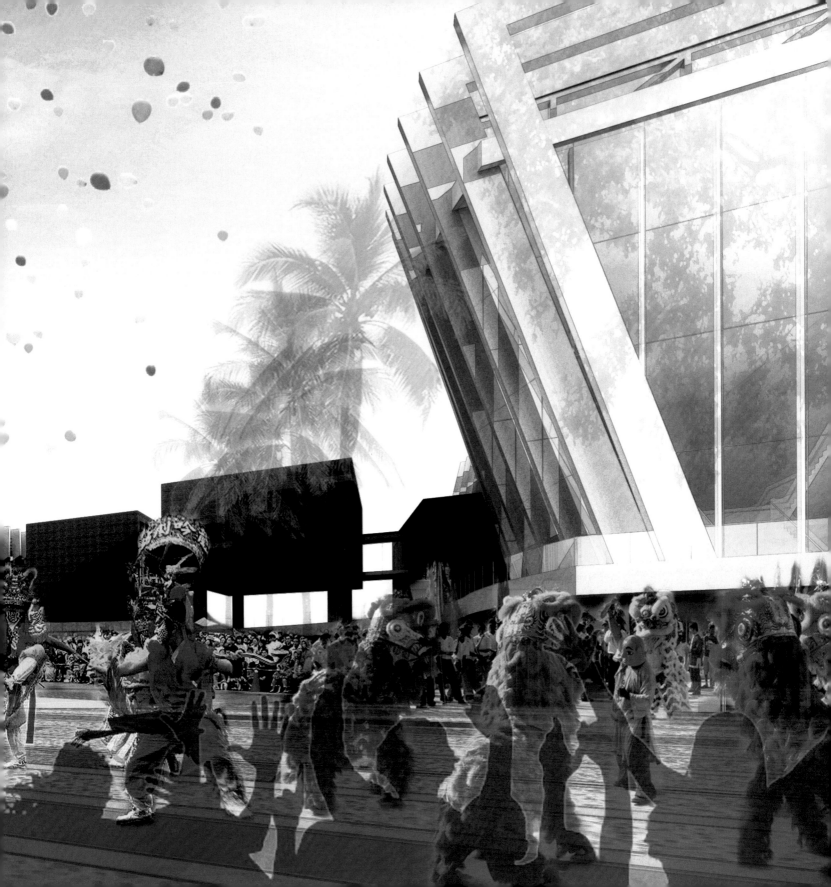

archieve

P공동. public.

privacy

14m

Visitors are first taken to encounter the "present" through a sloped glass tube, and then travel counter-clockwise down back in time to explore the hidden order laying beneath...

NATIONAL MUSEUM OF PREHISTORY, TAINAN
National Museum of Prehistory

As a major part of the mission to rescue abundant archeological relics, found accidentally during the construction of the Southern Taiwan Science Park, the National Museum of Prehistory has been established. It houses artifacts that date as far back as 6,000 years. The fact that the museum is located on this site where layers of ancient culture have accumulated presents the interesting paradoxical notion of "exploring downwards to travel back in time". This is the concept that has inspired the building's design.

Taking advantage of the adjacent High Speed Rail line, the museum first brings visitors through a square glass tube up to the same elevation as the passenger's train seat. At an interval of every 11.7 minutes, a train stops at the platform for exactly 3.5 seconds. At this moment, facing the latest technology of transportation and its surrounding facilities, visitors are metaphorically brought back to the present. They then begin the journey of traveling downwards in a counter-clockwise fashion, similar to archaeological explorations, to encounter the lost cultures that once flourished in the same location during a different era.

There are two sets of building grids that interlock to define the geometry of the building. One of the axes, representing the past, points almost due north—this follows the orientation of an ancient burial ground that has been discovered. The other axis, which represents the present, follows the existing city grid line at a 19° angle to the cardinal axis. The overlapping of grids is a metaphor for the essence of archeology—using a modern system to surmise the unknown past. These axial relationships also exist in the building as well as in the museum's circulation and artifact displays, providing an interesting and meaningful juxtaposition across time and space.

PROJECT DATA

LOCATION
TAINAN COUNTY, TAIWAN

FUNCTION
MUSEUM

DESIGN / COMPLETION
2009 / EXPECTED 2013

SITE AREA
24,400 M

GROSS FLOOR AREA
20,000 M

FLOOR LEVELS
4 FLOORS ABOVE GROUND, 1 FLOOR BELOW GROUND

STRUCTURE
STEEL FRAME AND REINFORCED CONCRETE CONSTRUCTION

MATERIALS
ALUMINUM PANELS, CLEAR FLOAT GLASS

GREEN BUILDING AWARD
TAIWAN EEWH

NOTE
FIRST PRIZE, NATIONAL MUSEUM OF PREHISTORY, TAINAN PROJECT COMPETITION

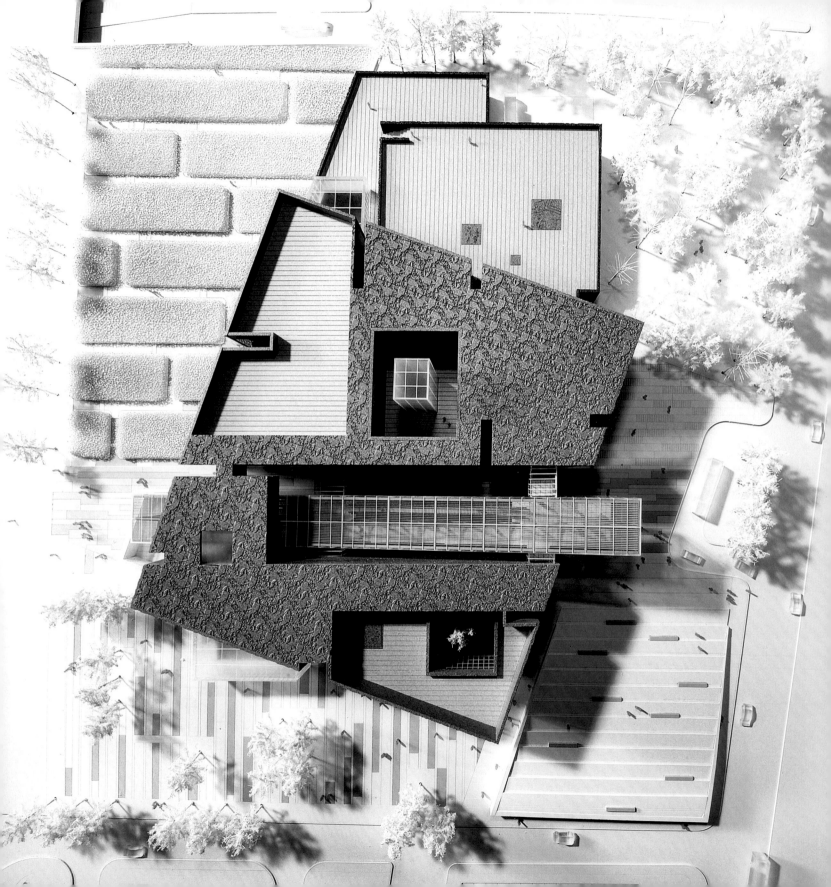

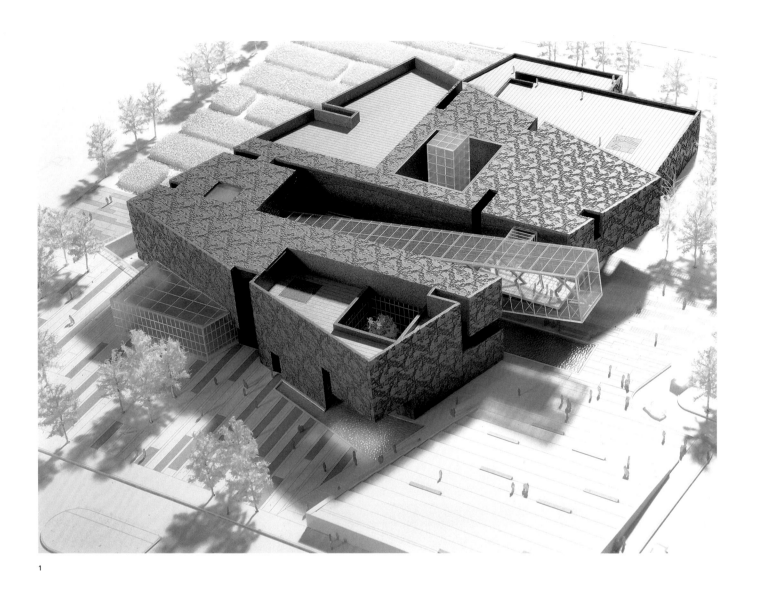

1

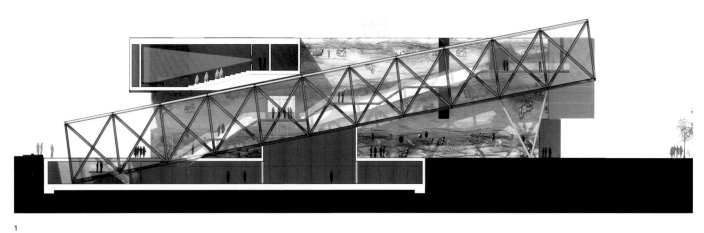

1

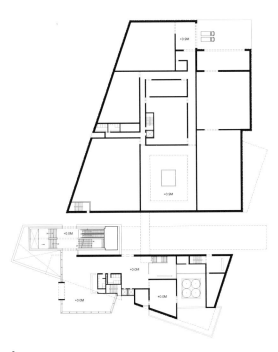

2

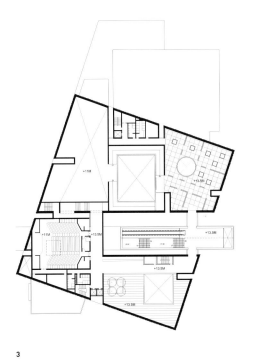

3

1 LONGITUDINAL SECTION
2 FIRST FLOOR PLAN
3 FOURTH FLOOR PLAN

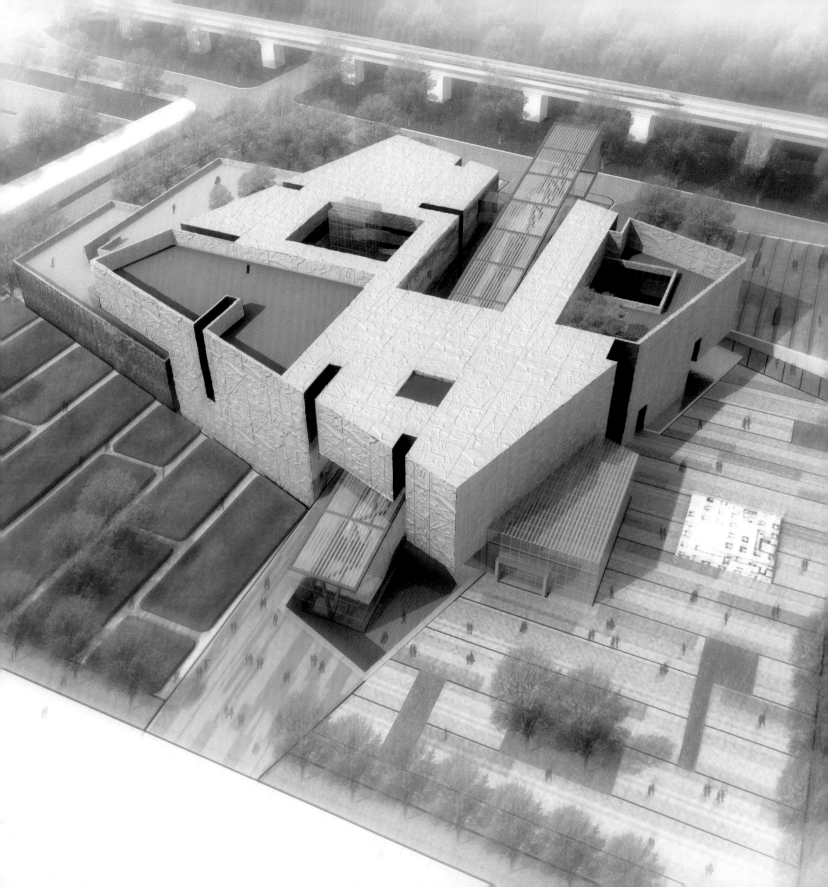

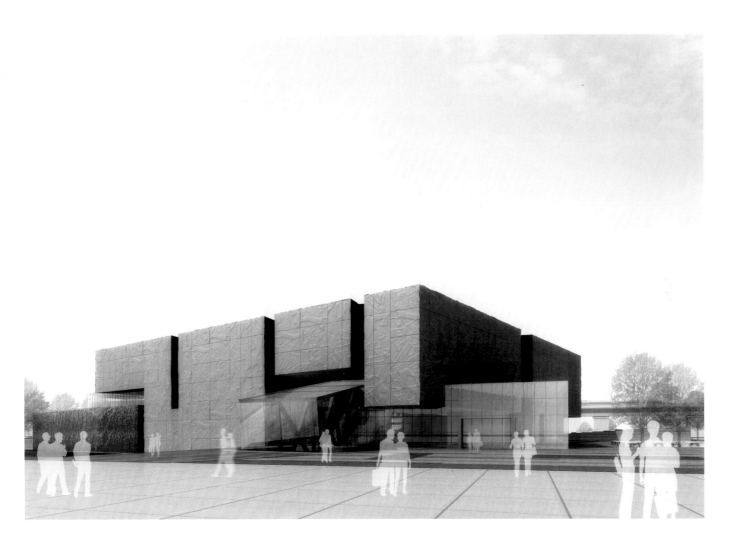

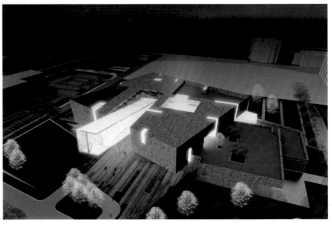

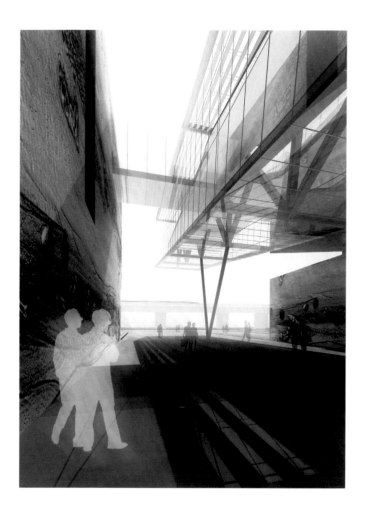
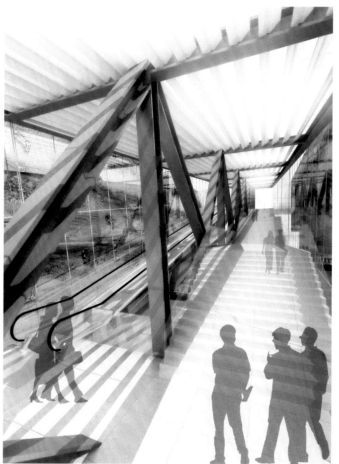

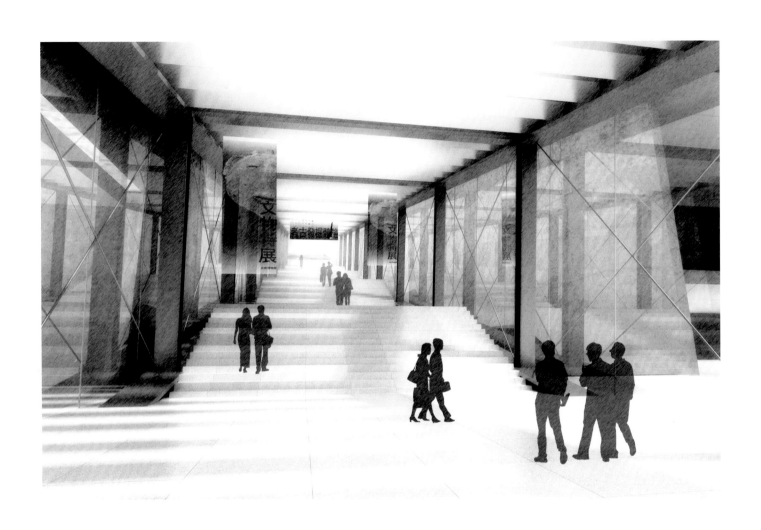

A Performing Arts Center as a home for performers and musicians, to foster interactions among artists and audience.

TAIWAN TRADITIONAL PERFORMING ARTS CENTER
National Center for Traditional Art

The Taiwan Traditional Performing Arts Center will be the first repertoire theater in Taiwan for the Chinese Opera troupe Guoguang Opera Company. It will also contain additional facilities to house the National Chinese Orchestra, the National Symphony Orchestra, and the Taiwan National Choir. It will include performance venues for the public, and provide a place for artists from different disciplines to interact with each other in the process of creating art.

The architecture is composed of two main volumes: the north volume houses the theatrical discipline, while the southern volume accommodates the musical discipline. The facilities provide both individual and shared resources. At the top floor where the creative departments and rehearsal rooms are located, a "tube" bridges the two parts of the building functionally and symbolically. On these upper floors, artists can enjoy great spaces and views. On the lower levels, the general public is able to attend performances in the theaters, or follow an access that runs from the plaza level through the gap between the two volumes and ascends to reach the dike by the river to the west. This pedestrian path creates a vibrant promenade where casual performances, arts vendors, and other street activities can occur. This path will also guide visitors to the riverbank, where they can enjoy the spectacular view of the park across the river.

PROJECT DATA

LOCATION
TAIPEI, TAIWAN

FUNCTION
PERFORMING CENTER

DESIGN / COMPLETION
2009 / EXPECTED 2013

SITE AREA
17,600 M²

GROSS FLOOR AREA
36,000 M²

FLOOR LEVELS
11 FLOORS ABOVE GROUND, 2 FLOORS BELOW GROUND

STRUCTURE
STEEL FRAME STRUCTURE

MATERIALS
ALUMINUM PANELS, LOW-E GLASS, STONE

GREEN BUILDING AWARD
TAIWAN EEWH

NOTE
FIRST PRIZE, TAIWAN TRADITIONAL PERFORMING ARTS CENTER COMPETITION

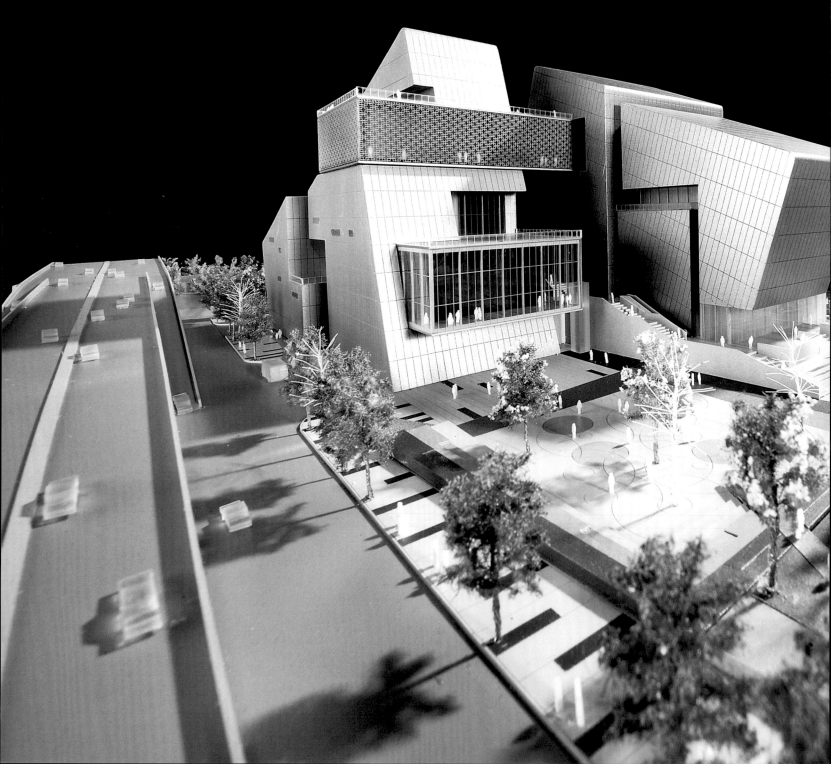

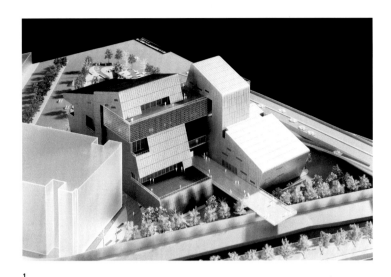

1 MODEL, AERIAL VIEW
2 MODEL, VIEW OF SOUTH ELEVATION
OPPOSITE PAGE MODEL, VIEW OF SOUTHEAST

1

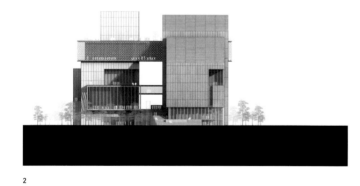

2

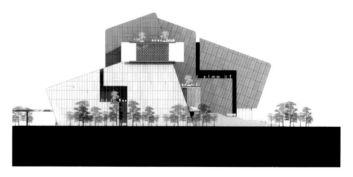

3

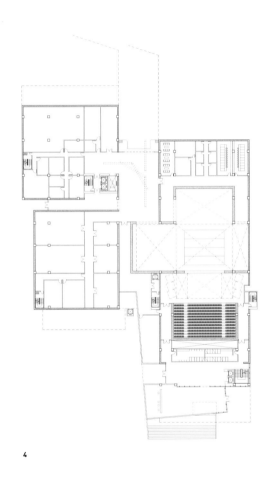

4

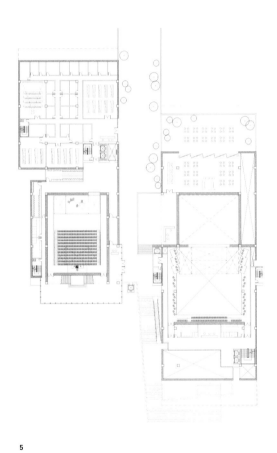

5

1 PROGRAM DIAGRAM
2 EAST ELEVATION
3 NORTH ELEVATION
4 FIRST FLOOR PLAN
5 THIRD FLOOR PLAN

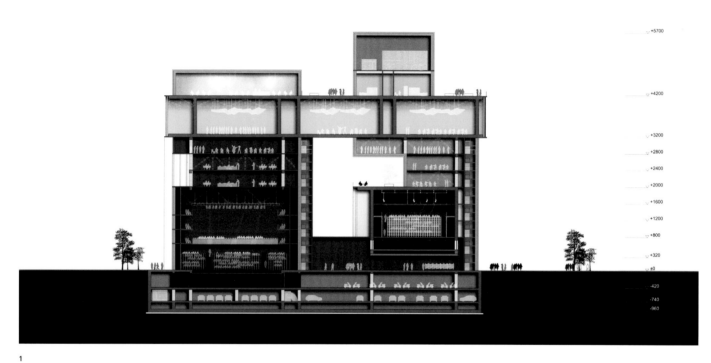

1

+5700

+4200

+3200
+2800
+2400
+2000
+1600
+1200
+800
+320
±0
-420
-740
-960

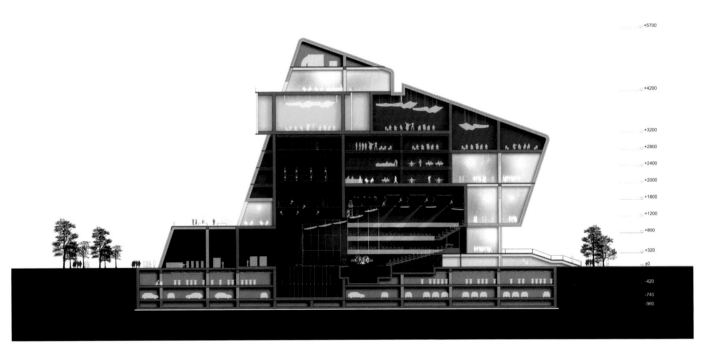

+5700
+4200
+3200
+2800
+2400
+2000
+1600
+1200
+800
+320
±0
-420
-740
-960

2

1 CROSS SECTION
2 LONGITUDINAL SECTION

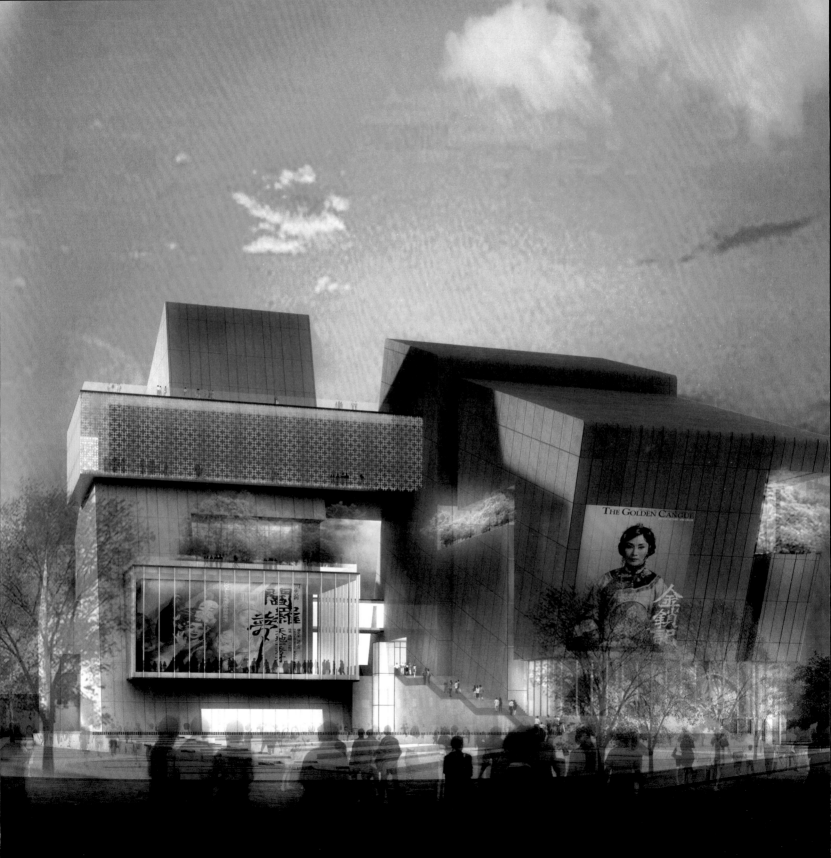

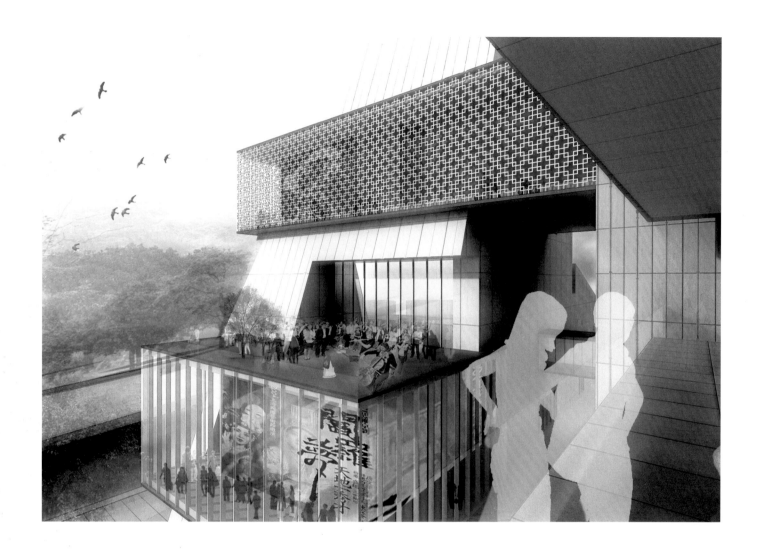

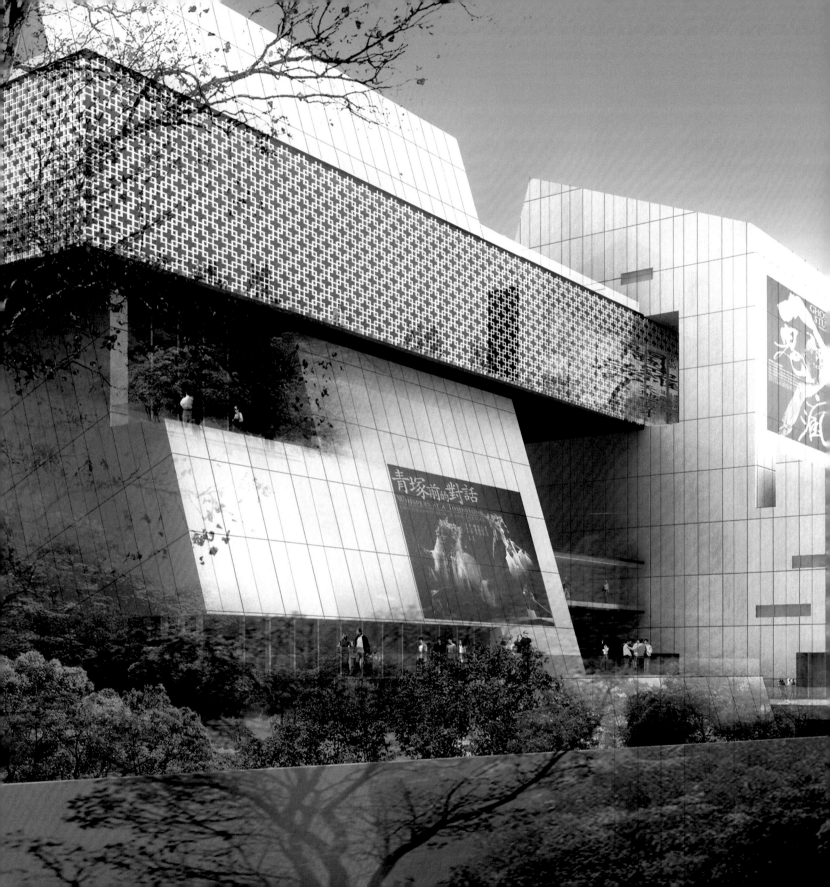

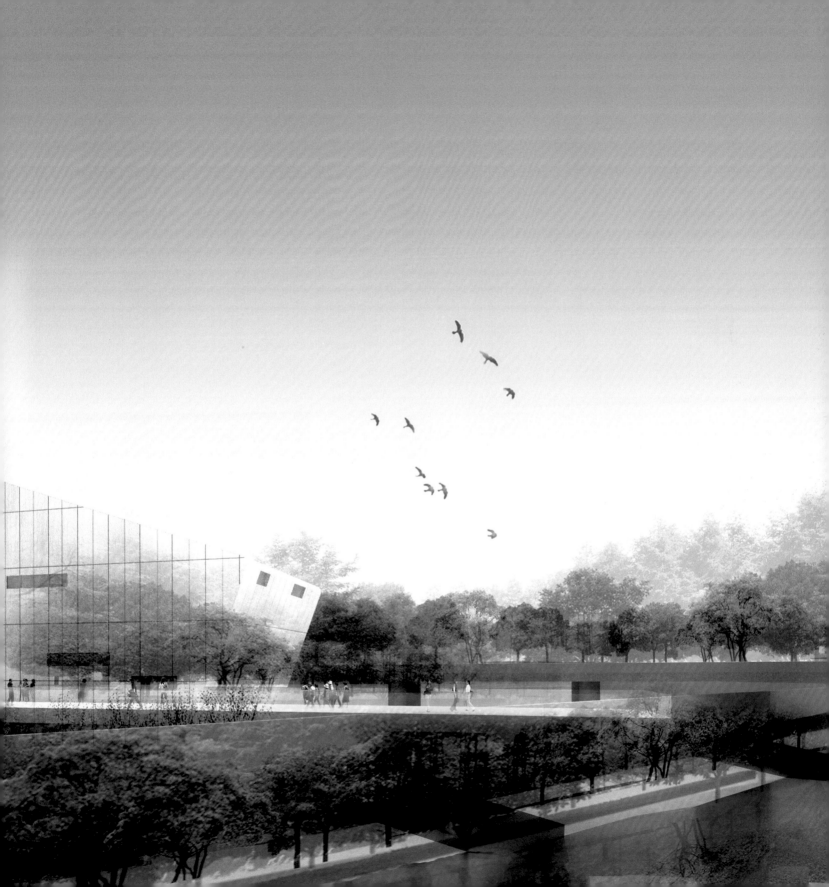

Like a twin lotus, the theatres rise from the water in this dream-like town...

WUZHEN THEATER

Wuzhen Tourism Development Co., Ltd

In this romantic and surreal water village in China, the owner of the development decided that Wuzhen would be an important name in the global atlas of theater, and would be where an international theater festival would be held. In order to complete his vision, ARTECH was asked to design the Wuzhen Grand Theater.

The greatest challenge was to design a large building containing two theaters with 1,200 and 600 seats back to back, with modern theater functions, in this small, traditional water village in southern China. Using the culturally auspicious "twin lotus" as its metaphor, which functions perfectly with two theatres sharing one stage area, the design is composed of two oval shapes interlocking with one another—one is transparent and the other opaque in form.

Given their dual purposes of the theater festival and tourism, the functions of the theaters are multiple. Possibilities include formal stage performances, avant-garde creations, fashion shows, conventions, and wedding ceremonies.

Visitors arrive at the theaters by wooden boats, or on foot from an island across a bridge. The smaller theater to the right is located within the "solid' volume, where petal-like segments of thick reclining walls, clad in ancient super-sized brick, wrap around the foyer. The grand theater to the left, enclosed within a zigzag, fan-shaped glass front with a Chinese window motif, glows in the evenings and reflects on the water, adding charm to the already misty and surreal atmosphere of this otherworldly water village.

PROJECT DATA

LOCATION
ZHEJIANG, CHINA

FUNCTION
THEATER

DESIGN / COMPLETION
2010 / EXPECTED 2011

SITE AREA
54,980 M²

GROSS FLOOR AREA
17,430 M²

FLOOR LEVELS
2 FLOORS ABOVE GROUND, 1 FLOOR BELOW GROUND

STRUCTURE
REINFORCED CONCRETE CONSTRUCTION

MATERIALS
BLACK BRICK, CLEAR FLOAT GLASS, STONE, WOODEN GRILLE

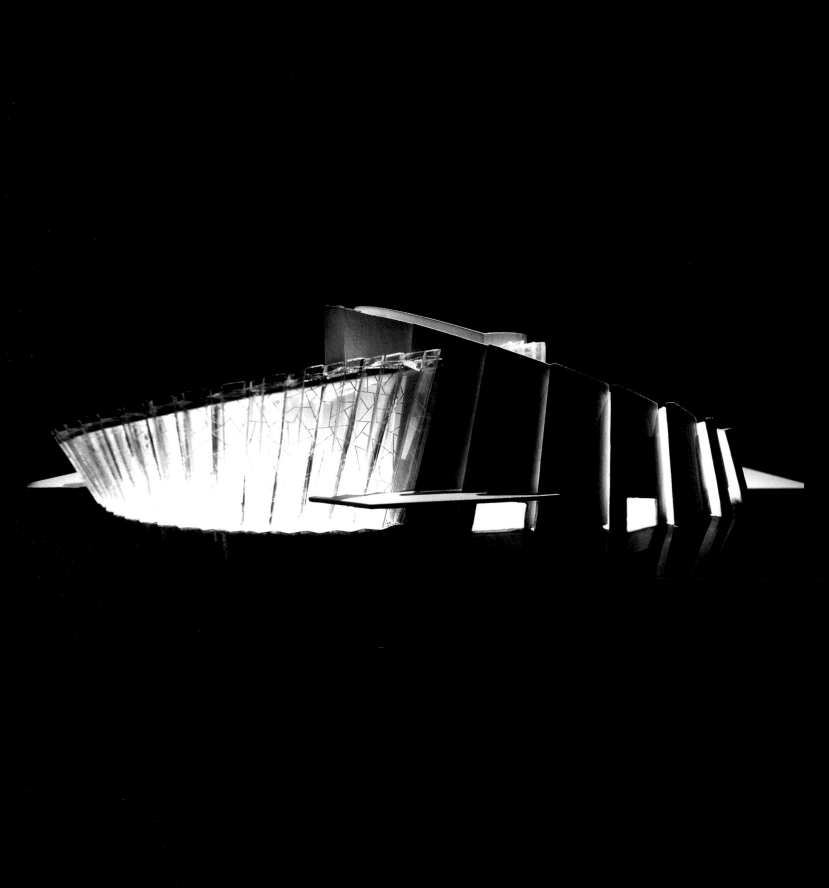

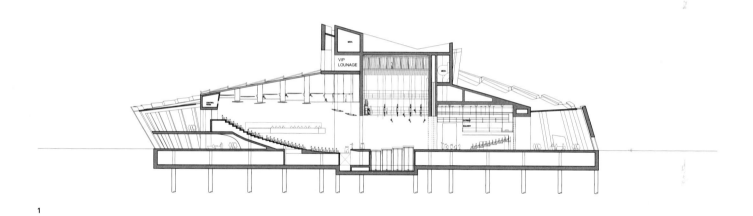

1 LONGITUDINAL SECTION

OPPOSITE PAGE MODEL, VIEW OF SOUTHWEST ELEVATION

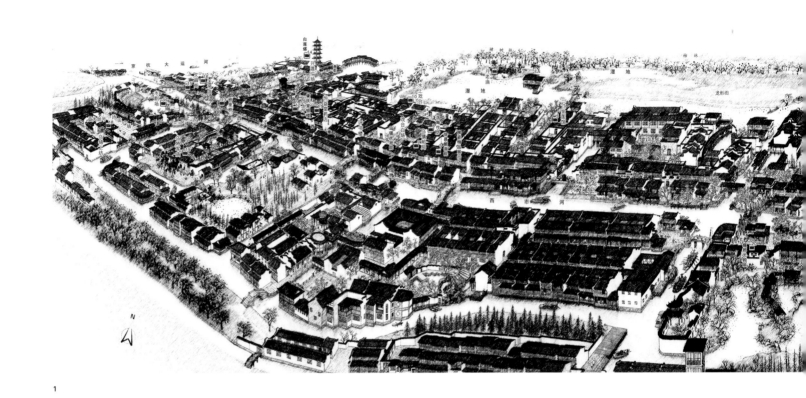

1

 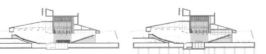

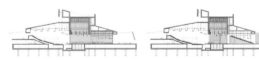

2

3

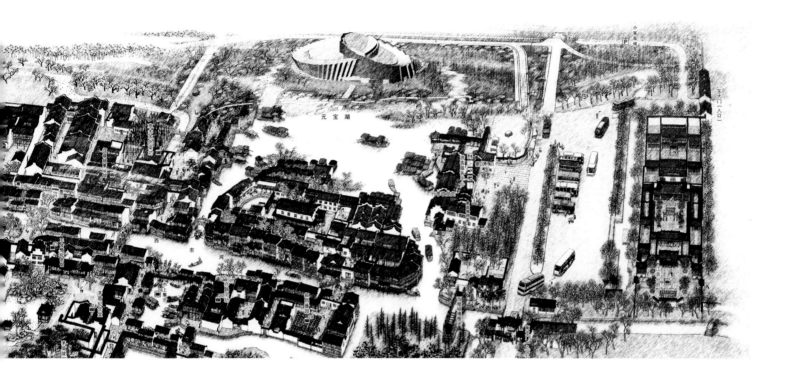

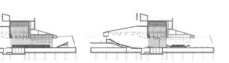

4

5

1 AERIAL VIEW, WUZHEN CITY MAP

2,3,4,5 THEATER CONFIGURATION DIAGRAM

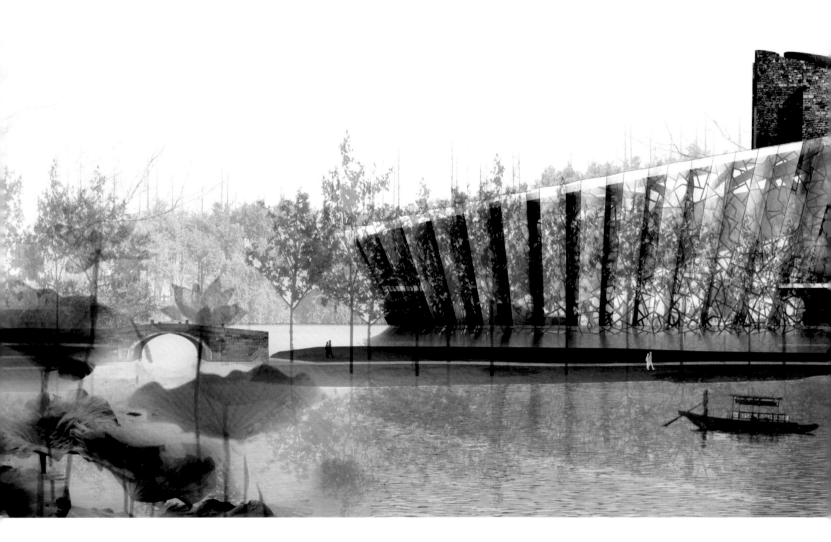

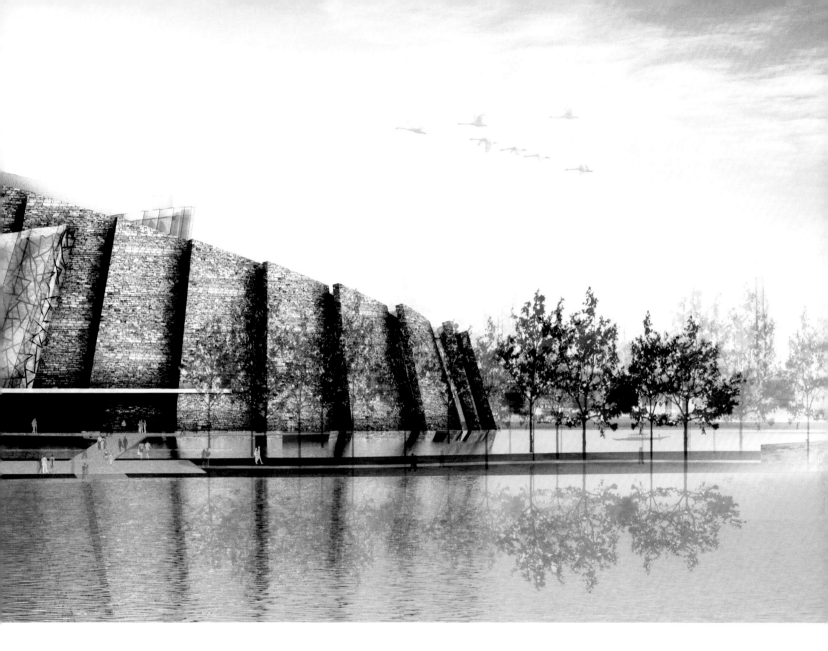

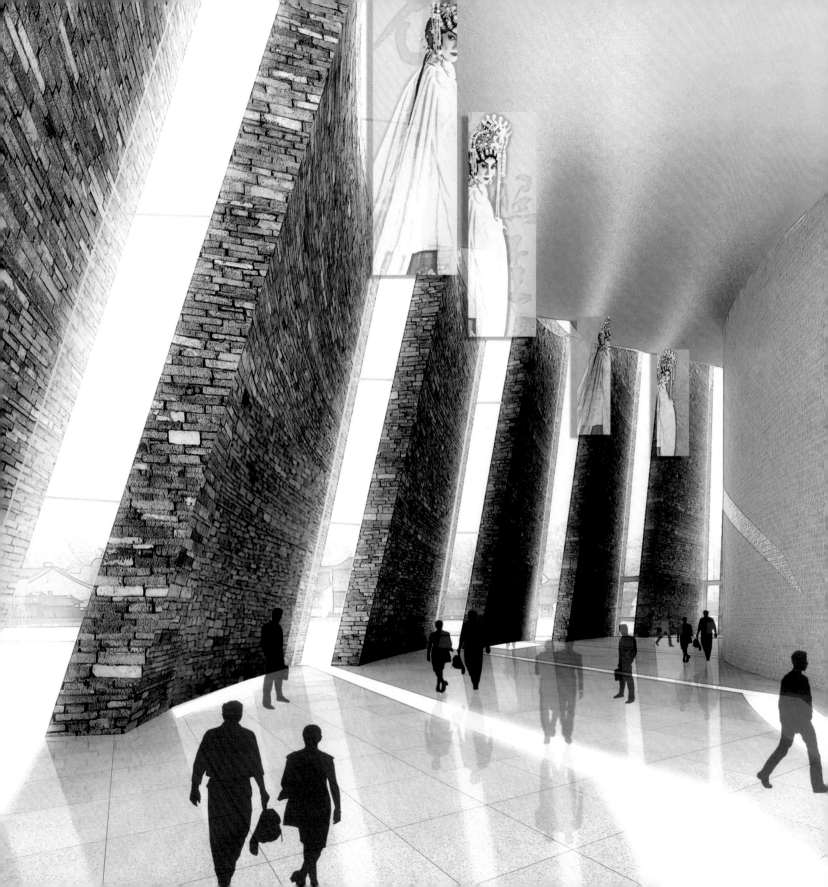

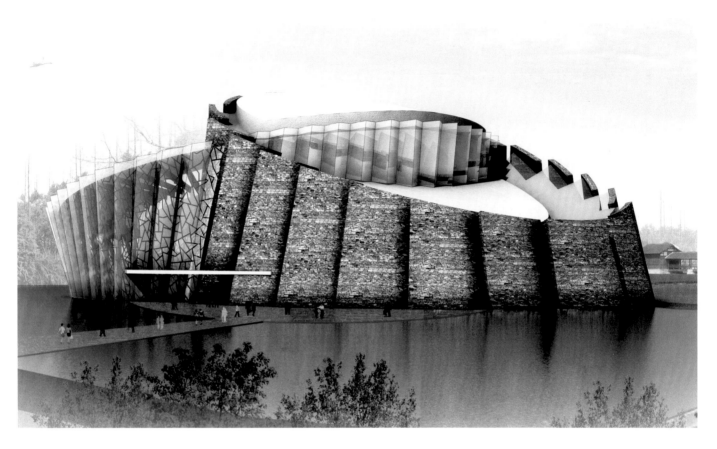

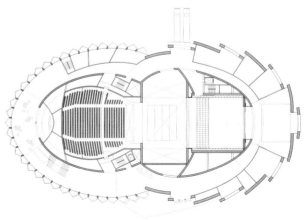

1 FIRST FLOOR PLAN
OPPOSITE PAGE BLACK BOX LOBBY

1

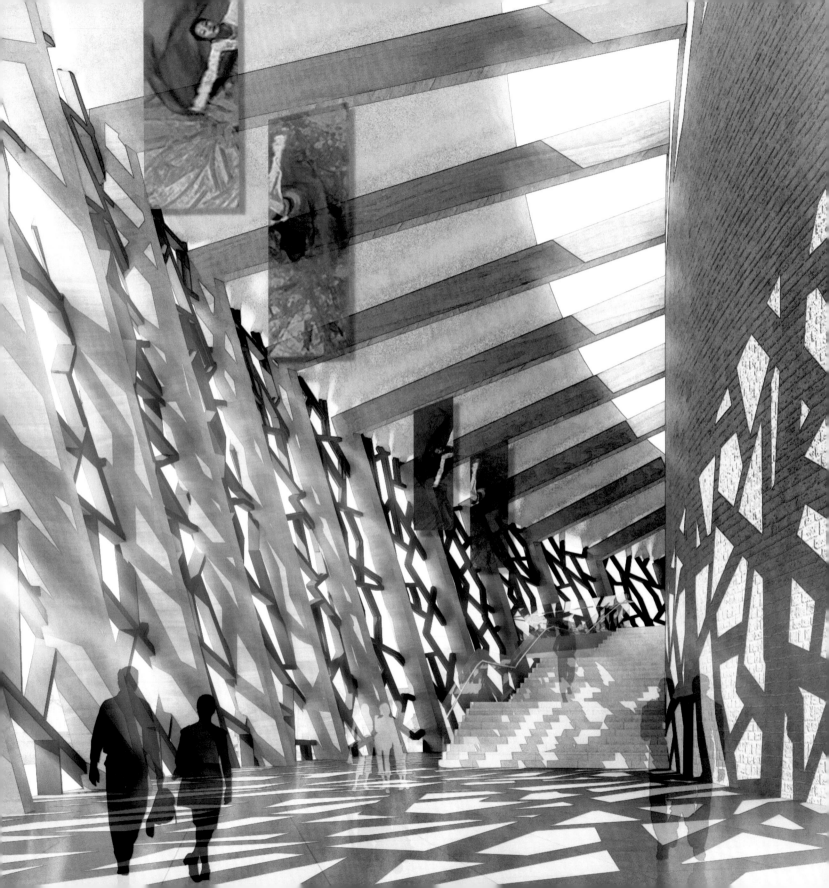

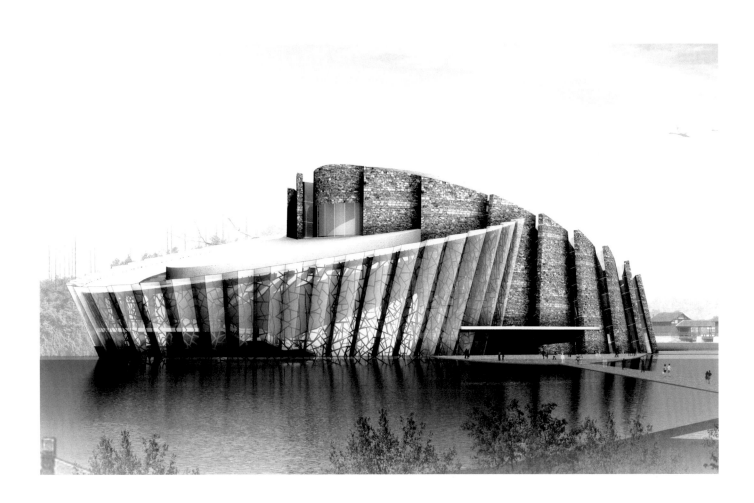

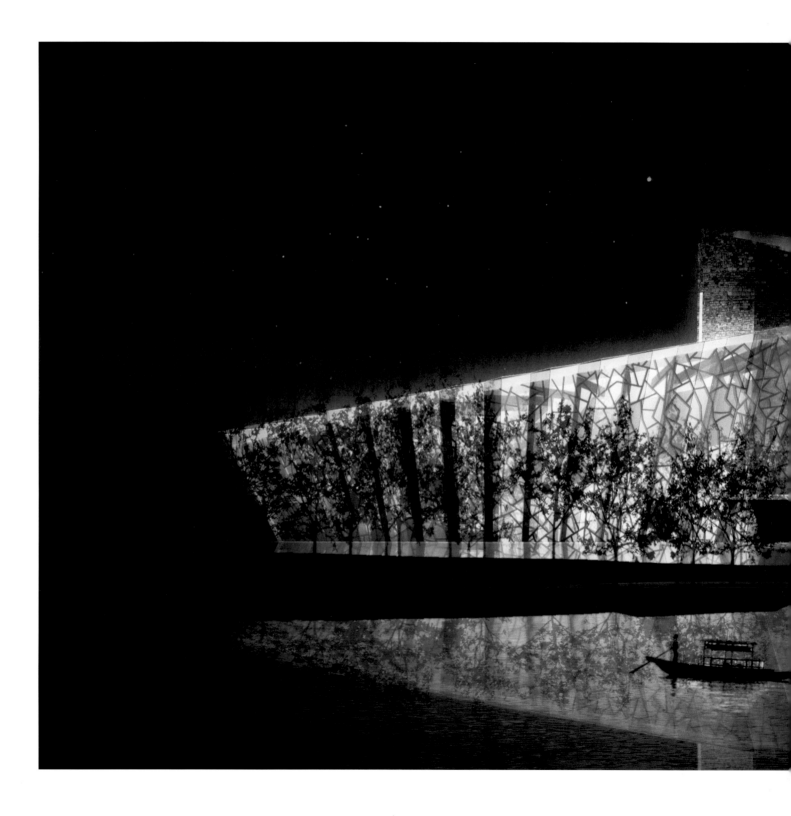

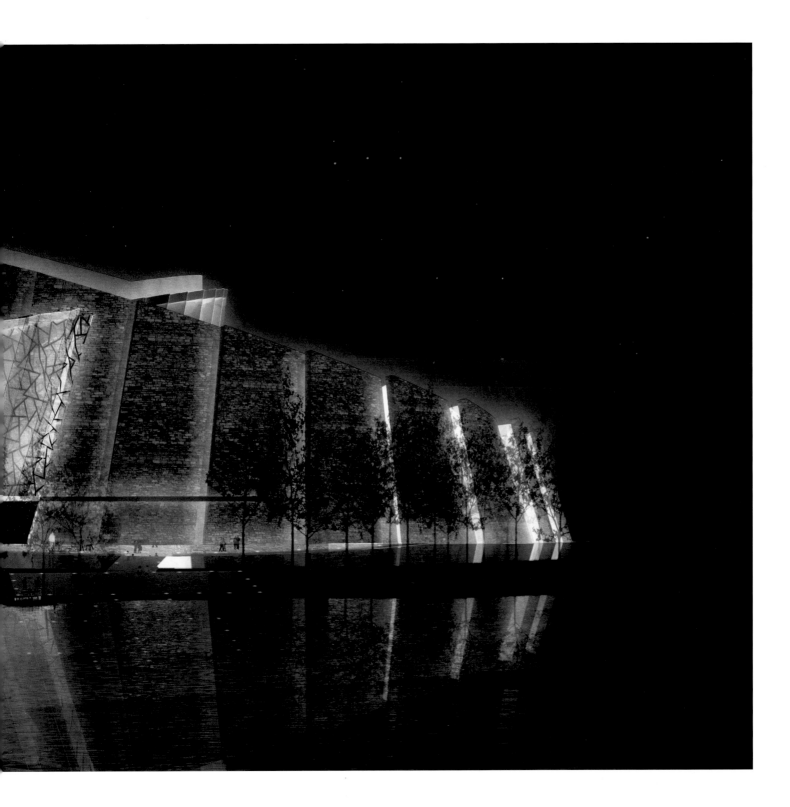

A cube and a cylinder anchor the center of the campus.

YUAN ZE UNIVERSITY LIBRARY AND ADMINISTRATION/ ACADEMY BUILDING

Yuan Ze University

ARTECH completed the Library Building in 1998 and continued to design the adjacent Administration/Academy Building two years later. These two anchor buildings complete the campus's central plaza because they are located on the ends of the east–west and north–south axes of the Yuan Ze University campus.

The award winning Library Building is a large, portal-framed structure that houses three major functions: the L-shaped Information Science Department, a conference center in a suspended glass box, and a library section that extends to the south. Facing west, the building's heavy, monumental façade anchors the central plaza. An upward passage composed of grand stairs, ramps, and bridges takes people through the

building to the various functions and outdoor terraces at different levels, facilitating impromptu exchanges and activities along the path.

Next to the Library Building, the Administration/ Academy Building houses two major programs: administrative office and research centers in a cylindrical tower, and classrooms in a rectangular, horizontal volume. The cylindrical tower accentuates its verticality with slender openings on the façade, and transforms itself into a transparent volume at the top with the glazed curtainwall constructions. On the ground floor, the lobby encloses another circular volume built with perforated metal panels, creating an interesting "circle within a circle" space.

PROJECT DATA

LOCATION
TAOYUAN COUNTY, TAIWAN

FUNCTION
EDUCATIONAL BUILDING

DESIGN / COMPLETION
LIBRARY BUILDING: 1995 / 1998
ADMINISTRATION/ACADEMY BUILDING: 2000 / 2003

SITE AREA
155,372 M²

GROSS FLOOR AREA
LIBRARY BUILDING: 84,550 M²
ADMINISTRATION/ACADEMY BUILDING: 19,325 M²

FLOOR LEVEL
LIBRARY BUILDING:
7 FLOORS ABOVE GROUND, 1 FLOOR BELOW GROUND
ADMINISTRATION/ACADEMY BUILDING:
14 FLOORS ABOVE GROUND, 2 FLOORS BELOW GROUND

STRUCTURE
PRE-CAST REINFORCED CONCRETE CONSTRUCTION

MATERIALS
ARCHITECTURAL CONCRETE, CLEAR FLOAT GLASS,
EXTRUDED ALUMINUM LOUVERS, GLASS UNIT MASONRY

NOTE
LIBRARY BUILDING:
HONOR AWARD, THE 20ᵀᴴ CHINESE ARCHITECT JOURNAL
AWARD 1999
FIRST PRIZE, THE 1ˢᵀ FAR EASTERN ARCHITECTURAL
DESIGN AWARD 1999

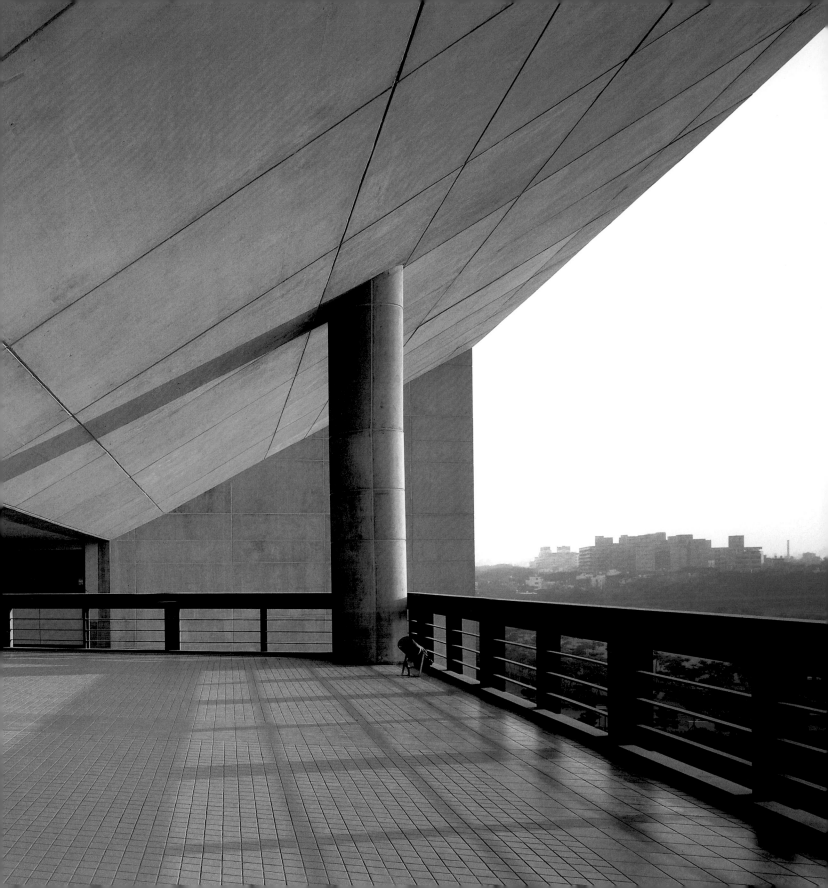

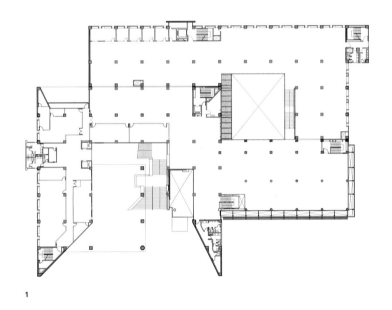

1

1 SECOND FLOOR PLAN (LIBRARY BUILDING)

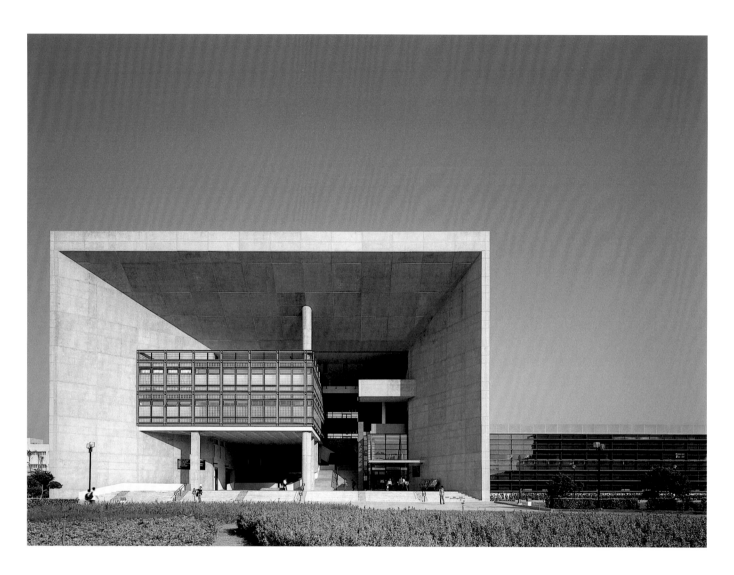

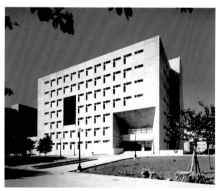

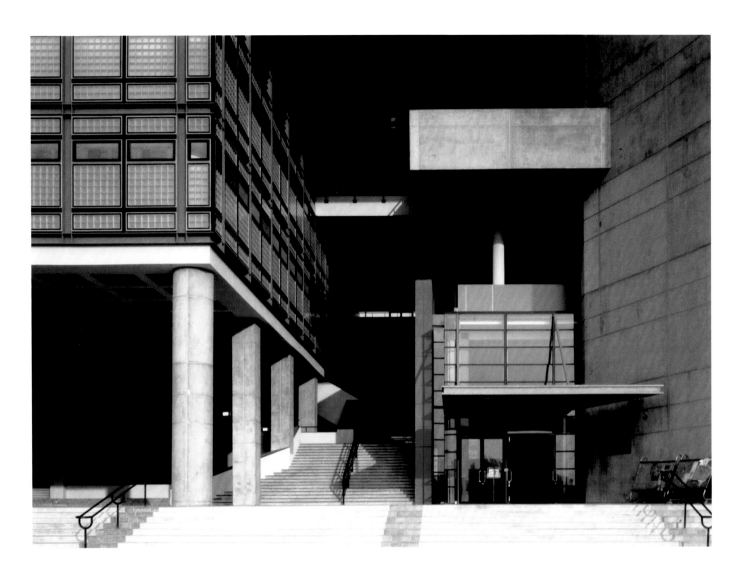

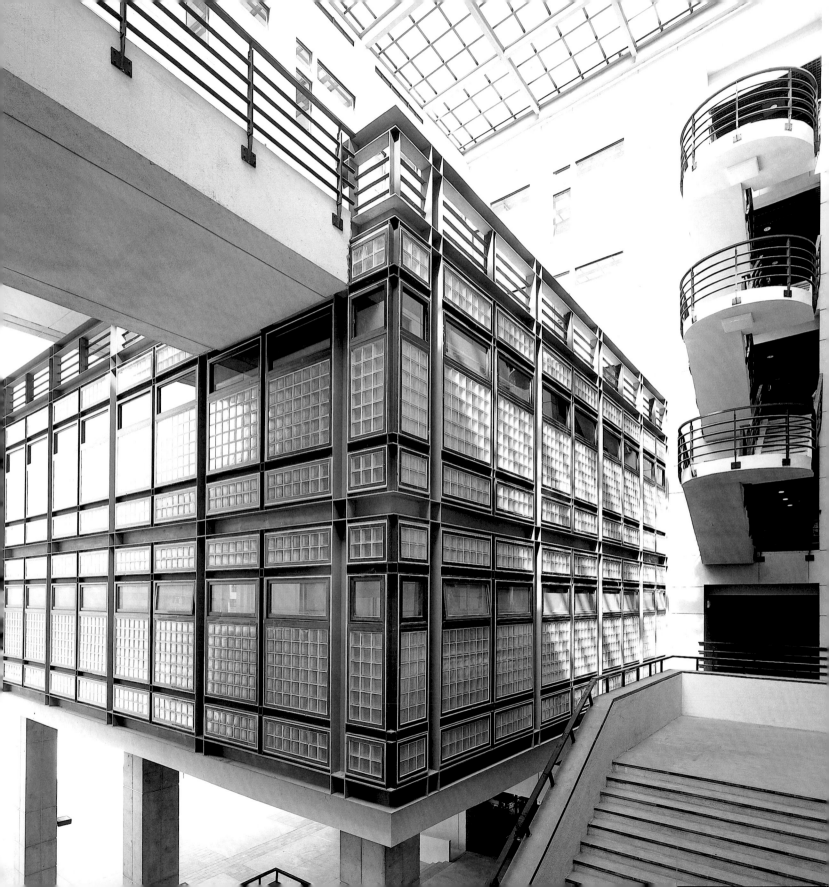

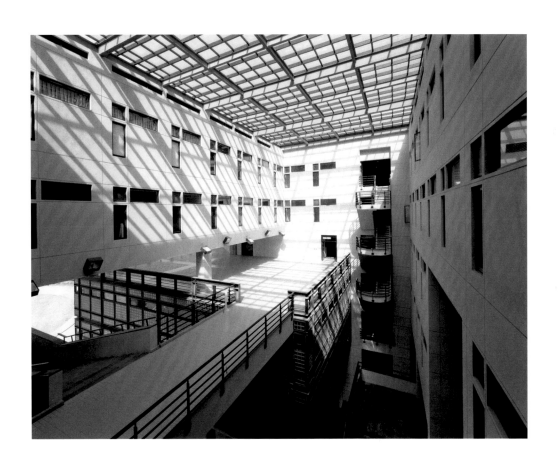

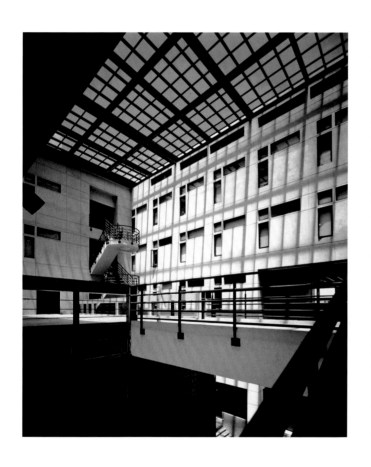 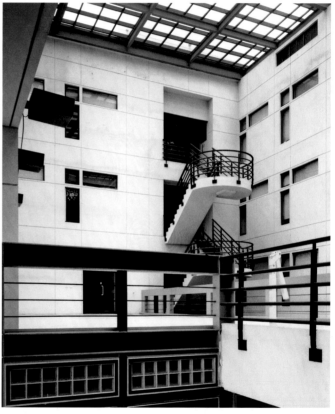

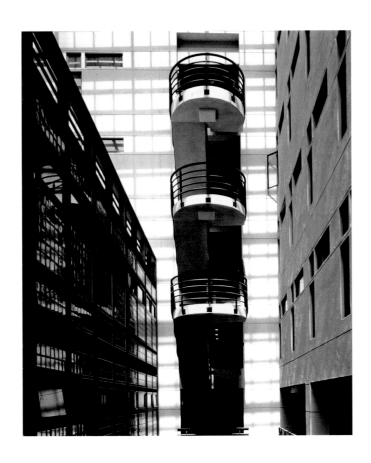
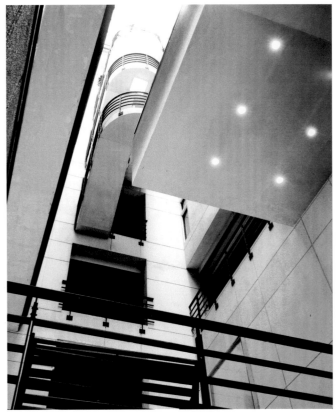

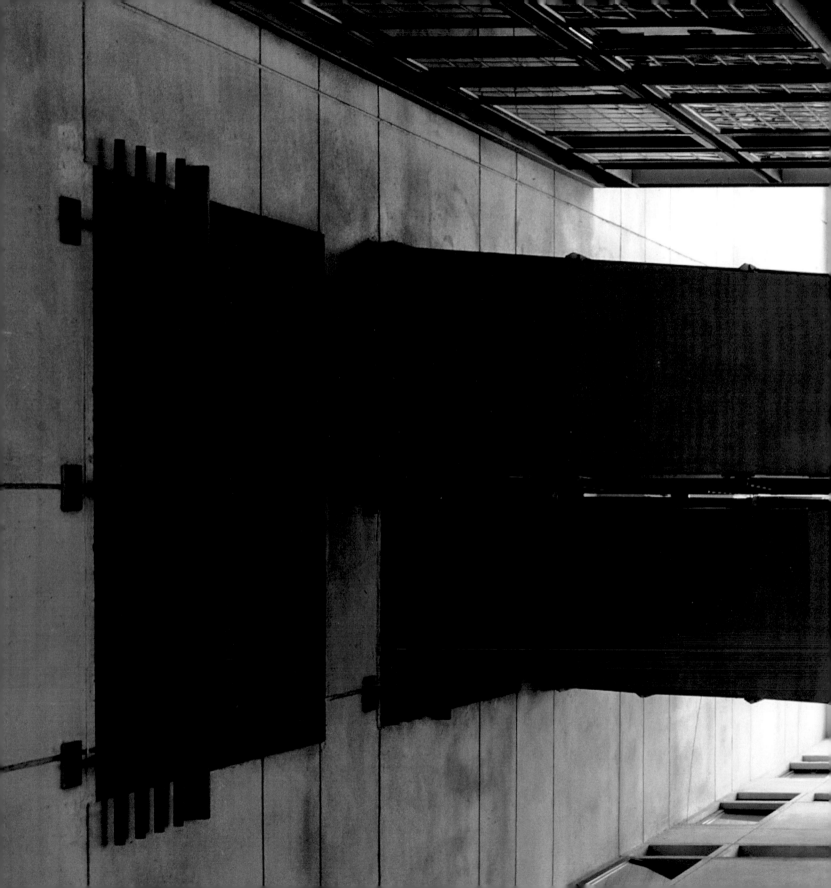

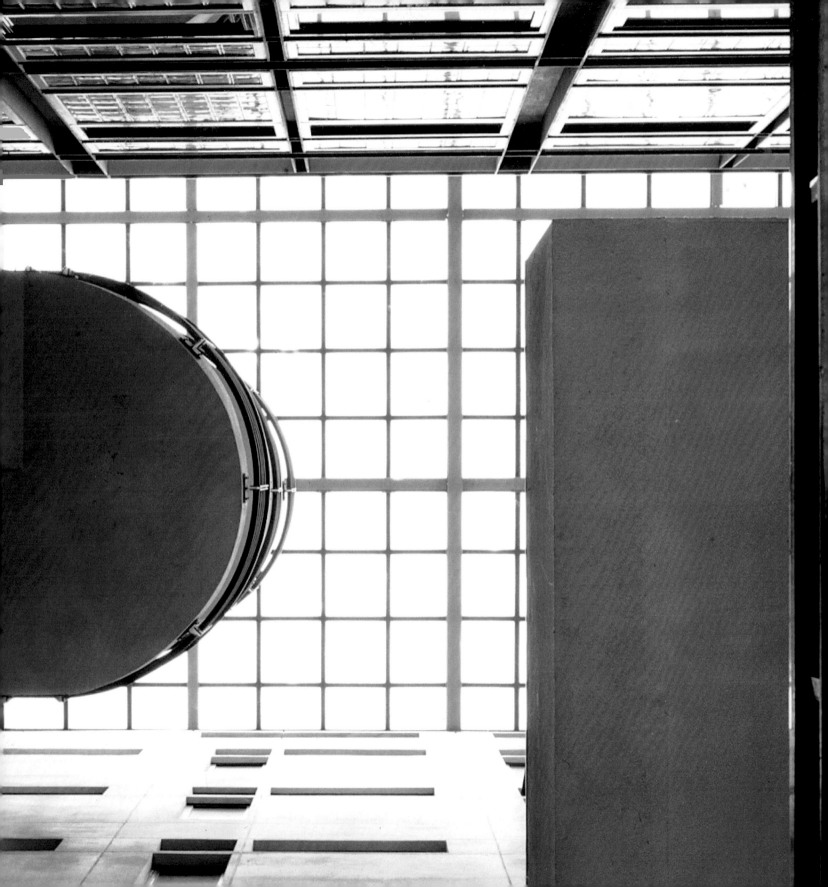

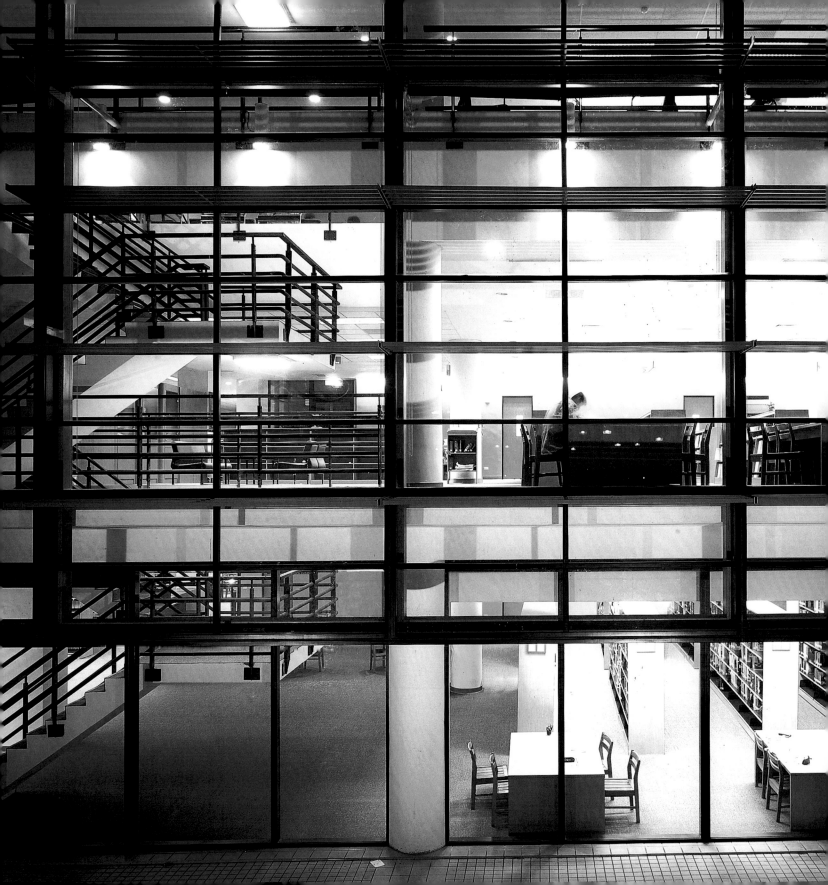

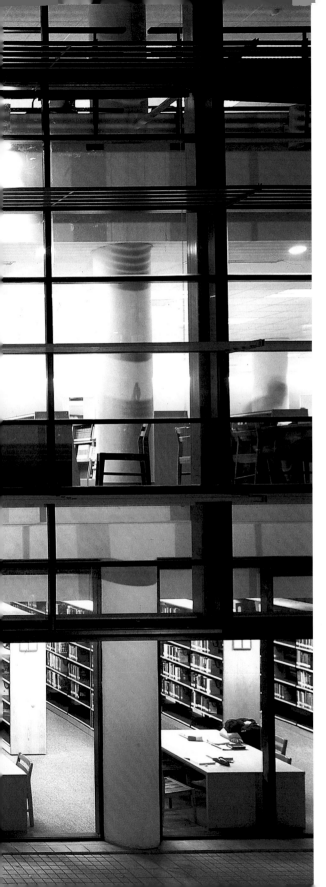

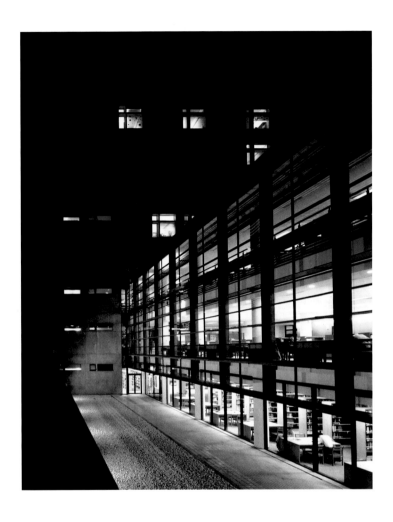

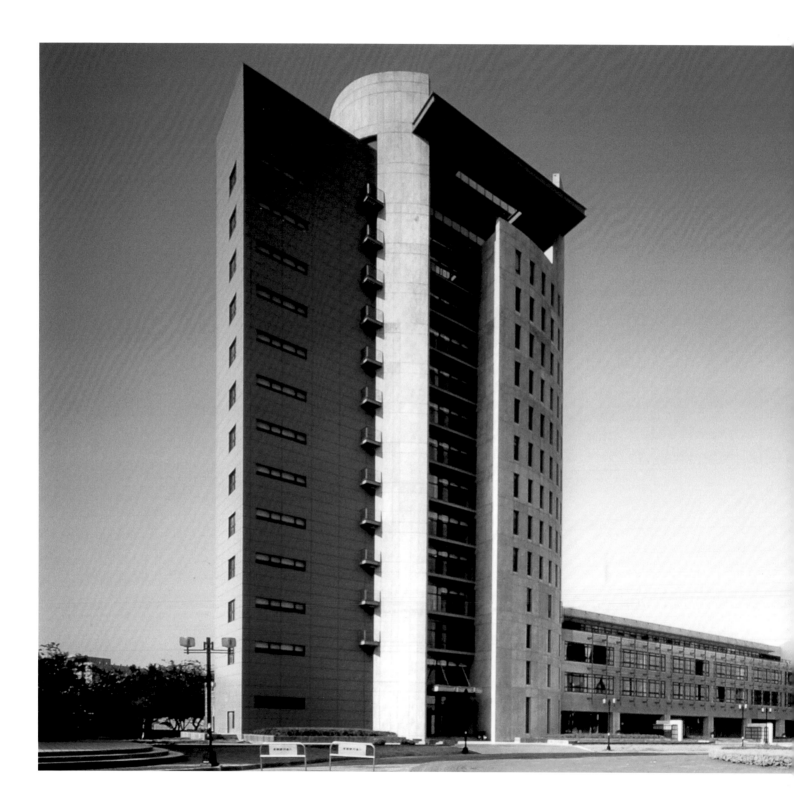

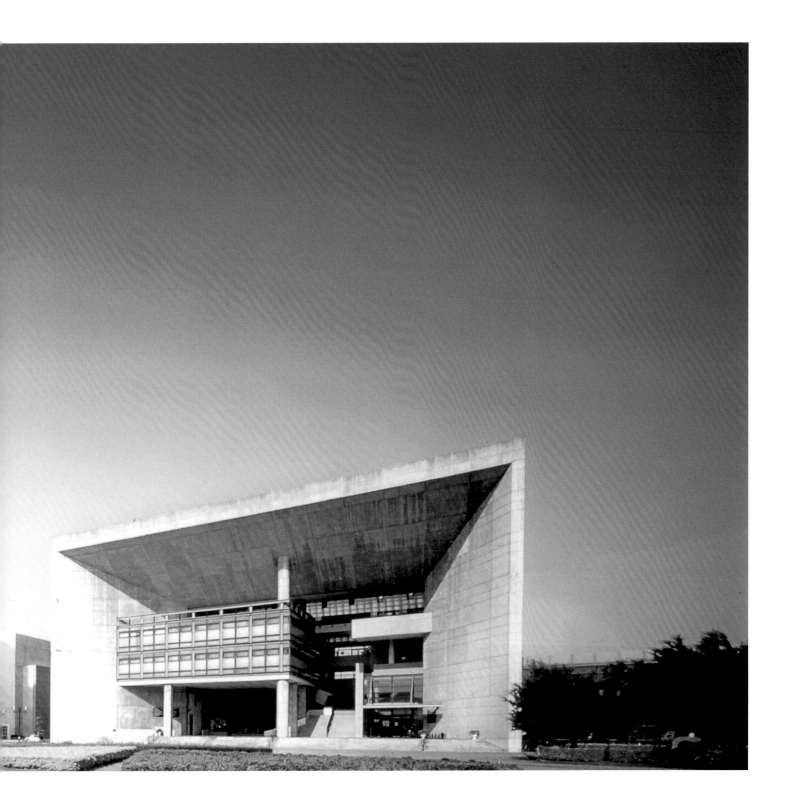

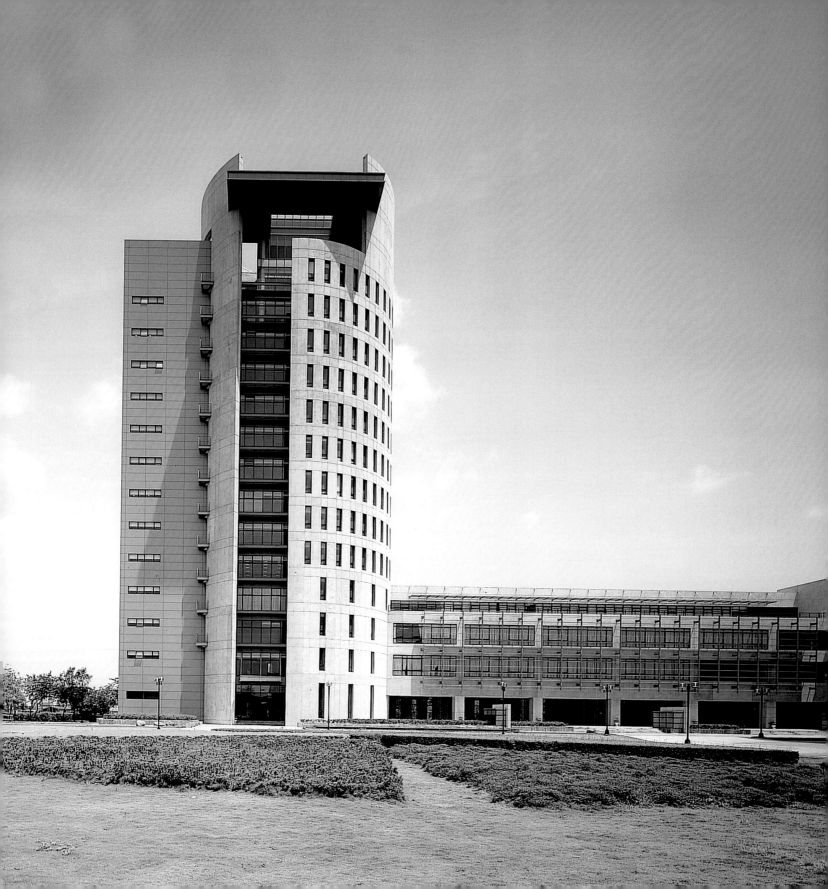

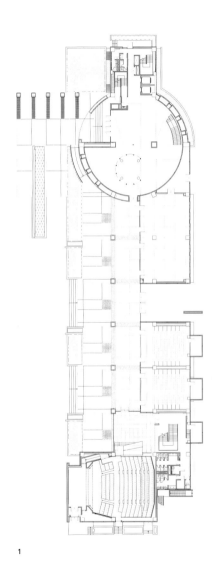

1

1 FIRST FLOOR PLAN (ADMINISTRATION/ACADEMY BUILDING)

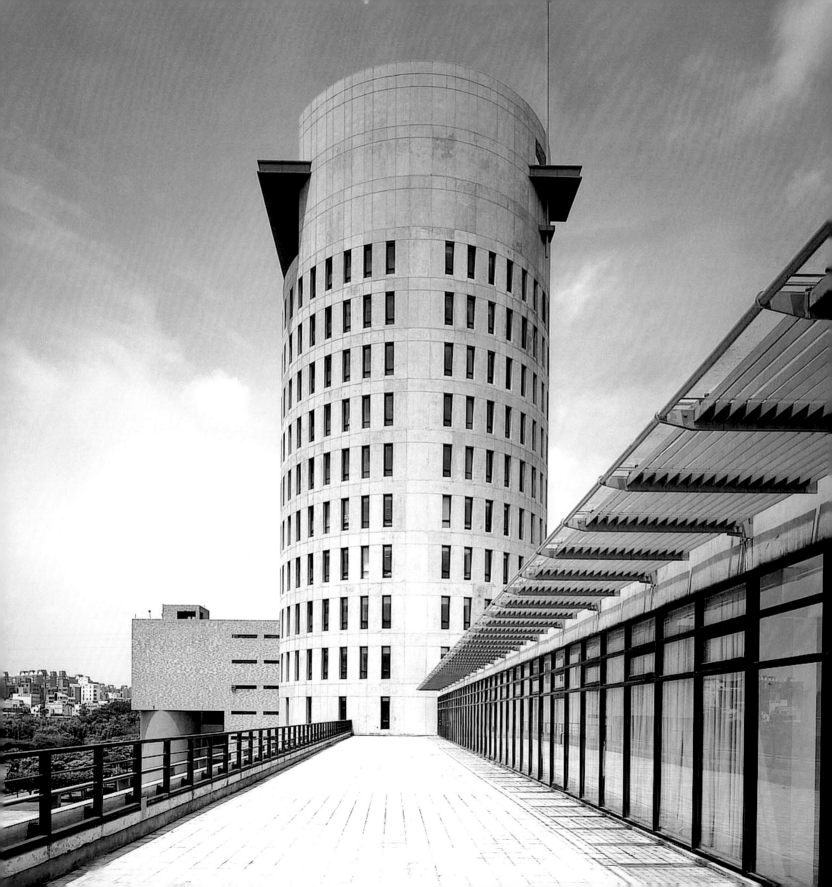

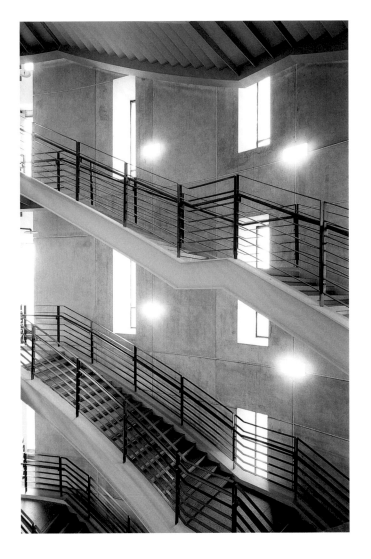
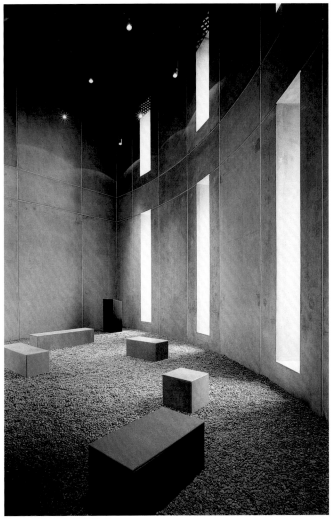

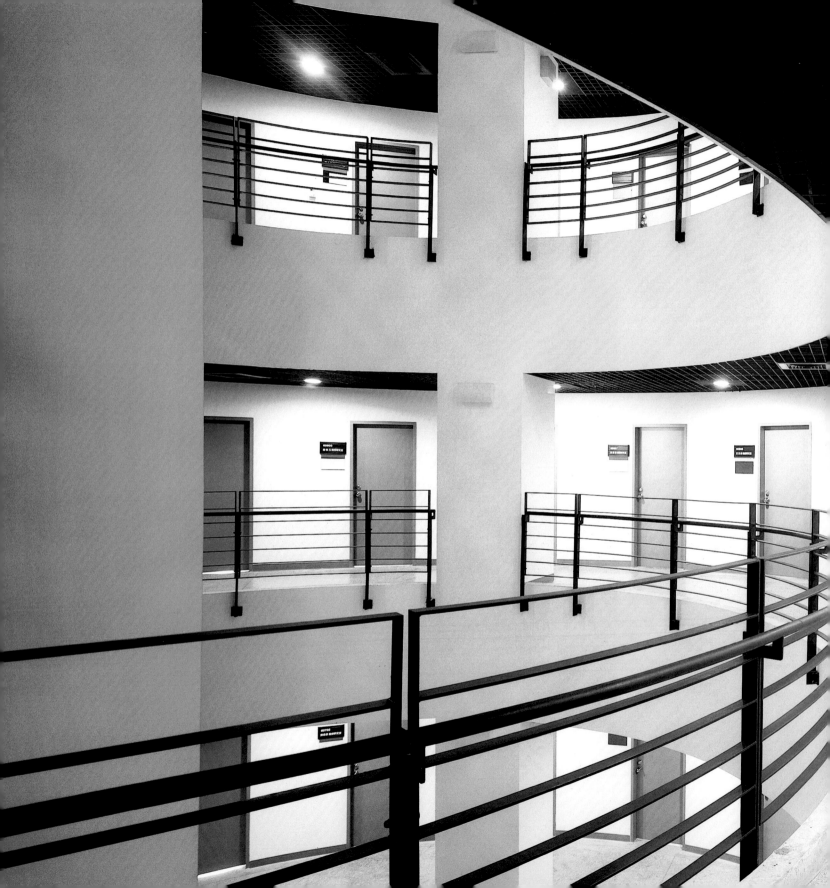

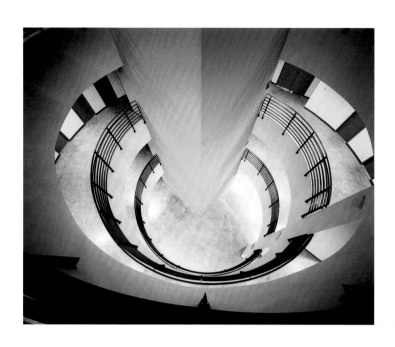

ALL IMAGES INTERIOR OF ADMINISTRATION/ACADEMY BUILDING

A wedged-shaped podium nestled in the valley with a green roof shields out the intense heat and light of Southern Taiwan.

TAINAN ARTS UNIVERSITY COLLEGE OF SOUND AND IMAGE ARTS

Tainan National University of The Arts (TNNUA)

With lush green hills surrounding it on three sides, the College of Sounds and Image Arts nestles its main tower and wedge-shaped podium in a valley, with only its west side open to the main campus. To further integrate into its natural surroundings, the roof of the podium, angled at a 1:6 ratio, is completely covered with soil and grass. The interior spaces underneath remain cool and comfortable as the green roof serves as a buffer to the intense heat of southern Taiwan.

Two architectural masses protrude from the slope. The lower mass houses a movie theater, where students' final projects are showcased. The taller mass overlooking the nearby reservoir accommodates various research rooms for professors and students. Courtyards of varying sizes are carved into the podium, providing light and ventilation for the lower levels and offering informal gathering spaces for students.

The dormitory complex set into the southern hill is designed as another wedge-shaped building with a 1:3 slope, providing terraces for each dormitory unit. In front of the dormitory building is a circular common room with the same size and shape as the entry plaza to represent a cut out of the main building.

PROJECT DATA

LOCATION
TAINAN COUNTY, TAIWAN

FUNCTION
EDUCATIONAL BUILDING

DESIGN / COMPLETION
1996 / 1998

SITE AREA
542,721 M²

GROSS FLOOR AREA
550,052 M²

FLOOR LEVELS
8 FLOORS ABOVE GROUND, 1 FLOOR BELOW GROUND

STRUCTURE
REINFORCED CONCRETE CONSTRUCTION

MATERIALS
CONCRETE MASONRY UNIT, SANDSTONE, TEXTURED STUCCO, WASH PEBBLE

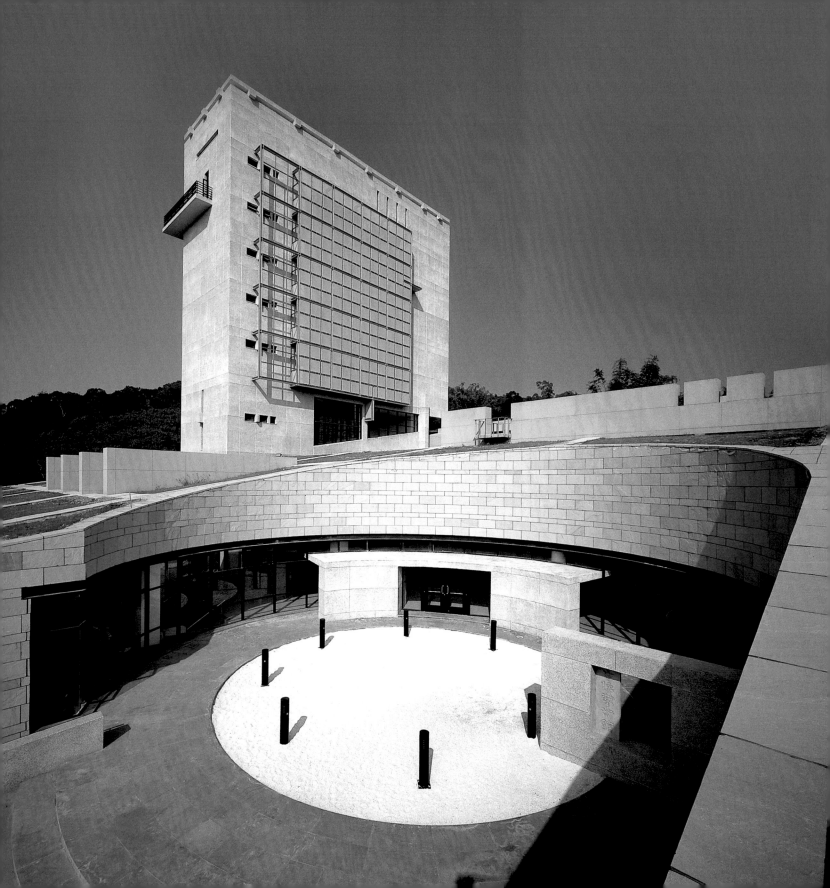

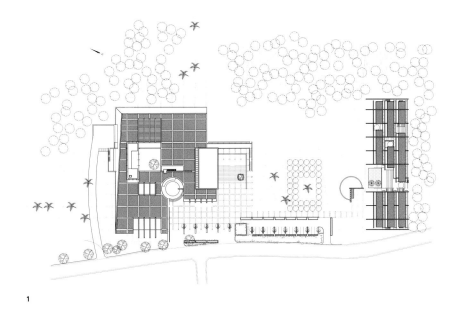

1

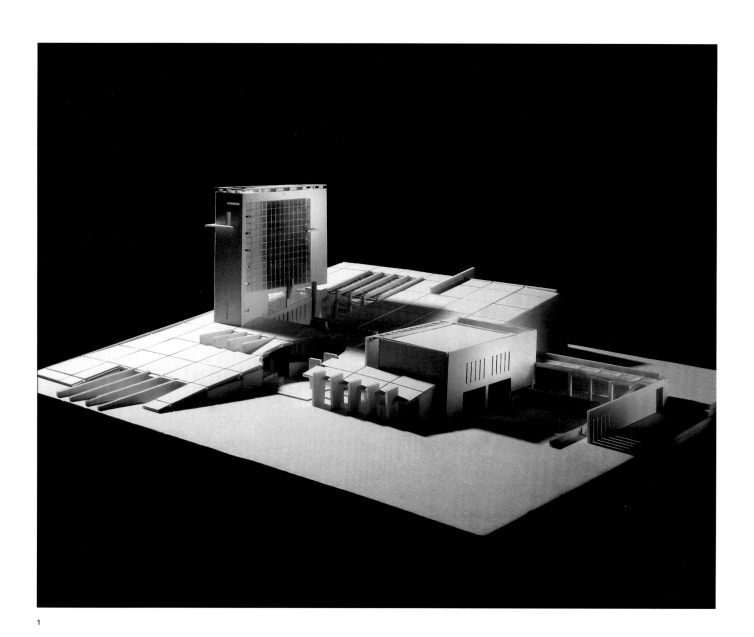

1

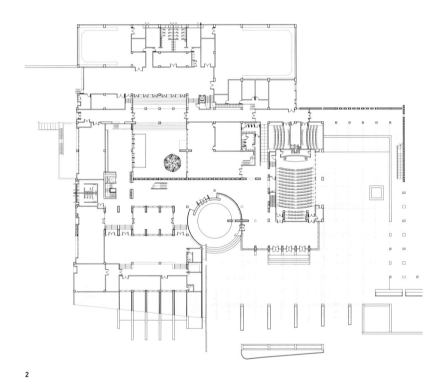

2

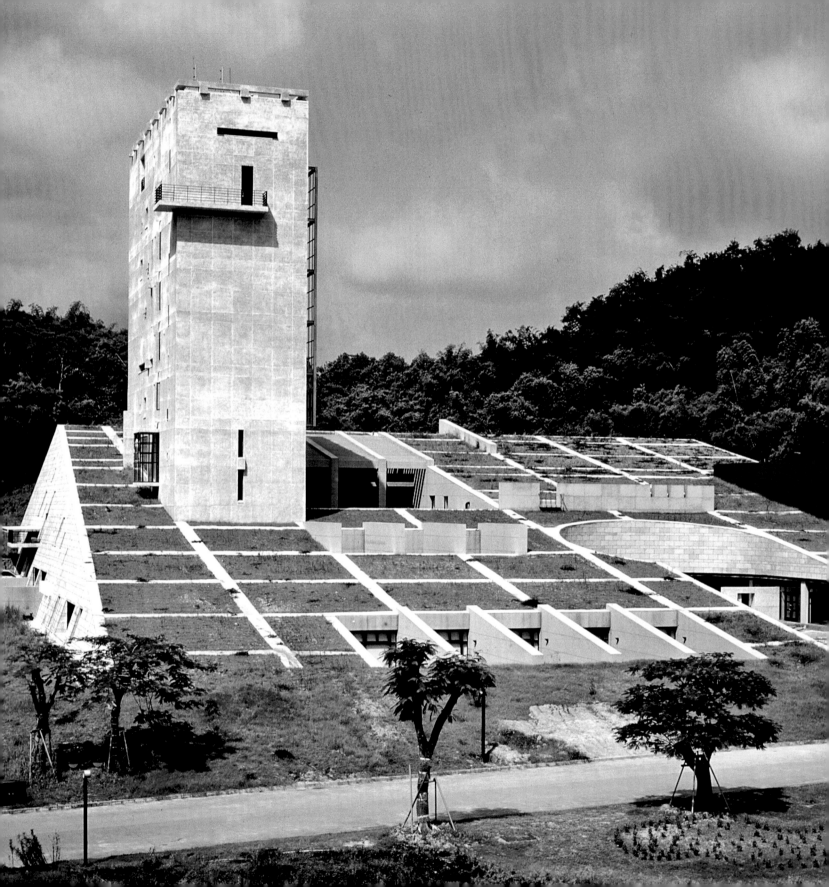

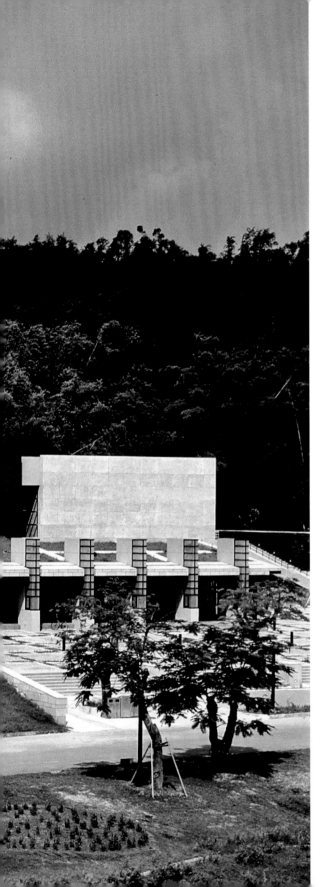

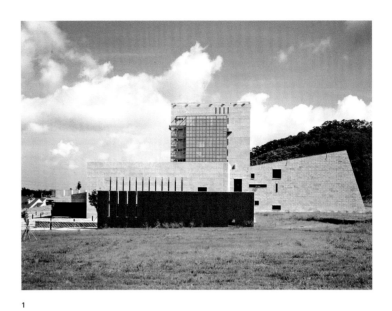

1

2

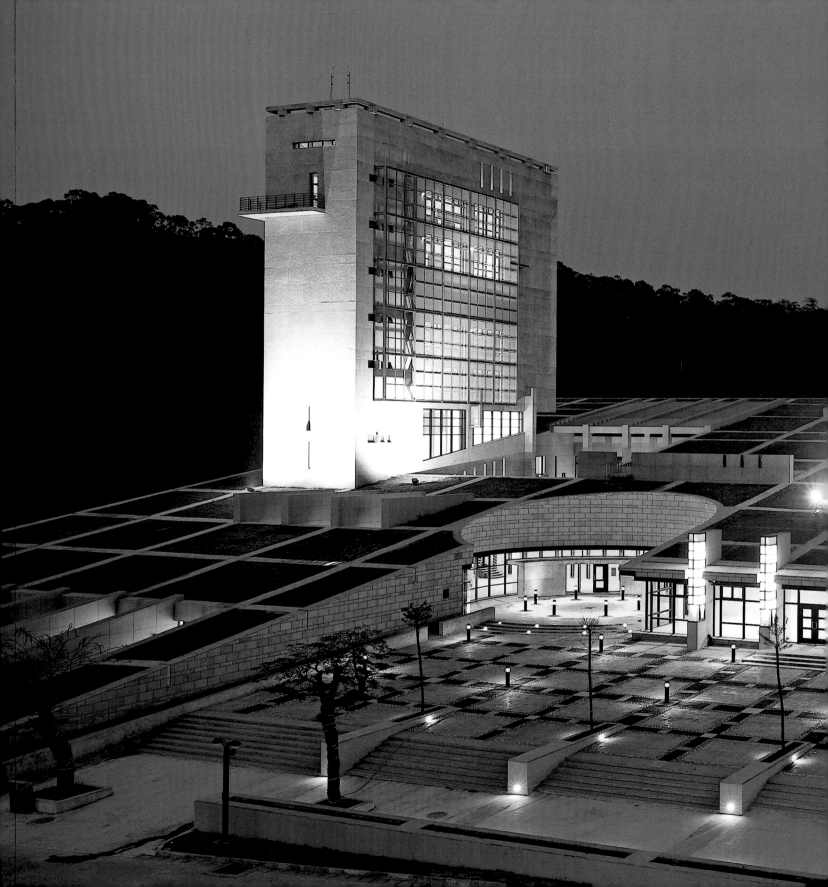

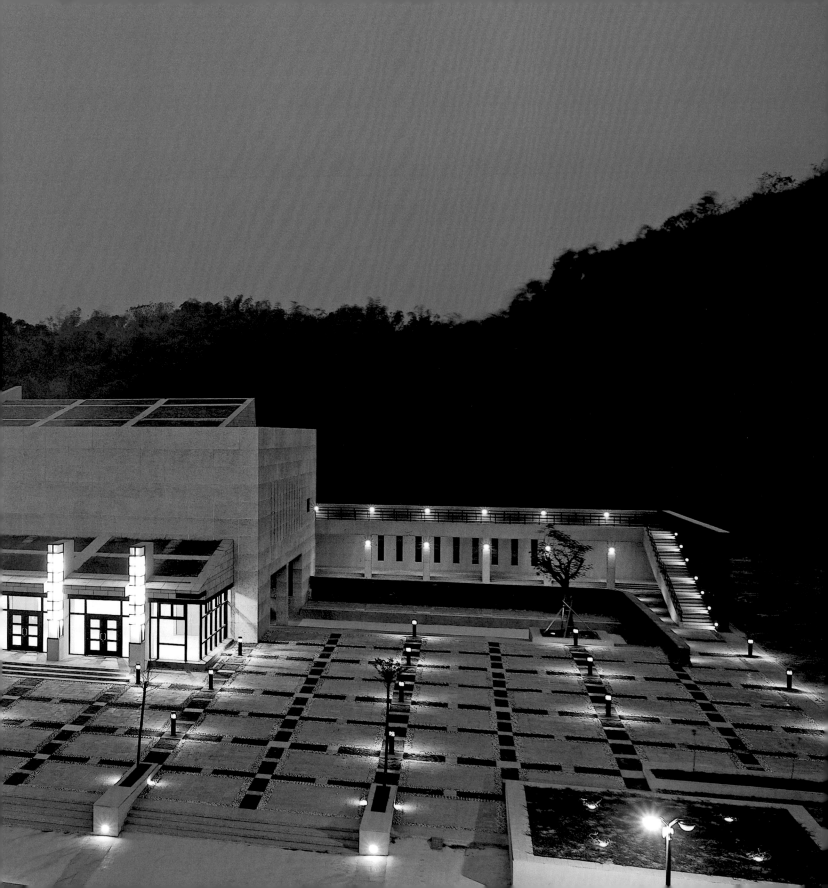

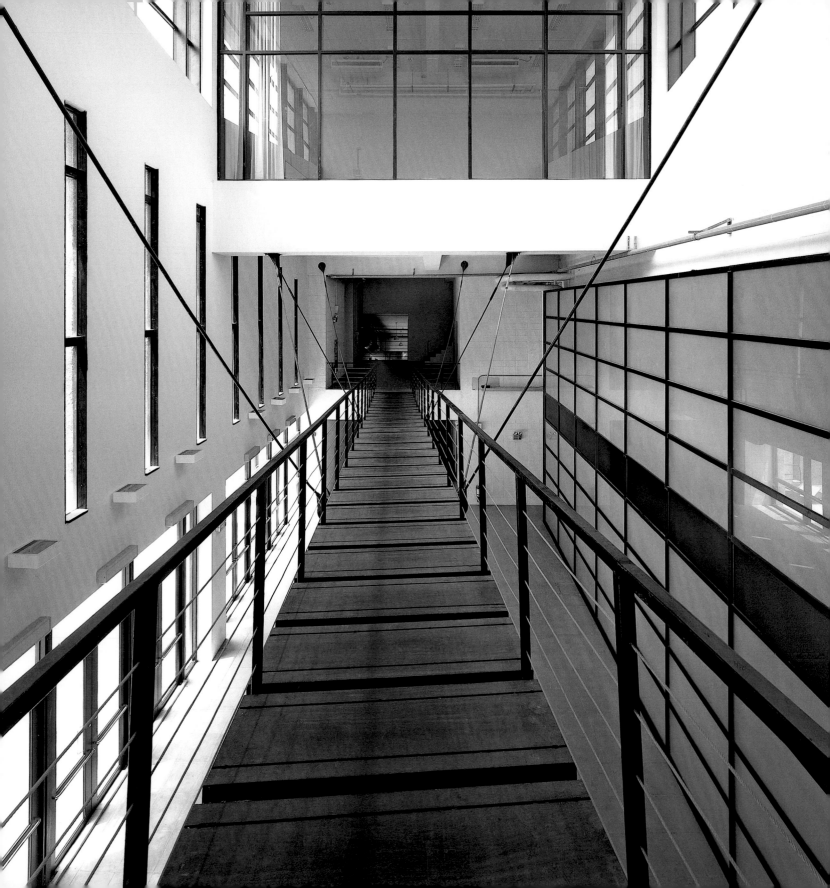

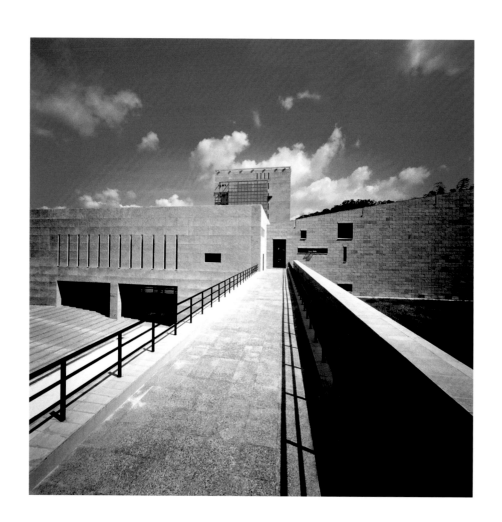

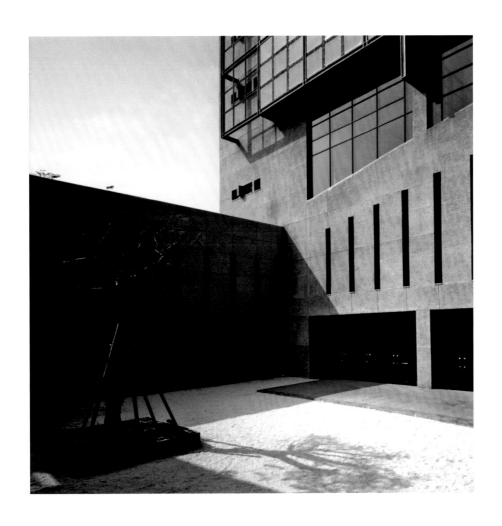

The campus is designed to be in harmony with nature, physically merging architecture into the terrain while programmatically employing sustainability.

DHARMA DRUM UNIVERSITY
The Chung-Hwa Institute of Buddhist Studies

Situated on a magnificent wooded hill, the university is located on two connecting sites. The larger site to the southwest is in a shallow valley, with two streams running through and views towards the nearby plains below. The other site to the east is on a terraced hill, with spectacular views to the ocean. Established by a Buddhist group, the university strongly emphasizes harmony with nature and ecological sustainability in the development of the campus.

The campus sought to maintain most of its natural terrains and resources, while the architecture aims to blend into its natural settings as much as possible. As a result, low-rise, multi-layered buildings are placed on the various terrains on the site, allowing smooth horizontal links between nature and the buildings.

A footbridge over a stream links the two academic areas. Its design is minimal yet poetic, serving as a symbolic and iconic feature for the campus. The landscape plays an important role in shaping the character of the campus through careful attention to blending in with nature, the use of recycled water and rainwater for irrigation, and the allocation of various meditative settings.

PROJECT DATA

LOCATION
TAIPEI COUNTY, TAIWAN

FUNCTION
EDUCATIONAL BUILDING

DESIGN / COMPLETION
1998 / EXPECTED 2011

SITE AREA
249,113 M²

FLOOR LEVELS
6 FLOORS ABOVE GROUND, 2 FLOORS BELOW GROUND

STRUCTURE
STEEL FRAME AND REINFORCED CONCRETE CONSTRUCTION

MATERIALS
ARCHITECTURAL CONCRETE, ALUMINUM PANELS, CLEAR FLOAT GLASS, WOOD

NOTE
FIRST PRIZE, DHARMA DRUM UNIVERSITY CAMPUS DESIGN COMPETITION

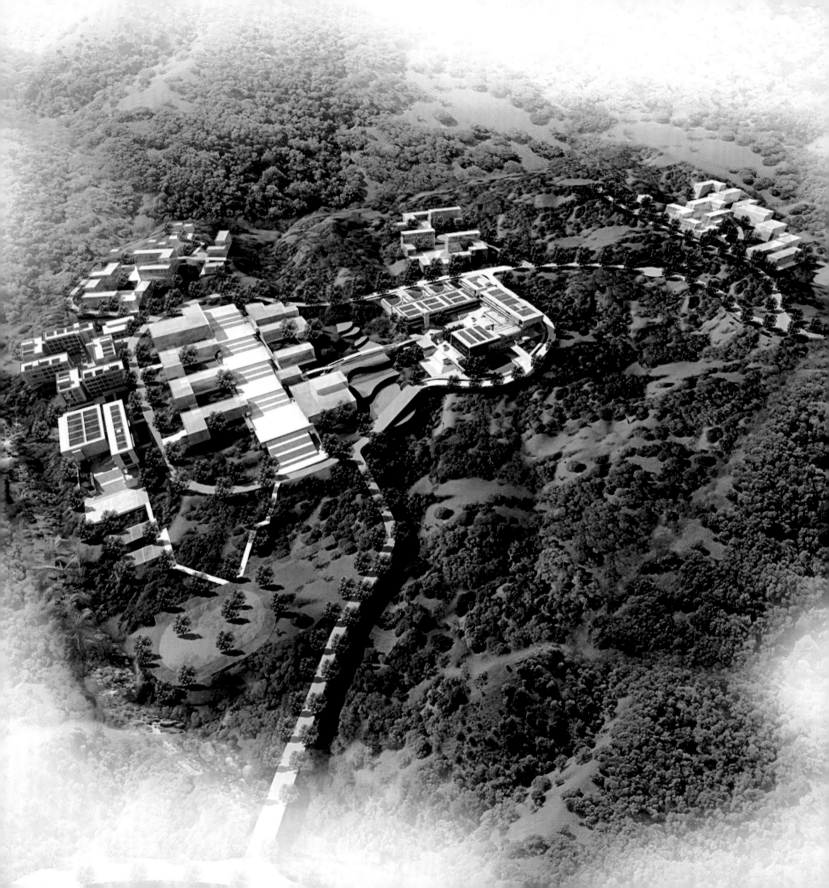

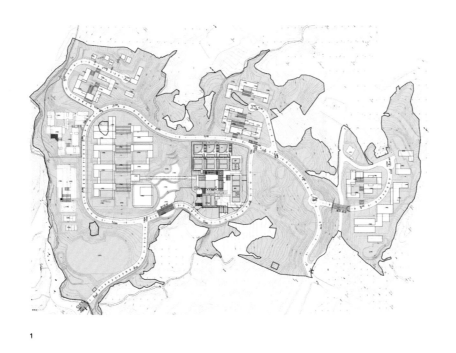

1

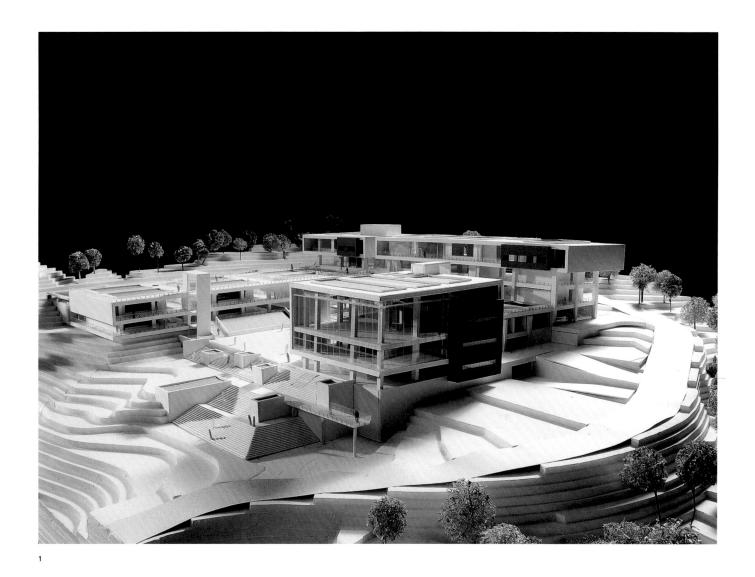

1

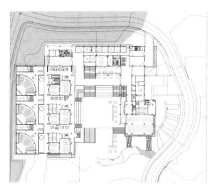

2

1 MODEL, ADMINISTRATION AND EDUCATION BUILDING
2 GROUND FLOOR PLAN (ADMINISTRATION AND EDUCATION BUILDING)
3 MODEL, GYMNASIUM
4 GROUND FLOOR PLAN (GYMNASIUM)

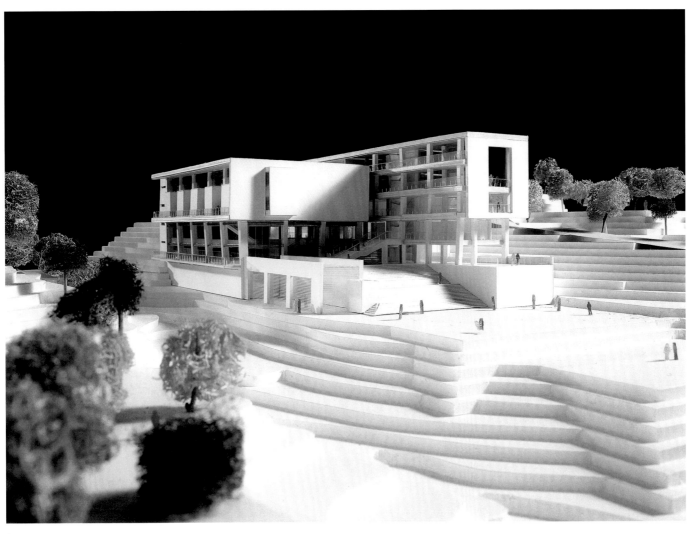

3

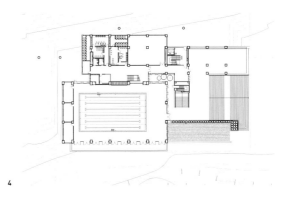

4

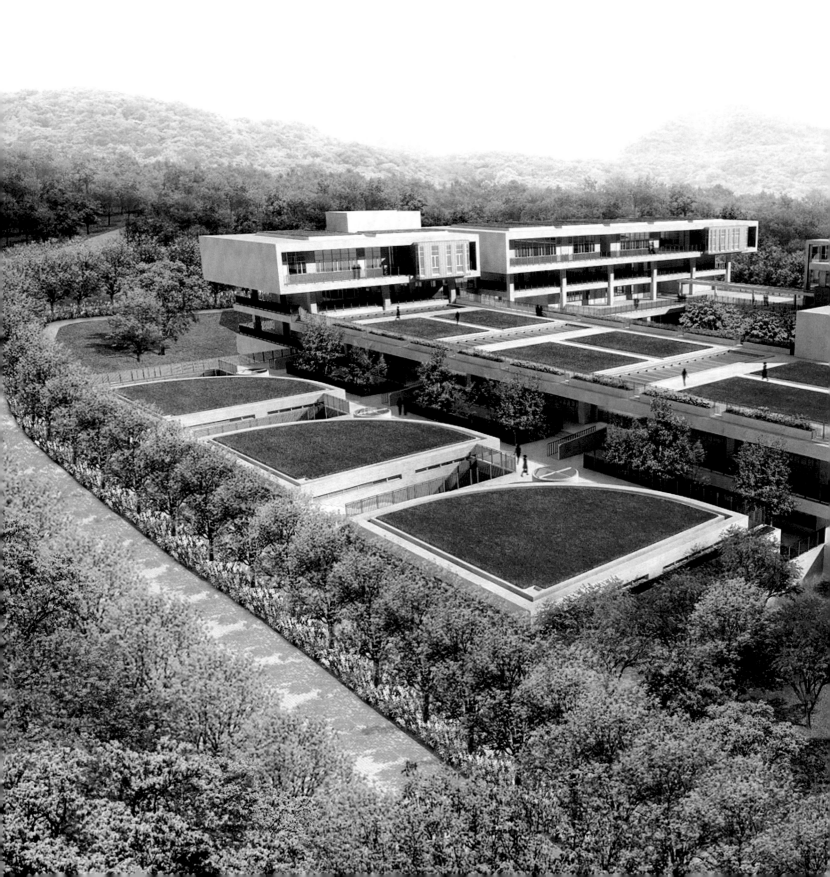

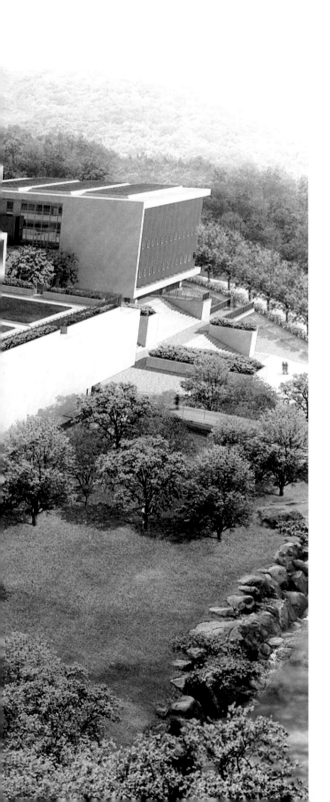

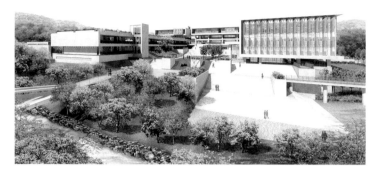

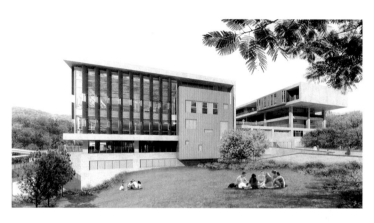

ALL IMAGES ADMINISTRATION AND EDUCATION BUILDING

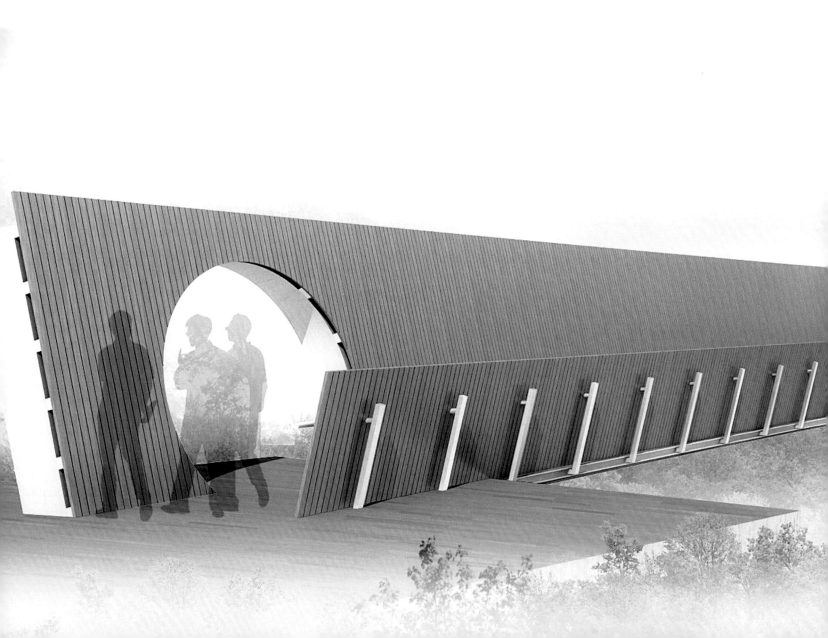

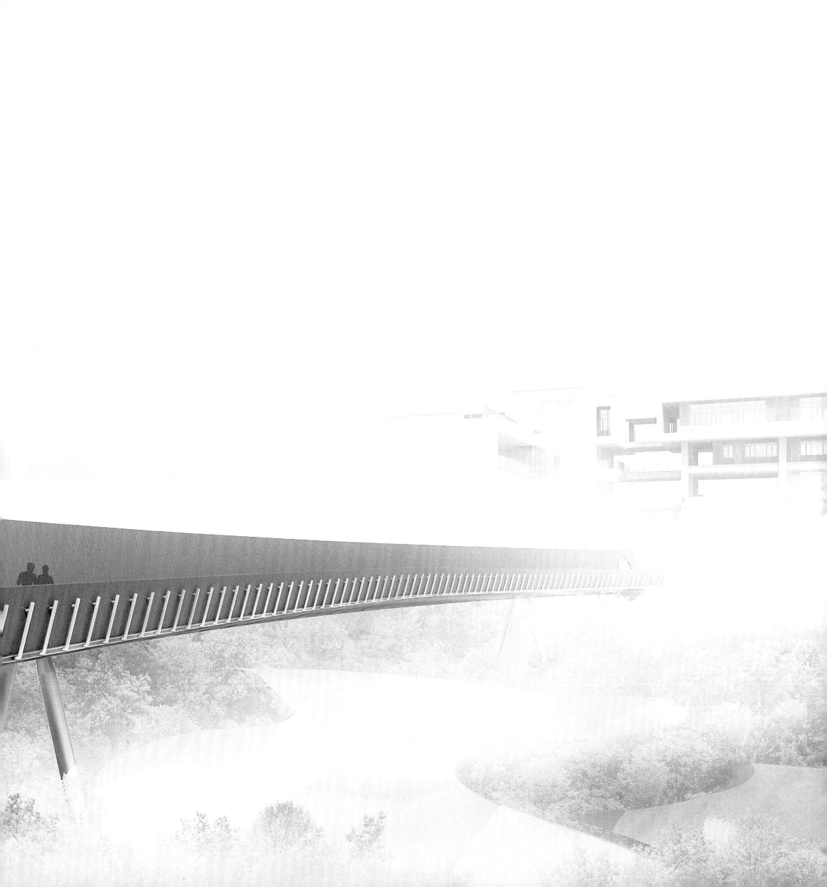

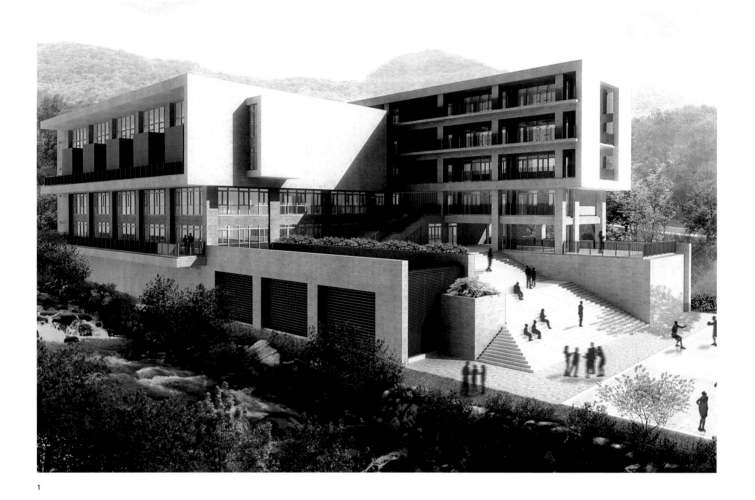

1

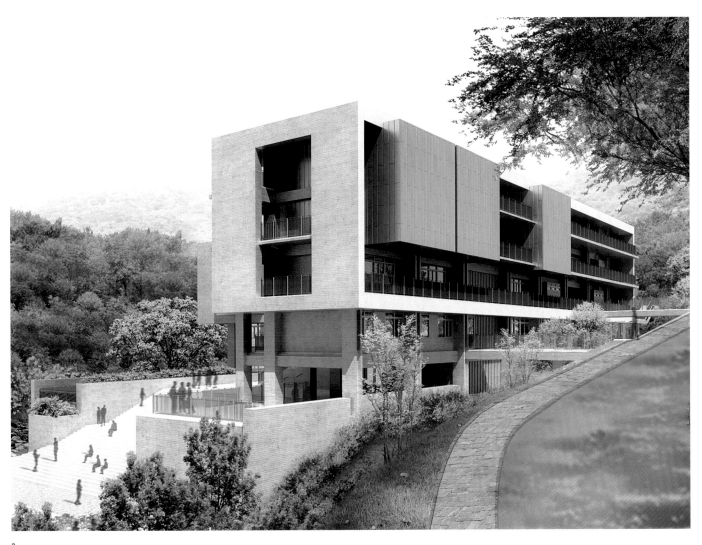

2

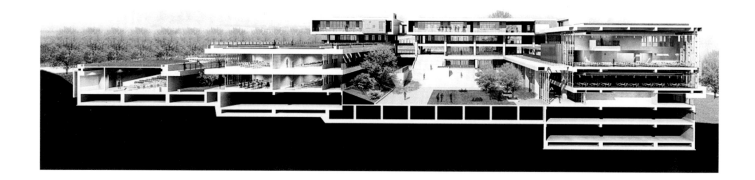

1

1 ADMINISTRATION AND EDUCATION BUILDING SECTION
2 GYMNASIUM SECTION

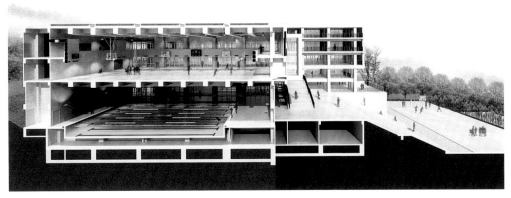

2

An architectural concrete gateway for a small urban university.

SHIH CHIEN UNIVERSITY COLLEGE OF DESIGN
Shih Chien University

The College of Design building is located at the south entrance of the Shih Chien University campus. Aiming to break away from conventional enclosed campuses and to connect the neighboring community with an open campus, this new College of Design is created of two triangular volumes that form a 45° diagonal walkway, extending an inviting entrance to the public.

Primarily constructed with architectural concrete, aluminum panels, steel, and glass, the building maintains neutral gray hues and exudes simple elegance. Aluminum sun shading louvers, a key element of the design, are placed horizontally or vertically on the east and south elevations. The geometric repetition of these louvers creates a tectonic rhythm to the building. In the evenings, light streams through the louvers, resulting in a different ambience from the daytime.

For interior planning, emphasis is placed on spatial fluidity and openness that is designed to encourage social interaction. Classrooms are located around the public areas on the lower levels. Design studios and professors' offices are placed between the 5th and 7th floors. An internal atrium spanning the three floors connects three different departments. The presentation rooms and library are housed in double-height spaces at the top of the building.

PROJECT DATA

LOCATION
TAIPEI, TAIWAN

FUNCTION
EDUCATIONAL BUILDING

DESIGN / COMPLETION
1999 / 2003

SITE AREA
42,132 M²

GROSS FLOOR AREA
20,896 M²

FLOOR LEVELS
9 FLOORS ABOVE GROUND, 3 FLOORS BELOW GROUND

STRUCTURE
REINFORCED CONCRETE CONSTRUCTION

MATERIALS
ARCHITECTURAL CONCRETE, CLEAR FLOAT GLASS, EXTRUDED ALUMINUM LOUVERS

NOTE
HONORABLE MENTION, THE TAIWAN ANNUAL ARCHITECTURE AWARD 2003
FIRST FAR EASTERN SCHOOL CAMPUS ARCHITECTURE HONORARY AWARD 2004

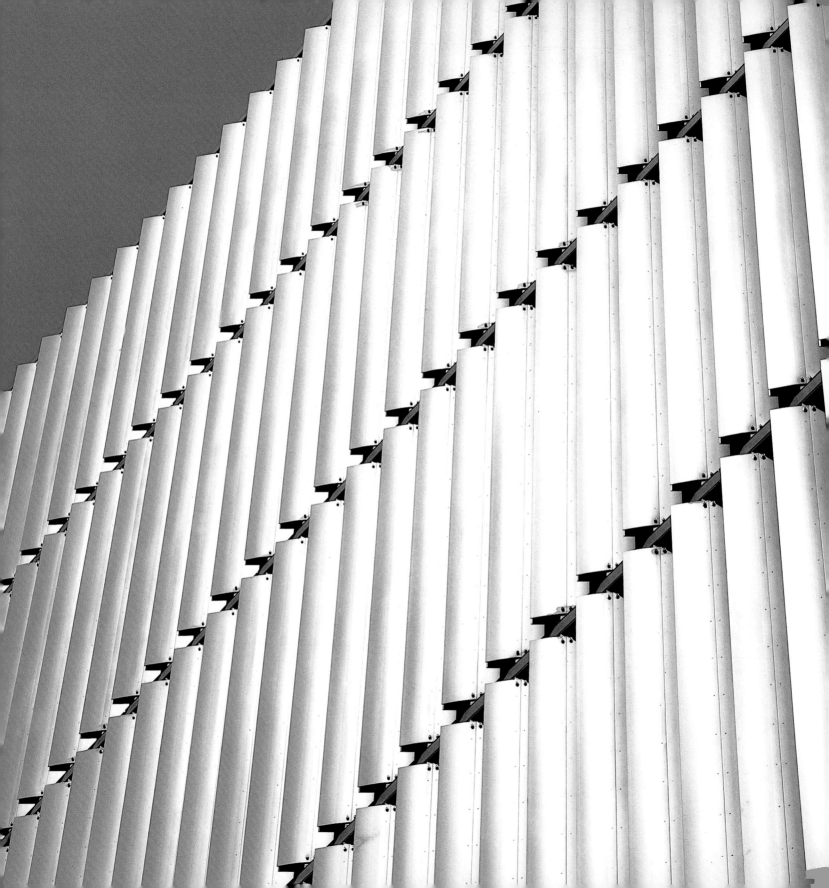

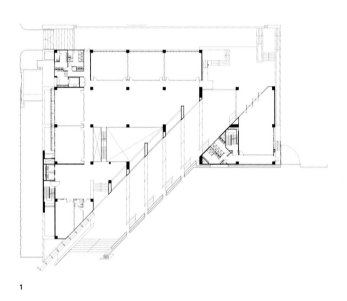

1 FIRST FLOOR PLAN
2 FIFTH FLOOR PLAN

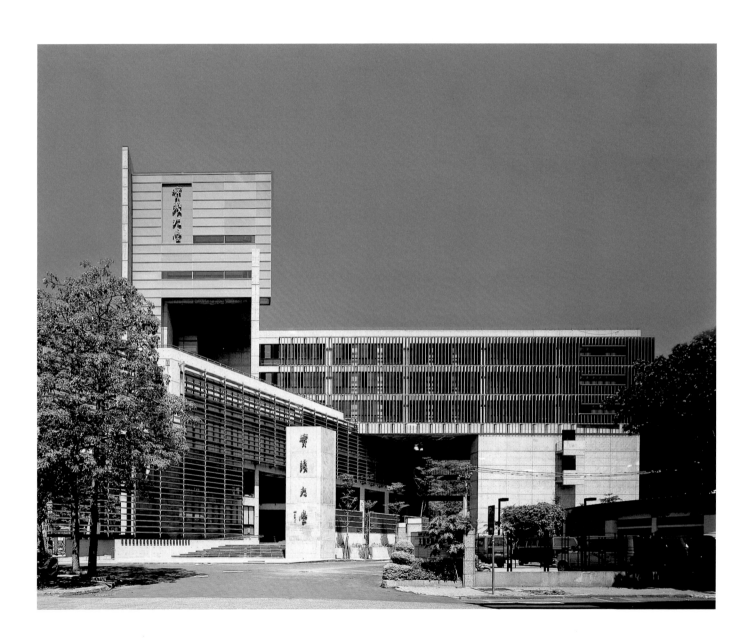

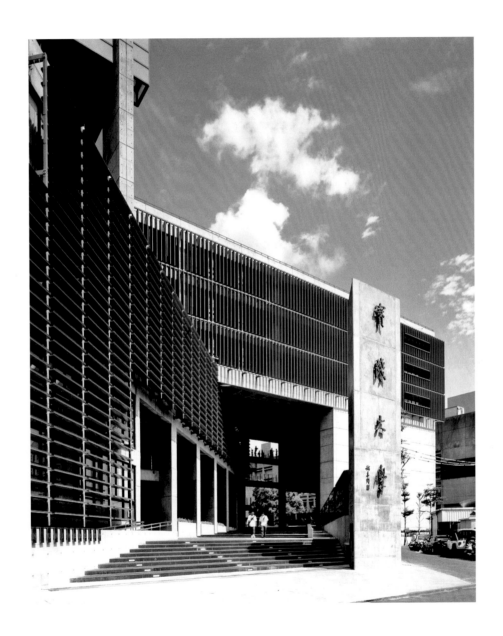

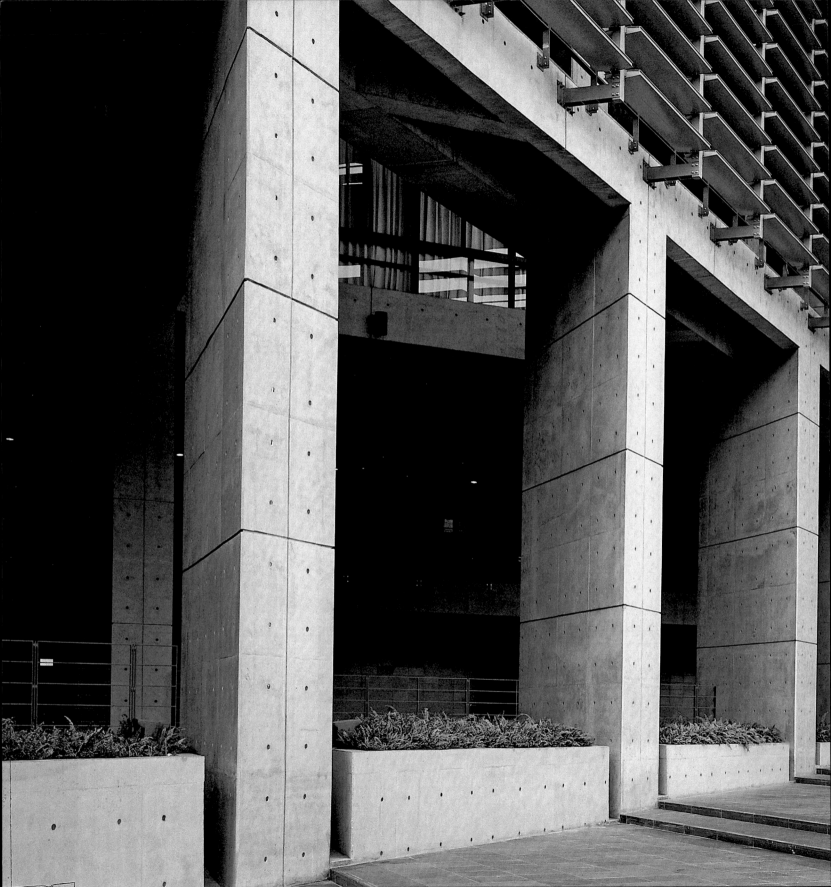

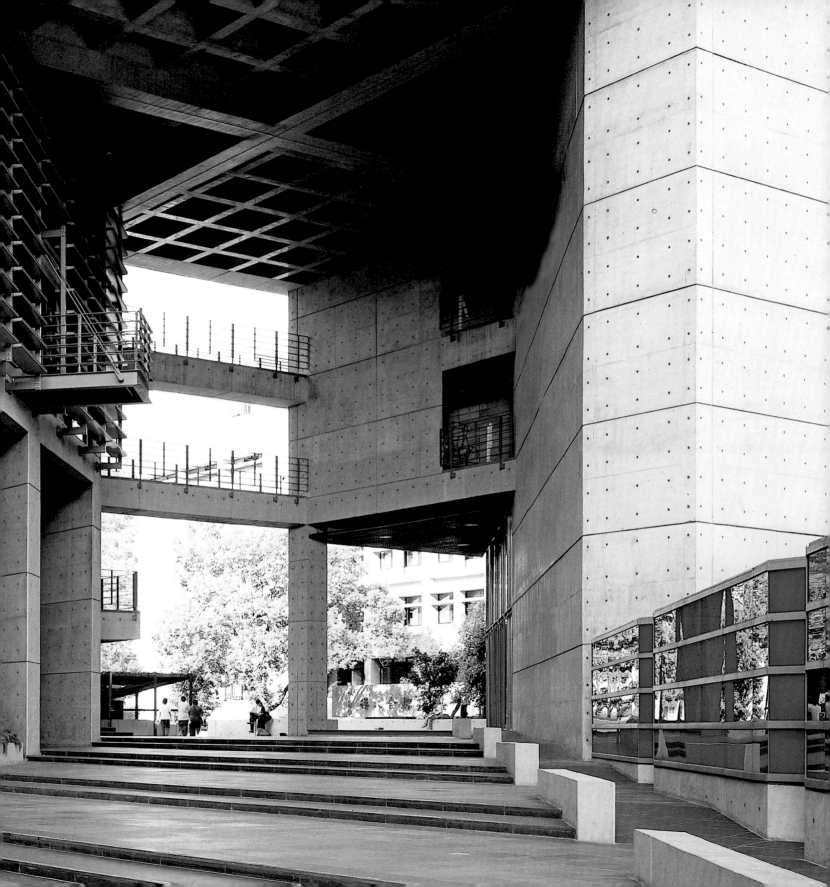

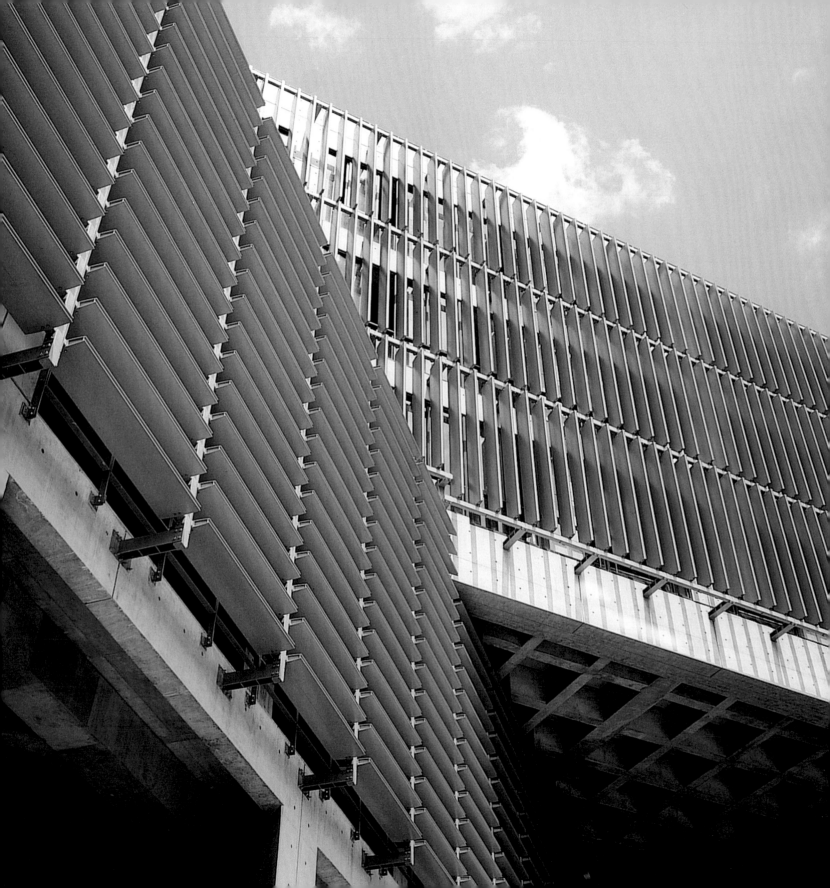

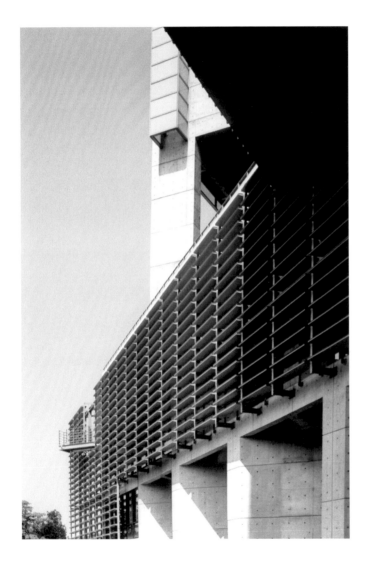
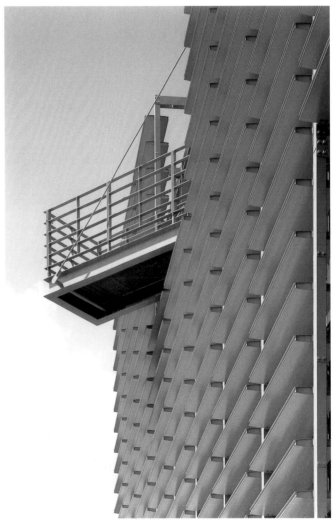

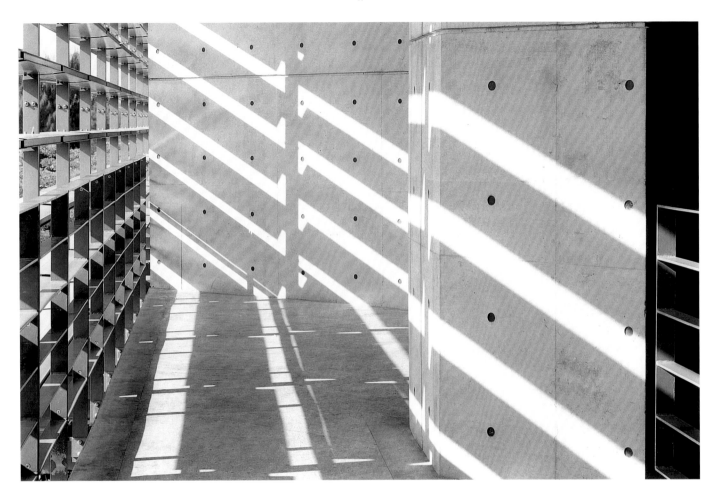

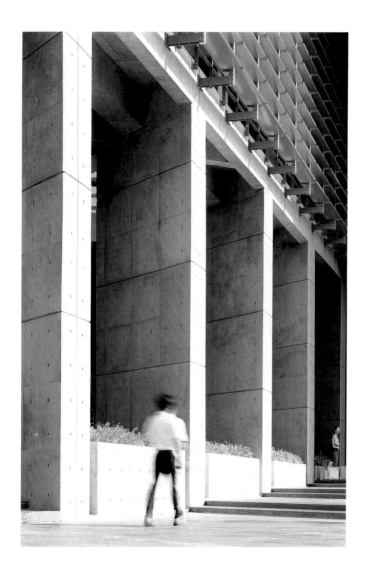
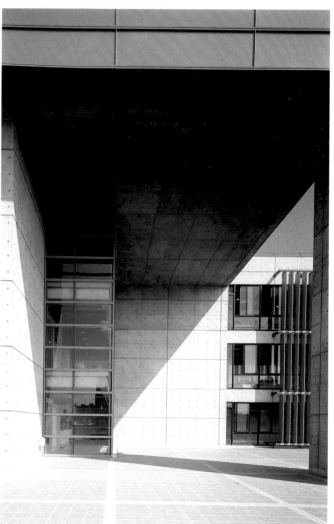

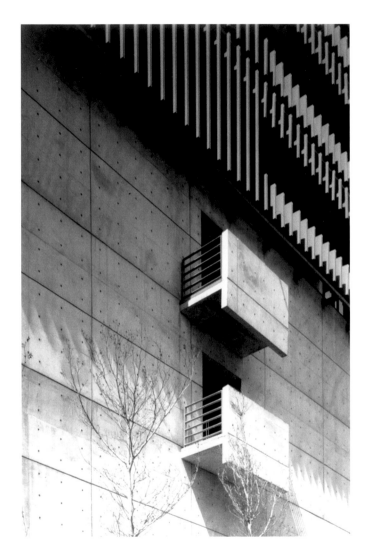
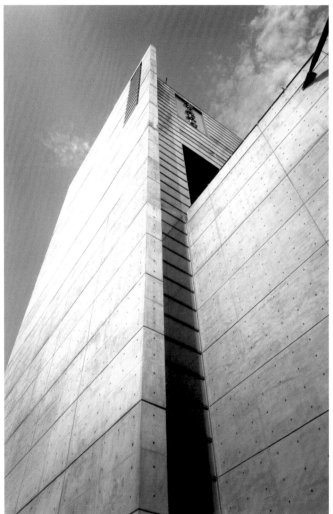

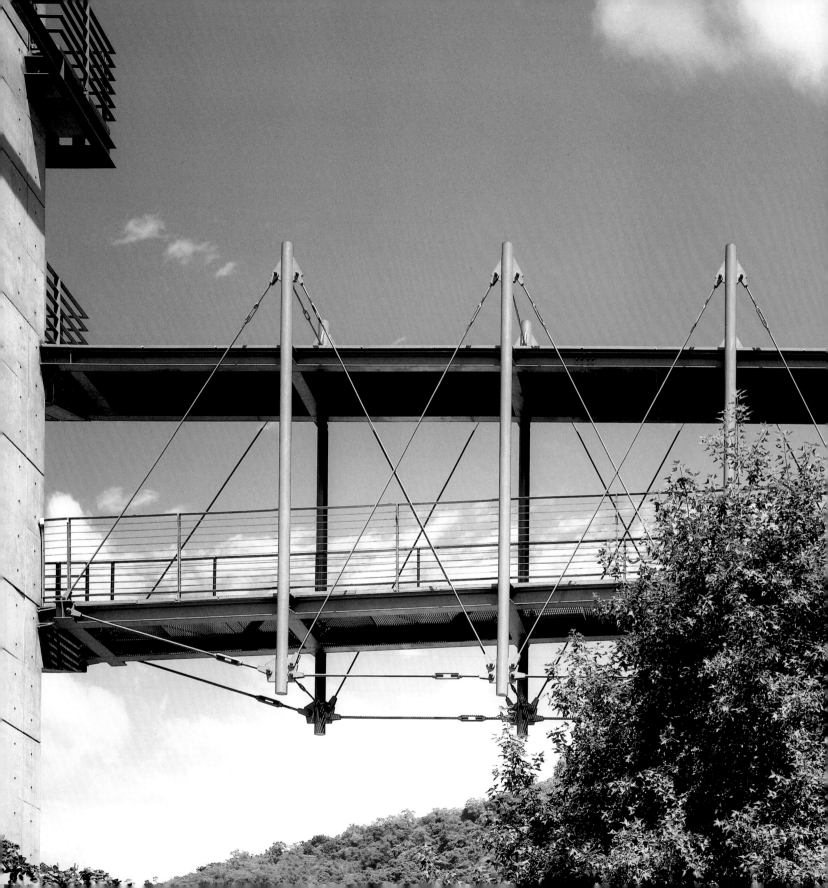

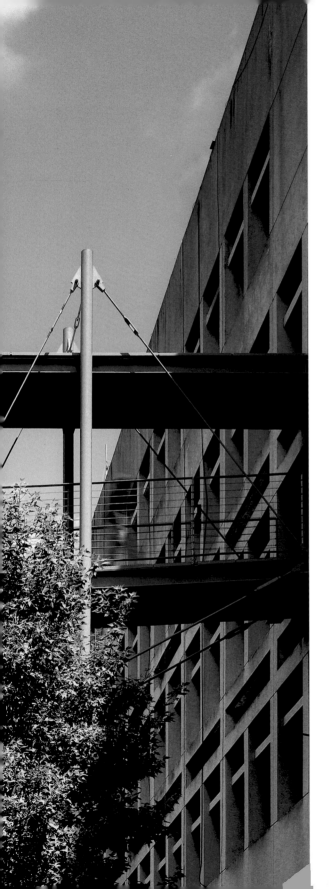

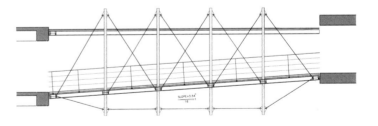

1

1 DETAIL OF SKY BRIDGE

OPPOSITE PAGE THE SKY BRIDGE CONNECTING TO ADJACENT BUILDING

Inside out: the exposed stairways open up the internal spaces, creating vertical connections with visibility in this otherwise dense city center school.

FU SHIN SCHOOL
Taipei Fuhsing Private School

With nearly 3,000 students in an approximately 10,000-square-meter site, the Fu Shin School is densely packed to accommodate K–12 programs. It is located in an upscale central urban area with a beautiful tree-lined boulevard to its east and residential areas on its other sides. Instead of a conventional front schoolyard building that differentiates the inside from the outside, ARTECH's plan turns the brick-veneered buildings 90° so that the courtyards are connected to the main boulevard in a continuous flow. As a result, the campus is less congested, creating a sense of openness for the students and the community.

To accommodate all the program requirements, the basements are extensively utilized to house the auditorium/gym, a swimming pool with a health center, a student center with a dining hall, and drop-off and parking spaces. Upper level classrooms, the library, and the administrative offices are arranged around a series of three courtyards, with the taller buildings placed on the north side to allow more sunlight for the activity fields.

The classrooms are distributed with respect to age groups: kindergarten to second grades are located on the lower two levels for easy access to the playing fields, while the high school classrooms are located on the top level with outdoor terraces for their activities. A layer of shared laboratories and common facilities is sandwiched between the high school and middle school levels, and is structurally designed as a Vierendeel truss to allow large openings below for the grand open stairways.

PROJECT DATA

LOCATION
TAIPEI, TAIWAN

FUNCTION
EDUCATIONAL BUILDING

DESIGN / COMPLETION
2000 / 2007

SITE AREA
10,518 M²

GROSS FLOOR AREA
45,474 M²

FLOOR LEVELS
8 FLOORS ABOVE GROUND, 3 FLOORS BELOW GROUND

STRUCTURE
REINFORCED CONCRETE CONSTRUCTION

MATERIALS
CLEAR FLOAT GLASS, RED GAGGED BRICK, WASH PEBBLE

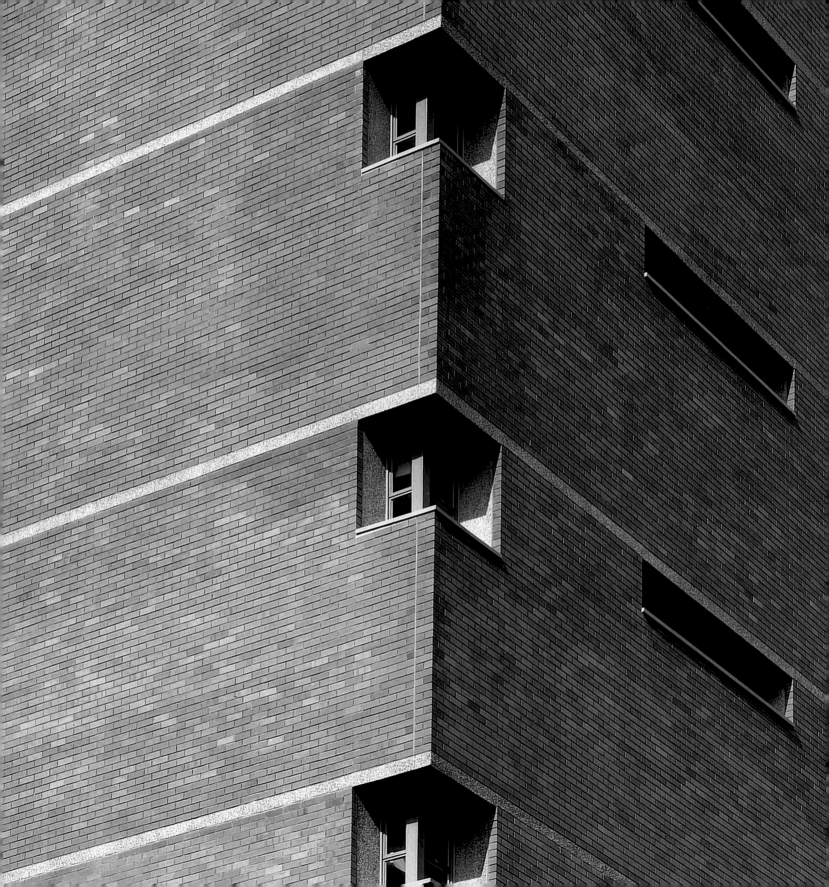

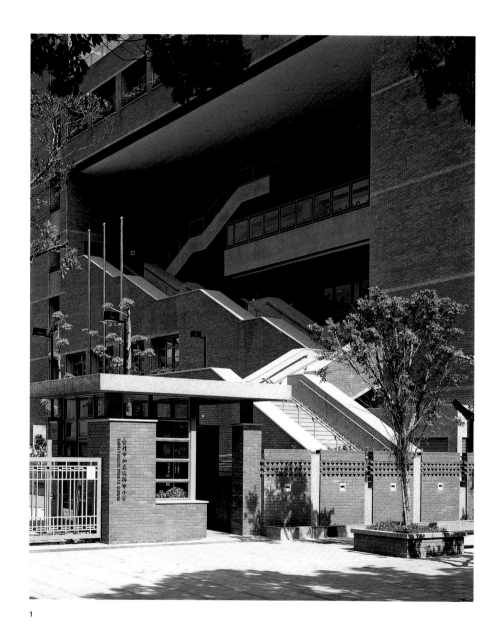

1

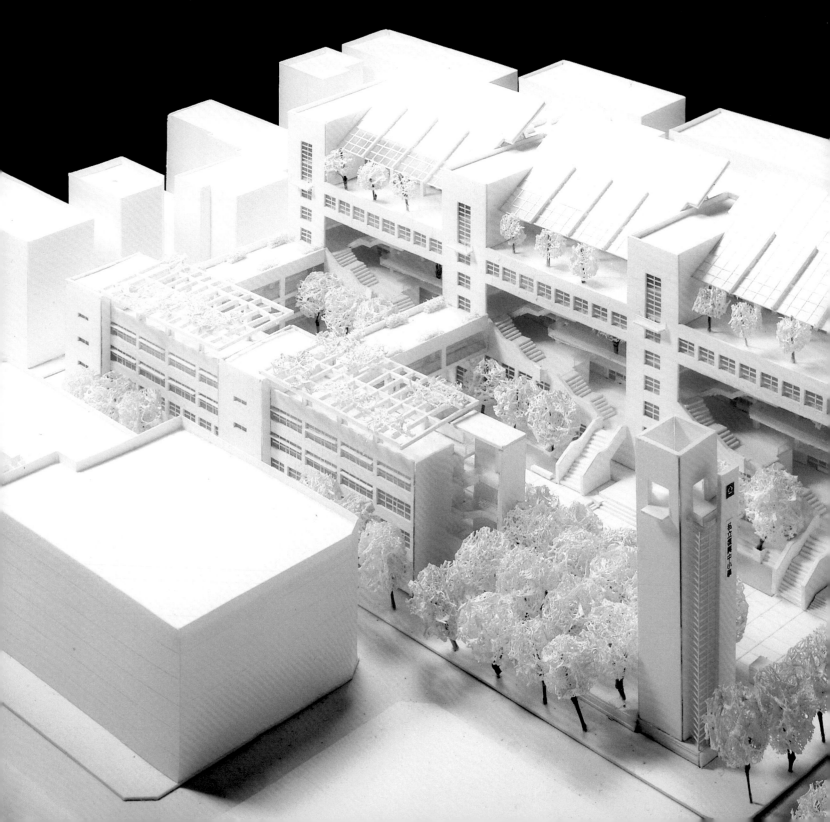

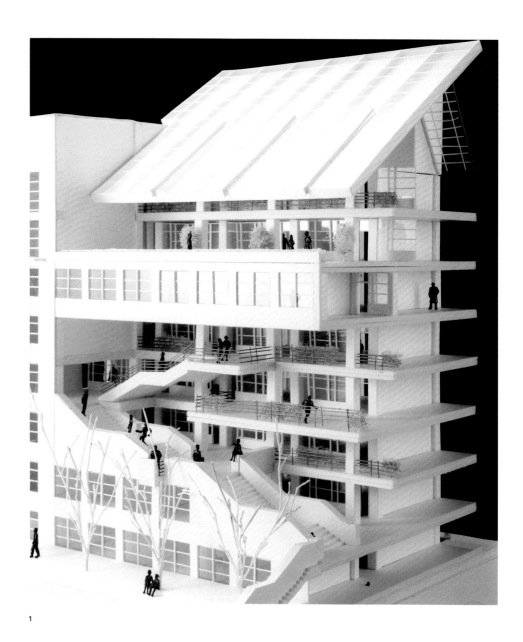

1

1 MODEL, UNIT SECTION
OPPOSITE PAGE MODEL, AERIAL VIEW

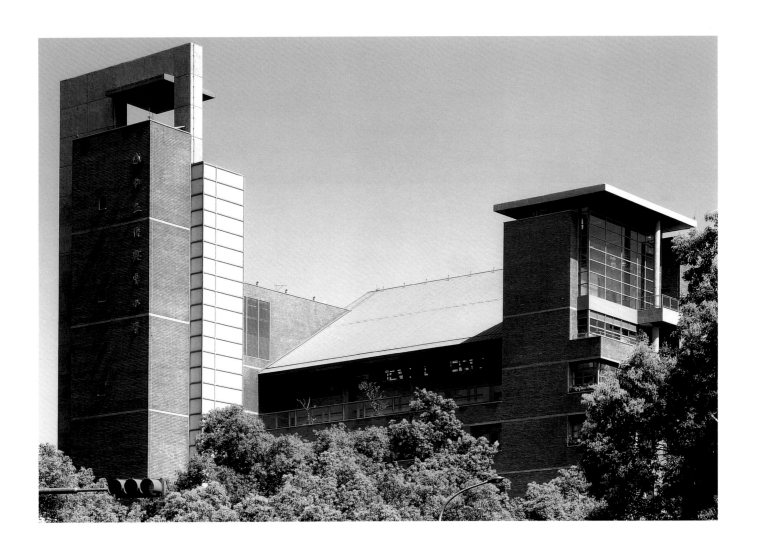

1 GROUND FLOOR PLAN
2 EAST ELEVATION

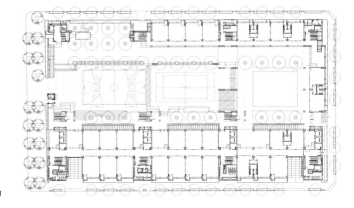

1

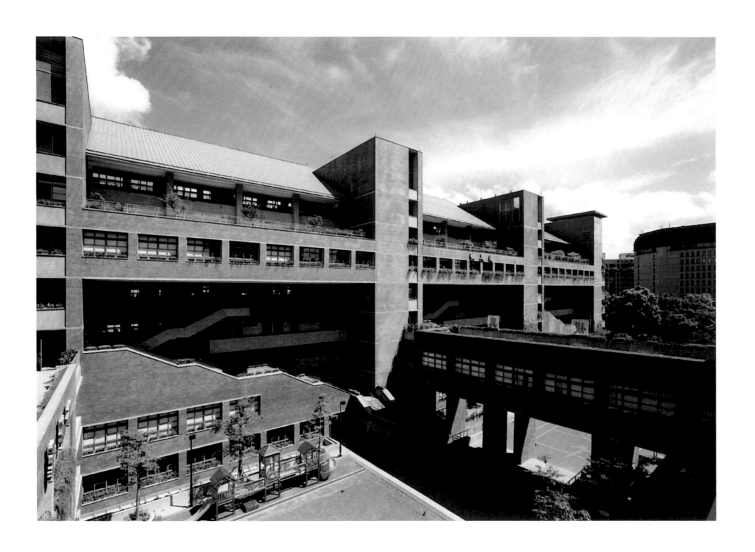

2

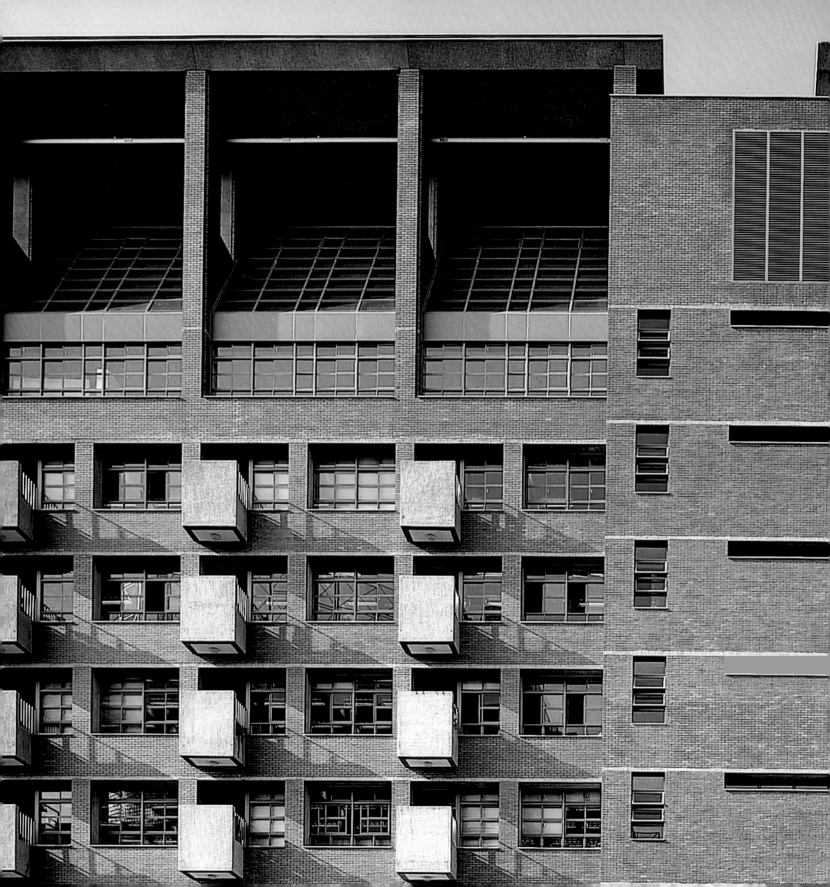

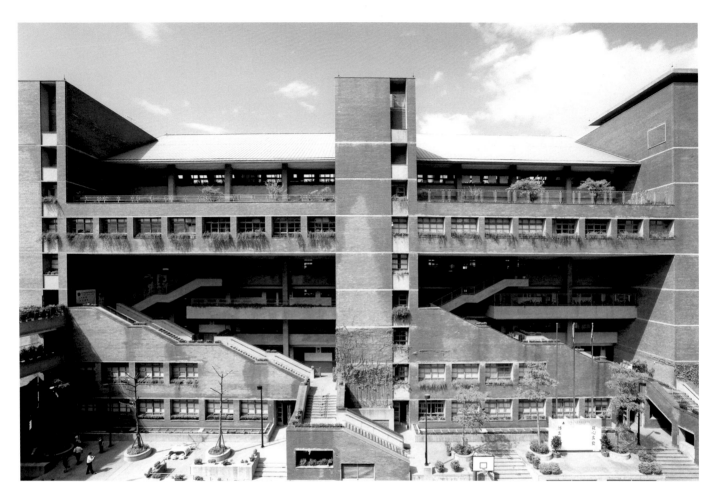

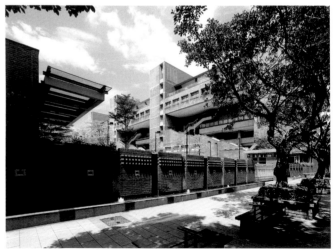

1 SIDEWALK IN FRONT OF MAIN ENTRANCE 1

A kaleidoscope.

GUANG REN CATHOLIC ELEMENTARY SCHOOL

Guan Ren Catholic Elementary School

This school with a substantial history was unfortunately cut into three irregular pieces of property by the city's recent zoning plan. These new streets jam together at odd angles, creating an unsettling urban juncture. To reconnect the separated campus and renovate the school, the design proposed a carefully placed L-shaped building and a footbridge diagonal to the main street, anchoring the chaotic urban fabric with a clear and dominant order.

The basement underneath the playground houses the gym and auditorium, allowing more open space above ground. The classrooms are designed to face east in order to minimize the impact of noise pollution from the streets. The south side of campus offers a new entrance, vertical circulation, and a connection to the footbridge.

The exterior wall is designed with milk-white gravel, anodized aluminum trims, and perforated aluminum louvers that provide shading and ventilation while also accentuating the façade. The classroom walls facing the outdoor field are painted in multiple colors to resemble kaleidoscope patterns.

PROJECT DATA

LOCATION
TAIPEI, TAIWAN

FUNCTION
EDUCATIONAL BUILDING

DESIGN / COMPLETION
2002 / 2005

SITE AREA
4,735 M²

GROSS FLOOR AREA
9,661 M²

FLOOR LEVELS
6 FLOORS ABOVE GROUND, 2 FLOORS BELOW GROUND

STRUCTURE
STEEL FRAME AND CONCRETE CONSTRUCTION

MATERIALS
COLORED LAMINATED GLASS, GLASS MOSAIC TILE, EPOXY RESIN PAINT, PERFORATED ALUMINUM PANELS

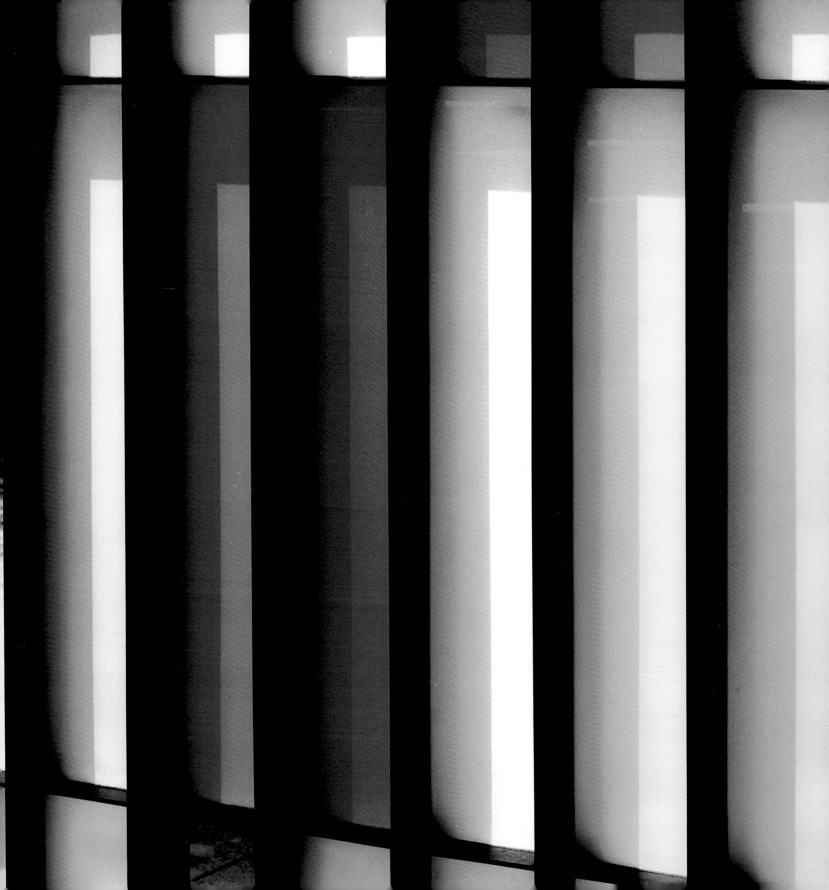

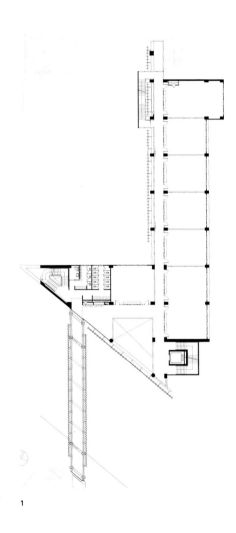

1 SECOND FLOOR PLAN

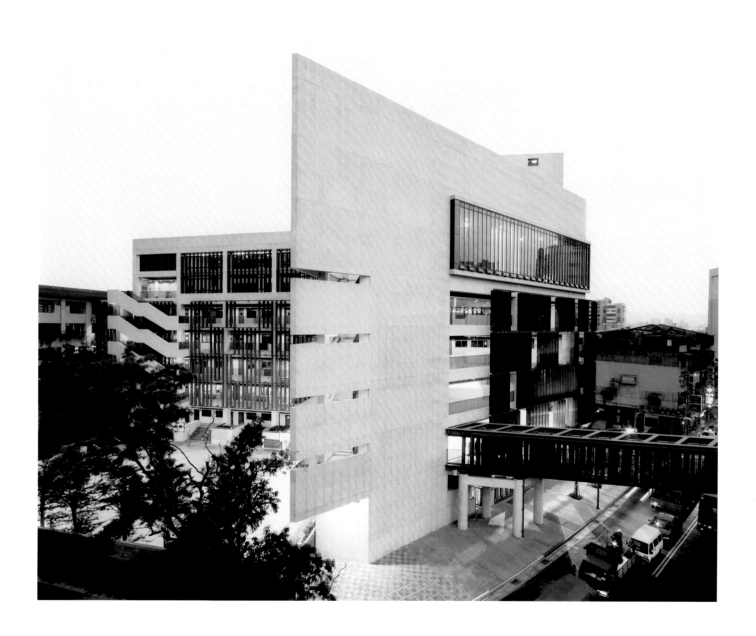

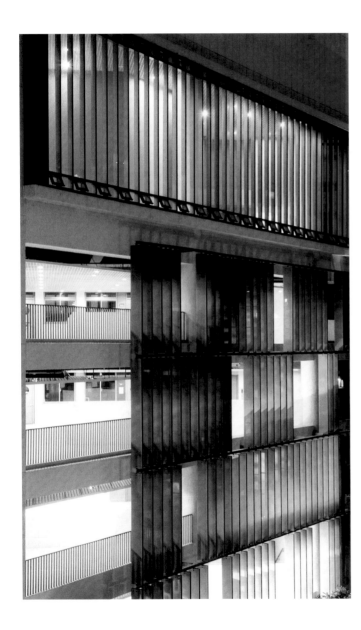
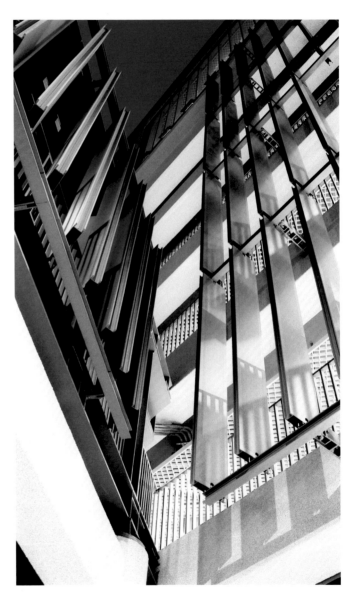

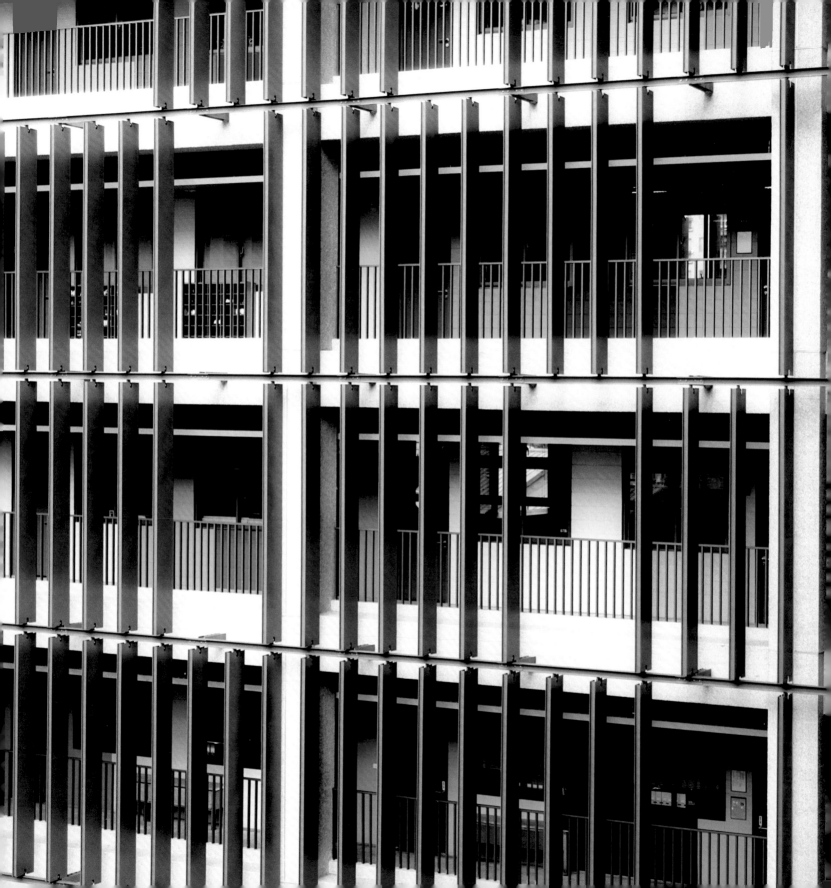

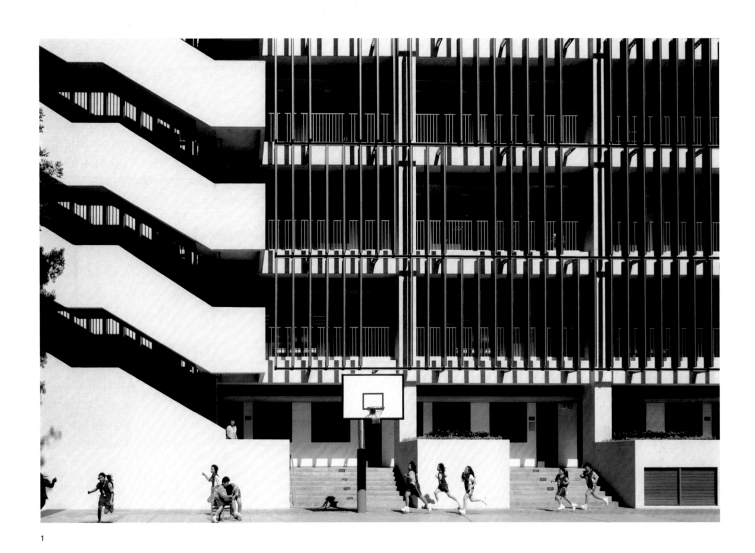

1

1 PLAYGROUND
OPPOSITE PAGE DETAIL OF FAÇADE

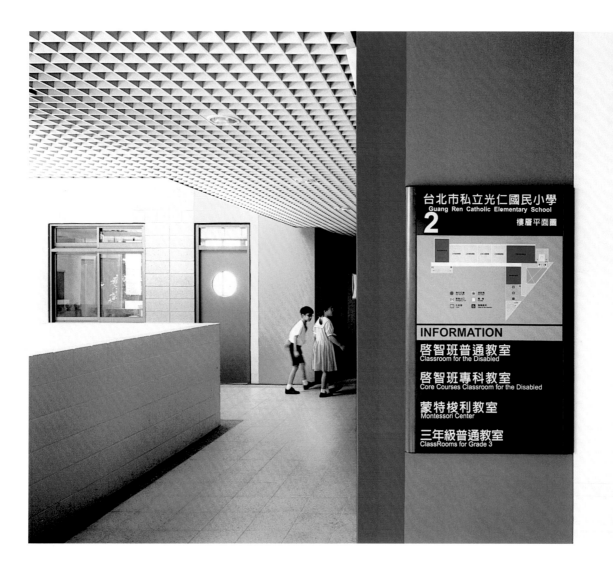

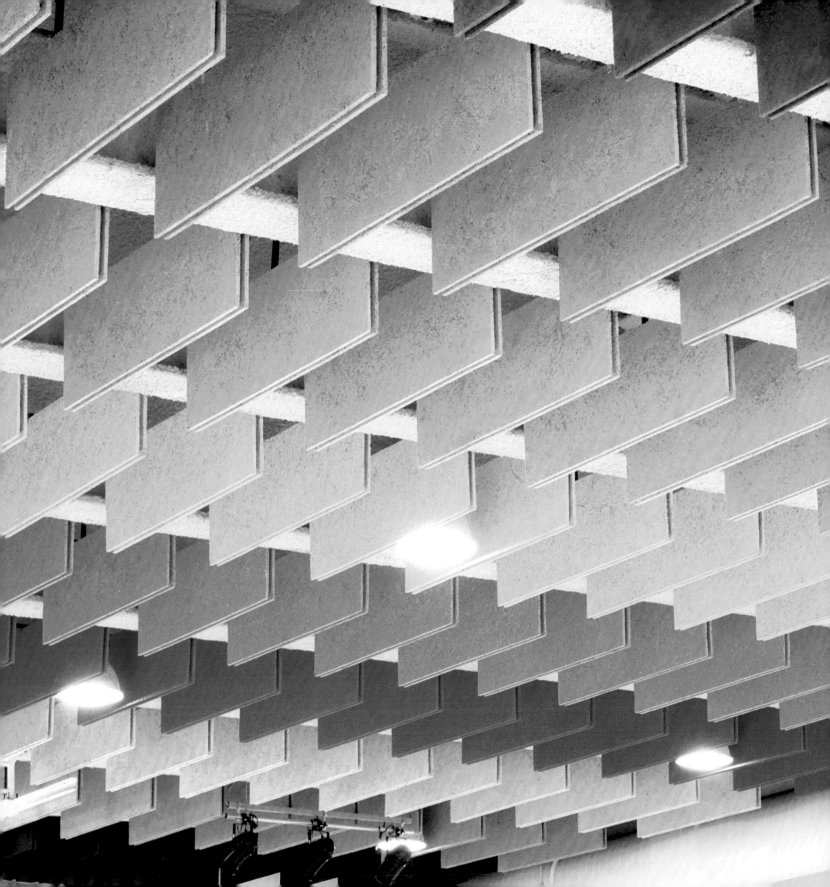

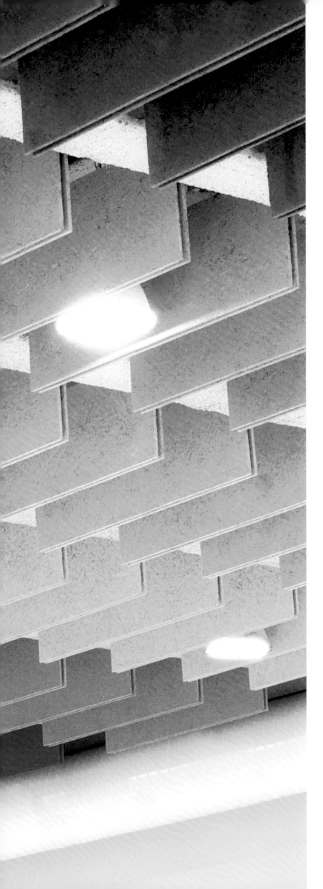

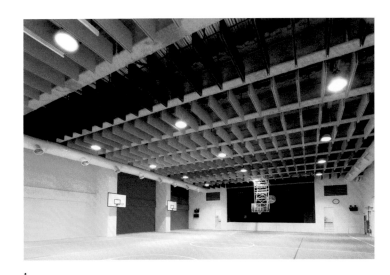

1

A wooden box in the forest perceived from outside, a tranquil courtyard seen from inside, and a series of colorful rooms complete the private domain.

CHIAO TUNG UNIVERSITY GUEST HOUSE
National Chiao Tung University

Located on a slope adjacent to the north gate of the main campus and kept under nine meters in height, the university Guest House sits quietly in the midst of pine woods, camouflaged as a simple floating box with random openings, folded surfaces and a teak façade.

Visitors enter from underneath the wooden box to encounter a tranquil courtyard carved out from the cube. The courtyard is white with a square pond in the middle and a bamboo landscape around its edges. It reflects the sky and transmits serenity into this natural setting.

In the guestrooms, strong colors are applied on the ceiling, walls, and floors of the private quarters. Personal-scaled windows are placed strategically for guests to view the pine woods. They are a mixture of vertical and horizontal orientations, and they serve to connect the guests to the natural scenery outside.

PROJECT DATA

LOCATION
HSINCHU, TAIWAN

FUNCTION
GUEST HOUSE

DESIGN / COMPLETION
2003 / 2007

SITE AREA
2,450 M²

GROSS FLOOR AREA
3,100 M²

FLOOR LEVELS
3 FLOORS ABOVE GROUND, 1 FLOOR BELOW GROUND

STRUCTURE
REINFORCED CONCRETE CONSTRUCTION

MATERIALS
ALUMINUM PANELS, CLEAR FLOAT GLASS, TEAKWOOD, WASH PEBBLE

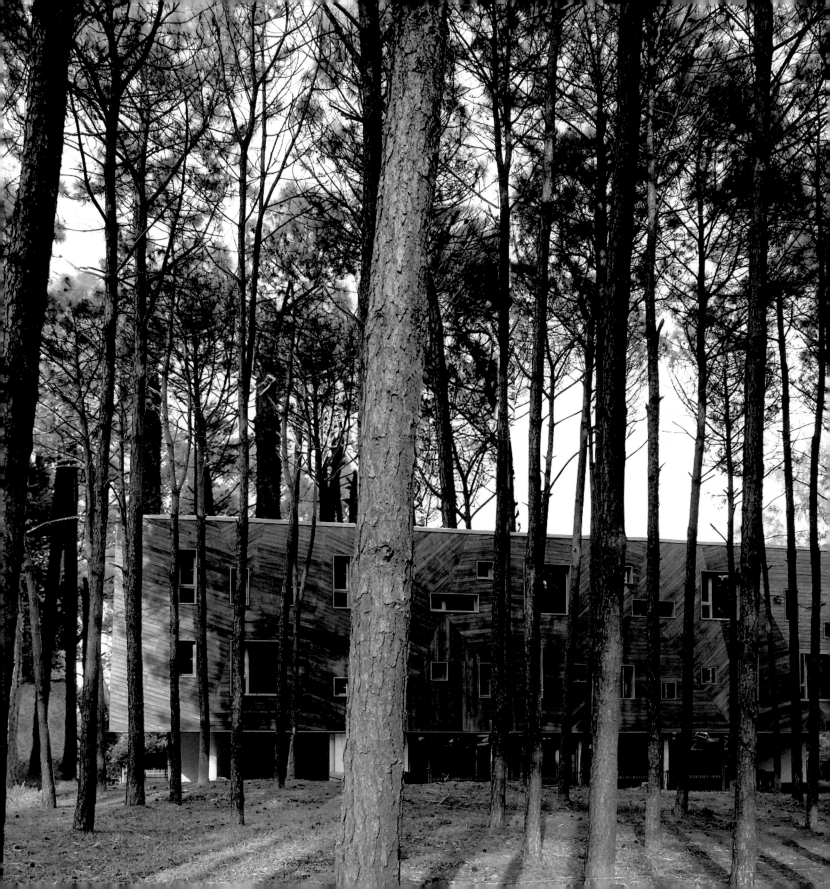

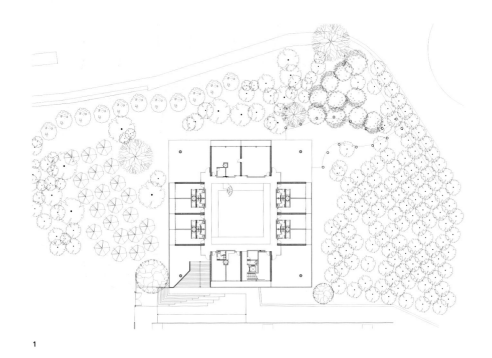

1

1 GROUND FLOOR PLAN

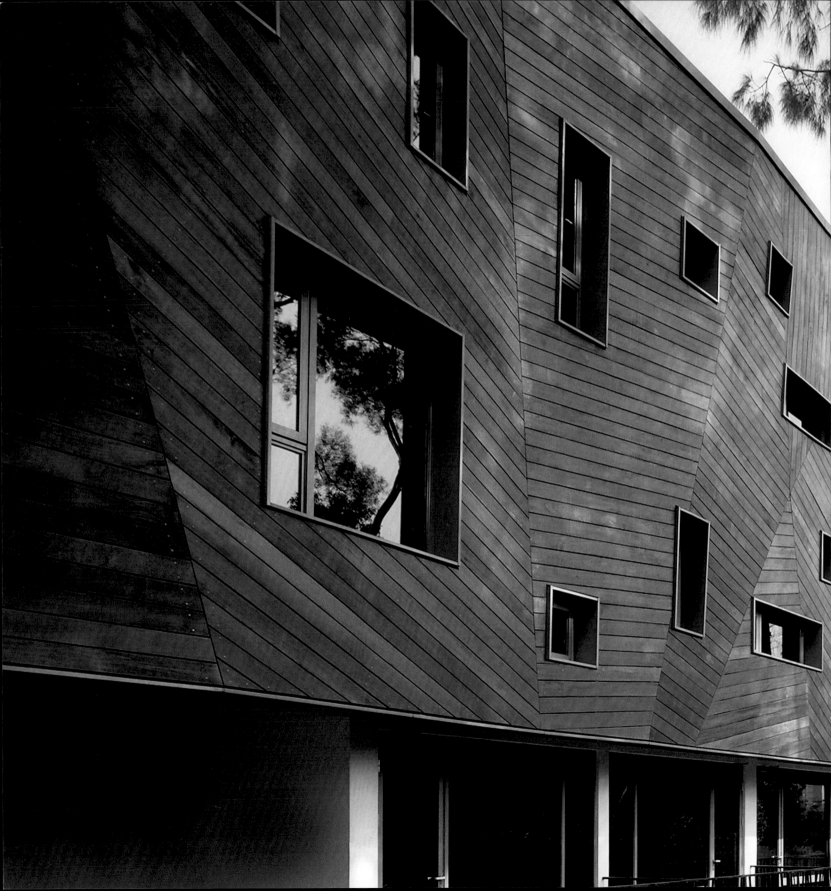

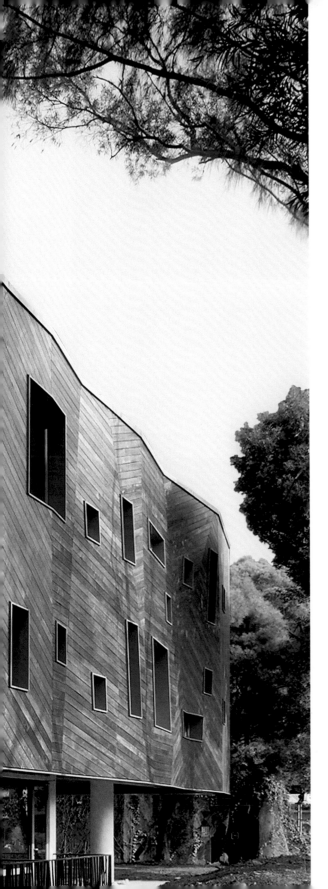

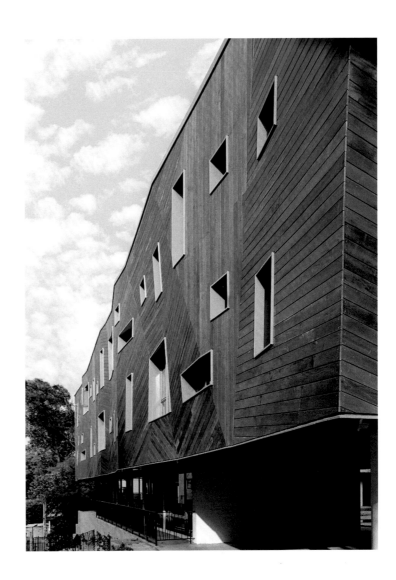

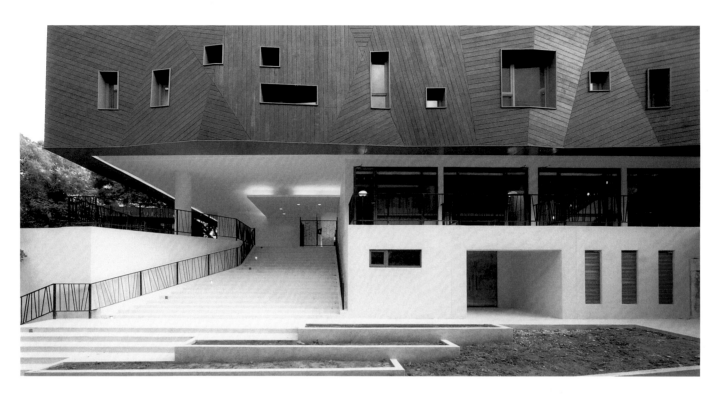

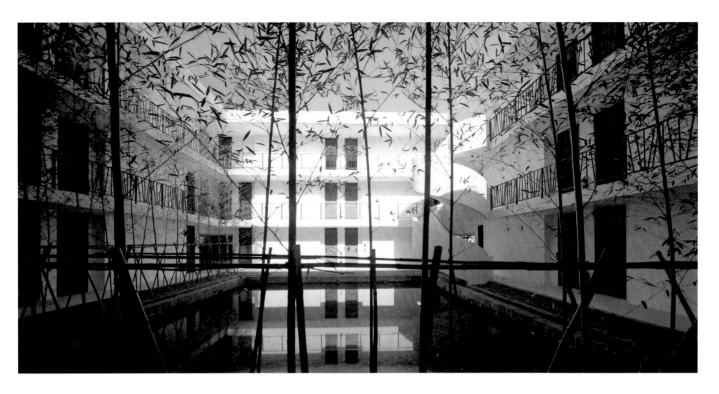

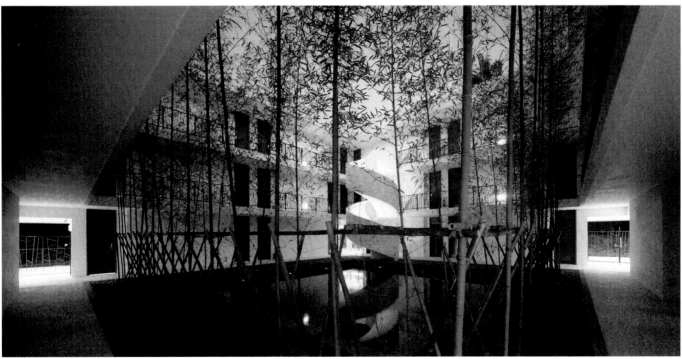

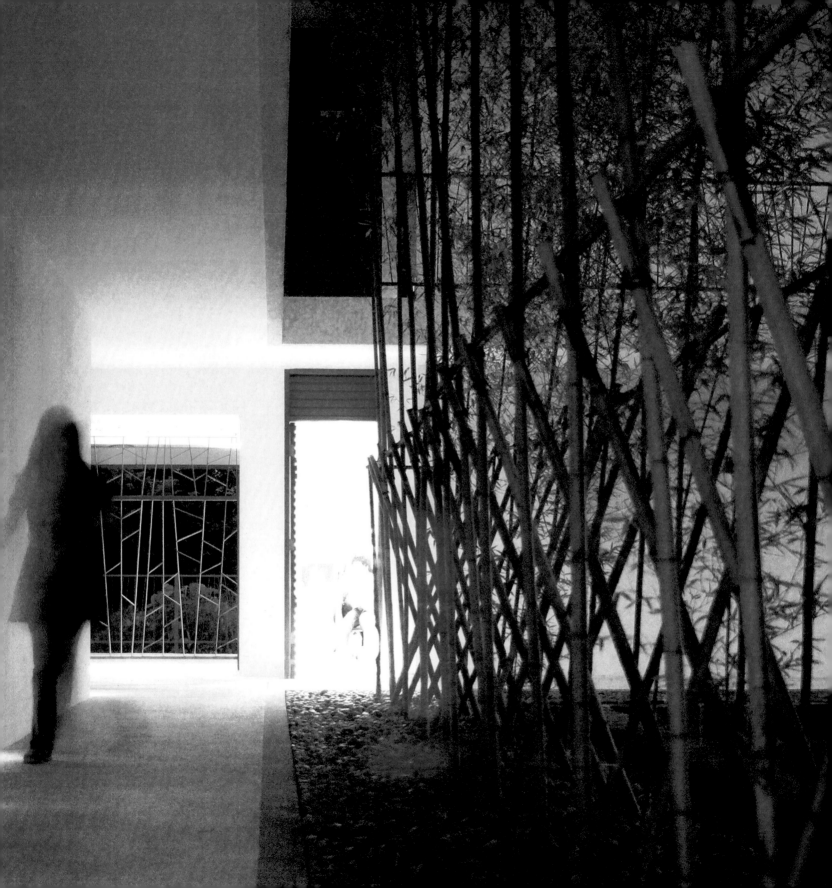

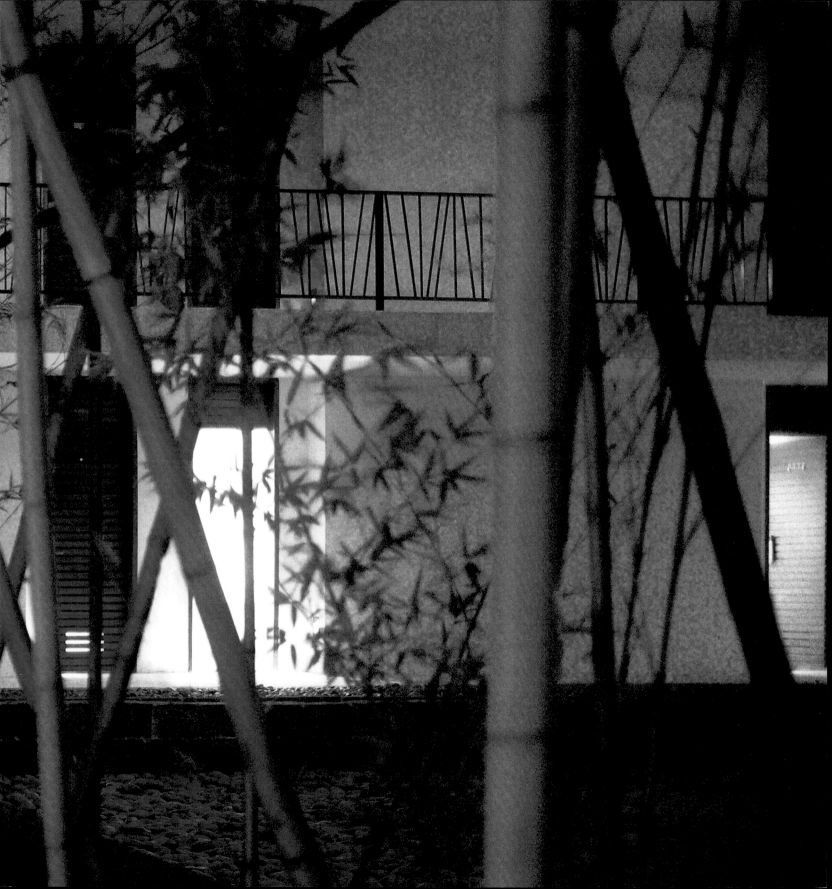

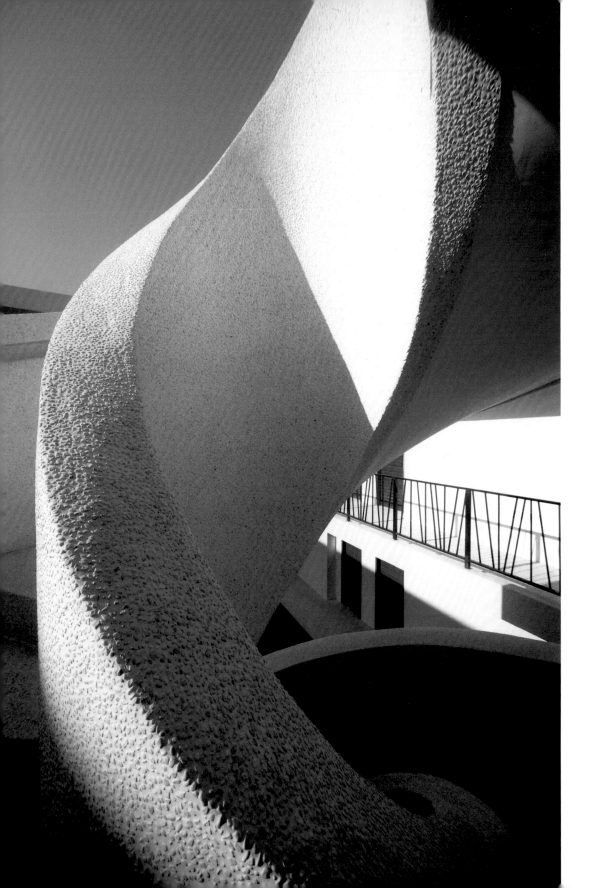

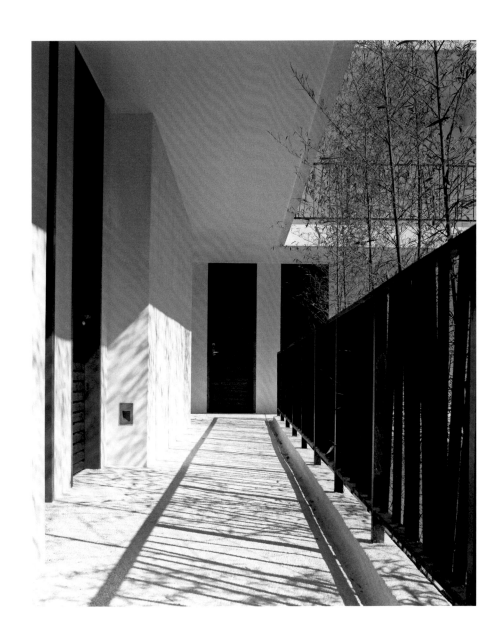

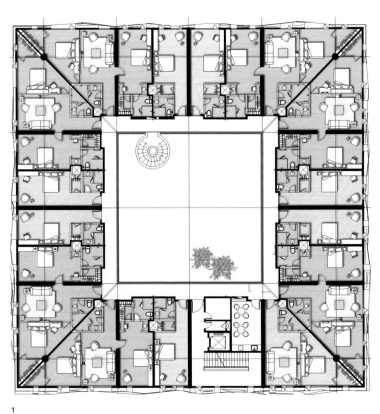

1

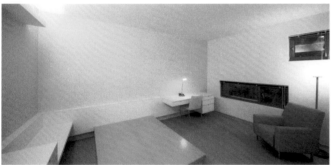

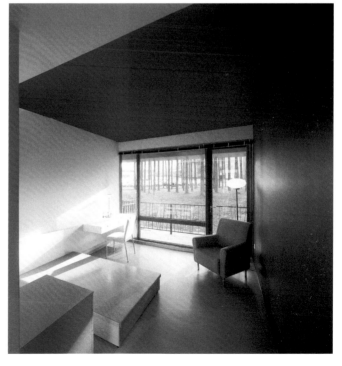

1 FURNITURE LAYOUT PLAN
ABOVE IMAGES INTERIOR OF GUEST HOUSE

A dialogue between a space of silence and a space for activity.

SHIH CHIEN UNIVERSITY GYMNASIUM AND LIBRARY

Shih Chien University

After the completion of the College of Design, the university proceeded to collaborate with ARTECH on new projects including a library, gymnasium, and a cultural/conference center on the second quad of this limited urban campus.

The new design preserves existing open space and turns it into a landscaped courtyard, placing the library and gymnasium on either end to facilitate interaction with the renovated quad. The library has a double-height space carved out from the façade, and the gymnasium has a large cantilevered terrace. The two buildings both overlook the green courtyard and provide numerous opportunities for gatherings or performances in the vibrant campus. Classrooms, conference facilities, and an auditorium are located underneath the landscaped courtyard along the sky-lit thoroughfare. Although they are located on subterranean levels, ample light from skylights and varied activities from the architectural program help to create a pleasant and lively atmosphere in this weatherproof indoor walkway.

Architecturally, the use of ephemeral materials and a series of void spaces in between maximize the permeability of all the spaces. As a result, one experiences a visual and spatial continuity that blurs the outside and the inside. The use of interlaced metal mesh for the upper gym is a prime example: from the inside, the space extends to the courtyard and the mountains beyond; from the outside, one sees the silhouettes of students playing in the gym with a visual effect that is almost illusory.

PROJECT DATA

LOCATION
TAIPEI, TAIWAN

FUNCTION
EDUCATIONAL BUILDING

DESIGN / COMPLETION
2003 / 2009

SITE AREA
42,132 M²

GROSS FLOOR AREA
26,989 M²

FLOOR LEVELS
5 FLOORS ABOVE GROUND, 2 FLOORS BELOW GROUND

STRUCTURE
STEEL FRAME AND REINFORCED CONCRETE CONSTRUCTION

MATERIALS
ARCHITECTURAL CONCRETE, CLEAR FLOAT GLASS, EXTRUDED ALUMINUM LOUVERS, STAINLESS STEEL NET

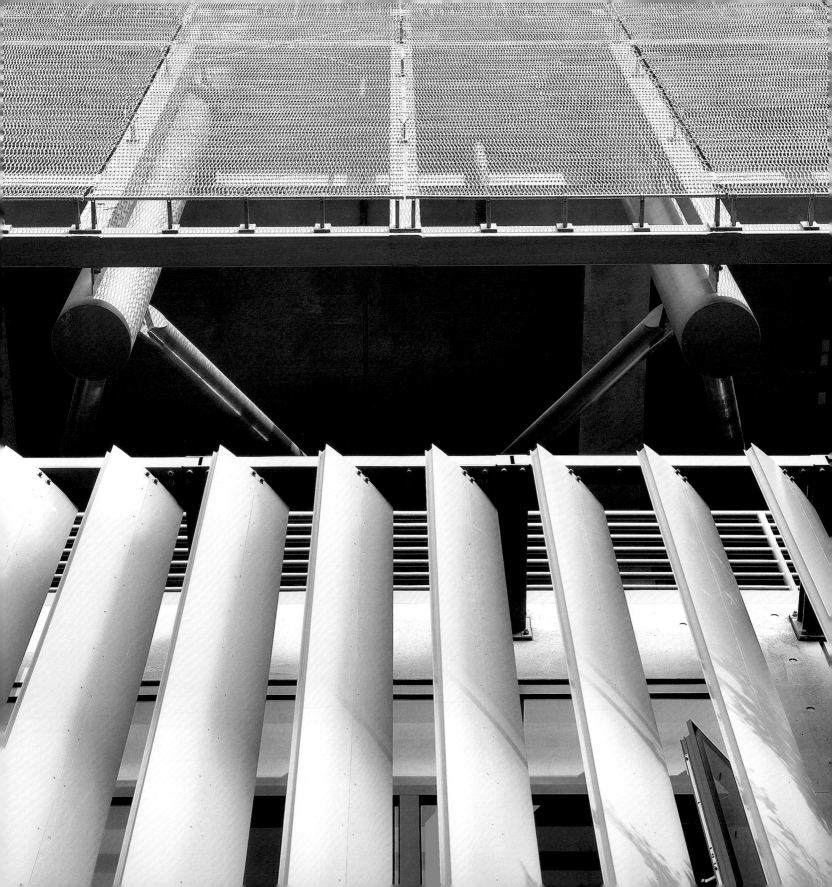

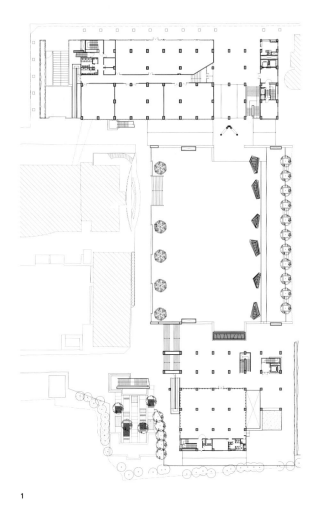

1

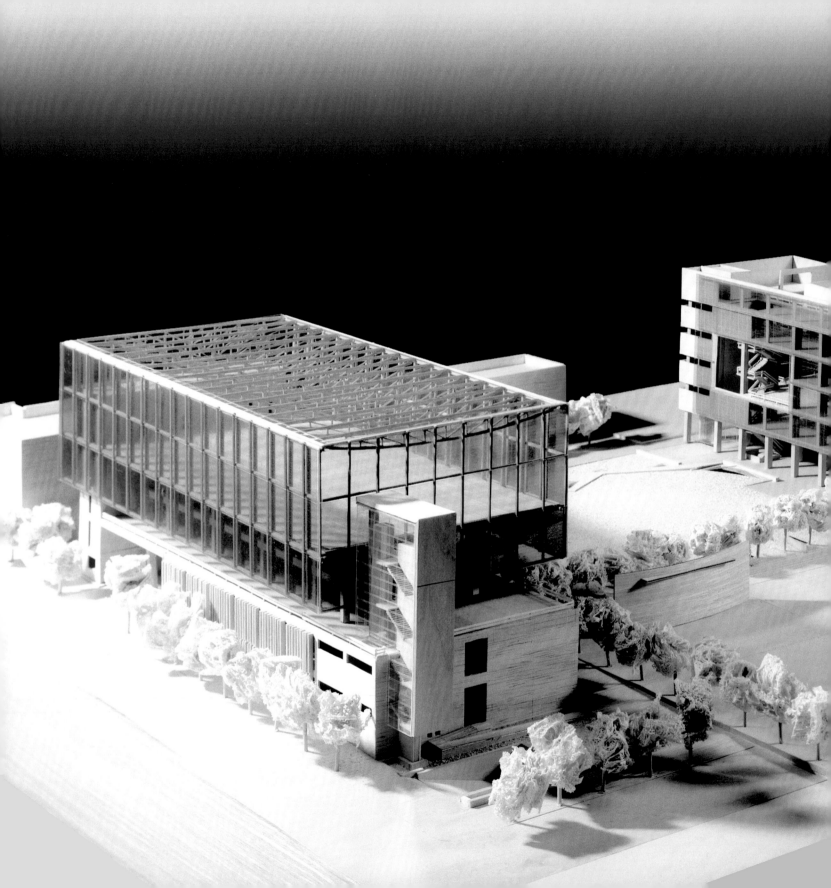

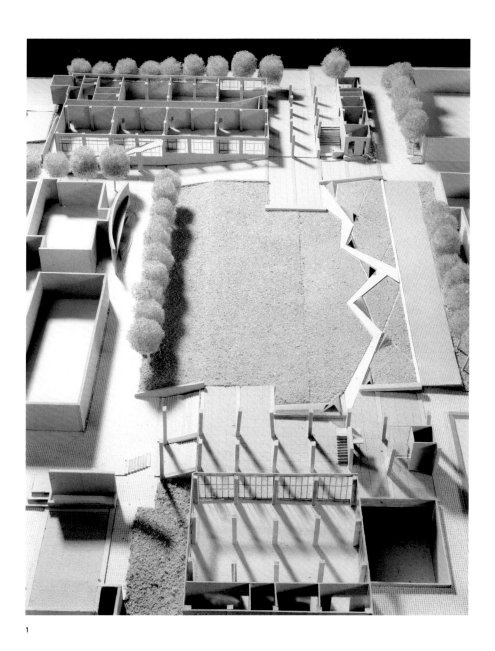

1

1 MODEL, GROUND FLOOR
OPPOSITE PAGE MODEL, AERIAL VIEW

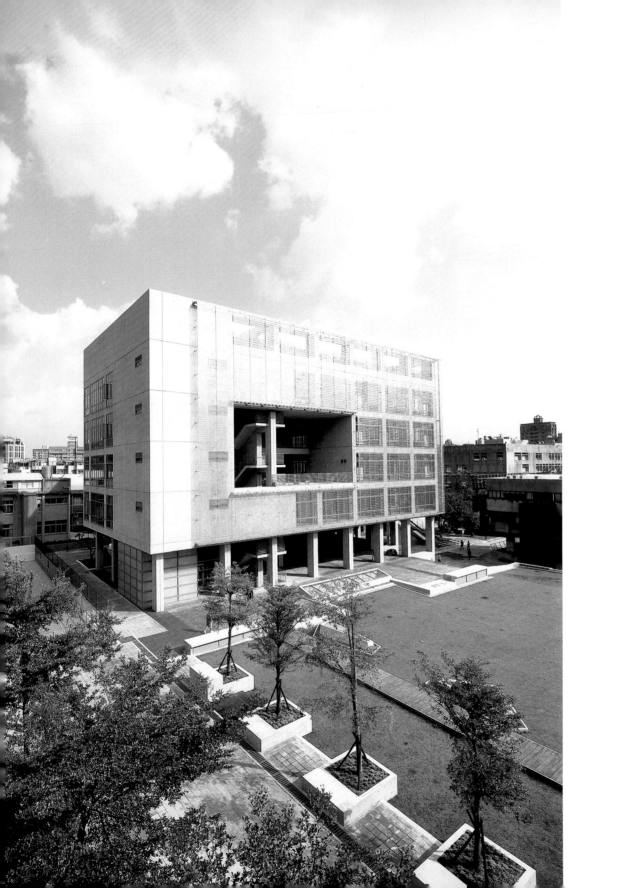

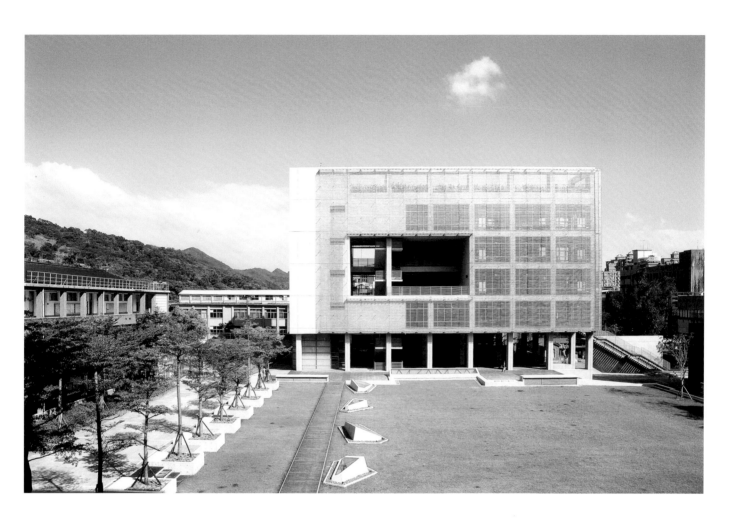

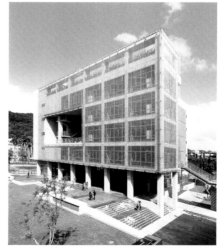

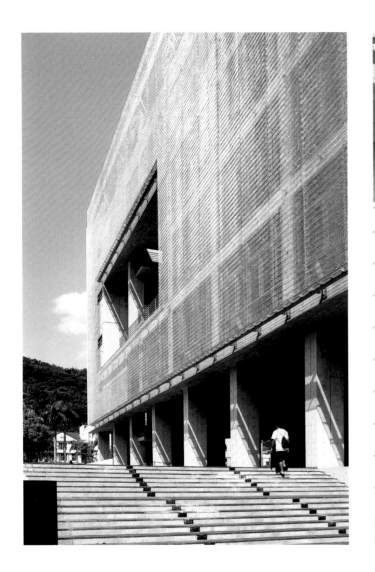
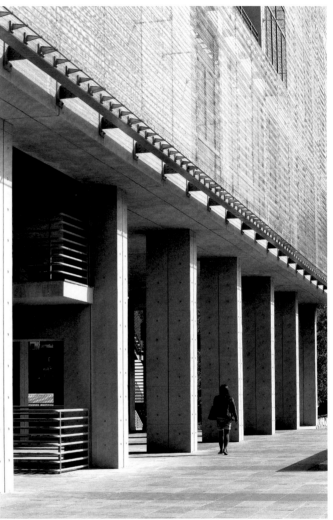

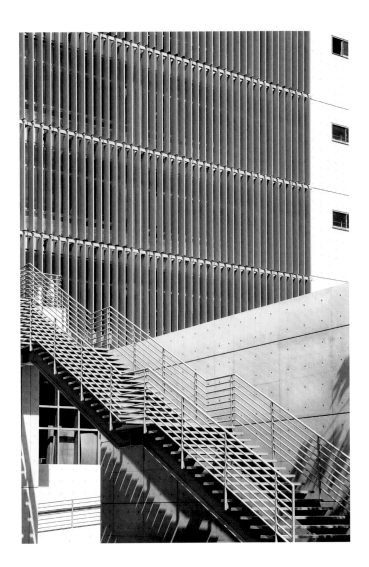

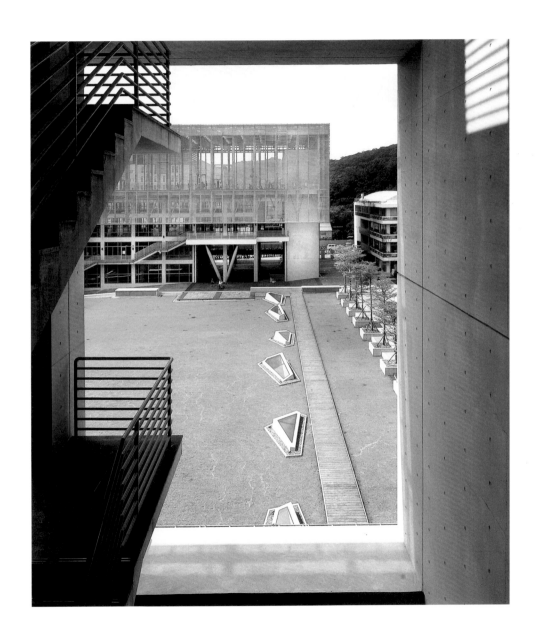

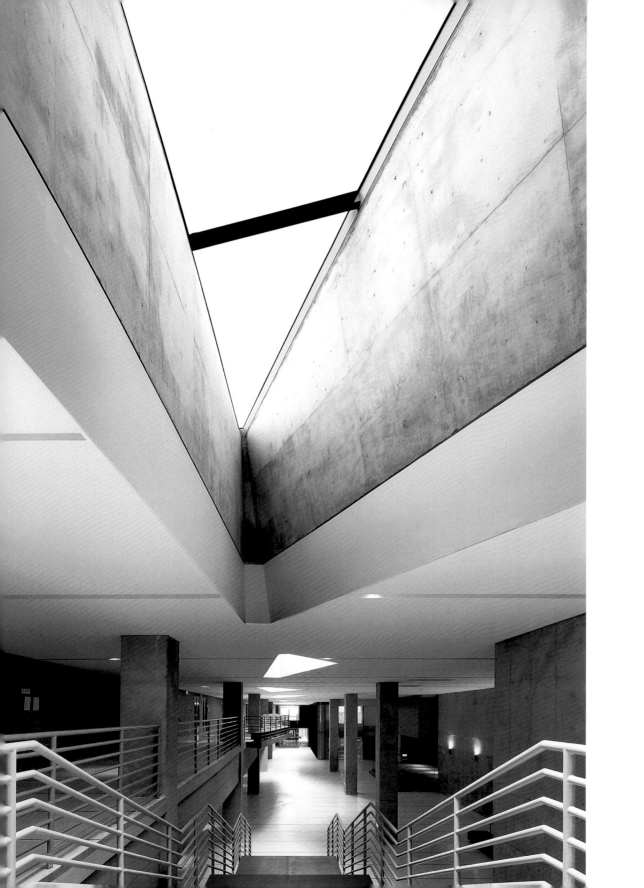

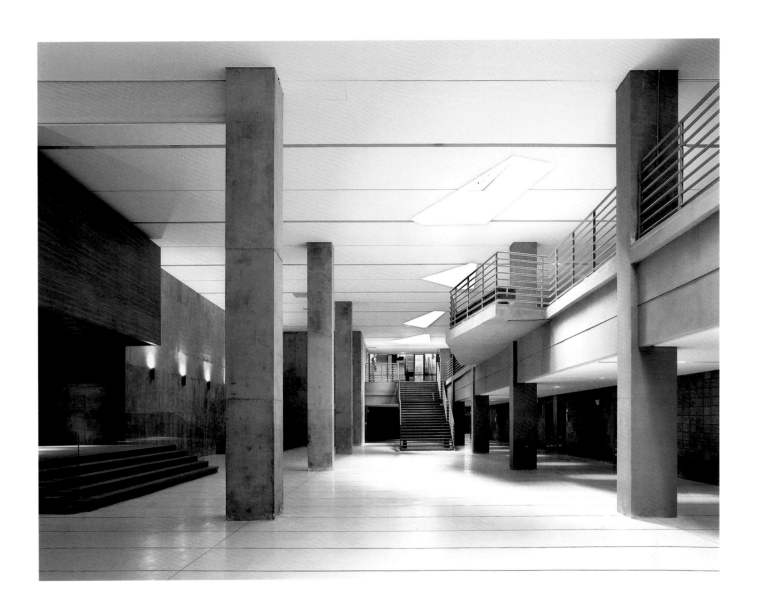

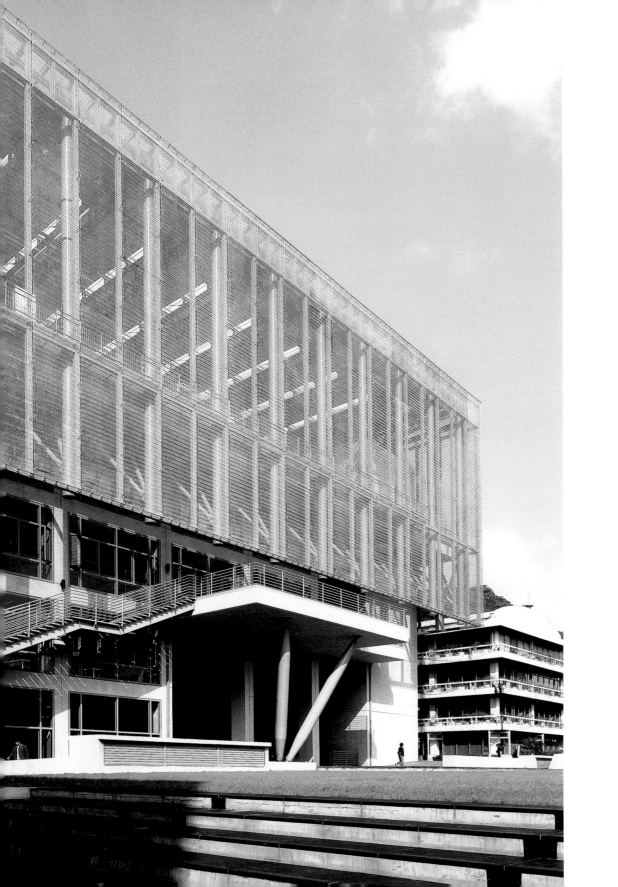

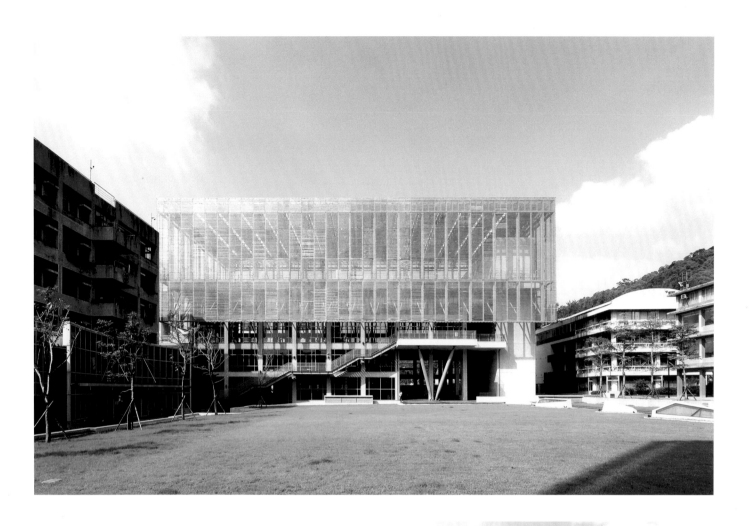

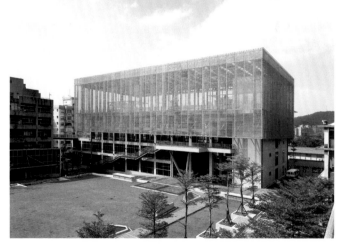

ALL IMAGES GYMNASIUM

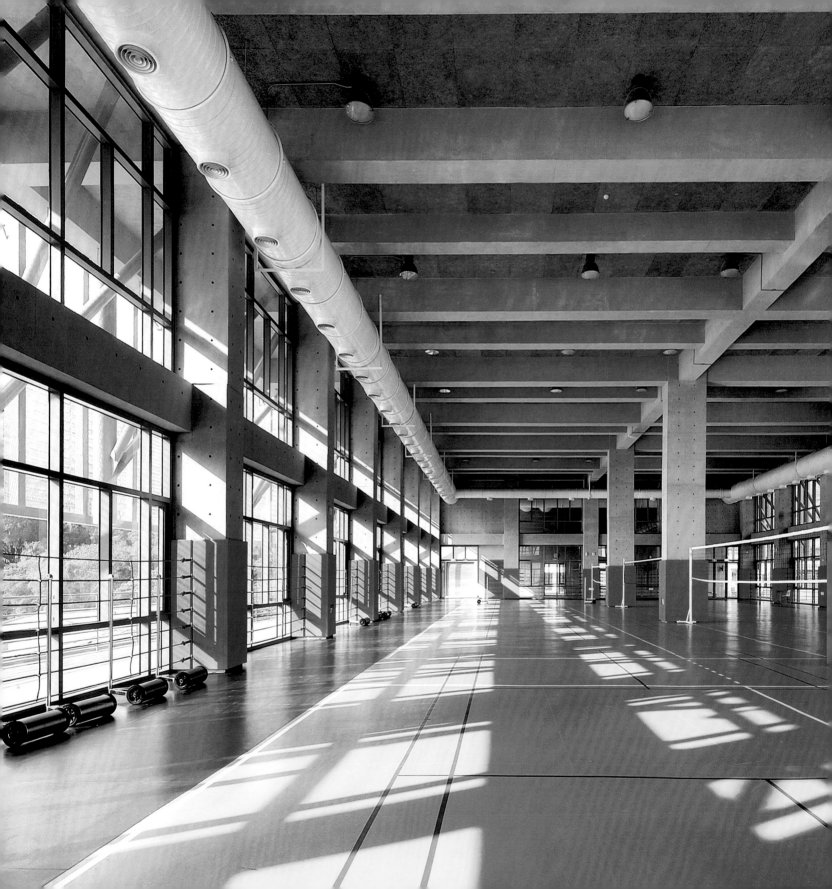

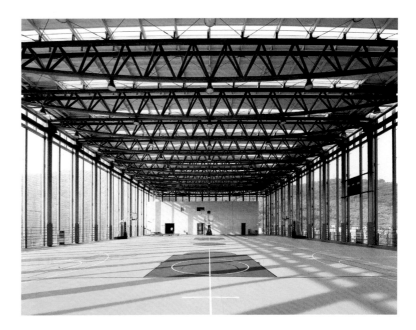

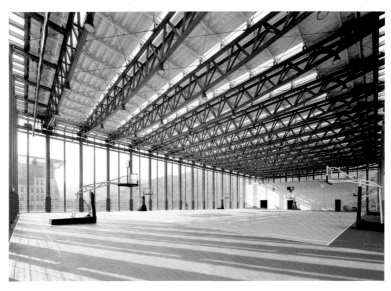

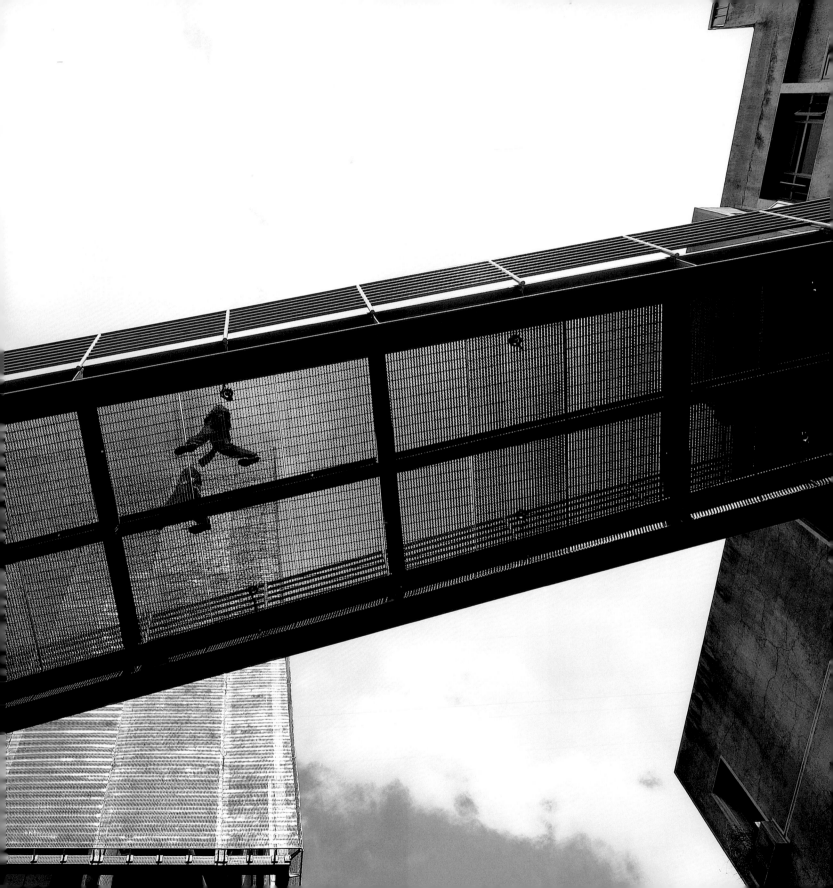

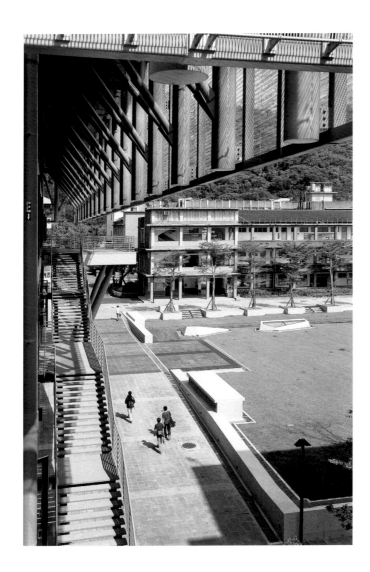
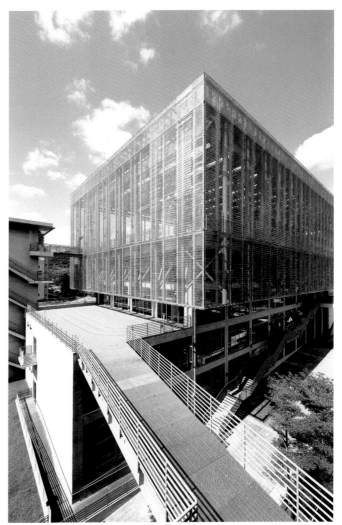

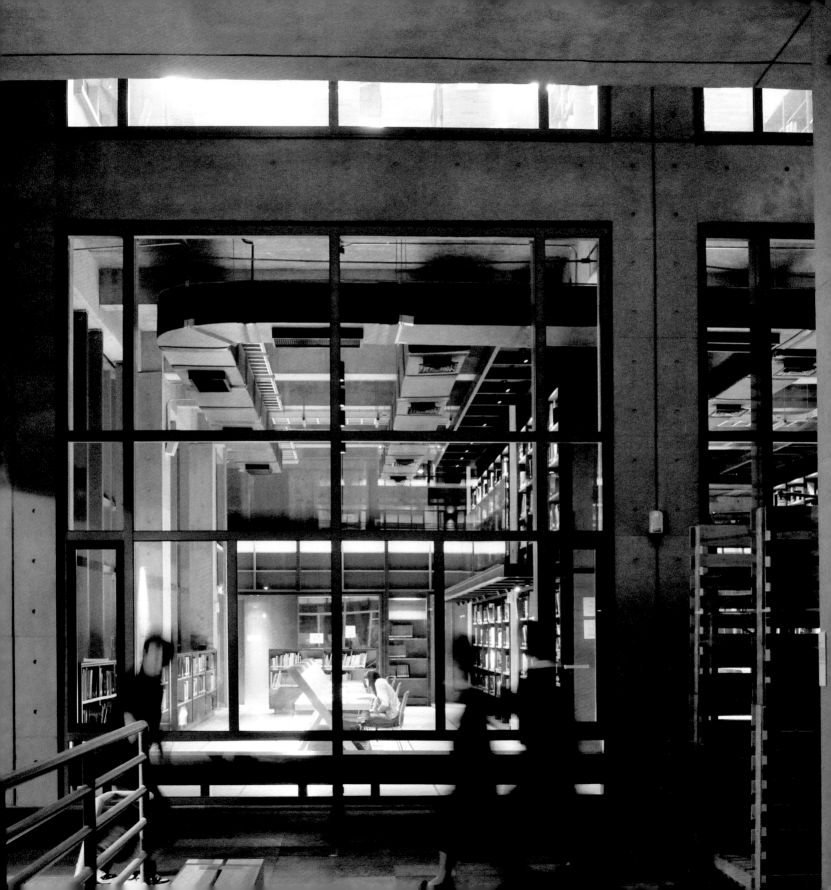

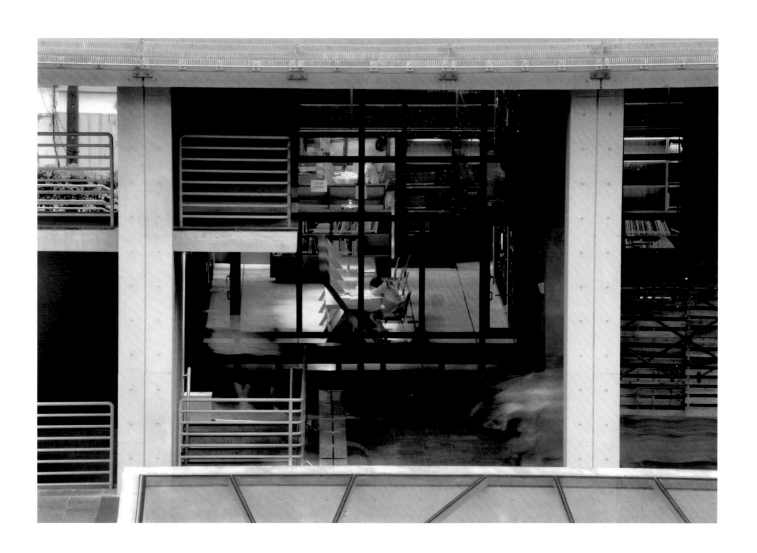

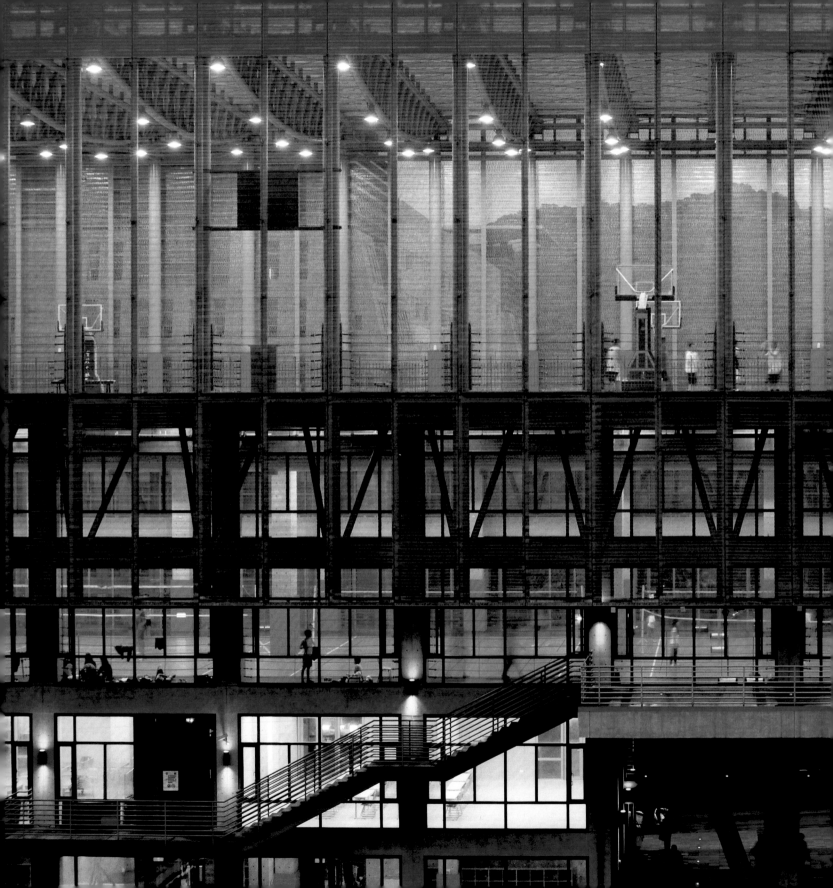

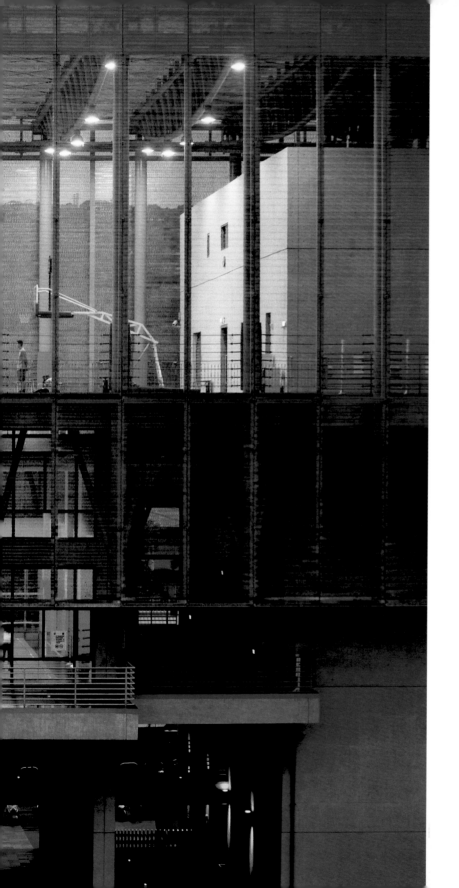

The relocation of the existing university completes itself with a grand quad and a centrally located library as the landmark of the new campus.

KUNMING UNIVERSITY OF SCIENCE AND TECHNOLOGY
Kunming University of Science and Technology

ARTECH was selected as the winning team for the Kunming University of Science and Technology new campus master plan in the southwestern province of Yunnan, China. The new campus planning takes advantage of the sloping site to develop an ecologically friendly campus. The goals of creating an efficient, humanistic, and community-oriented campus are achieved through careful placement of the academic, research, sports, and recreational facilities for the university.

Three major axes run through the campus: the formal east–west axis begins at the entrance plaza and ascends gradually along the natural slope, passing the twin administration buildings and running through the central green quad, finally reaching the main library at the end. The north–south axis is an ecological corridor, connecting all the campus cultural facilities such as the art museum, auditorium, student center, and cafés, with their landform architecture half-hidden in a belt of trees. These two axes meet at a central point where the tallest building, the main library, is located. A third curvilinear axis runs parallel to the contour of the site, accommodating three major departments, each with their own individual facilities of lecture halls, research rooms, offices, classrooms, laboratories, and dormitories.

The extensive use of red brick throughout the campus seeks to emphasize the Yunnan highland's local red earth, and to create a strong visual juxtaposition with the greenery around the site.

PROJECT DATA

LOCATION
KUNMING, CHINA

FUNCTION
EDUCATIONAL BUILDING

DESIGN / COMPLETION
2007 / 2009

SITE AREA
232,788 M²

FLOOR LEVELS
12 FLOORS ABOVE GROUND, 1 FLOOR BELOW GROUND

STRUCTURE
REINFORCED CONCRETE CONSTRUCTION

MATERIALS
ALUMINUM PANELS, CLEAR FLOAT GLASS, RED GAGGED BRICK, STONE

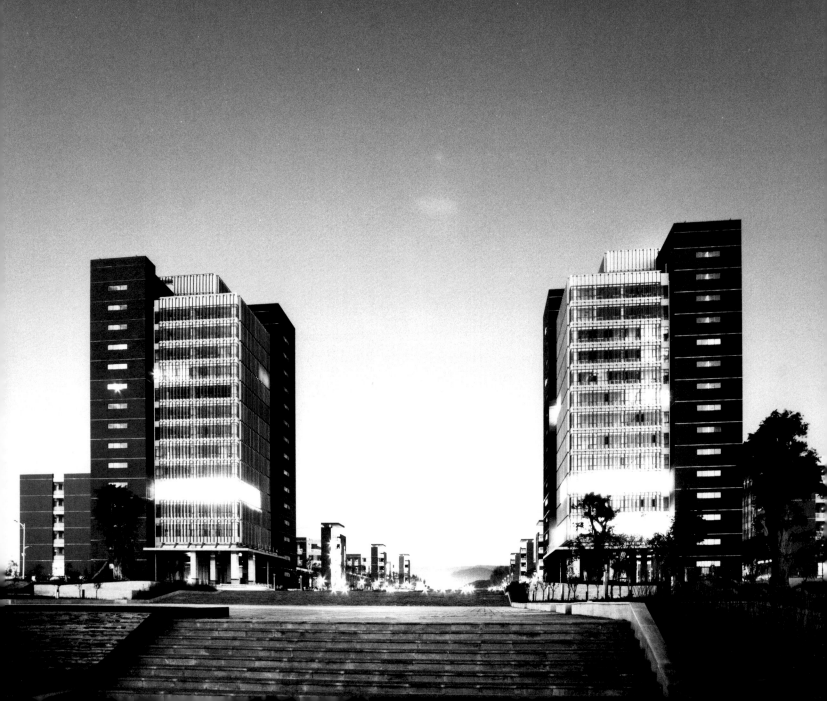

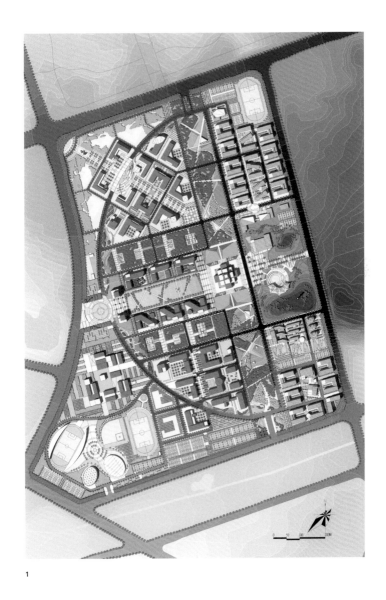

1

1 SITE PLAN
OPPOSITE PAGE CAMPUS MAIN ENTRANCE

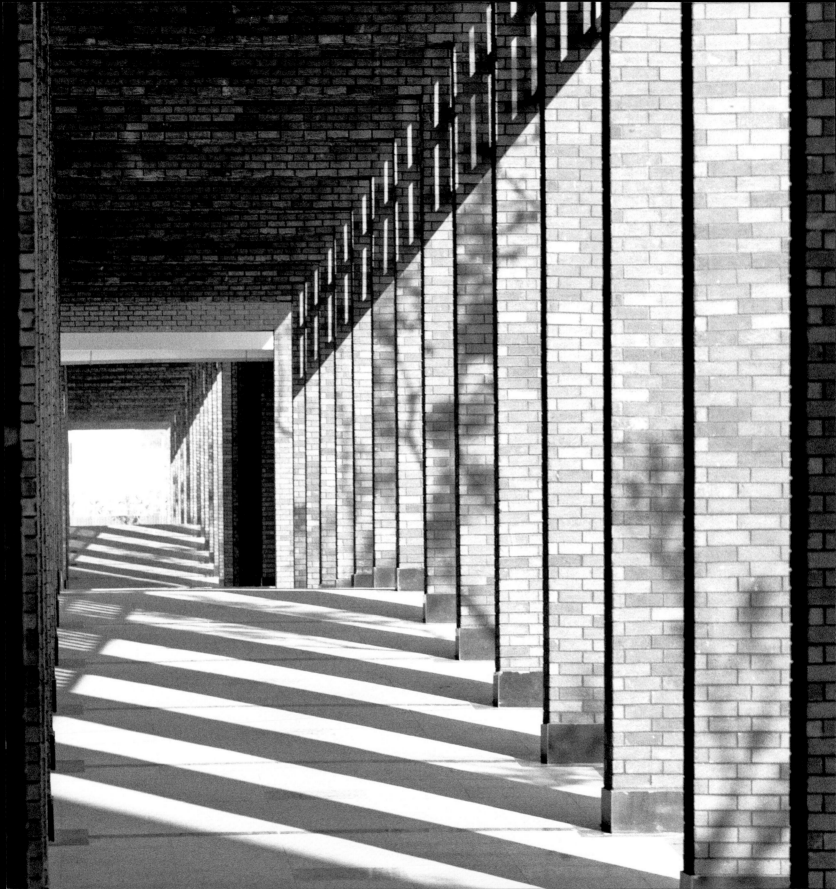

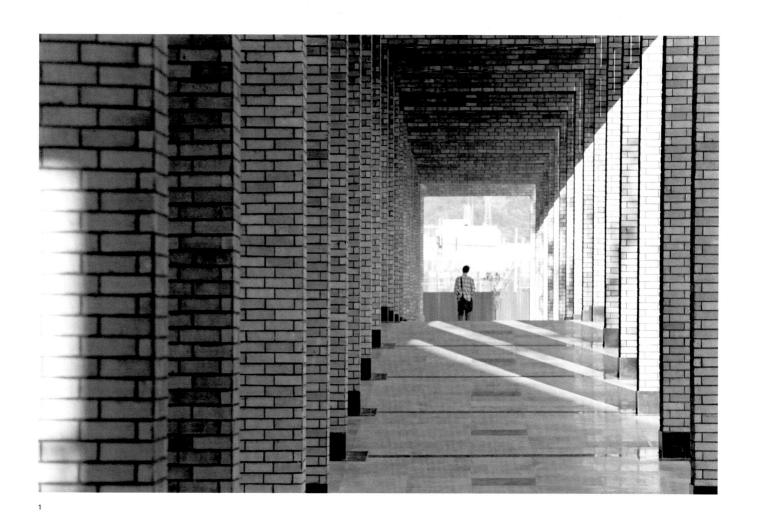

1

1 THE HALLWAY OF CAMPUS
OPPOSITE PAGE THE HALLWAY OF CAMPUS

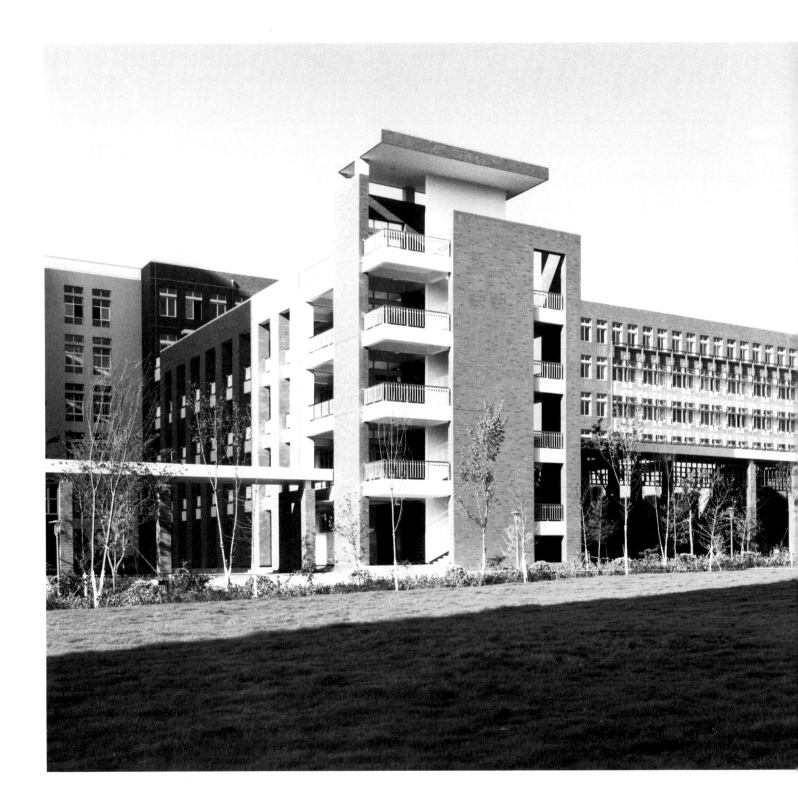

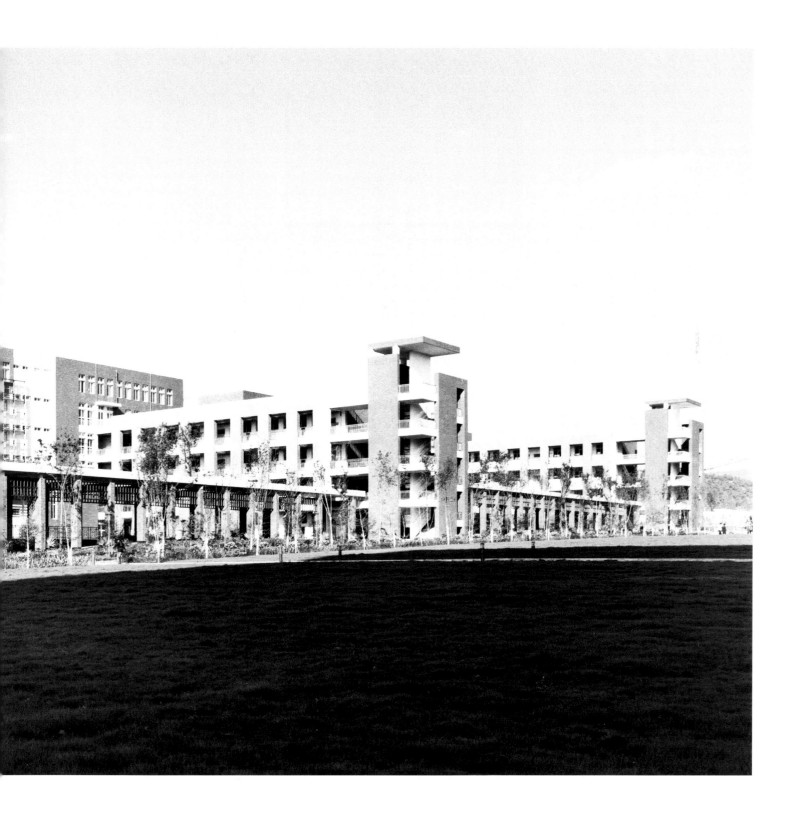

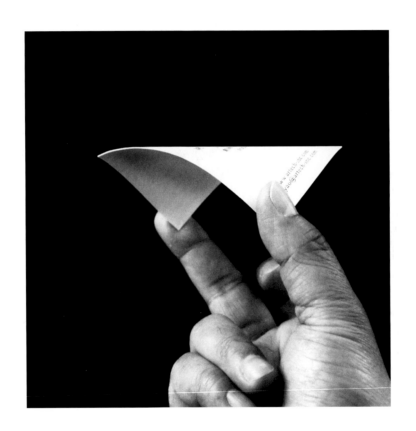

Spanning 115 meters, a graceful grand roof hovers over the station as if being floated by the strong wind in this windy town.

TAIWAN HIGH SPEED RAIL HSINCHU STATION

Taiwan High Speed Rail Corporation

The Taiwan High Speed Rail Hsinchu Station is the new gateway to the Hsinchu metropolis; since its debut in 2005, it has gained a strong identity as a local icon. During the day, the streamlined grand roof dominates visitors' sight with its majestic yet graceful form; in the evenings, the transparent oval-shaped station building attracts passengers' attention with its lantern-like warm glow and welcoming atmosphere.

The station roof is designed in response to the infamous Hsinchu winds, protecting visitors from strong gusts at the entry and platform levels. The curved roof also reads as a metaphor for a tent-like roof being held by the wind. Supported by seven sets of incomplete arches, it has dimensions of 100 meters in length, 70 meters in width, and 26 meters in height. It covers the entire station below, with the center

portion left open to avoid the "piston effect" when trains pass through at high speed. From the outside, the grand roof is seen anchored at only two points on the plaza ground, enhancing its lightweight, aerodynamic qualities.

Enclosed by two curved glass curtainwalls and two long granite walls, the symmetrical oval volume of the station is a design inspired by the traditional Hakka roundhouse. On the two long arc walls, art installations each themed "tradition" and "future" are collaborations created by architects and artists. Spanning the lobby is a glass bridge, from which an unobstructed view of this pair of themed walls can be seen as a symbol of the station linking the past and the future.

PROJECT DATA

LOCATION
HSINCHU COUNTY, TAIWAN

FUNCTION
STATION

DESIGN / COMPLETION
1999 / 2006

SITE AREA
79,900 M²

GROSS FLOOR AREA
20,360 M²

FLOOR LEVELS
3 FLOORS ABOVE GROUND

STRUCTURE
STEEL FRAME AND CONCRETE CONSTRUCTION

MATERIALS
ARCHITECTURAL CONCRETE, LOW-E GLASS, METAL PANELS, STAINLESS STEEL

NOTE
FIRST PRIZE, THE TAIWAN ANNUAL ARCHITECTURE AWARD 2006
HONORABLE MENTION, THE 6TH FAR EASTERN ARCHITECTURAL DESIGN AWARD 2007

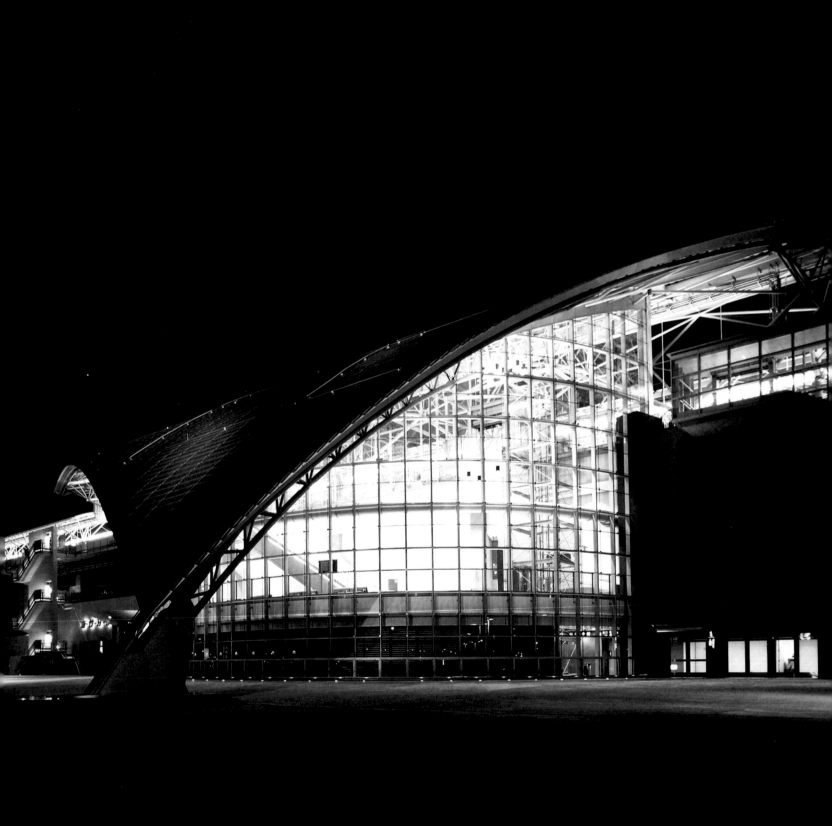

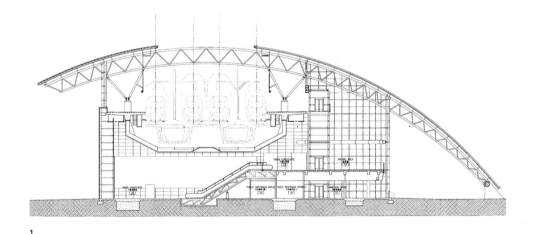

1

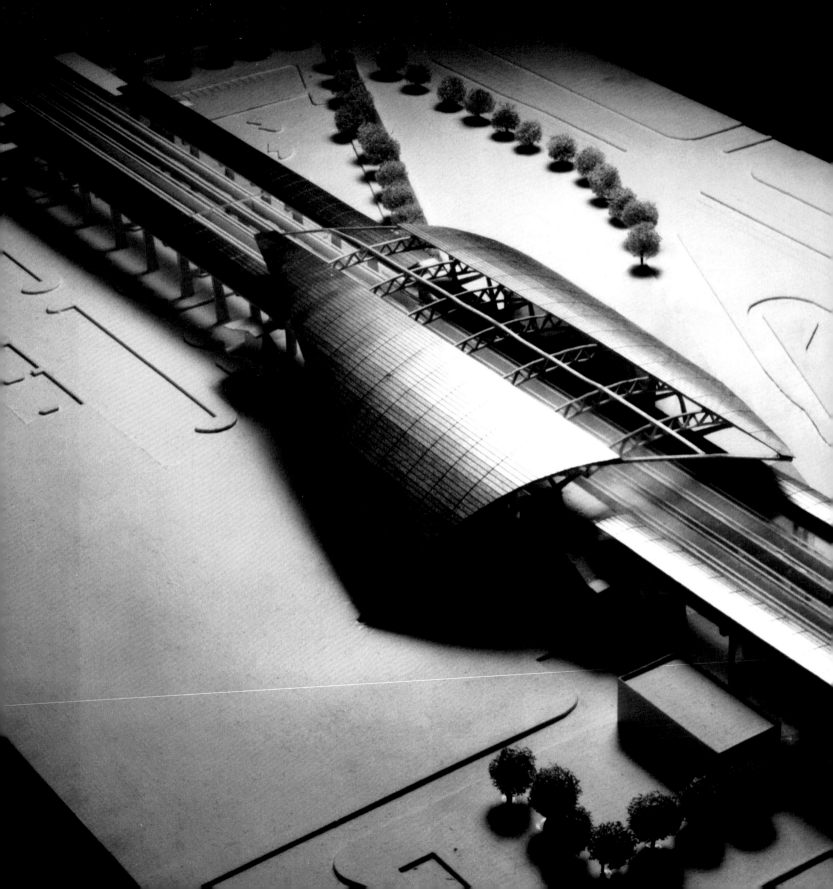

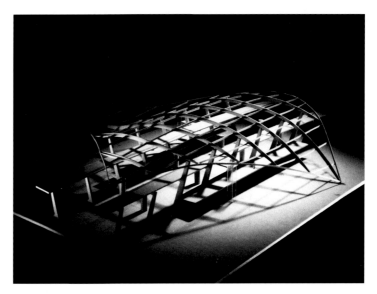

1

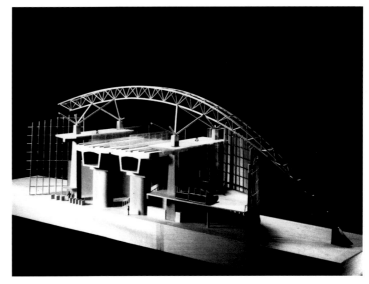

2

1 MODEL, CONCEPT OF THE STATION'S MAIN STRUCTURE
2 MODEL, SECTION OF THE STATION'S MAIN STRUCTURE
OPPOSITE PAGE MODEL, AERIAL VIEW

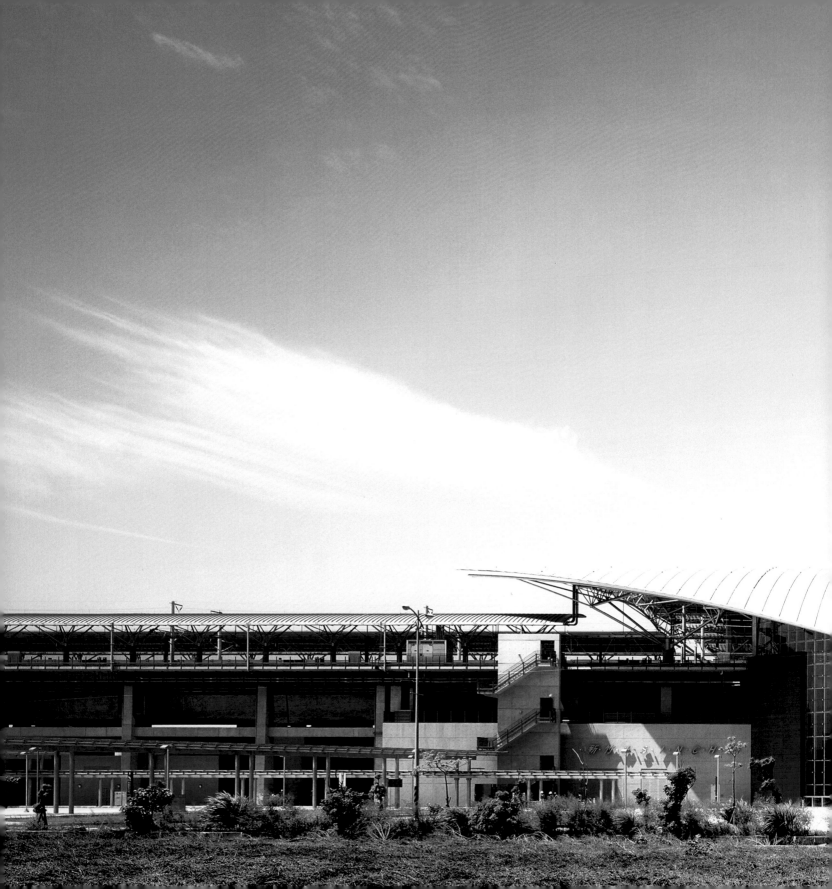

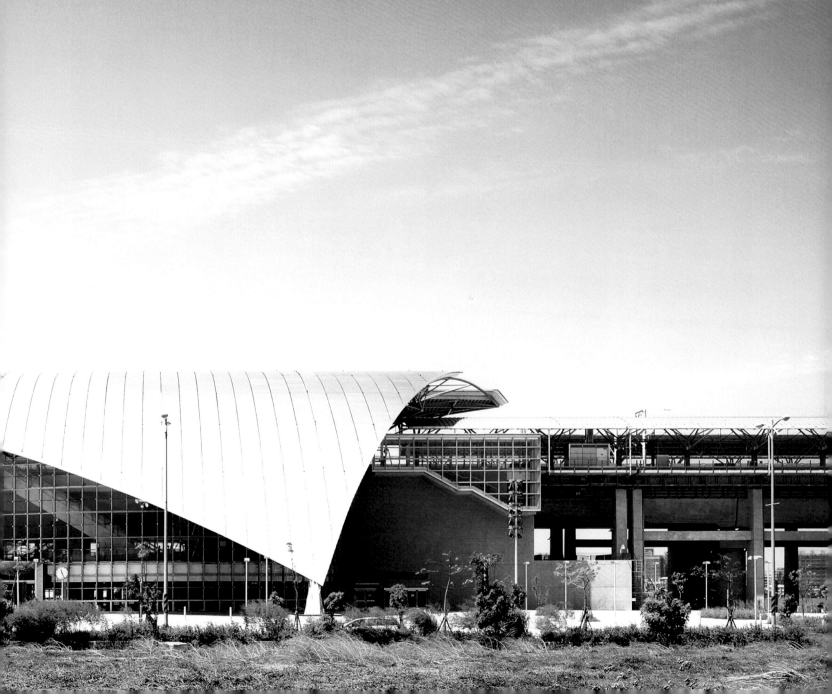

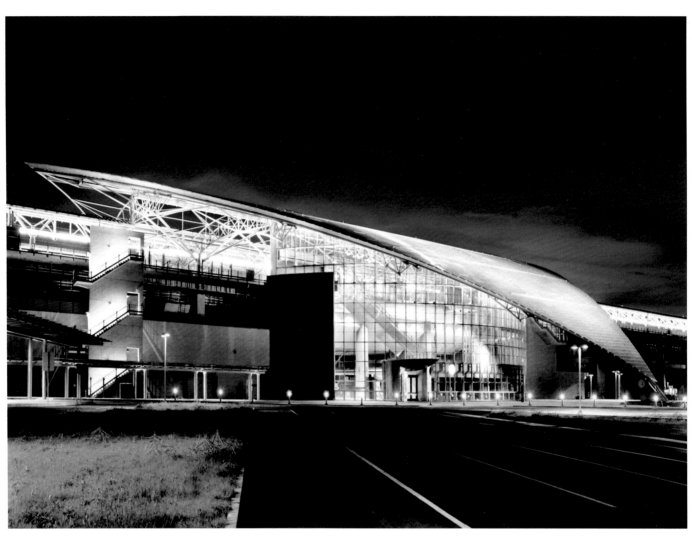

1

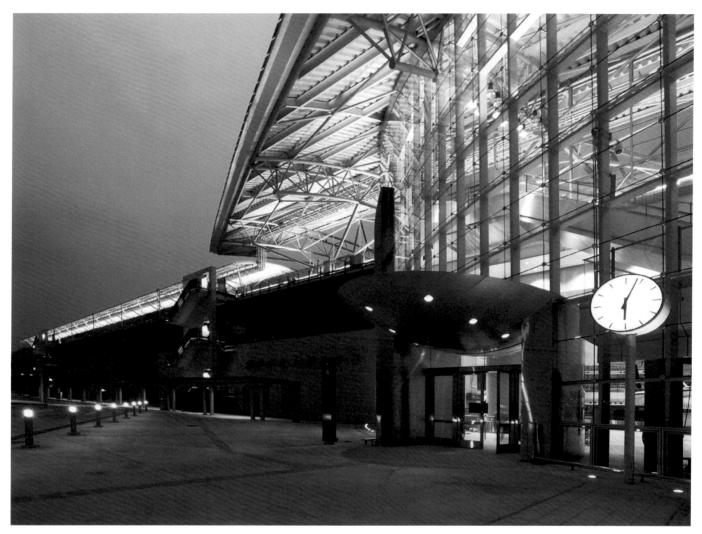

2

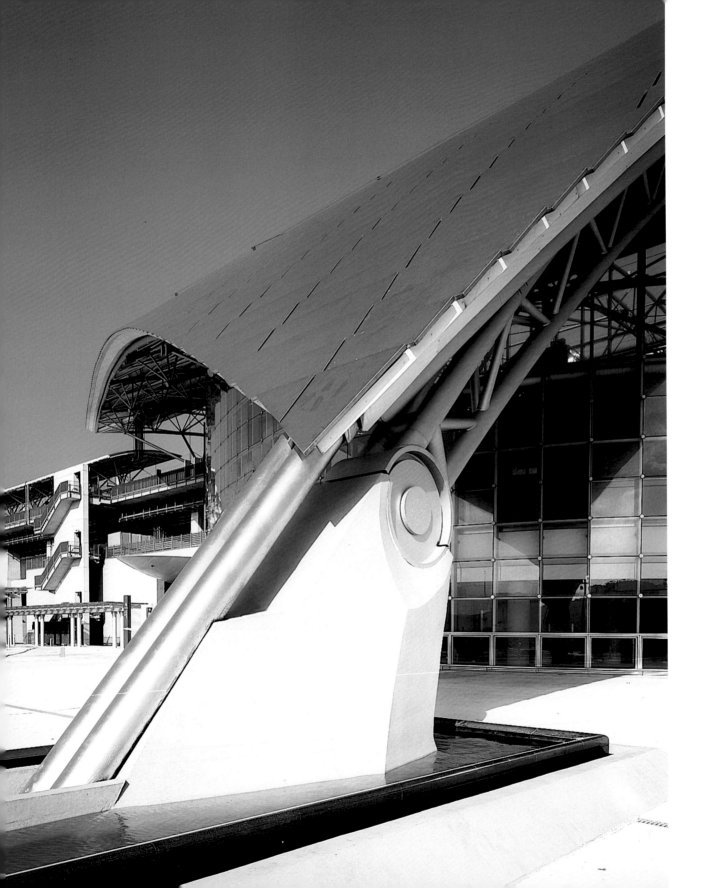

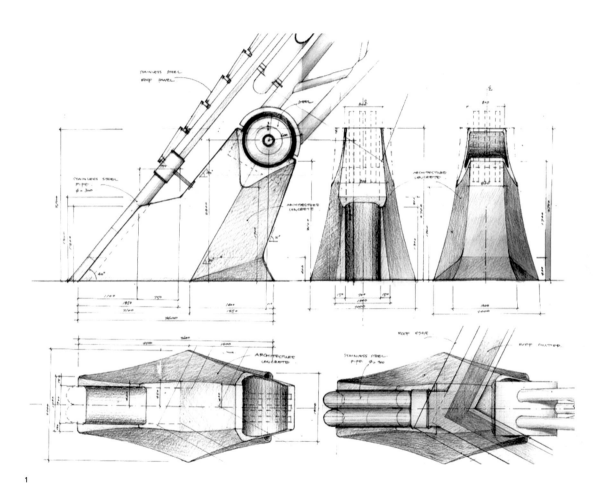

1 DETAIL OF CONCRETE COLUMN

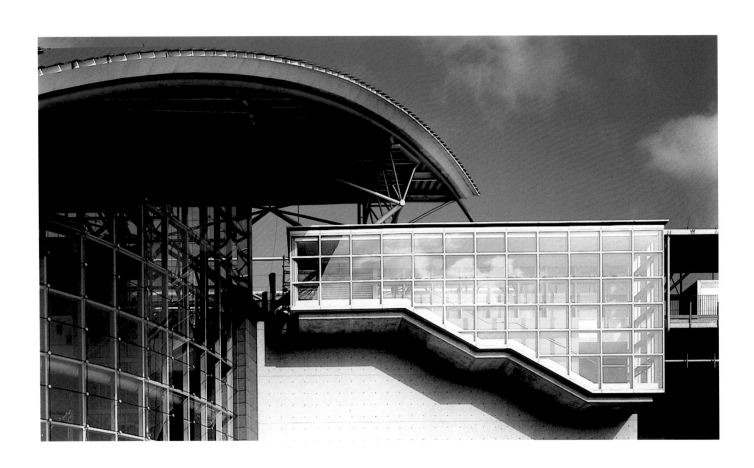

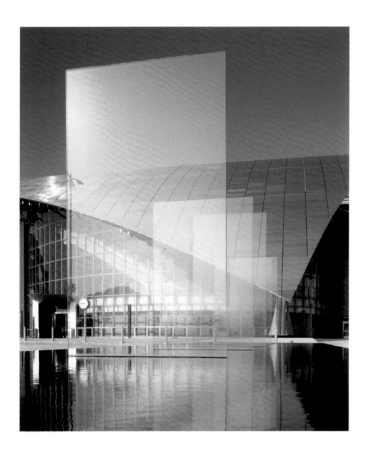
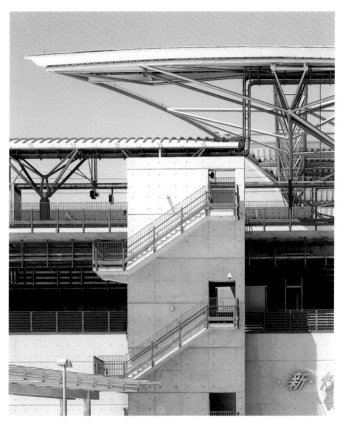

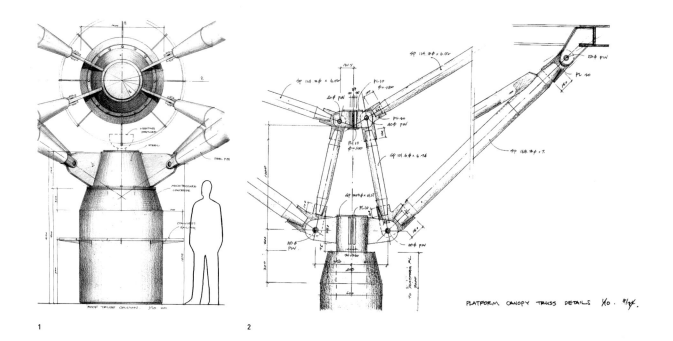

1

2

PLATFORM CANOPY TRUSS DETAILS ⅒. ¹⁄₄⅛.

1,2 DETAIL OF CONCRETE COLUMN

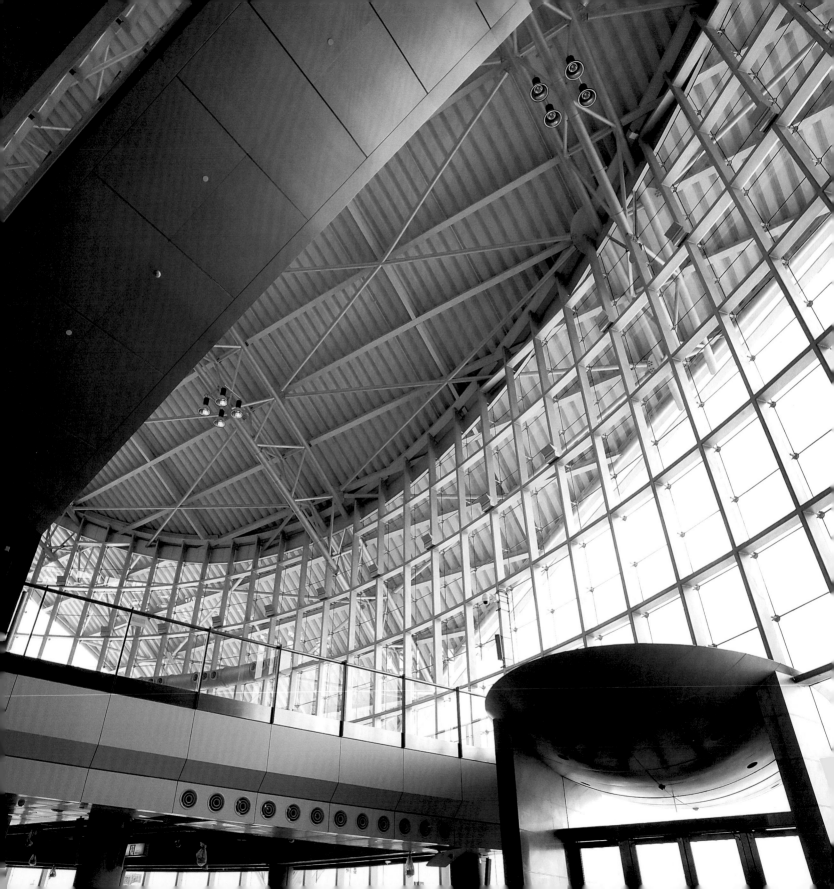

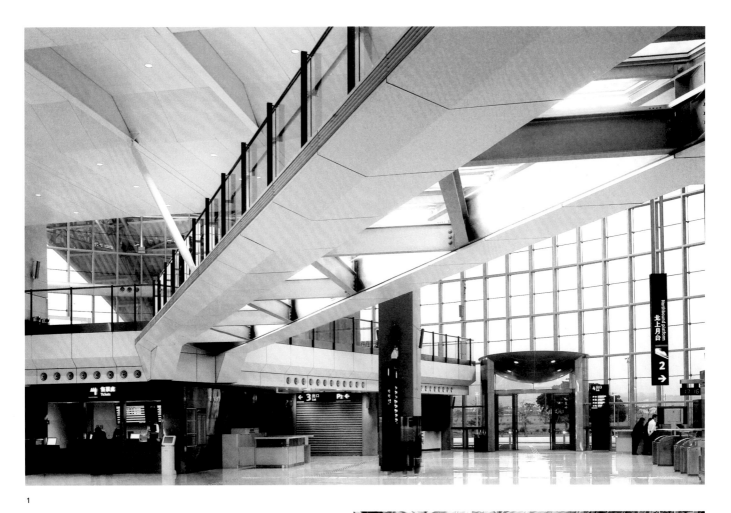

1

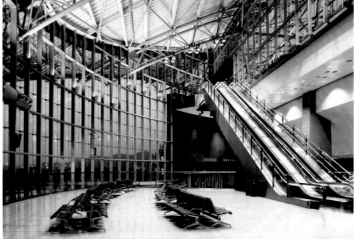

1 LOBBY
2 DEPARTURE HALL

2

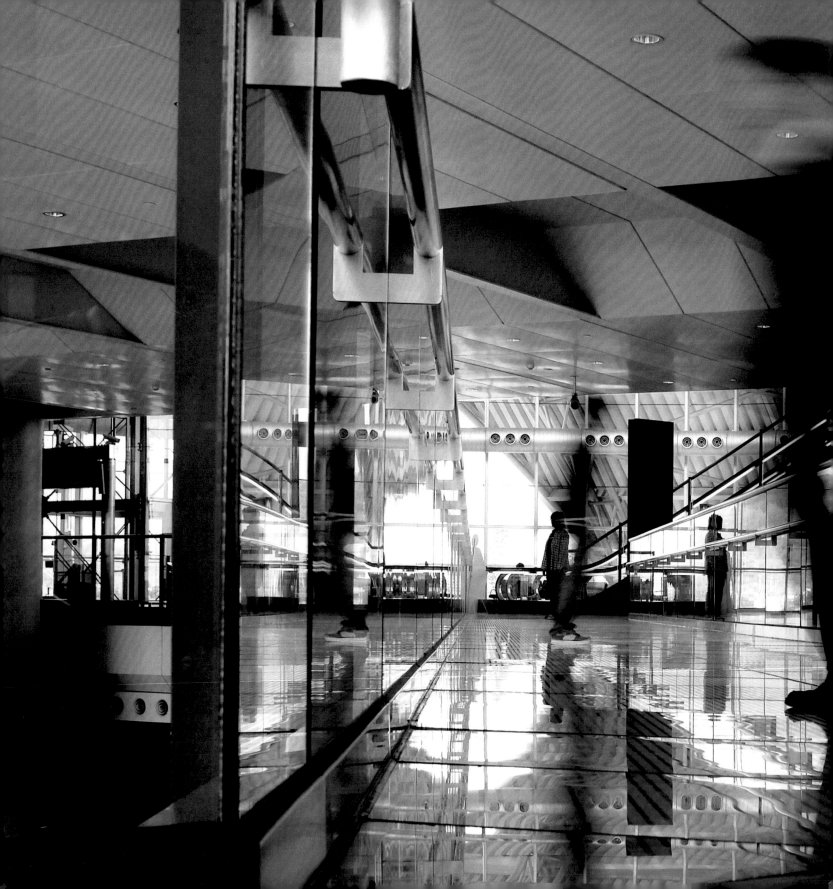

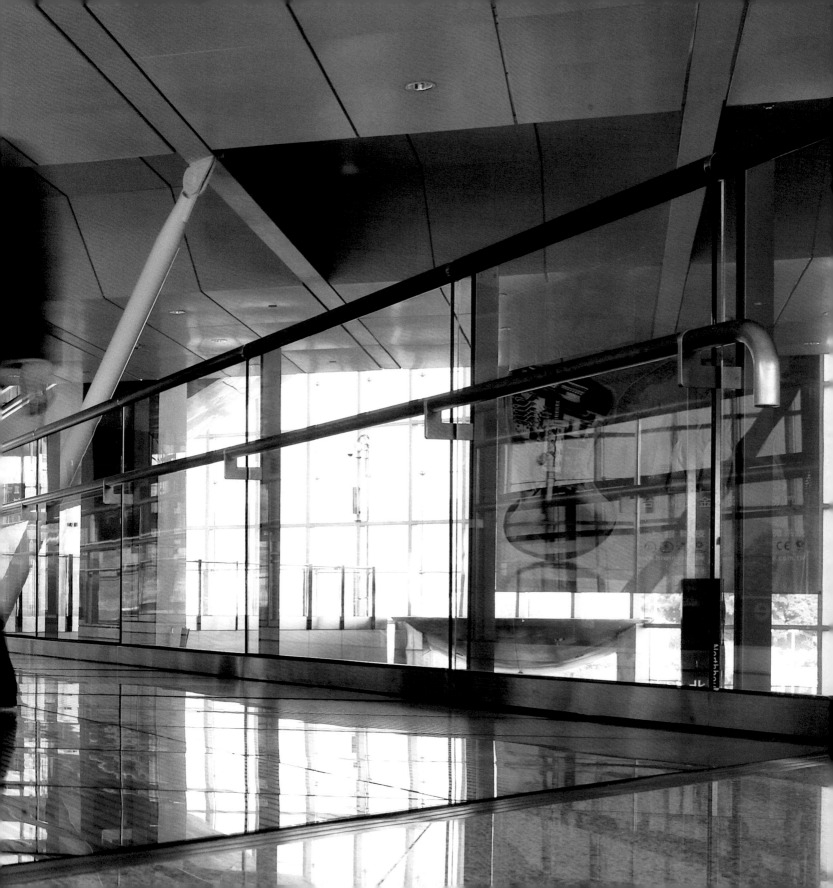

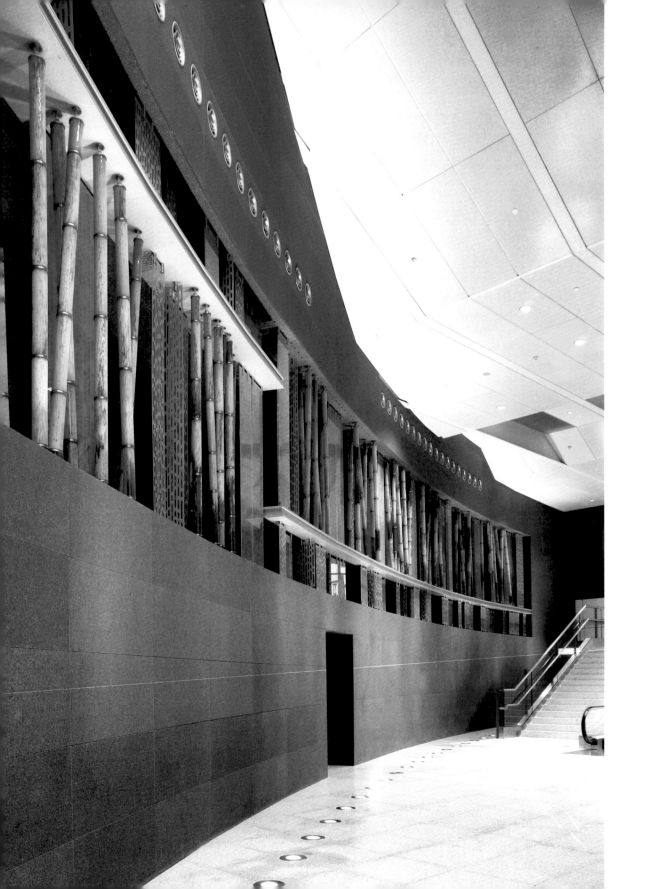

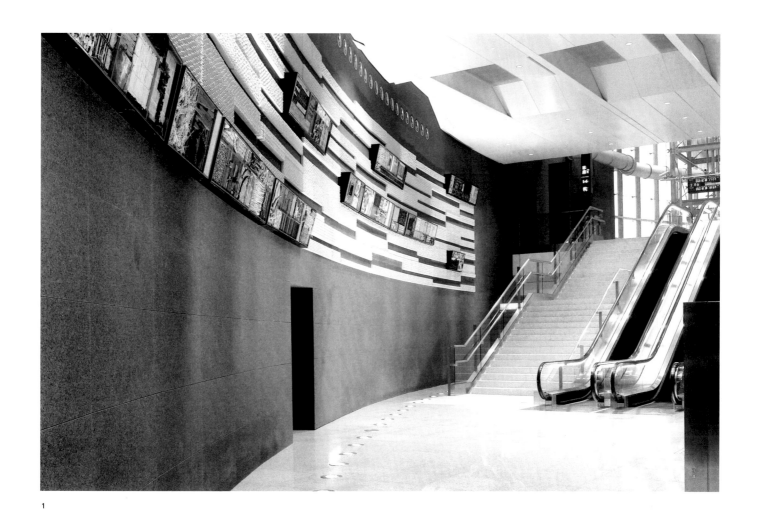

1

1 WALL OF TRADITION
OPPOSITE PAGE WALL OF FUTURE

The simple, long-spanned, easy-built, sky-lit "umbrella-like" prefabricated roof units meet the challenge of expanding the terminal while it is still in operation.

TAOYUAN INTERNATIONAL AIRPORT TERMINAL 1 RENOVATION COMPETITION

Civil Aeronautics Administration, MOTC

The proposed renovation plan for the 25-year-old Taoyuan International Airport Terminal 1 has two objectives: to revamp and expand the airport to accommodate the increase in passengers, and to improve the flow and quality of space in order to meet the criteria of a modern, friendly, and efficient airport terminal. Both objectives are approached while respecting the existing architecture and the practical constraints of renovating the airport while it is still in operation.

While the original Request for Submission called for expanding both sides of the existing building, our design team proposed adding an annex on one side only in order to minimize the distance that passengers must walk within the terminal

and to simplify the construction for operation purposes. The new Grand Hall, the annex, will include a departure hall on top and an arrival hall below, eliminating the obscure "crisscross" circulation of the current terminal.

Inspired by the shape of a kite, the design team dissected the geometry of the existing curved roof into smaller units, then rotated and reassembled them to create a roof system that is structurally simple and aesthetically graceful. Based on this concept, a unifying roof structure is created with two symmetrical triangular shells tied together by steel wires and beams. The eye-shaped skylights allow natural light to enter, while smaller apertures provide cross-ventilation.

PROJECT DATA

LOCATION
TAOYUAN COUNTY, TAIWAN

FUNCTION
AIRPORT TERMINAL

DESIGN
2003

GROSS FLOOR AREA
18,450 M²

FLOOR LEVELS
2 FLOORS ABOVE GROUND

STRUCTURE
STEEL FRAME CONSTRUCTION

MATERIALS
CLEAR FLOAT GLASS, METAL PANELS, STAINLESS STEEL

NOTE
SECOND PRIZE, TAOYUAN INTERNATIONAL AIRPORT TERMINAL 1 RENOVATION COMPETITION

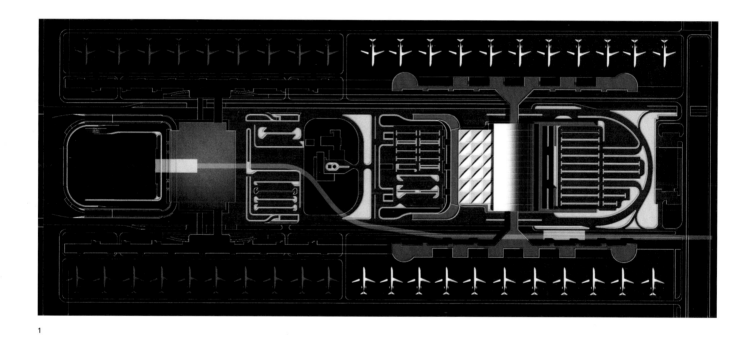

1

1 SITE PLAN
OPPOSITE PAGE DEPARTURE HALL

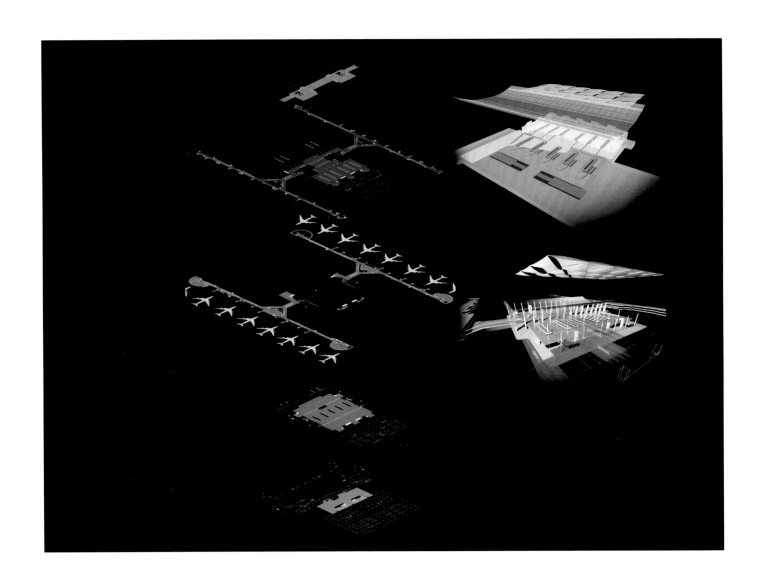

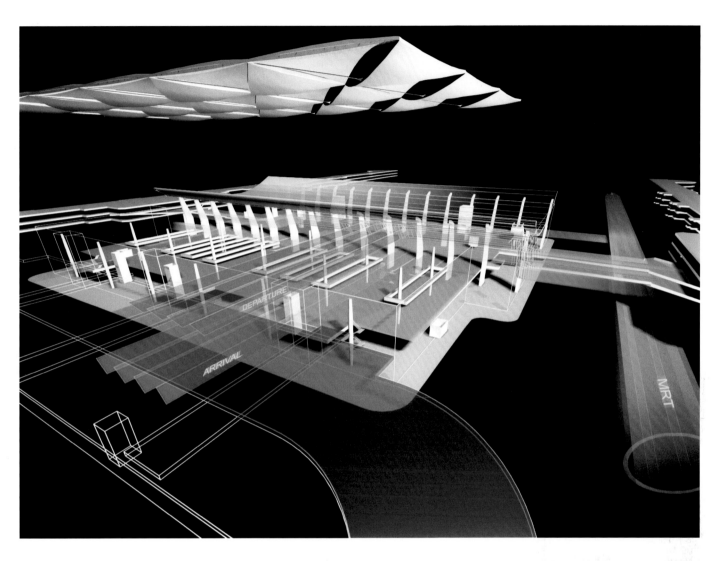

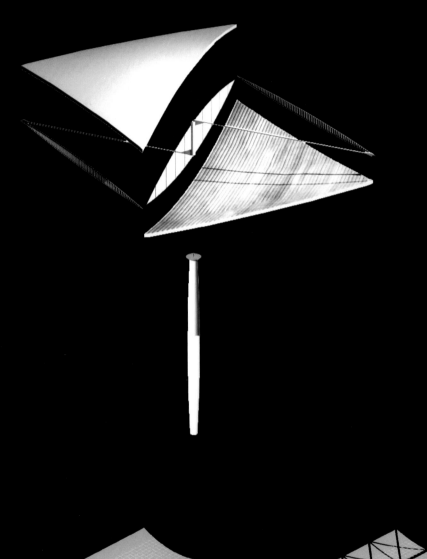

EXISTING ROOF

RE-SLICING

UNIT

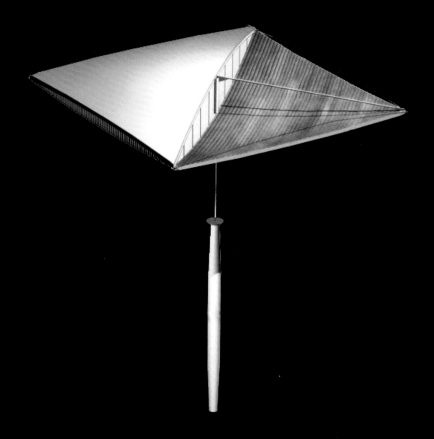

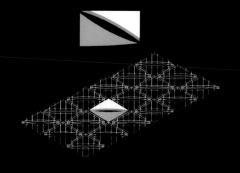

ROTATE REASSEMBLE

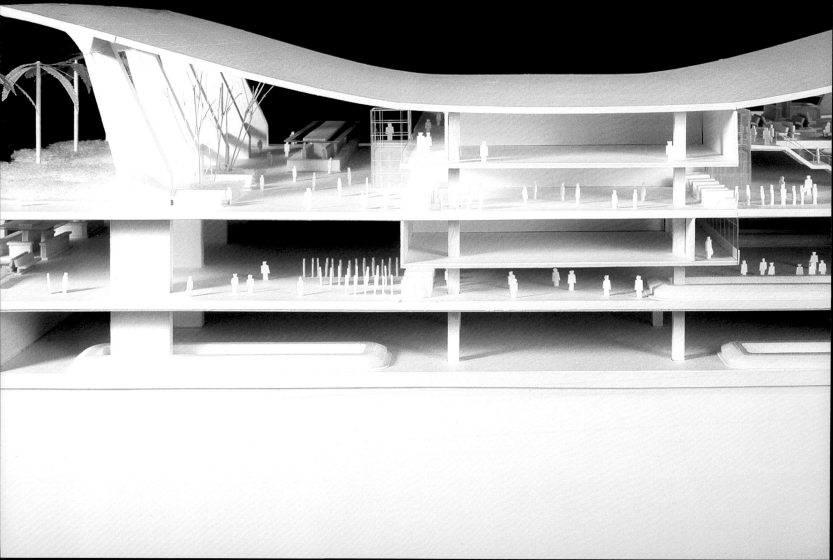

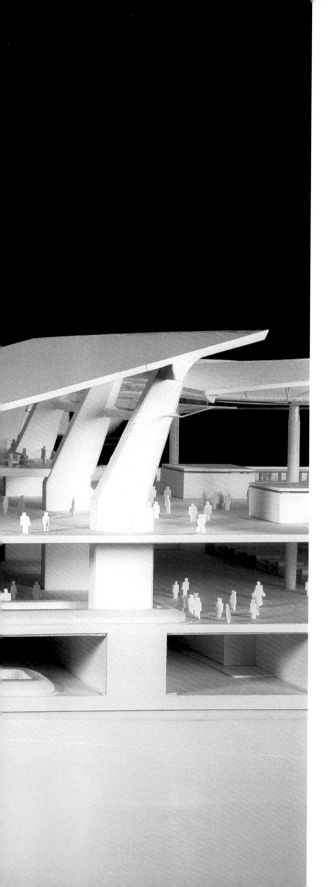

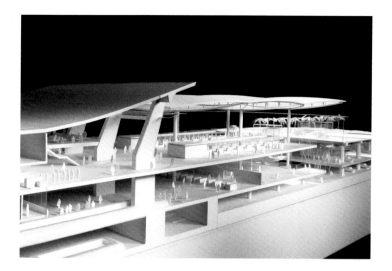

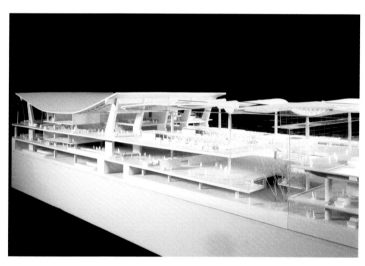

ALL IMAGES MODEL, SECTION

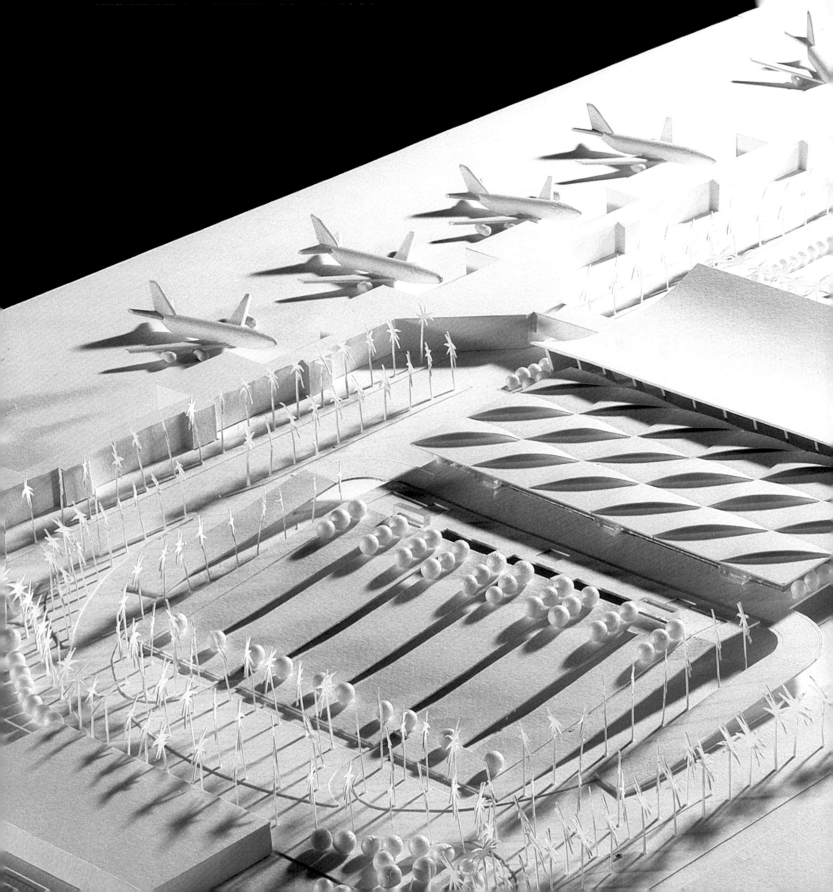

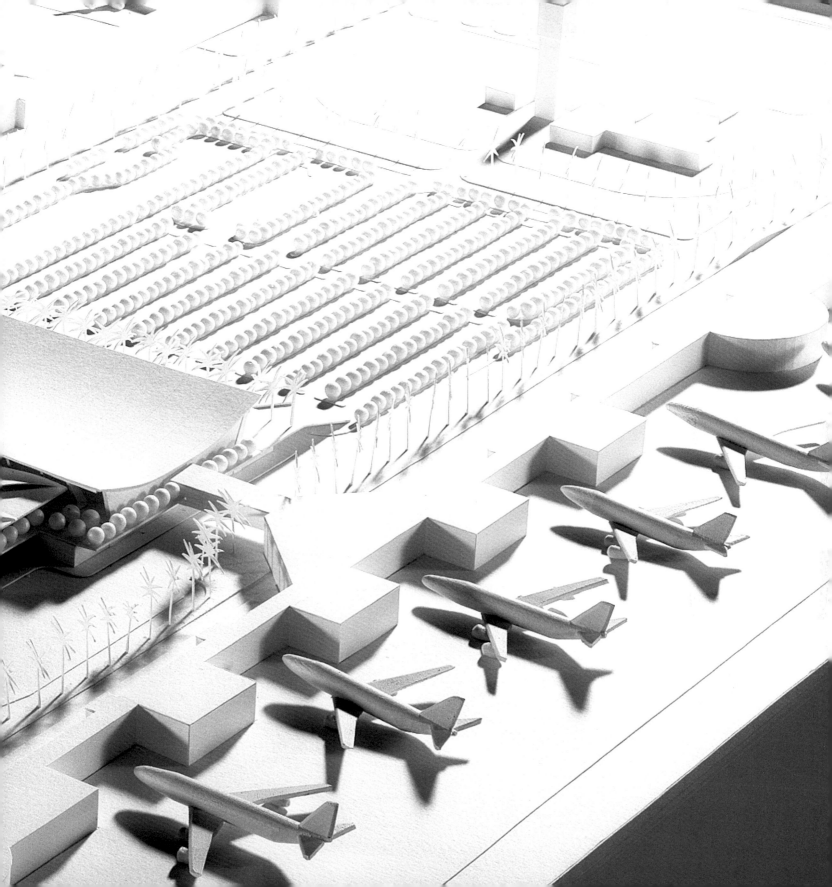

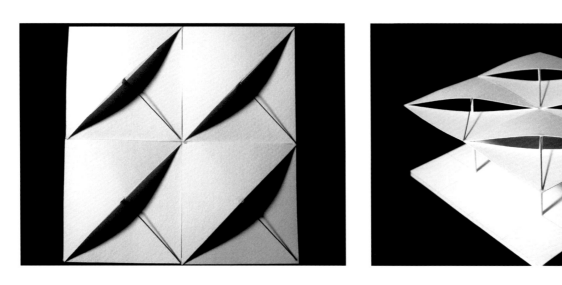

A station supported by a structural system resembling a calla lily and enclosed within a band of greenhouse for this flora and plantation center in Taiwan.

TAIWAN HIGH SPEED RAIL CHANGHUA STATION

Taiwan High Speed Rail Corporation

The name of the town "Tienchung" in Chunghua literally means "in the middle of the rice fields". It is a showcase town set in central Taiwan's fertile farmland; during the harvest season, the town is surrounded by beautiful golden rice fields. In recent years, the Chunghua area has also become the center of the flower industry, with pastures abounding and an annual exposition held in the area. The theme of the new station reflects these unique local characteristics.

Utilizing contextual imageries, the team designed the station from the outside in. First, the overall landscape for the station plaza is designed as a tapestry woven with various kinds of flowers, plants, water channels, and pavement patterns.

The landscape is further extended into the station building itself with a greenhouse in the shape of a ring along the station's large glass façade, allowing passengers an experience of continuity when approaching the station. The highlights of the station are the structural columns inside the station. Inspired by the shape of a flower, these graceful curved columns not only support the roof above, but also bring north light into the lobby through openings at the top, giving the space unique additions of the local character on a grand public scale.

PROJECT DATA

LOCATION
CHANGHUA COUNTY, TAIWAN

FUNCTION
STATION

DESIGN / COMPLETION
2007 / EXPECTED 2015

SITE AREA
78,100 M²

GROSS FLOOR AREA
16,620 M²

FLOOR LEVELS
3 FLOORS ABOVE GROUND

STRUCTURE
REINFORCED CONCRETE CONSTRUCTION

MATERIALS
ARCHITECTURAL CONCRETE, ALUMINUM PANELS, LOW-E GLASS

GREEN BUILDING AWARD
TAIWAN EEWH: SILVER

NOTE
FIRST PRIZE, TAIWAN HIGH SPEED RAIL CHANGHUA STATION COMPETITION

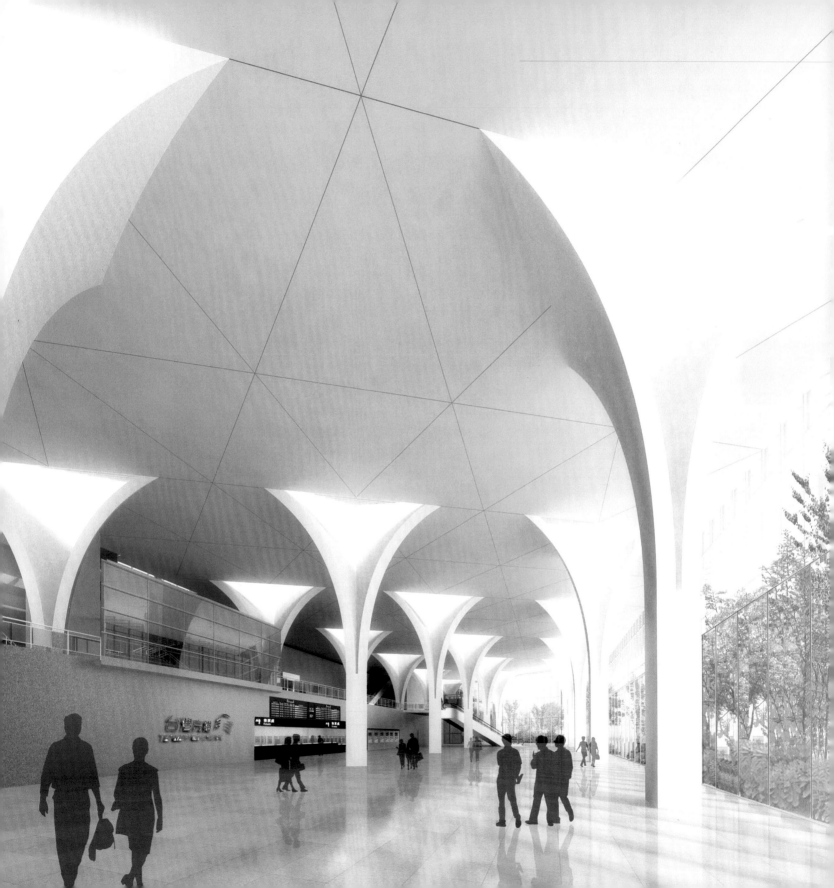

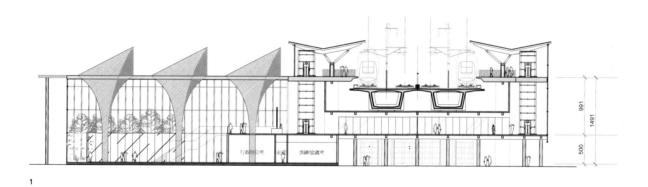

991

1491

500

1

1 CROSS SECTION
OPPOSITE PAGE LOBBY

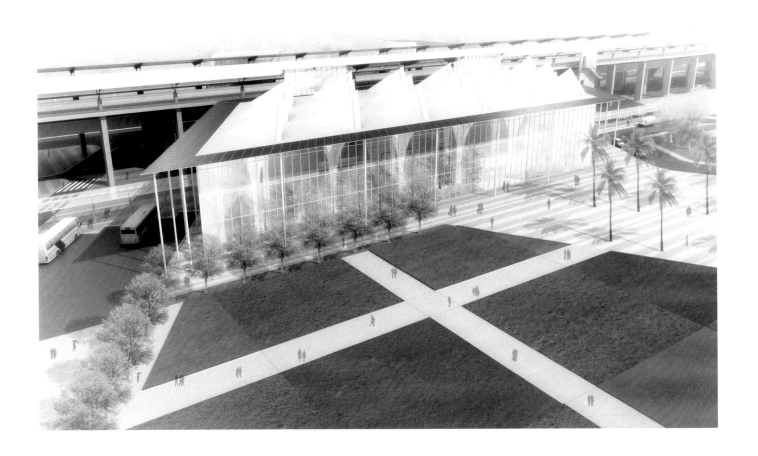

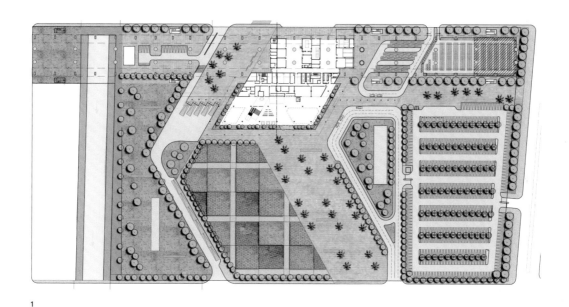

1

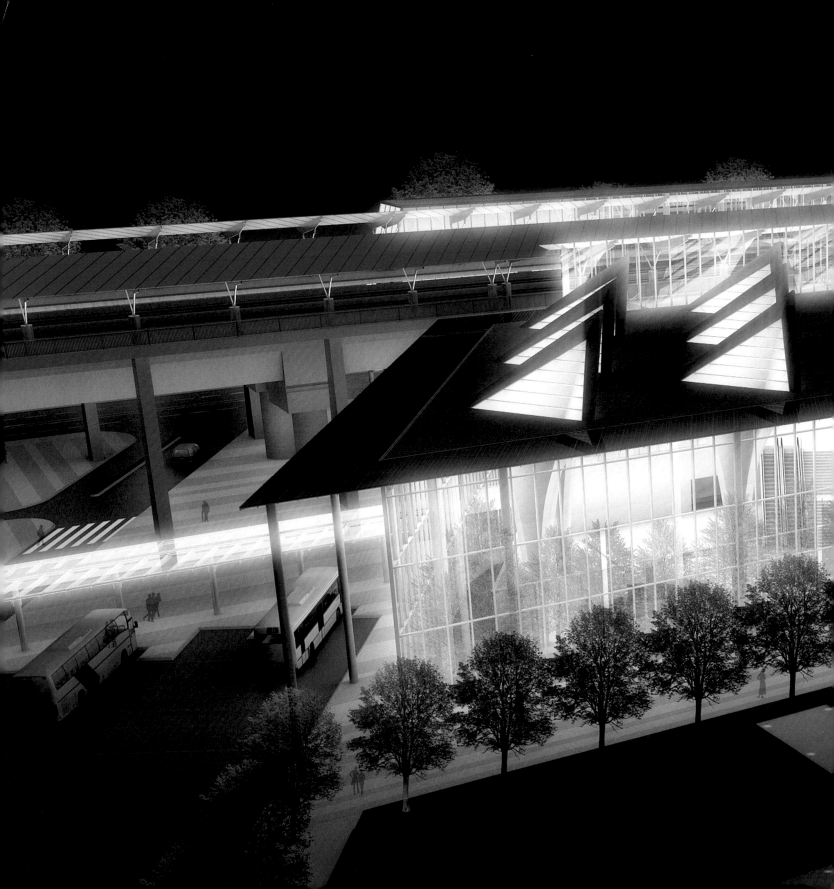

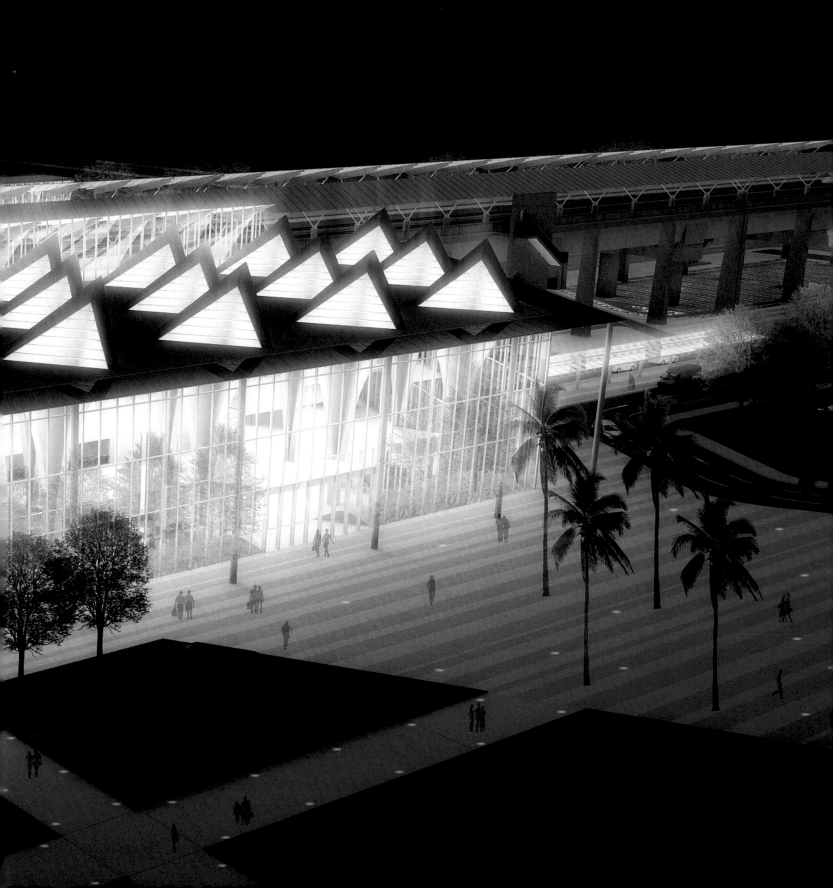

The exhibition explores the shared emotions of transience and impermanence in the minds of travelers.

LA BIENNALE DI VENEZIA, THE 8TH INTERNATIONAL ARCHITECTURE EXHIBITION 2002

In 2002, ARTECH was chosen to represent Taiwan in the Venice Biennale with the Taiwan High Speed Rail Hsinchu Station project. Installed in the Palazzo delle Prigioni, the exhibition was titled "NEXIT" (NEXT EXIT), offering a dual meaning with its typography and abstract symbolism.

The exhibition utilized the existing chambers to create three major exhibition spaces: the "Platform Theater", "Station Architecture" and "Design Concept." The High Speed Rail Station was presented as a stage, assembling a group of traveling strangers together to share a fleeting, collective experience. The intention was to make use of the impermanent nature of space and time associated with the station to create the central theme of the exhibition.

The exhibition opened with two parallel platforms separated by a translucent white screen set under the vaulted roof, designed to create a spatial reality for the station. Photographs of life-size travelers on the platform were hung on one side of the walls, with images of the visitors also projected onto these photographs. On the other side, abstract silhouettes of more travelers were set to stand on a surreal platform. Movies of moving trains and travelers were projected to the screen between the platforms, while music filled the vaulted space. As viewers passed through these installations, the virtual line separating reality from imagination blurred. The exhibition ended at the platforms where visitors began their journey, signifying the countless stories of impermanence written between the transitory travelers at the station.

PROJECT DATA

LOCATION
VENICE, ITALY

FUNCTION
EXHIBITION

DESIGN / COMPLETION
2002 / 2002

DESIGN THEME
2050 VISION TAIWAN : NEXT EXIT

DIRECTOR
COUNCIL FOR CULTURAL AFFAIRS, EXECUTIVE YUAN

ORGANIZER
NATIONAL TAIWAN MUSEUM OF FINE ARTS

CO-SPONSORD
ARTE COMMUNICATIONS

EXHIBITION SITED
PALAZZO DELLE PRIGIONI, VENICE

NOTE
LA BIENNALE DI VENEZIA, THE 8TH INT'L ARCHITECTURE EXHIBITION, TAIWAN PAVILLION

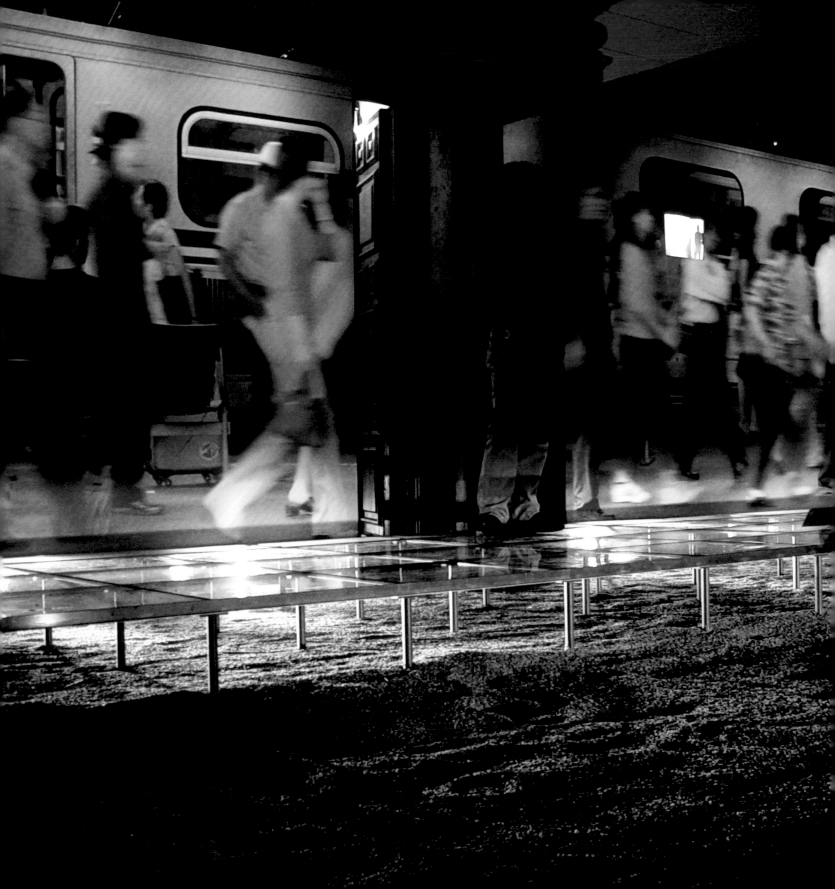

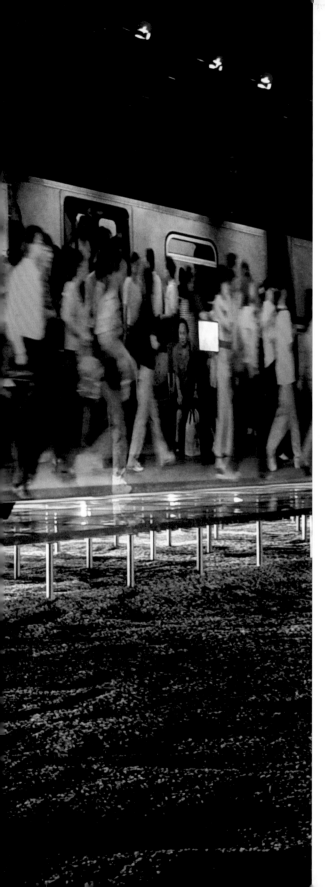

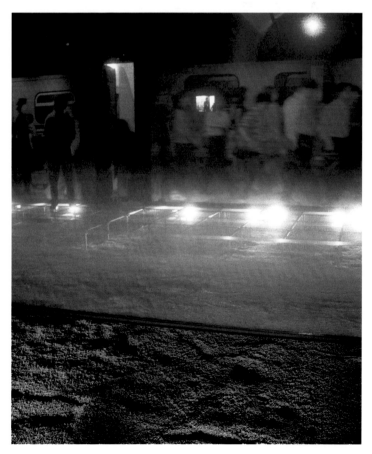

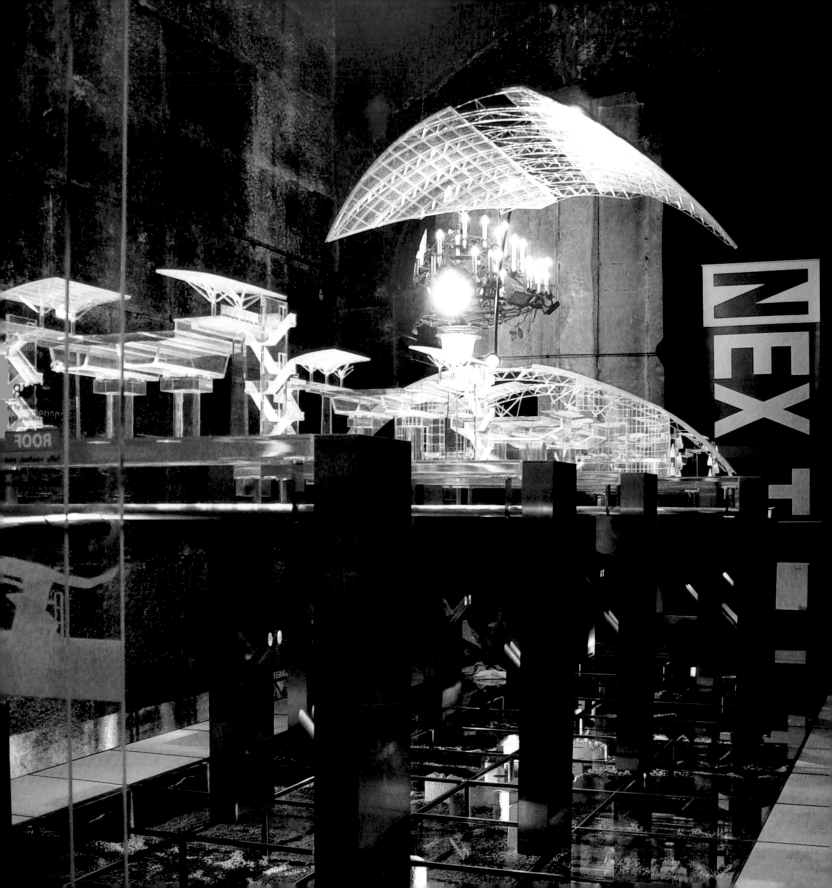

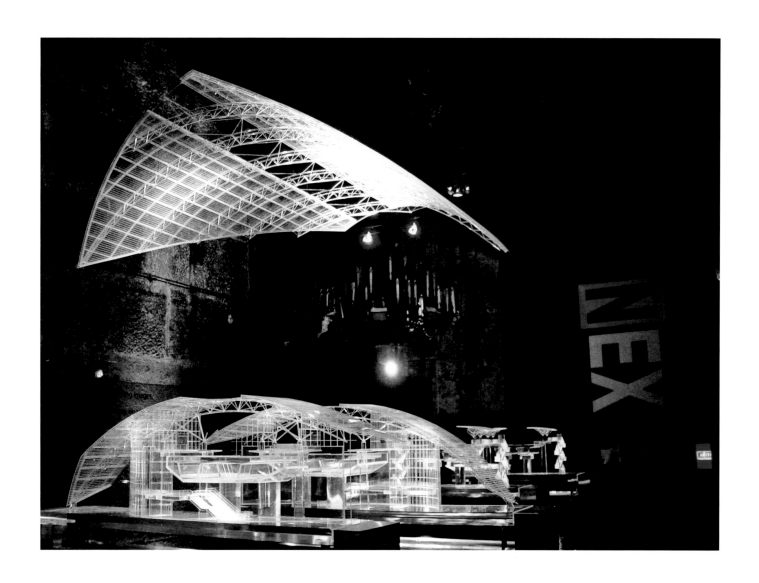

Four clips of films depicting the sensations experienced in architecture-in-the-dark.

LA BIENNALE DI VENEZIA, THE 11ᵀᴴ INTERNATIONAL ARCHITECTURE EXHIBITION 2008

In 2008, Mr. Yao was again invited to join the Taiwan team of six architects to participate in the Venice Biennale. There, four clips of films were presented.

The exhibition had two underlying perspectives that it wished to communicate. One was an attempt to demonstrate the city's looming energy and those ambiguous affairs that take place in the evenings; the other was to challenge viewers' subconscious and to invoke its symbiotic relationship with this dark side of the city. By day, modern Asian cities are characterized by fast-paced activities. It is not until the evening that people can finally awaken their sensory understanding and interact with their surroundings, facing the other aspect of self. Hence, most people are citizens of the Dark City. In the dark, the city begins to deconstruct itself, the spatial layers begin to blur, and the unspoken, ambiguous emotions and underlying tensions gradually spread. The exhibition of the Dark City portrayed the juxtaposition of these two opposing aspects.

Through digital films, the installation interpreted our perception of the Dark City through its architecture. Four films of architectural footage continuously projected from both sides of the projector screen—in this way, the exhibition sought to present Taiwanese cities at night. The images were at times independent and at times combined to form one large picture. The juxtaposition of the front and back projection and the viewers' silhouettes were designed to imply both the surreal superficiality of the city and the underlying dark currents and energy of the city.

PROJECT DATA

LOCATION
VENICE, ITALY

FUNCTION
EXHIBITION

DESIGN / COMPLETION
2008 / 2008

DESIGN THEME
DARK CITY / DARK AFFAIR

DIRECTOR
COUNCIL FOR CULTURAL AFFAIRS, EXECUTIVE YUAN

ORGANIZER
NATIONAL TAIWAN MUSEUM OF FINE ARTS

CO-SPONSORD
MINISTRY OF FOREIGN AFFAIRS- REPUBLIC OF CHINA(TAIWAN),TAIPEI REPRESENTATIVE OFFICE IN ITALY, CONSTRUTION AND PLANNING AGENCY MINISTRY OF THE INTERIOR, CULTURAL CENTER OF TAIPEI IN PARIS, ARTE COMMUNICATIONS

EXHIBITION SITED
PALAZZO DELLE PRIGIONI, VENICE

NOTE
LA BIENNALE DI VENEZIA, THE 11TH INT'L ARCHITECTURE EXHIBITION, TAIWAN PAVILLION

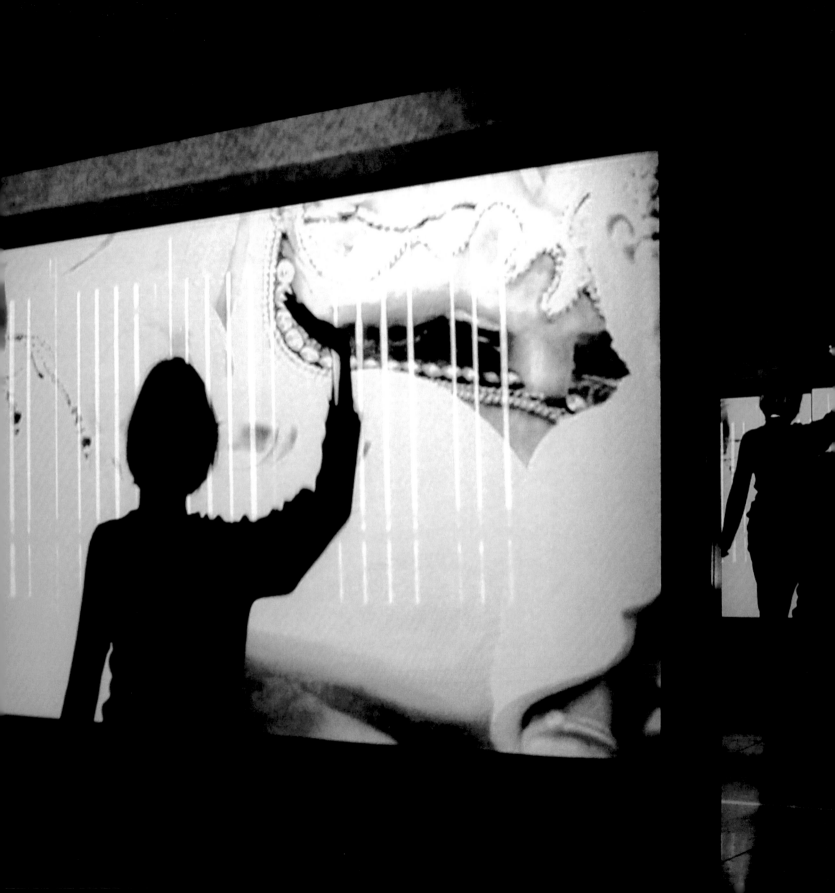

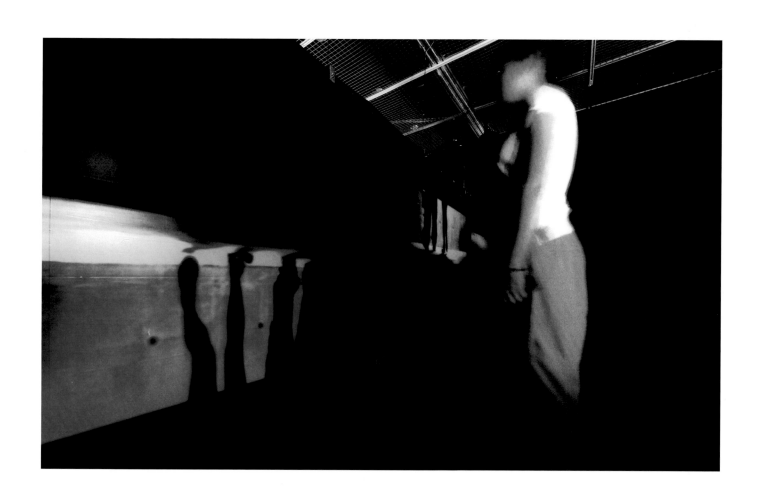

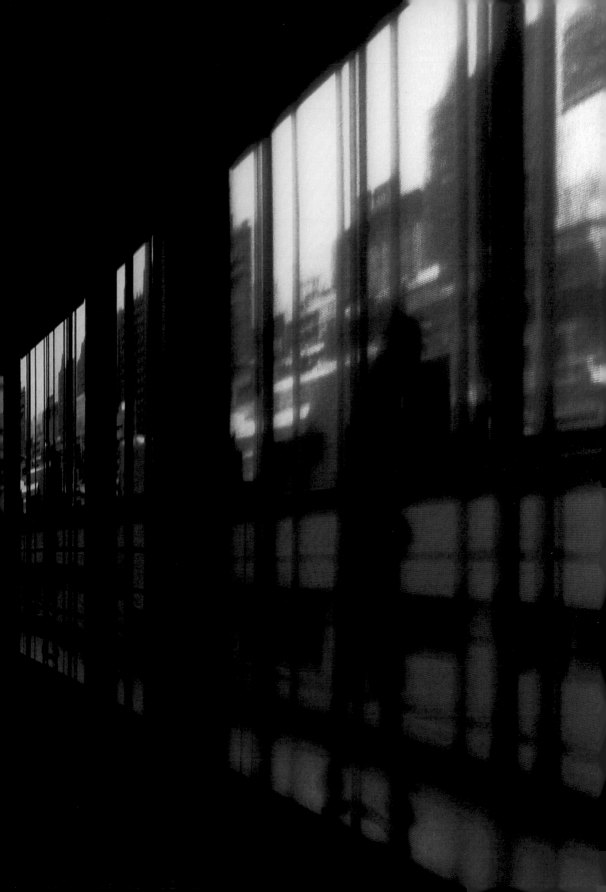

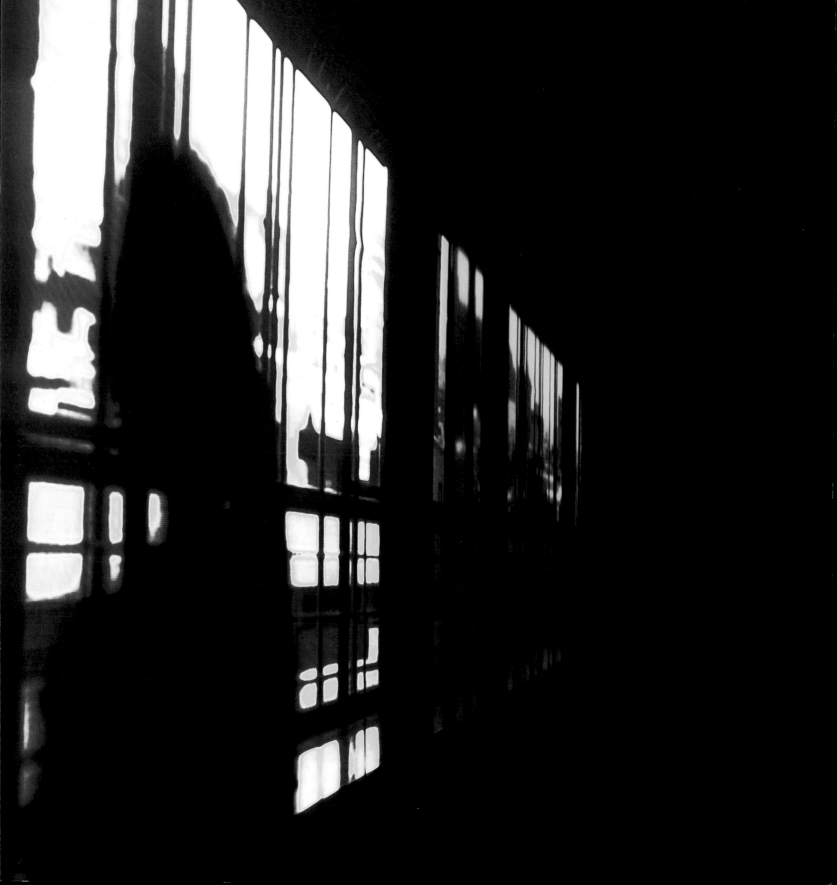

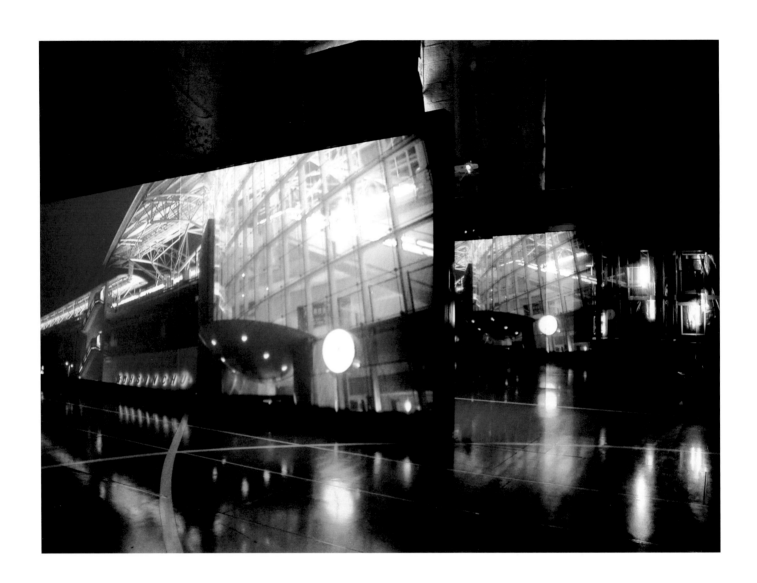

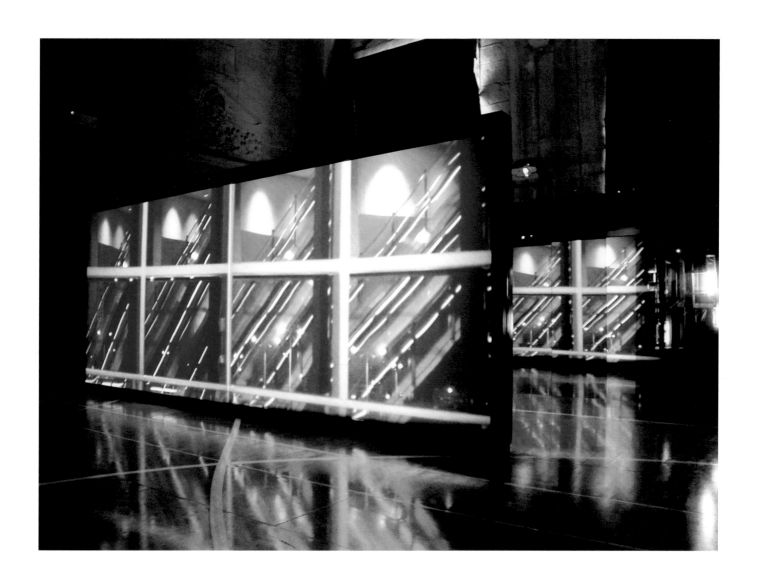

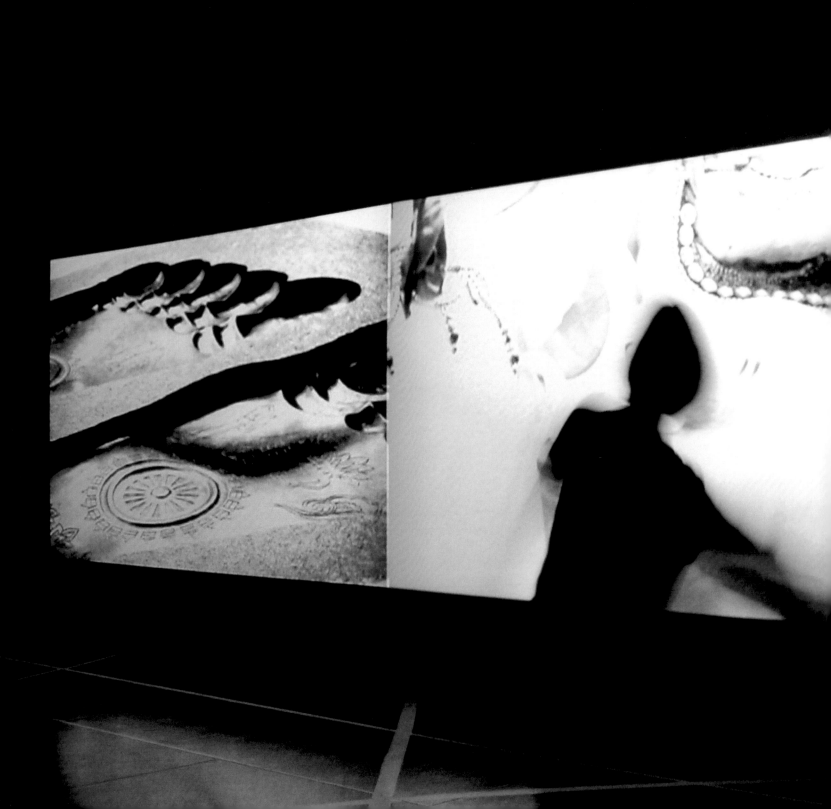

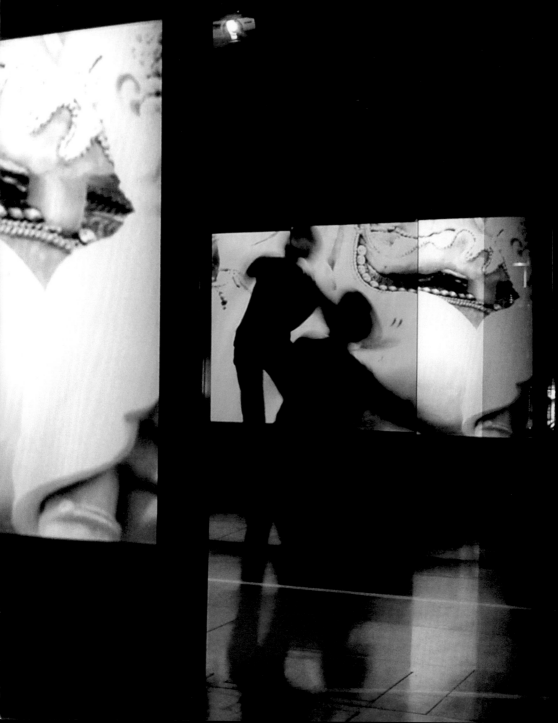

FIRM PROFILE

BIOGRAPHIES

KRIS YAO
FOUNDER

Mr. Kris Yao obtained a Bachelor of Architecture from Tunghai University in 1975, and a Master of Architecture from the University of California, Berkeley in 1978. In 1985, Mr. Yao established ARTECH Architects in Taipei, Taiwan, and in 2001, ARTECH International in Shanghai, China. In 1999, the London-based *World Architecture Magazine* recognized ARTECH Architects as "the most impressive practice in Taipei," and Mr. Yao as being "at the forefront of the revolution" of the architectural scene in Taiwan.

The firm now employs over 160 professionals, with projects including corporate/institutional, residential, cultural, educational, medical, hospitality, retail, transportation, industrial and interiors. The projects are located in Taiwan, Hong Kong, China, India, Europe and the United States.

In 2003, Mr. Yao represented Taiwan in the 8th International Architecture Exhibition at La Biennale di Venezia, Italy. The following year, his Hsinchu High Speed Rail Station was invited to participate in the 1st International Architecture Biennial Rotterdam. In 2004, he was invited to present projects in the first Beijing International Architecture Biennale. In 2008, he was once again invited to join the Taiwan team in the 11th International Architecture Exhibition at La Biennale di Venezia.

In 1997, Mr. Yao was awarded the 3rd annual "Chinese Outstanding Architect Award." He received the Distinguished Alumnus Award from the College of Environmental Design from UC Berkeley in 2005. In 2007, he became the first practicing architect to receive the "National Award for Arts and Architecture," the highest honor in cultural and art disciplines in Taiwan. In 2009, he obtained the Class I registration architect qualification in China. In addition to the numerous awards and honors he has obtained, Mr. Yao also frequently appears in architectural critique magazines and is featured in newspapers.

ARTECH's first monograph, *Kris Yao / ARTECH Selected and Current Works*, was published in 2001 by the Images Publishing Group Pty Ltd, Australia. The Chinese version of the monograph was published by Beijing China Architecture & Building Press in 2003.

WILLY Y. W. YU, AIA
SENIOR PARTNER

Mr. Willy Y. W. Yu obtained a Bachelor of Architecture from Tunghai University in Taiwan in 1975, and a Master of Architecture with a major in Architectural Administration from the University of California, Berkeley in 1980.

Mr. Yu joined ARTECH Architects in 1990 as a Senior Partner. In addition to his duties supervising the firm's administrative management and writing contracts, he serves as a project principal in construction documentation, technique, and construction administration. Significant projects for which he was the project principal include Continental Engineering Corporation Headquarters, Fubon Banking Center, Lite-On Headquarters, and the Core Pacific City projects.

Mr. Yu is an AIA member, and a registered architect in California and Taiwan. Prior to joining ARTECH Architects, he was an associate at MBT Associates in San Francisco.

Selected projects from his time at MBT include NASA's Automation Sciences Research Center, the Human Performance Research Laboratory, and the Life Science Building Addition for the University of California at Berkeley.

XIANG JEN
SENIOR PARTNER

Ms. Xiang Jen was born in Taipei, Taiwan. In 1983 she obtained a Bachelor degree from The Fashion Institute of Design & Merchandising in Los Angeles.

Ms. Jen is a Senior Partner at ARTECH Architects. She manages the administrative and public relations for the firm. She is also responsible for the Information Technology system and operations in the office. Starting from April 2006, she has facilitated the complete data digitization of the firm, both for administrative matters and architectural records. This digital advancement in architectural firm operations has been celebrated for its resonance in environmentally friendly practice.

Ms. Jen also conducts interior, graphic, and creative design for the firm's innovative projects. She designs many of ARTECH's creative projects, which have been widely and popularly received. She is also the author of several articles that have been published in local newspapers, and an innovator in life design and cultural appreciation. She has just published an encyclopedic book, containing a series of four books, on Chinese culture.

BIOGRAPHIES

Partners

GLEN LU PARTNER
ARTECH TAIPEI

HUA-YI CHANG PARTNER
ARTECH TAIPEI

Mr. Glen Lu was born in 1963, obtained his Bachelor of Architecture degree from Tunghai University in 1985, and is a licensed architect in Taipei. In 1988, Mr. Lu joined ARTECH Architects at the beginning of his career. Due to his passion, acute professional management skills in architecture, and extraordinary performance, he was promoted to the position of Partner of ARTECH Architects in 2000.

As a Partner of the firm, Mr. Lu is adept at all types of architectural planning, building code analysis, and project coordination and management. His current key projects include A10 Hotel Complex, Prince Housing & Development Xinyi Residential Tower, Taiwan NEXT-GENE Ao-Di Grand Land Architecture International Project, Kenting Resort Hotel, Ching Shin Elementary & Middle School, Dharma Drum University, and Fo Guang Shan Monastery, Bussy, France. Completed projects that he has managed include Silks Palace National Palace Museum, Fu Shin School, Chiaokuo Residential Tower, ShangHai Commercial & Savings Bank Residential Tower, Mingdong Daoying Residential Tower, Lite-On IT Research & Development Center, NY², Luminary Buddhist Center, and Da-Ai Television Center. The design competition projects he has participated in include the Far Eastern Taichung Shopping Center Design Competition.

Ms. Hua-Yi Chang was born in 1967 and obtained her Bachelor of Architecture degree from Feng Chia University in 1991. From 1991 to 1996, Ms. Chang was an architect for Ricky Liu & Associates Architects + Planners, and for Haigo Shen & Partners Architects & Engineers. She joined ARTECH Architects in 1997. She has demonstrated exceptional service, creative design, quality, and efficiency in her profession, and has earned much praise from clients and the professional field. She was promoted to Partner of ARTECH Architects in 2010.

Ms. Chang specializes in the design of high-rise office buildings, planning of large research & development centers, Taipei's metro stations, and other transportation design and construction projects. Her current major projects include Hua Nan Bank Headquarters, United Daily News Group Office Tower, Taiwan Life Insurance Financial Headquarters, China Steel Corporation Headquarters, Far Eastern Banciao Skyscraper, and TIAA MRT System. Completed projects she has managed include Lanyang Museum, SET TV Headquarters, Lite-On Headquarters, Quanta Research and Development Center, and Shih Chien University Gymnasium and Library. She has also participated in several design competition projects such as Formosa Television Headquarters and China Trust Commercial Bank Headquarters.

VINCENT CHAO PARTNER
ARTECH SHANGHAI

YEH-CHIN HSU PARTNER
ARTECH SHANGHAI

WEN-HONG CHU PARTNER
ARTECH SHANGHAI

Mr. Vincent Chao was born in 1962. He graduated with an Architecture Major from Taiwan's Dong-Hai University. Mr. Chao obtained his Master of Architecture degree from Cornell University in New York. From 1988 to 1997, he joined ARTECH Architects and worked as a Senior Designer and Project Manager for the firm. He returned to ARTECH Architects in 2001 and became a Partner for ARTECH Shanghai Office and took charge of managing ARTECH's architectural projects in China.

Mr. Chao worked with I.M. Pei Architects on the 66-floor Shining Park Hyatt Hotel Project as the Project Manager. His current major projects include Yunnan Cultural Park, Guangzhou Nansha Business Center, Chengdu High-tec Park Office Building, Fuoguangshan Haiqin Temple, Pengxing Boao Resort, and Green Land Xuhui District Residential Community. His completed projects include Want Want Group Headquarters, Shanghai-Nanjing High Speed Rail Huishan Station, West Shanghai Holiday Inn, Champs-Elysees Apartment, Goldfield Green Villa-Fengqing Street, Kunming University of Science and Technology, and Walsin Group Hexi New Town Development Plan.

Mr. Yeh-Chin Hsu was born in 1959. He graduated from Dong-Hai University School of Architecture in Taiwan in 1983. Mr. Hsu obtained his Master Degree in Architecture and Urban Design from Harvard University in the United States. He received admission as a doctoral candidate from Massachusetts Institute of Technology in the United States in 1993. From 1994 to 2002, he worked as a Partner at Cosmos Inc. Planning & Design Consultants and as a Managing Director at Fei & Cheng Associates. He joined ARTECH Architects in 2002 and became a Partner for ARTECH Shanghai Office in charge of urban design and planning projects, and business development in China.

Mr. Hsu has over 20 years of experience in urban design and city planning. He has worked on many prominent design and planning projects for different counties and cities. His current major projects include Urban Design for Shanghai-Nanjing Inter-city Railway Huishan Station Special District, Master Plan for the Auto-City, and Master Plan and Control Plan for Xinjin Garden City. His completed projects include Master Plan for Jiangwan-Wujiaochang Sub-City center of Shanghai, Taiwan High Speed Rail Taichung Station, Chiayi Station, Tainan Station Master Plan, and Chung Shing Village Master Plan.

Mr. Wen-Hong Chu was born in 1965. He graduated from National Cheng Kung University School of Architecture in 1987 and obtained his Master of Architecture from the University of California, Berkeley in 1993. Mr. Chu worked for Bobrow, Thomas & Associates in the United States, as a Principal of Tongji ES Shanghai Office and as an Associate Principal of Environmental Design Services (EDS). He also taught at Tongji University in Shanghai and at the National Taipei University of Technology Graduate School of Urban Design. He joined ARTECH Architects in 2009 and became a Partner of ARTECH Shanghai Office in charge of architectural design and business development in China.

Mr. Chu has almost 20 years of professional experience in many types of architectural design, planning and urban design projects. He has participated in and led several remarkable projects such as City of Hope Medical Center, National Yang-Ming University Library and Information Center, NTU New Chemistry Building, Academia Sinica Agricultural Science Building, and Porsche Centre in Qingdao. His works have received awards from Taiwan Architect Magazine and he was nominated for the Far Eastern Architectural Design Award. He has done much research on large-scale development projects and the design and planning of medical and biotechnology research facilities.

BIOGRAPHIES

*Principals, Directors
and Associates*

JUN-REN CHOU PRINCIPAL
ARTECH TAIPEI

KUO-CHIEN SHEN PRINCIPAL
ARTECH TAIPEI

Mr. Jun-Ren Chou was born in 1965. Mr. Chou graduated with an Architectural Construction Major from the Hwa Hsia Institute of Technology in 1987 and obtained his Bachelor of Architecture at National Taipei University of Technology in 2001. During the period from 1989 to 2001, he worked as a Construction Site Manager for Hui An Construction Corporation, as a Real Estate Audit Engineer in the Sales Department of Fubon Real Estate Management Corporation, and as a Construction Site Manager for HOA Architects & Engineers. He joined ARTECH Architects in 2001, and has brought ARTECH's projects to another level of perfection. His good work has been affirmed in the professional field, and he became a Principal of the firm in 2010.

Mr. Chou specializes in construction communication and coordination, budget control and planning, schedule control, and the overall coordination between design drawings and construction. The current projects that are under his construction management and monitoring include China Steel Corporation Headquarters and Meridian Hotel and Office Complex. The projects he has completed include Lanyang Museum, Kelti Center, Shih Chien University Gymnasium and Library, and Taiwan High Speed Rail Hsinchu Station.

Mr. Kuo-Chien Shen was born in 1973. Mr. Shen received his Masters of Arts in Applied Arts at National Chiao-Tung University in 2000, and subsequently joined Peter Eisenman Architects in New York. In 2001, he received the Phillips/NTIO Scholarship to study at the Berlage Institute in the Netherlands. He earned his Master of Excellence in Architecture in 2003. He has won numerous prizes including the Far Eastern International Digital Architectural Design Award for his personal project and Italy's Virtual Museum Design Competition. He has been teaching design courses at the National Chiao-Tung University Graduate School of Architecture and the Tunghai University Graduate School of Architecture since 2004. He joined ARTECH Architects in 2004 and was promoted to the position of Principal in 2010.

Mr. Shen's current projects include Taiwan Traditional Performing Arts Center, National Museum of Prehistory in Tainan, Pingtung Performing Arts Center, Yulon Corporation Headquarter, and Shuangsi Villa. His completed projects include Kelti Center. The various competitions he has been involved in include Taipei Performing Arts Center, Weiwuying Performing Arts Center, National Palace Museum Southern Branch, and National Art Museum of China, Beijing.

FEI-CHUN YING DESIGN DIRECTOR
ARTECH SHANGHAI

Mr. Fei-Chun Ying was born in 1968. He graduated from the Architecture School of National Cheng Kung University in 1991 and obtained his Master of Architecture degree in Architectural Design at the Bartlett School of Architecture, University of London in 1997. Mr. Ying is a licensed architect in Taiwan. In the period between 1998 and 2000, he worked at Huang, Chang & Associates/Architects and taught in the Spatial Design Department of Shih Chien University in Taiwan. He joined ARTECH Architects in 2000 and worked as a Project Designer for architectural design and planning projects. He then became a Design Director of ARTECH Shanghai Office in 2006.

Mr. Ying specializes in architectural design and planning for residential, office, commercial, institutional, art and cultural, and transportation buildings. His current major projects include Din-Shin Group Headquarters Building, 1788 Nanjing Road West, Shanghai, Nanjing Walsin Group Commercial Complex, and Tianjin Binhai Yujiapu Financial District Office Tower. His completed projects include Kunming University of Science and Technology, Huashan Square, Yuan Ze University, Taiwan High Speed Rail Hsinchu Station, Lanyang Museum, Quanta Research and Development Center, and La Biennale di Venezia 8th International Architecture Exhibition Taiwan Pavilion – NEXIT.

KASAN LEE ASSOCIATE PRINCIPAL
ARTECH TAIPEI

Mr. Kasan Lee was born in 1967 and graduated from Chung Yuan Christian University with a Bachelor of Architecture degree in 1992. From 1994 to 2006, Mr. Lee worked as a Designer for Lin Ji-Yao Architects, and as a Design Project Manager for Wei Hom-tai Architects, Chen Chong-Yi Architects, and Archasia Design Group. He joined ARTECH Architects in 2007. His extensive experience in participation and design execution of diverse types of projects such as housing, shopping malls, hospitals, gymnasiums, industrial buildings, exhibition centers, and local community centers has led him to become an Associate Principal at ARTECH Architects.

Mr. Lee specializes in architectural design and planning, construction detail planning, communication and project execution, and construction site coordination. His current major projects include Taipei Performing Arts Center, Far Eastern Banciao Shopping Center, Prince Housing & Development Xinyi Residential Tower, Cathay Hangzou N Rd. Residential Tower, and LE Office Tower. His completed projects include The Cypress Court.

DAVID CHANG ASSOCIATE
ARTECH TAIPEI

Mr. David Chang was born in 1969 and graduated from Nanya Institute of Technology with a major in Architectural Construction. From 1992 until 2002, Mr. Chang worked as a Construction Engineer at Cheng Sheng Construction Corporation and as an Architectural Construction Project Specialist at Pacific Construction Corporation. He joined ARTECH Architects in 2002. Due to his extensive years of experience with construction management, planning, and administration, and his great performance at the firm, he became an Associate at ARTECH Architects in 2010.

Mr. Chang specializes in construction coordination, management, planning, and administration. The current major projects that are under his construction management and monitoring include Meridian Hotel and Office Complex, Far Eastern Banciao Shopping Center & Office Tower, Fubon 777 Residence Tower, Taiwan Life Insurance Financial Headquarters, and Dharma Drum University. His completed projects include Kelti Center, Far Eastern Telecomm Park, Silks Palace National Palace Museum, WK Technology Headquarters, Tongshan Residence Tower, Hua Hsing High School, Guang Ren Catholic Elementary School, and Quanta Research and Development Center.

BIOGRAPHIES

YI-LIN CHOU ASSOCIATE
ARTECH TAIPEI

SHIH-KUO YANG ASSOCIATE
ARTECH SHANGHAI

GRACE LIN ASSOCIATE
ARTECH TAIPEI

Mr. Yi-Lin Chou was born in 1976. Mr. Chou graduated with a Bachelor of Architecture and Urban Design from Chinese Culture University in Taiwan in 1998, and later obtained his Master of Architecture from the University of East London in the United Kingdom. From 1998 to 2001, he worked as a Design Architect at Fei & Cheng Associates. He joined ARTECH Architects in 2003. With his accumulated years of experience in overall project design and planning, he became an Associate of the firm in 2010.

Mr. Chou specializes in project administration, design development, detail design, and high-rise office building design. His current major projects include United Daily News Group Office Tower and Hua Nan Bank Headquarters. His completed projects include Far Eastern Telecomm Park, Yuan-Ze University Library Project, Hua Hsing High School, and D-Housing Apartment. He has also participated in various design competition projects including the Taiwan Pavilion at Shanghai World Expo, MRT Airport Line – Taipei Transfer Building, and National Palace Museum Southern Branch.

Mr. Shih-Kuo Yang was born in 1973. He received his Bachelor of Architecture from Tunghai University in Taiwan in 1997 and a Master of Architecture from Tunghai University in 2000. Mr. Yang worked as a Design Architect at Fei & Cheng Associates. He joined ARTECH Architects in 2002 and became an Associate at ARTECH Shanghai Office due to his rich experience in diverse types of projects.

Mr. Yang has extensive experience in residential, commercial, and retail architectural design, and in overall planning. His current major projects include Fo Guang Shan Dajue Temple, Fuo Guang Shan Haiqin Temple, Pengxing Boao Resort, and COB Majestic City. He has completed projects such as DongXi Intensive Agriculture Technology Research Center, SYNNEX High-Tech Logistic Service Center, Goldfield Green Villa Residential Tower, Goldfield Green Villa-Fengqing Street, the Expansion Site of Gejiu No.1 Middle School Master Plan, and Tianjin Port Free Trade Zone Residential District. He has also worked on many design competitions including Shanghai Fisheries University Campus Plan and Kumning Iron & Steel Corporation Headquarters.

Ms. Grace Lin was born in 1975. Ms. Lin graduated from the University of California at Berkeley with a Bachelor of Arts degree in Architecture in 1997, and received a Master of Architecture degree from Columbia University in 2001. She is a licensed architect in New York and a LEED Accredited Professional. From 1997 to 2006, she worked as a Design Architect for STV Incorporated in New York and Hisaka Associates in Berkeley. She joined ARTECH Architects in 2006. Her great performance in management, communication and project execution led to her promotion to Associate of the firm in 2010.

Ms. Lin specializes in design concepts, schematic design, project coordination and administration, performing arts and high-rise office building design. Her current key projects include Taiwan Traditional Performing Arts Center, Taipei Performing Arts Center, and A3 complex. Her completed projects include Kelti Center. She has also participated in many design competition projects including Taiwan Pavilion of Shanghai World Expo and National Art Museum of China, Beijing.

QING-FANG YANG ASSOCIATE
ARTECH SHANGHAI

ALBERT LIU ASSOCIATE
ARTECH TAIPEI

PEI-XUN XIE ASSOCIATE
ARTECH SHANGHAI

Ms. Qing-Fang Yang was born in 1967 and received a Bachelor of Architecture from Feng Chia University in Taiwan in 1991. From 1991 to 2006, Ms. Yang worked as a Design Architect at Huang Shi Ping Architects, UTECH, and completed individual projects such as Songjing LOMO Commercial Development in Shanghai. She joined ARTECH Shanghai Office as an Associate in 2007.

Ms. Yang specializes in retail architectural design and planning, overall planning, and project management. Her current major projects include Tianjin Binhai Yujiapu Financial District Office Tower, Kunming University of Science and Technology (Phase IV), Jiading Residential Community, and Huashin Group Office Tower. She has completed projects such as Kunming University of Science and Technology. She has also participated in design competition projects such as Walsin Group Hexi New Town Development Plan.

Mr. Albert Liu was born in 1978. In 1999, Mr. Liu graduated from Hwa Hsia Institute of Technology with a major in Architecture and obtained a Bachelor of Architecture from National Taiwan University of Science and Technology in 2001. He passed the Taiwan National Examination for Architect in 2007. Between 2001 and 2007, he worked as a Design Architect for Audi International Interior Design, Collins Planning & Design Consulting, and Ricky Liu & Associates. He joined ARTECH Architects in 2007. His passionate and eager attitude together with his excellent skills in project execution led him to become an Associate of the firm in 2010.

Mr. Liu specializes in project coordination and administration, building codes, construction documentation, residential design projects, and school campus planning. His current major projects include Dharma Drum University, Square Land Development S Rd. Residential Tower, Kenting Resort Hotel, Tashee Residential Project, and Far Eastern Xinyi Shopping Center. His completed projects include Chiaokuo Residential Tower and ACME Toufen R&D Center.

Ms. Pei-Xun Xie was born in 1976. Ms. Xie graduated from National Taiwan University with a major in Landscape Design and obtained her Master of Landscape Architecture from the University of Pennsylvania in 2002. Between 2003 and 2006, she worked at Old Farmer Landscape Architecture Corporation Shanghai Office. She joined ARTECH Shanghai Office in 2007 and became an Associate of the firm in 2009.

Ms. Xie specializes in all types of landscape design and planning as well as project administration and management. Her current major projects include Landscape Design for Shanghai-Nanjing Inter-city Railway Huishan Station Plaza, Landscape Design for Fuyang River Waterfront, and Landscape Design for Shanghai Bailemen Hotel. She has completed projects such as Landscape Design for Schools of Applied Technology, Kunming University of Science, and Technology Chenggong Campus.

CHRONOLOGICAL LIST OF BUILDINGS AND PROJECTS 1985–2009

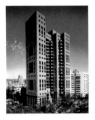

JEN AI TOWER
LOCATION TAIPEI, TAIWAN

COMPLETED 1989

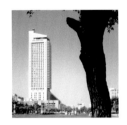

THE LINDEN HOTEL
LOCATION KAOHSIUNG, TAIWAN

COMPLETED 1994

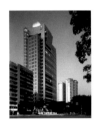

FUBON BANKING CENTER
LOCATION TAIPEI, TAIWAN
COLLABORATING ARCHITECTS
SOM LOS ANGELES

COMPLETED 1995

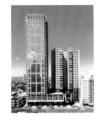

SHENG YANG CONDOMINIUM
LOCATION TAIPEI, TAIWAN

COMPLETED 1999

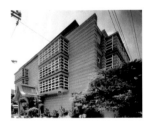

**BUDDHIST TZU CHI FOUNDATION
ASSEMBLY HALL**
LOCATION TAICHUNG, TAIWAN

COMPLETED 1992

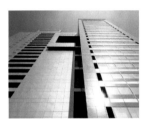

**FUBON KAOHSIUNG OFFICE
BUILDING**
LOCATION KAOHSIUNG, TAIWAN

COMPLETED 1997

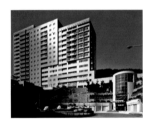

SHENG YANG CONDOMINIUM
LOCATION TAIPEI, TAIWAN

COMPLETED 1996

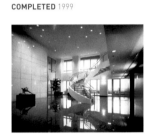

**FUBON BANKING CENTER,
EXECUTIVE FLOOR**
LOCATION TAIPEI, TAIWAN

COMPLETED 1996

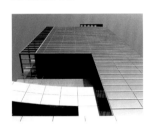

FUYANG TOWER
LOCATION TAIPEI, TAIWAN

COMPLETED 1996

HUI YU BOULEVARD TOWER
LOCATION TAICHUNG, TAIWAN

COMPLETED 1994

TUNG HWA UNIVERSITY FACULTY CLUB
LOCATION HUALIEN COUNTY, TAIWAN

COMPLETED 1995

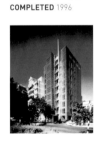

225 TUNG HWA SOUTH ROAD
LOCATION TAIPEI, TAIWAN

COMPLETED 1996

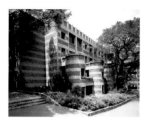

WEIGO ELEMENTARY SCHOOL II
LOCATION TAIPEI, TAIWAN

COMPLETED 1990

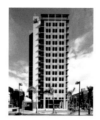

**FUBON LIFE INSURANCE CO.,
HEADQUARTERS**
LOCATION TAIPEI, TAIWAN

COMPLETED 1999

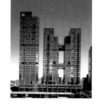

SKYCITY TOWER
LOCATION TAIPEI COUNTY, TAIWAN

COMPLETED 1995

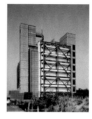

YAGEO CORP. KAOHSIUNG PLANT II
LOCATION KAOHSIUNG, TAIWAN

COMPLETED 1997

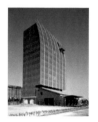

B.G.C. BUILDING
LOCATION TAICHUNG, TAIWAN

COMPLETED 1999

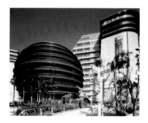

**BUDDHIST TZU CHI FOUNDATION
ASSEMBLY HALL**
LOCATION TAIPEI, TAIWAN

DESIGN PROJECT

CORE PACIFIC CITY
LOCATION TAIPEI, TAIWAN
DESIGN ARCHITECT THE JERDE
PARTNERSHIP INTERNATIONAL

COMPLETED 2001

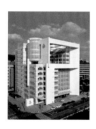

TAIWAN GSM HEADQUARTERS
LOCATION TAIPEI, TAIWAN

COMPLETED 2001

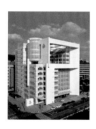

COMPAL HEADQUARTERS
LOCATION TAIPEI, TAIWAN

COMPLETED 1999

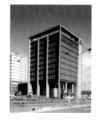

NY²
LOCATION TAIPEI, TAIWAN

COMPLETED 2000

MITAC HEADQUARTERS
LOCATION TAIPEI, TAIWAN

COMPLETED 2000

JI JI ELEMENTARY SCHOOL
LOCATION NANTOU COUNTY, TAIWAN

COMPLETED 2001

CHRONOLOGICAL LIST OF BUILDINGS AND PROJECTS 1985–2009

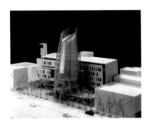

BEITOU CATHOLIC CHURCH
LOCATION TAIPEI, TAIWAN

COMPETITION

DINGHOW 921 MEMORIAL PLAZA
LOCATION TAIPEI, TAIWAN

COMPLETED 2000

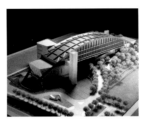

**ETHON-MUSIC CENTER DESIGN
COMPETITION**
LOCATION TAIPEI, TAIWAN

COMPETITION FIRST PRIZE

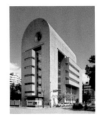

**NATIONAL WOMEN'S LEAGUE
HEADQUARTERS**
LOCATION TAIPEI, TAIWAN

COMPLETED 2003

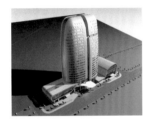

DBTEL HEADQUARTERS
LOCATION SHANGHAI, CHINA

DESIGN PROJECT

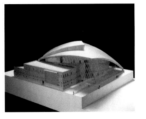

**THE ROYAL THEATER, NEW
PLAYHOUSE ON THE COPENHAGEN
WATER FRONT**
LOCATION COPENHAGEN, DENMARK

COMPETITION

**DONG CHENG INTERNATIONAL
CENTER**
LOCATION NANJING, CHINA

COMPETITION

FO GUANG SHAN NAN TAI TEMPLE
LOCATION TAINAN, TAIWAN

COMPLETED 2006

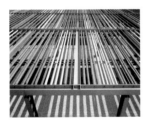

HUA HSING HIGH SCHOOL
LOCATION TAIPEI, TAIWAN

COMPLETED 2006

**WANT WANT GROUP
HEADQUARTERS**
LOCATION SHANGHAI, CHINA

COMPLETED 2008

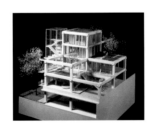

**ACCTON TECHNOLOGY CORPORATION
HEADQUARTERS**
LOCATION HSINCHU COUNTY, TAIWAN

COMPETITION FIRST PRIZE

**COMMERCIAL CENTER, YANGPU
PARCEL NO.2 INTERNATIONAL
DESIGN COMPETITION**
LOCATION SHANGHAI, CHINA

COMPETITION

**CONCEPTUAL PLAN FOR HONGKOU
EAST BUND GATEWAY**
LOCATION SHANGHAI, CHINA

URBAN PLANNING & DESIGN

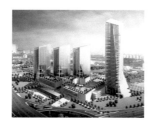

**GUANGZHOU NANSHA BUSINESS
CENTER**
LOCATION GUANGZHOU, CHINA

COMPETITION FIRST PRIZE

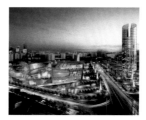

**MASTER PLAN FOR JIANGWAN-
WUJIAOCHANG SUB-CITY CENTER
OF SHANGHAI**
LOCATION SHANGHAI, CHINA

URBAN PLANNING & DESIGN

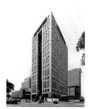

**MERIDIAN HOTEL AND OFFICE
COMPLEX**
LOCATION TAIPEI, TAIWAN

COMPLETED 2010

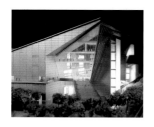

TAIPEI NANGANG EXHIBITION CENTER
LOCATION TAIPEI, TAIWAN

COMPETITION

TONGSHAN RESIDENTIAL TOWER
LOCATION TAIPEI, TAIWAN

COMPLETED 2007

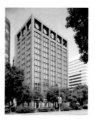

YUANTA FINANCIAL TOWER
LOCATION TAIPEI, TAIWAN
ARCHITECT OF RECORD
TMA ARCHITECTS & ASSOCIATES

COMPLETED 2007

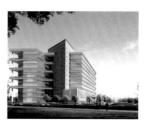

FAR EASTERN TELECOM PARK
LOCATION TAIPEI COUNTY, TAIWAN

COMPLETED 2010

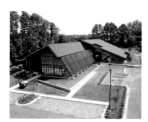

**FO GUANG SHAN MONASTERY,
NORTH CAROLINA**
LOCATION NORTH CAROLINE, US

COMPLETED 2008

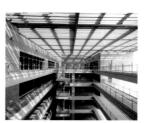

**LITE-ON IT RESEARCH &
DEVELOPMENT CENTER**
LOCATION HSINCHU, TAIWAN

COMPLETED 2006

MERCK LIQUID CRYSTAL CENTER
LOCATION TAOYUAN COUNTY, TAIWAN

COMPLETED 2005

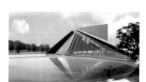

**SUANG-LIEN PRESBYTERIAN
CHURCH SANZHI CHAPEL
COMPETITION**
LOCATION TAIPEI COUNTY, TAIWAN

COMPETITON

CHRONOLOGICAL LIST OF BUILDINGS AND PROJECTS 1985–2009

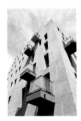

THE FIRST SOCIAL WELFARE FOUNDATION
LOCATION TAIPEI, TAIWAN

COMPLETED 2009

URBAN DESIGN FOR XING HAI BAY CBD
LOCATION SHENGYANG, CHINA

URBAN PLANNING & DESIGN

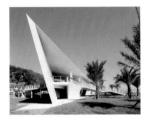

WUSHIH BEACH PAVILION
LOCATION YILAN COUNTY, TAIWAN

COMPLETED 2007

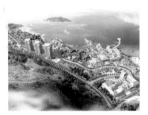

CONCEPTUAL PLAN FOR WEIHAI BINHAI BEACH RESORT DEVELOPMENT
LOCATION SHANDONG, TAIWAN

URBAN PLANNING & DESIGN

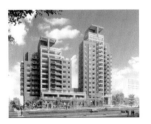

FUBON 777 RESIDENTIAL TOWER
LOCATION TAIPEI, TAIWAN

TO BE COMPLETED IN 2011

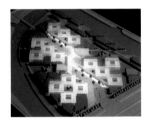

PROJECT N PHARMACEUTICAL RESEARCH AND DEVELOPMENT FACILITY COMPETITION
LOCATION SHANGHAI, CHINA

COMPETITION

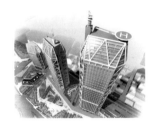

TAIPEI MRT AIRPORT LINK (DA115)
LOCATION TAIPEI, TAIWAN
COLLABORATING ARCHITECTS
RICHARD ROGERS PARTNERSHIP

COMPETITION SECOND PRIZE

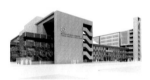

CHING SHIN ELEMENTARY & MIDDLE SCHOOL
LOCATION TAIPEI, TAIWAN

TO BE COMPLETED IN 2012

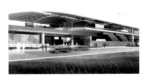

TIAA MRT SYSTEM
LOCATION TAOYUAN COUNTY, TAIWAN

TO BE COMPLETED IN 2012

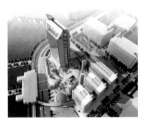

CHINATRUST COMMERCIAL BANK
LOCATION TAIPEI, TAIWAN
COLLABORATING ARCHITECTS
RICHARD ROGERS PARTNERSHIP

COMPETITION SECOND PRIZE

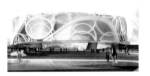

SHANGHAI WORLD EXPO COMPETITION
LOCATION SHANGHAI, CHINA

COMPETITION

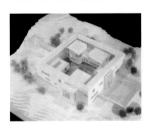

SHUANGSI VILLA
LOCATION TAIPEI COUNTY, TAIWAN

TO BE COMPLETED IN 2012

TAIWAN HAKKA CULTURE CENTER COMPETITION
LOCATION MIAOLI COUNTY, TAIWAN

COMPETITION

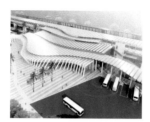

TAIWAN HIGH SPEED RAIL YUNLIN STATION
LOCATION YUNLIN COUNTY, TAIWAN

TO BE COMPLETED IN 2015

TAIWAN NEXT-GENE AO-DI GRAND LAND ARCHITECTURE INTERNATIONAL PROJECT
LOCATION TAIPEI COUNTY, TAIWAN

DESIGN STAGE

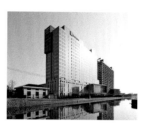

WEST SHANGHAI HOLIDAY INN
LOCATION SHANGHAI, CHINA

COMPLETED 2009

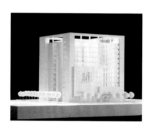

WINBOND JHUBEI OFFICE BUILDING
LOCATION HSINCHU COUNTY

DESIGN PROJECT

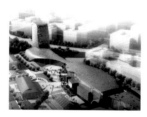

CONCEPTUAL PLAN FOR WORLD HEADQUARTERS ECONOMIC FORUM - YANGPU DISTRICT PLOT 1
LOCATION SHANGHAI, CHINA

URBAN PLANNING & DESIGN

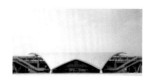

SHANGHAI-NANJING HIGH SPEED RAIL HUISHAN STATION
LOCATION WUXI, CHINA

TO BE COMPLETED IN 2010

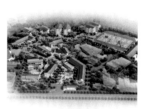

XIUSHUI ELEMENTARY SCHOOL
LOCATION SICHUAN, CHINA

TO BE COMPLETED IN 2010

YULON / HTC CORPORATION TWIN TOWER
LOCATION TAIPEI COUNTY, TAIWAN

COMPETITION FIRST PRIZE

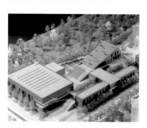

KINMEN INSTITUTE OF TECHNOLOGY STUDENT CENTER
LOCATION KINMEN COUNTY, TAIWAN

TO BE COMPLETED IN 2012

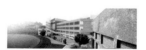

TAS FACILITIES DEVELOPMENT PROJECT
LOCATION TAIPEI, TAIWAN

TO BE COMPLETED IN 2012

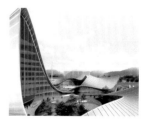

YUNNAN CULTURAL PARK
LOCATION YUNNAN, CHINA

TO BE COMPLETED IN 2012

CHRONOLOGICAL LIST OF BUILDINGS AND PROJECTS 1985–2009

1985

AMC Headquarters Taipei - Interior Design - Completed

Cathay Condominium Taipei - Consultancy Project

Far Eastern Training Center Hsinchu - Interior Design - Completed

Grand Formosa Regent Taipei - Completed

Great Taipei New Town Cluster Housing Taipei - Consultancy Project

Hung-Tai Minsheng Condominium Taipei - Completed

Hung-Tai Royal Garden Condominium Taipei - Completed

Li Yang Company Taipei - Interior Design Project

San Jiu Condominium Taichung - Completed

Tainan Tuntex City Department Store Tainan - Interior Design - Completed

Taiwan Cooperative Bank Branch Office Taipei - Interior Design - Completed

Weigo Elementary School Taipei - Completed

Zebra Restaurant Tainan - Completed

1986

Cogito Corp. Taipei - Interior Design - Completed

Continental Community Taipei County - Planning & Urban Design Project

Far Eastern Department Store Taichung - Interior Design - Completed

Far Eastern Department Store Tainan - Interior Design - Completed

Far Eastern Department Store Jen-Ai Branch Taipei - Interior Design - Completed

Far Eastern Department Store Main Store Taipei - Interior Design - Completed

Hung-Tai East Lake Condominium Taipei - Consultancy Project

Hung-Tai Hsin-Yi Condominium Taipei - Completed 1999

National Taiwan University Women's Dormitory Competition Taipei - Competition

Oriental Institute of Technology Conference Center Taipei County - Interior Design - Completed

San Jiu Condominium II Taichung - Completed

Taiwan Television Enterprise Taipei - Interior Design Project

Yuan-Ze Kindergarten Taipei County - Interior Design - Completed

Yuan-Ze University College of Engineering Taoyuan County - Completed

1987

Cathay Condominium Taipei - Completed

Cathay East Asia Hotel Competition Taipei - Competition

Hsin Yi Foundation Taipei - Interior Design - Completed

Jen Ai Tower Taipei - Completed 1989

Kee Tai Condominium Taipei - Completed

Kong Cheng Office Building Taipei - Consultancy Project

Kong Cheng Securities Branch Taipei - Completed

Kong Cheng Securities Co. Ltd. Taipei - Interior Design - Completed

Ming Qiao Building Taipei - Completed

National Taiwan University College of Engineering Taipei - Competition

National Taiwan University Dormitory Taipei - Completed 1992

Pacific Place Condominium Taipei - Completed 1989

Tian Long Office Building Taipei - Completed

Weigo Elementary School II Taipei - Consultancy Project

Xing Wu Office Building Taipei - Consultancy Project

1988

Asia Securities Taipei - Interior Design - Completed

Bull Dog Restaurant Taipei - Interior Design - Completed

Cathay Commercial Building Kaohsiung - Design Project

Cathay Condominium Taipei County - Design Project

Cathay International Plaza Kaohsiung - Design Project

Cathay Mix-Use Development Tainan - Design Project

Continental Hsindien Condominium A Taipei County - Completed 1991

Continental Hsindien Condominium C Taipei County - Completed 1995

Far Eastern Textile Factory Taoyuan County - Consultancy Project

Grand Hyatt Taipei - Interior Design - Completed

Kindom Condominium Taipei - Completed 1992

Kong Cheng Condominium Taipei - Completed

Lai Lai Department Store Taichung - Interior Design - Completed

Oriental Hospital II Taipei County - Consultancy Project

Taiwan Business Center Taichung - Completed

Ta Tsung Condominium Taichung - Completed

The Linden Hotel Kaohsiung - Completed 1994

Trans Universe Investment Taipei - Interior Design - Completed

United European Bank Taipei - Interior Design - Completed

1989

Continental Dan Shui Condominium Taipei County - Design Project

Far Eastern Hanson Road Taipei County - Competition

Collaborating Architects: SOM

Architect Journal Award 1996

Fubon Banking Center Taipei - Completed 1995

Collaborating Architects: SOM

Honor Award, The 18th Chinese Architect Journal Award 1996

Fubon Hsinsun Condominium Taipei - Completed 1992

Honorable Mention The 18th Chinese Architect Journal Award 1995

Fubon Office Building Taipei - Completed 1997

Kee Tai Daj Condominium Taipei - Completed 1993

Kuang-Du Sheng Yang Hill Town Taipei County - Completed 1993

Landis Hotel and Office Complex Taichung - Completed 1994

Pacific Hotel Kota Kinabalu Sabah - Consultancy Project
Sheng Yang Banking Center Taipei - Completed 1995
Sheng Yang Condominium Taipei - Completed 1999

1990

Buddhist Tzu Chi Foundation Assembly Hall Taichung - Completed 1992
Honorable Mention, The 18th Chinese Architect Journal Award 1995
Condominium Tower Fuzhou - Design Project
Fubon Kaohsiung Office Building Kaohsiung - Completed 1997
Guo Yang Condominium Taipei - Design Project
Guo Yang Securities Building Taipei - Completed
Pacific Green Bay Resort Condominium Taipei County - Completed
Ring Road Redevelopment Taipei - Planning & Urban Design Project
Tak Ming Institute Of Technology Taipei - Consultancy Project
UWCC Bank Taipei - Completed

1991

ARTECH International Hong Kong Office Hong Kong - Interior Design - Completed
Asia Cement Headquarters Taipei - Interior Design - Completed
China Life Insurance Headquarters Taipei - Design Project
Far Eastern International Bank Taipei - Interior Design Completed
Far Eastern International Bank Taipei Branch Taipei - Interior Design - Completed
Fuyang Condominium Taipei County - Completed
Goldsun Condominium Taichung - Completed
Jing Zhan Condominium II Taichung - Completed
Kee Tai Condominium Taipei - Consultancy Project
Kindom Condominium Taipei - Completed
Prince Condominium Tainan - Completed
Prince Housing Condominium Taoyuan County - Completed
Sheng Yang Condominium Taipei - Completed 1996
Tainan Municipal Social Education Hall Competition Tainan - Competition
The Far Eastern Headquarters Taipei - Interior Design - Completed
Collaborating Architects: Gensler Associates
Tong Ren Yuen Condominium Taipei - Completed
Zhong Fu Hotel Hsienyang - Consultancy Project

1992

De Jie Condominium Taipei - Completed
Far Eastern Textile Commercial Building Hsinchu - Consultancy Project
Fubon Banking Center Executive Floor Taipei - Interior Design - Completed 1996
Fuyang Tower Taipei - Completed 1996

Hui Yu Boulvard Tower Taichung - Completed 1994
Landis Hotel and Office Complex Taichung - Interior Design Project
Mckinsey & Company Inc. Taipei - Interior Design - Completed
New York Bank Taipei Branch Taipei County - Interior Design Project
OMNI Hotel Hong Kong - Interior Design - Completed
Railroad Building Competition, Kowloon Hong Kong - Competition
The Linden Hotel Kaohsiung - Interior Design - Completed
Tung Hwa University College Of Science Hualien County - Completed 1996
Tung Hwa University Faculty Club Hualien County - Completed 1995
Tung Hwa University Graduate Student Housing Hualien County - Completed 1996
Honorable Mention, The 18th Chinese Architect Journal Award 1996
UWCC Bank Taichung County - Completed
Wanchai Tower Hong Kong - Completed
West Island Hotel Hangchow - Consultancy Project
Collaborating Architects: KPF
Xi-Hu International Hotel Hangchow - Consultancy Project

1993

225 Tung Hwa South Road Taipei - Completed 1996
Acer Community Taoyuan - Planning Project
Cathay Tanshui Condominium II Taipei County - Completed
Fubon Naihu Condominium Taipei - Completed 1999
H.K. Industry Office Building Hong Kong - Consultancy Project
Hong Kong Hotel Kowloon Hong Kong - Interior Design Project
Hua Shan Road Condominium Shanghai - Consultancy project
Hui Yu Condominium Taichung - Completed
Hung Pu Shijr Condominium Taipei - Completed
Koos Real Estate Office and Condominium Complex Taipei County - Design Project
National Pre-Historical Museum Competition Taitung - Competition
NOVELL Inc. Taipei - Interior Design - Completed
Pacific Green Bay Resorts Club House Taipei - Completed
Pacific Green Bay Resorts Residential Development Taipei County - Consultancy Project
Passageway of Weigo Middle School Taipei - Completed 1996
Saatchi & Saatchi Advertising Taipei - Interior Design - Completed
Tsai's Residence Taoyuan - Completed
United Government Office Building Taipei - Competition
Weigo Elementary School II Taipei - Completed

1994

166 Electric Road Hong Kong - Consultancy Project
Cheng-Gong University Main Library Competition Tainan - Competition

CHRONOLOGICAL LIST OF BUILDINGS AND PROJECTS 1985–2009

Continental Engineering Corporation Headquarters Taipei - Completed 1999

Honorable Mention, The Taiwan Annual Architecture Award 1999

Dzogchen Monastery Szuchuan - Design Project

Eslite Book Store Flagship Store Taipei - Interior Design - Completed

Fubon Condominium Complex Taipei - Completed 1997

Fubon Life Insurance Co. Headquarters Taipei - Completed 1999

Green Lake Garden Condominium Beijing - Completed

Hua Tai Hotel Keelung - Design Project

Kindom Condominium Taipei - Completed 1995

Li Chong Elderly Nursing Home Hong Kong - Completed 1998

New Taipei Residential Development Taipei County - Planning Project

Shining Park Tower Taichung - Design Project

Collaborating Architects: P.C.F.

SkyCity Tower Taipei County - Completed 1995

Taipei Youth Center Competition Taipei - Competition

The Village Taipei County - Completed 2000

1995

Chinese Petroleum Headquarters Competition Taipei - Competition

Chung Hsiao East Road Pedestrian Sidewalk ReDesign Taipei - Urban Design Project

Der Chao Retail Complex Taipei - Design Project

Fu Cheng Housing Project Taoyuan - Completed

Fu Tsu Construction Co. Taipei - Interior Design - Completed

Luminary Buddhist Center Taichung - Completed 1998

First Prize, The Taiwan Annual Architecture Award 1999

Shin Shen Cineplex Taipei - Completed 2000

Yageo Corp. Kaohsiung Plant II Kaohsiung - Completed 1997

Yuanta Condominium Taipei - Completed 1997

Yuan-Ze University Main Library Taoyuan County - Completed 1998

Honor Award, The 20th Chinese Architect Journal Award 1998

1996

B.G.C. Building Taichung - Completed 1999

Buddhist Tzu Chi Foundation Assembly Hall Taipei - Design Project

Children's Museum Taipei - Design Project

Core Pacific City Taipei - Completed 2001

Design Architect: The Jerde Partnership International

Architect of Record: ARTECH Architects

HCG Headquarters Taipei - Design Project

Hung Kuo Hsinchung Condominium Taipei - Completed

Hung Kuo Naihu Condominium Taipei - Completed

Long Bon Tienmou Residential Building Taipei - Completed 1998

National Research Center for the Preservation of Culture and Resources Tainan - Competition

P Residence Taipei - Completed 1999

Royal Hotel Hsinchu - Completed 1998

Tainan Arts University College of Sound and Image Arts Tainan - Completed 1998

Taiwan GSM Headquarters Taipei - Completed 2001

1997

Compal Headquarters Taipei - Completed 1999

Delpha Der-Hui Building Taipei - Completed 2001

Fubon Banking Center Kaohsiung - Interior Design - Completed

IT Building Taipei - Design Project

Landis Hotel and Office III Taichung - Consultancy Project

Lite-On Headquarters Taipei - Completed 2002

Long Bon Condominium Kuala Lumpur - Consultancy Project

Nin-Nan New District Planning Development & Urban Design Nanjing - Competition

No.14 & 15 City Park Planning Taipei - Consultancy Project

NY² Taipei - Completed 2000

Schal Bovis Office Shanghai - Interior Design - Completed

Taipei National Banking Center Taipei Competition

Collaborating Architects: SOM

Traditional Arts Center Yilan County - Competition

Wisdom Compassion Exhibition of Buddhist Art at Taipei - Exhibit Design Project

Yageo Corp. Suzhou Industrial Complex Suzhou - Completed 1998

1998

Da-Cin Headquarters Taipei - Design Project

Delpha Min-Chuan Tower Taipei - Completed 2001

Dharma Drum University Taipei County - To Be Completed in 2011

First Prize, Dharma-Drum University Campus Design Competition

Dr. Sun Yat-sen Memorial Hall Zhong Shan Gallery Taipei - Interior Design - Completed

Federal Office Building Taipei - Completed

Himalayas Foundation Taipei - Interior Design Project

Hung-Sheng Fu Lin Condominium Taipei - Planning Stage

Hung Yang Condominium Taipei - Design Project

IT Office Taipei - Interior Design - Completed

Lot A-1 Tower Taipei - Design Project

Collaborating Architects: SOM

MITAC Headquarters Taipei - Completed 2000

Performance Workshop Taipei - Design Project

Premier Headquarters Taipei - Completed 2002

President International Tower Competition Taipei - Competition

Collaborating Architects: Daniel, Mann, Johnson & Mendenhall

SET TV Headquarters Taipei - Completed 2002
Shin Min High School Music Center Taichung - Completed 2000
USI Office Building Taipei - Completed 2000

1999

Cathay Insurance Office Tower Nantou County - Completed 2001
Federal Shopping Center Taoyuan County - Design Project
Ji Ji Elementary School Nantou County - Completed 2001
Ji Ji Middle School Nantou County - Completed 2001
Pacific Village Hotel Hsinchu - Completed 2001
Prince Housing & Development Xinyi Residential Tower Taipei - To Be Completed in 2012
REBAR High-Tech Park Taipei County - Design Project
Shih Chien University College of Design Taipei - Completed 2003
 Honorable Mention, The Taiwan Annual Architecture Award 2003
 First Far East School Campus Architecture Honorary Award 2004
Shih Chien University Tung-Min Memorial Building College of Design Taipei - Completed 2004
Shuang Wen Middle School Nantou County - Completed 2001
Sun Jet Headquarters Taoyuan - Design Project
Taiwan High Speed Rail Hsinchu Station Hsinchu - Completed 2006
 First Prize, High Speed Rail Hsinchu Station Competition
 First Prize, The Taiwan Annual Architecture Awards,
 Taiwan High Speed Rail Hsinchu Station, 2006
 Honorable Mention, Sixth Annual Far Eastern Architectural Design
 Award -Taiwan High Speed Rail Hsinchu Station 2007
The Maitreya Project Bodhgaya - Design Project
Westside Urban Design Asia Design Forum Taipei - Design Project
Yuan-Ze University Administration and Academy Building Taoyuan - Completed 2002
Zhong Liao Middle School Nantou County - Completed 2001

2000

Beitou Catholic Church Taipei - Competition
Cathay Insurance Office Tower Taitung County - Completed 2002
Changho Elementary School Nantou County - Completed 2001
China Life Residential Tower Taipei - Design Project
Dinghow 921 Memorial Plaza Taipei - Completed 2000
Ethon-Music Center Design Competition Taipei - Competition
 First Prize, Ethon-Music Center Design Competition
Everest Office Building Taichung - Design Project
Fu Shin Middle & Primary School Taipei - Completed 2007
Lanyang Museum Yilan County - Completed 2010
 Collaborating Architects: Sun & Associates
 First Prize, Yi-Lan Lan Yan Museum Phase One Development Planning Competition

National Women's League Headquarters Taipei - Completed 2003
Taipei Banking Center Taipei - Completed 2010
The Cypress Court Taipei - Completed 2010
WK Technology Headquarters Taipei - Completed 2008
Y Residence Taipei - Completed 2003

2001

Academia Sinica Overseas Graduate Student Accommodation Taipei - Completed 2005
Champs Elysees Residential Tower Shanghai - Completed 2004
Cheng Hsin Rehabilitation Medical Center Project Taipei - Competition
Da-Ai Television Center Taipei - Completed 2005
DBTEL Headquarters Shanghai - Design Project
DongXi Intensive Agriculture Technology Research Center Jiangsu - Design Project
Earthquake Museum of Taiwan Taichung County - Competition
National Museum of Taiwan Historic Competition Taitung County - Competition
National Tsing Hua University School of Technology and Management Hsinchu - Completed 2005
Office of the President Republic of China (Taiwan) Project
 Taipei - Interior Design - Completed 2003
Quanta Research and Development Center (QRDC) Taoyuan County - Completed 2004
 Honorable Mention, The Taiwan Annual Architecture Award 2005
Ralec Office & Factory Complex Jiangsu - Completed 2003
Shin Nan Zhang Bin Electrical Factory Changhua County - Completed 2005
Sun Ba Power Corp. Fong Der Power Plant Tainan County - Completed 2004
Taipei Zhongshan Hall Project Taipei - Interior Design - Completed 2003
The Royal Theater New Playhouse on the Copenhagen Water Front Competition
 Copenhagen - Competition
Tomihiro Art Museum Competition Japan - Competition
Transpace Technology Office & Factory Complex Jilin - Completed 2005
Tsing Hua University School of Technology and Management Hsinchu - Completed 2005

2002

Buddha Memorial Hall Kaoshiung County - Design Project
Conceptual Plan for Qufu New District Shandong - Urban Planning & Design Project
D-Housing Apartment Taipei - Completed 2007
Dong Cheng International Center Competition Nanjing - Competition
Fo Guang Shan Nan Tai Temple Tainan - Completed 2006
Guang Ren Catholic Elementary School Taipei - Completed 2005
Hua Hsing High School Taipei - Completed 2006
Huashan Square Shanghai - Completed 2008
La Biennale di Venizia - The 8th International Architecture Exhibition
 Taiwan Pavilion – NEXIT Venice - Completed 2002
Mingdong Daoying Residential Tower Taipei - Completed 2006

CHRONOLOGICAL LIST OF BUILDINGS AND PROJECTS 1985–2009

SYNNEX High-Tech Logistic Service Center (Phase I) Shanghai - Completed 2005

Taoran Garden Residential Blocks Beijing - Completed 2004

Tech-Front Overseas' Staff Dormitory Building Shanghai - Design Project

Urban Design for Jining Canal Tourism District

 Shandong - Urban Planning & Design Project

Want Want Group Headquarters Shanghai - Completed 2008

Wenzhou Station Boulevard Condominium Zhejiang - Design Project

2003

Accton Technology Corporation Headquarters Competition Hsinchu - Competition

 First Prize, Accton Technology Corp. Headquarters Competition

Chiao Tung University Guest House Hsinchu - Completed 2007

China Airlines Park Competition Taoyuan County - Competition

Chung Shin Hall Taichung - Design Project

Commercial Center Yangpu Parcel No.2 International Design Competition

 Shanghai - Competition

Conceptual Plan for Ditang Southbank District Zhejiang - Urban Planning & Design Project

Conceptual Plan for Hongkou East Bund Gateway Shanghai - Urban Planning & Design Project

Conceptual Plan for Yangpu International Purchasing Center Special District

 Shanghai - Urban Planning & Design Project

Control Plan for Gejiu New District (Reclaimed Mining Area)

 Yunnan - Urban Planning & Design Project

Control Plan for Jiangwan-Wujiaochang Sub-City center of Shanghai

 Shanghai - Urban Planning & Design Project

Far Eastern Xinyi Shopping Center Taipei - To Be Completed in 2013

Goldfield Green Villa - Fengqing Street Shanghai - Completed 2005

Goldfield Green Villa - Grade 1~9 Continuous School Shanghai - Completed 2007

Goldfield Green Villa - Kindergarten Shanghai - Completed 2007

Goldfield Green Villa - Retail Mall Shanghai - Completed 2008

Guangzhou Nansha Business Center Guangzhou - Competition

 First Prize, Guangzhou Nansha Business Center International Design Competition

Hoya Hotel Taipei Taipei - Design Project

Master Plan for Jiangwan-Wujiaochang Sub-City center of Shanghai

 Shanghai - Urban Planning & Design Project

Master Plan for Weiqu Hi-tech Industrial Park Shanxi - Urban Planning & Design Project

Master Plan for Xicheng East District Yunnan - Urban Planning & Design Project

Media Tek Inc. Research & Development Center Hsinchu - Design Project

Meridian Hotel and Office Complex Taipei - Completed 2010

National Cheng Chi University Camp Landscape Taipei - Completed 2005

Shih Chien University Gymnasium & Library Taipei - Completed 2009

Song Chuan Shu-Lin Factory Taipei County - Completed 2007

Strategic Plan for Shanghai Media & Entertainment Group Media Park

 Shanghai - Urban Planning & Design Project

Taipei American School Landscape Taipei - Completed 2005

Taipei Nangang Exhibition Center Competition Taipei - Competition

Taoyuan International Airport Terminal 1 Renovation Competition Taoyuan County - Competition

 Second Prize, Taoyuan International Airport Terminal 1 Redevelopment Competition

The Biennale Rotterdam The 1st Int'l Architecture Exhibition Mobility Taiwan

 Exhibition – In Transferring Rotterdam Exhibition - Completed 2003

The Drape House Nanjing - To Be Completed 2012

The Expansion Site of Gejiu No.1 Middle School Master Plan Yunnan - Completed 2005

The Hospital of Kunming Medical School Competition Yunnan - Competition

Tongshan Residential Tower Taipei - Completed 2007

Yuanta Financial Tower Taipei - Completed 2007

 Design Architect: ARTECH Architects

 Architect of Record: TMA Architects & Associates

Yuan Ze University Administrative Education Building Taoyuan County - Completed 2003

Yuan Ze University Swimming Pool Taoyuan County - Completed 2006

2004

2008 Taiwan EXPO Competition Tainan County - Competition

Academia Sinica Taiwan History Museum Competition Taipei - Competition

ACME Electronics Factor District Planning & Design Guangdong - Completed 2006

China Steel Corporation Headquarters Kaohsiung - To Be Completed in 2011

Conceptual Plan for JinShan Industrial Park Shanghai - Urban Planning & Design Project

Conceptual Plan for Pujiang Industrial Park Shanghai - Urban Planning & Design Project

Control Plan for Weiqu Hi-tech Industrial Park Central Area

 Shanxi - Urban Planning & Design Project

Detailed Plan for No.2 & 3 Plots of Yangpu District Shanghai - Urban Planning & Design Project

Far Eastern Telecom Park Taipei County - Completed 2010

Farglory Group Xuhui Garden Residential Shanghai - To Be Completed in 2011

Fo Guang Shan Japan - Planning Project

Fo Guang Shan Monastery Bussy, France - To Be Completed in 2011

 Design Architect: ARTECH Architects

 Architect of Record: Atelier Frederick Rolland

Fo Guang Shan Monastery North Carolina - Completed 2008

Fo Guang Shan Monastery Vienna - To Be Completed in 2010

Goldfield Green Villa Residential Tower Shanghai - Completed 2007

Kaohsiung Baoliai Hotel Competition Kaohsiung County - Competition

Lishui Xinting Low Density Residential Community Shanghai - Completed 2008

Lite-On IT Research & Development Center Hsinchu - Completed 2006

Mei Fu Chien-Kuo Office Tower Taipei - Completed 2007

Merck Liquid Crystal Center Taoyuan County - Completed 2005

National Museum of Marine Science & Technology Competition Keelung - Competition

National Palace Museum Southern Branch Competition Chiayi County - Competition

 Third Prize, National Palace Museum Southern Branch Competition

Rich Mingchuan East Rd. Residential Tower Taipei - Completed 2008

SET TV Headquarters (Phase II) Taipei - Completed 2008

Silks Palace, National Palace Museum Taipei - Completed 2008

Songshan Line Metro Taipei Nanjing E. Rd. & Taipei Gymnasium
Station Taipei - To Be Completed in 2010

Suang-lien Presbyterian Church Sanzhi Chapel Competition Taipei County - Competition

The First Social Welfare Foundation Taipei - Completed 2009

Ting Hsin International Group Headquarters Shanghai - To Be Completed in 2012

Urban Design for Tianjin Port Free Trade Zone Residential District
Tianjin - Urban Planning & Design Project

Urban Design for Xing Hai Bay CBD Shenyang - Urban Planning & Design Project

Walsin Group Hexi New Town Development Plan Nanjing - Design Project

Wushih Beach Pavilion Yilan County - Completed 2007

2005

Buddha Memorial Hall Plaza Kaohsiung County - Design Project

Cathay Tienmu Residential Tower Taipei - To Be Completed in 2014

Conceptual Plan for Haikou Meilisha Recreational Area
Hainan - Urban Planning & Design Project

Conceptual Plan for Sunqiao Modern Agricultural Park
Shanghai - Urban Planning & Design Project

Conceptual Plan for Tang Town New Town Shanghai - Urban Planning & Design Project

Conceptual Plan for Weihai Binhai Beach Resort Development
Shandong - Urban Planning & Design Project

Dharma Drum University Taipei County - To Be Completed in 2011
First Prize, Dharma Drum University Campus Design Competition

Formosa Television Headquarter Taipei - Design Project

Fubon 777 Residential Tower Taipei - To Be Completed in 2011

Jian Zhen Library Yangzhou - Completed 2007

Kelti Center Taipei - Completed 2009

National Art Museum of China, Beijing, Competition Beijing - Competition
Third Prize, National Art Museum of China Beijing Competition

Project N Pharmaceutical Research and Development Facility Competition
Shanghai - Competition

Shanghai Fisheries University Campus Plan Shanghai - Competition

Strategic Plan for Jinhui Modern Services Industrial Park
Shanghai - Urban Planning & Design Project

Strategic Plan for Pinggu District Mafang New Town Beijing - Urban Planning & Design Project

Strategic Plan for Yangshan Island Development Zhejiang - Urban Planning & Design Project

Sungshan Tobacco Factory Cultural Park Competition Taipei - Competition

Taichung Metropolitan Opera House Competition Taichung - Competition

Taipei American School Library Project Taipei - Design Project

Taipei MRT Airport Link (DA115) BOT Competition Taipei - Competition
Collaborating Architects: Richard Rogers Partnership
Second Prize, Taipei MRT Airport Link Competition

Taipei Private Wei Go Kindergarten Taipei - Completed 2009

Urban Design for Tianjin Port Free Trade Zone Residential Area
Tianjin - Urban Planning & Design Project

2006

Chiaokuo Residential Tower - Completed 2010

Ching Shin Elementary & Middle School Taipei - To Be Completed in 2010

Detailed Plan for Old Cadre College Dalian Liaoning - Urban Planning & Design Project

Far Eastern Taichung Shopping Center Competition Taichung - Competition

Jiangsu Provincial Art Museum Competition Jiangsu - Competition

Landscape Design for Century Park & Plaza Refurbishment Shanghai- Landscape Design Project

Landscape Design for HEYADA Technology Industrial Park Conference and Exhibition Center
Shandong - Landscape Design Project

Landscape Design for Huashan Square Shanghai - Landscape Design Project

Shanghai Commercial & Savings Bank Residential Tower Taipei - Completed 2010

Shanghai Yangpu District Parcel No.3 Block B Commercial Center Shanghai - Design Stage

Sungshan Taoyuan Residential Tower Taoyuan - To Be Completed in 2010

TIAA MRT System Taoyuan County - To Be Completed in 2012
First Prize, TIAA MRT System DE03 Link Competition
First Prize, TIAA MRT System DE03 Link Detail Design

Water-Moon Monastery Taipei - To Be Completed in 2011

Weiwuying Performing Arts Center Competition Kaohsiung - Competition
Honorable Mention, Weiwuying Performing Arts Center Competition
Collaborating Architects: Chien Architects & Associates Stonehenge Architects International

2007

1788 Nanjing Road West Shanghai - To Be Completed in 2011

ACME Toufen R&D center Miaoli County - Completed 2008

Asia University Art Museum Taichung County - To Be Completed in 2011
Design Architect: Tado Ando Architects & Associates
Architect of record: ARTECH Architects

Cathay Hangzou N Rd. Residential Tower Taipei - To Be Completed in 2013

Chiaokuo Chunghwa Rd. Residential Tower Taipei - To Be Completed in 2012

China Airlines Complex Competition Taoyuan County - Competition

Chinatrust Commercial Bank Headquarters Competition Taipei - Competition
Collaborating Architects: Richard Rogers Partnership

COB Majestic City Shanghai - To Be Completed in 2011

Conceptual Plan for the Golden Pebble Beach Yachts
Liaoning - Urban Planning & Design Project

CHRONOLOGICAL LIST OF BUILDINGS AND PROJECTS 1985–2009

Conceptual Plan for Longwan Beach Resorts Liaoning - Urban Planning & Design Project

Conceptual Plan for Xiongyue Wang'er Mount Resorts

Liaoning - Urban Planning & Design Project

Control Plan for Tidal Lake Tourism and Recreational District

Shandong - Urban Planning & Design Project

Control Plan for Xinchen Beach Side Resorts Liaoning- Urban Planning & Design Project

Far Eastern Banciao Shopping Center Taipei County - To Be Completed in 2012

Design Architect: Kisho Kurokawa Architects & Associates

Architect of Record: ARTECH Architects

Far Eastern Banciao Skyscraper Taipei County - To Be Completed in 2012

Master Plan & Phase One Architecture design by Kisho Kurokawa Architects & Associates

Gwanghua Road SOHO 2 Beijing - Competition

Collaborating Architects: Dada Architecture Design

Jiading Residential Community Shanghai - Design Stage

Jingan District Block No. 54-A Office Tower Shanghai - Design Stage

Kenting Resort Hotel Pingtung County - To Be Completed in 2012

King's Town High Rise Residential Tower Taipei - Design Project

Kunming University of Science and Technology – Library Auditorium & Classroom Buildings

Yunnan - Completed 2009

Master Plan and Detailed Plan for Kunming University of Science and Technology

Chenggong Campus (PhaseII) Yunnan - Urban Planning & Design Project

Master Plan for Hexi New Town Development Nanjing - Urban Planning & Design Project

Master Plan for Mauritius Tianli Economic Trade & Cooperation Zone

Mauritius - Urban Planning & Design Project

National Taichung Library Competition Taichung - Competition

Second Prize, National Taichung Library Competition

Shanghai World Expo Competition Shanghai - Competition

Shuangsi Villa Taipei - To Be Completed in 2012

Square Land Development Xinsheng S Rd. Residential Tower Taipei - Design Stage

Taiwan Hakka Culture Center Competition Miaoli County - Competition

Taiwan High Speed Rail Changhua Station Changhua - To Be Completed in 2015

First Prize, Taiwan High Speed Rail Changhua Station Competition

Taiwan High Speed Rail Yunlin Station Yunlin County - To Be Completed in 2015

First Prize, Taiwan High Speed Rail Yunlin Station Competition

Taiwan Life Insurance Financial Headquarters Taipei - To Be Completed in 2011

Taiwan NEXT-GENE Ao-Di Grand Land Architecture International Project

Taipei County - Design Stage

TMC Toufen Office Building Miaoli County - Design Project

West Shanghai Holiday Inn Shanghai - Completed 2009

Winbond Jhubei Office Building Hsinchu County - Design Project

2008

A-10 Hotel Complex Taipei - To Be Completed in 2012

Conceptual Plan for World Headquarters Economic Forum - Yangpu District Plot 1

Shanghai - Urban Planning & Design Project

Fo Guang Shan Dajue Temple Zhejiang - Completed 2009

HTC Taipei Headquarters Taipei County - To Be Completed in 2011

First Prize, Yulon / HTC Shindian Twin Tower Competition

Hua Nan Bank Headquarters Taipei - To Be Completed in 2012

First Prize, Hua Nan Bank Headquarters Competition

La Biennale di Venizia - The 11th International Architecture Exhibition

Taiwan Pavilion - Dark Affair Venice Exhibition - Completed 2008

Landscape design for school of Applied Technology, Kunming University of Science

and Technology Chenggong Campus Yunnan - Urban Planning & Design Project

LE Office Tower Taipei - To Be Completed in 2014

Master Plan and Control Plan for Lijiang Sheshan Recreation & Sports Park

Yunnan - Urban Planning & Design Project

Master Plan for Chaobai New Town Hebei - Urban Planning & Design Project

Master Plan for Chengdu Hi-tech Industrial Park Incubator

Sichuan - Urban Planning & Design Project

Shanghai Bailemen Hotel Shanghai - To Be Completed in 2010

Shanghai-Nanjing High Speed Rail Huishan Station Wuxi - To Be Completed in 2010

Taichung Railroad Station Competition Taichung Competition

Taipei Performing Arts Center Taipei To Be Completed in 2014

Design Architect: Office for Metropolitan Architecture

Architect of record: ARTECH Architects

Tashee Residential Project Taipei - Design Stage

Xiushui Elementary School Sichuan - To Be Completed in 2010

Yujiapu Financial District Lot 3-14 Office Tower Tianjin - To Be Completed in 2011

Yulon / HTC Corporation Twin Tower Taipei County - Competition

First Prize, Yulon / HTC Shindian Twin Tower Competition

2009

Chengdu High-tech Park Office Tower Sichuang - To Be Completed in 2012

Conceptual Plan for Pingqian Modern Industrial Park Jiangsu - Urban Planning & Design Project

Control Plan and Urban Design for Shanghai-Nanjing Inter-city Railway Huishan

Station Special District Jiangsu - Urban Planning & Design Project

Control Plan for Hengshui Lake National Preservation Area

Hebei - Urban Planning & Design Project

Fo Guang Shan Haiqin Temple Jiangsu - To Be Completed in 2012

Green Land Xuhui District Residential Community Shanghai - To Be Completed in 2012

Hengshui City Exhibition Center Hebei - Design Stage

Kinmen Institute of Technology Student Center Kinmen County - To Be Completed in 2012

First Prize, Kinmen Institute of Technology Student Center Competition

Landscape Design for Fuyang River Waterfront Hebei - Landscape Design Project

Landscape Design for Shanghai-Nanjing Inter-city Railway Huishan Station Plaza

Jiangsu - Landscape Design Project

Master Plan and Control Plan for Xinjin Garden City Sichuan - Urban Planning & Design Project

Master Plan and Development Strategies for the city of Hengshui

Hebei - Urban Planning & Design Project

Master Plan and Urban Design for Central City Redevelopment

Yunnan - Urban Planning & Design Project

Master Plan for the Auto-City Liaoning - Urban Planning & Design Project

Master Plan for the Golden Triangle New District Hebei - Urban Planning & Design Project

National Museum of Prehistory Tainan County - To Be Completed in 2013

First Prize, National Museum of Prehistory Tainan Project Competition

Pengxing Boao Resort Hainan - Design Stage

Pingtung Performing Arts Center Pingtung County - To Be Completed in 2012

First Prize, Pingtung Performing Arts Center Competition

Taiwan Life Insurance Songjiang Rd. Project Taipei - To Be Completed in 2011

Taiwan Pavilion of Shanghai World Expo Competition Shanghai - Competition

Taiwan Traditional Performing Arts Center Taipei - To Be Completed in 2013

First Prize, Taiwan Traditional Performing Arts Center Competition

TAS Facilities Development Project Taipei - To Be Completed in 2012

United Daily News Group Office Tower Taipei - To Be Completed in 2014

Urban Design for the Northern New Town Shanxi - Urban Planning & Design Project

Yunnan Cultural Park Yunnan - To Be Completed in 2012

First Prize, Yunnan Cultural Park Competition

AWARDS & COMPETITIONS

2010	FIRST PRIZE	Taiwan Traditional Performing Arts Center Competition
2010	FIRST PRIZE	National Museum of Prehistory, Tainan Competition
2009	FIRST PRIZE	Ping Tung Performing Arts Center Competition
2009	FIRST PRIZE	Yunnan Cultural Park Competition
2009	FIRST PRIZE	Kinmen Institute of Technology Student Center Competition
2009	FIRST PRIZE	Taipei Performing Arts Center Competition (Collaboration with OMA)
2008	EXHIBITION	La Biennale di Venezia 11th Int'l Architecture Exhibition Taiwan Exhibition – Dark Affair
2008	FIRST PRIZE	Yulon / HTC Shindian Twin Tower Headquarters Competition
2008	FIRST PRIZE	Hua Nan Bank Headquarters Competition
2007	HONOR AWARD	The 11th Annual National Award for Arts in Architecture
2007	HONORABLE MENTION	Sixth Annual Far Eastern Architectural Design Award, Taiwan High Speed Rail Hsinchu Station
2006	HONORABLE MENTION	The National Kaohsiung Performing Arts Center International Competition
2006	FIRST PRIZE	The Taiwan Annual Architecture Awards, Taiwan High Speed Rail Hsinchu Station
2006	FIRST PRIZE	Taipei MRT Airport DE03 Link Detail Design
2006	FOURTH PLACE	Jiangsu Art Museum International Design Competition
2005	HONOR AWARD	Distinguished Alumnus Award, College of Environmental Design, U.C. Berkeley
2005	SECOND PRIZE	China Fine Arts Museum Competition, Beijing, China
2005	HONORABLE MENTION	The Chinese Architect Journal Award, Quanta Research and Development Complex
2005	SECOND PRIZE	Taipei MRT Airport Link Competition
2004	THIRD PRIZE	National Palace Museum Southern Branch International Competition
2004	HONOR AWARD	First Far East School Campus Architecture Honorary Award, Shih Chien University Tung-Min Memorial Building College of Design, Taipei, Taiwan
2004	HONOR AWARD	Second Annual Green Architecture Design Award, Fubon Tian Mu Housing
2003	FIRST PRIZE	Accton Technology Corporation Headquarters Competition

2003	**HONORABLE MENTION**	The Taiwan Annual Architecture Award Shih Chien University Tung-Min Memorial Building College of Design, Taipei, Taiwan
2003	**FIRST PRIZE**	Guangzhou Nansha Commercial Center International Invitational Design Competition
2003	**EXHIBITION**	The Biennale Rotterdam 1st Int'l Architecture Exhibition Mobility Taiwan Exhibition - In Transferring
2002	**EXHIBITION**	La Biennale di Venezia 8th Int'l Architecture Exhibition- NEXT, Taiwan Exhibition – NEXT EXIT
2002	**HONORABLE MENTION**	WA Architecture Awards, Compal Headquarters, Taipei, Taiwan
2001	**FIRST PRIZE**	The Taiwan Annual Architecture Award, Compal Headquarters, Taipei, Taiwan
2000	**FIRST PRIZE**	The Outstanding Architectural Design Award in Chiangsu Province, Yageo Corp. Suzhou Factory, China
2000	**SECOND PRIZE**	The 2nd Far Eastern Architectural Design Award
2000	**FIRST PRIZE**	Special Award for 921 Campus Reconstruction Competition Ethon-Music Center Design Competition
2000	**FIRST PRIZE**	Yi-Lan Lanyang Museum Phase One Development Planning Competition
1999	**FIRST PRIZE**	The 1st Far Eastern Architectural Design Award
1999	**FIRST PRIZE**	The Taiwan Annual Architecture Award, Luminary Buddhist College, Taichung, Taiwan
1999	**HONORABLE MENTION**	The Taiwan Annual Architecture Award, Continental Engineering Corp. Headquarters, Taipei, Taiwan
1998	**FIRST PRIZE**	Dharma-Drum University Campus Design Competition
1998	**HONOR AWARD**	The 20th Chinese Architect Journal Award, Yuan-Ze Institutes of Library Technological Information
1997	**HONOR AWARD**	The 3rd Annual Chinese Outstanding Architect Award, Republic of China
1996	**HONOR AWARD**	The 18th Chinese Architect Journal Award, Fubon Banking Center
1996	**HONORABLE MENTION**	The 18th Chinese Architect Journal Award, Tung Hwa University Graduate Student Housing Hualien
1995	**HONORABLE MENTION**	The 17th Chinese Architect Journal Award, Hsinsun South Road Condominium Taipei, Taiwan

COLLABORATORS

3D Concepts Museum and Exhibition Design

Alfredo Arribas Arquitectos Asociados

ALT Cladding Design. Inc.

Ans Consulting Engineers Ltd.

Architekten von Gerkan, Marg und Partner. Hamburg, Germany

Belt Collins & Associates. Hong Kong

Bensley Design Group International

Bovis Lend Lease Corporation

Carol R. Johnson Associates Inc. Boston, U.S.A.

CERMAK PETERKA PETERSEN. U.S.A

Chang Jia M&E Engineering Corp.

Chin Tai Feng Consulting Inc.

Chiu Hui Huang Structure Engineers Office

Chroma 33 Architectural Lighting Design Inc.

C. M. Chung Partners & Associates Civil & Structure Engineering

CNHW Planning & Design Consultants

Connell Wagner International Pty Ltd. Australia

Continental Engineering Consultants, Inc.

CO-YOUNG ENGINEERING CONSULTANTS, Inc.

Creative Solution Integration Ltd.

Curtain Wall Design & Consulting. Dallas, TX. U.S.A.

David Consulting Inc.

Dillingham Associates Landscape Architects

East China Architectural Design & Research Institute Co., Ltd.

EDAW Urban Design Limited

EDS International Inc.

Envision Engineering Consultants

Ever Green Consulting Engineering, Inc.

Federal Engineering Consultants, Ltd.

Fisher Marantz Stone Partners in Architectural Lighting Design. NY. U.S.A.

H&K Associates

Han Ming Landscape Architect Associates

Handar Engineering & Construction Inc.

Heng Kai Engineering Consultants, Inc.

Huai Te Engineering Consultants, Inc.

Huang Wan Fu Civil Engineers Office

Hyder Consulting Limited

I. S. Lin and Associates Consulting Engineers

Innerscapes Designs

Jae-Lien International Engineering Consultants

Jauhung Consulting Engineers

Jellys Technology Inc.

Kai-Chu Engineering Consultant, Inc.

Kaichuan Planning Design Co., Ltd.

Kao Szu Engineering Consultants, Inc.

Keating, Mann, Jernigan, Rottet Architecture and Interiors

Kenzo Tange Associates Urbanists - Architects

Kisho Kurokawa Architect & Associates. Tokyo, Japan

Kuang Yu Engineering Consultants, Inc.

Kun-Tai Consultants & Associates

Lerch, Bates & Associates Inc. Littleton, CO. U.S.A.

Li Jeng Wei Structure Engineers Office

LInc.olne Scott Australia Pty Ltd. Queensland, Australia

M. Arthur Gensler Jr. & Associates. San Francisco, CA. U.S.A.

Majestic Electrical Engineers Office

Majetech Electrical Engineers Office

Marco Materials & Envelopes Consulting

Ming Sheng Engineering Co.,Ltd.

Moh and Associates, Inc.

National Taiwan University of Science and Technology

Ove Arup & Partners Consulting Engineers. Los Angeles, CA. U.S.A.

Parsons Brinckerhoff International, Inc. Taiwan Branch

Pei Cobb Freed & Partners Architects. NY. U.S.A.

Performance, Arts, Technology, Design Consultant Inc.

PLACEMEDIA, Landscape Architects Collabrative. Tokyo, Japan

Polshek and Partners Architects LLP

Rowan Williams Davies & Irwin Inc. Canada

RTKL International Ltd.

San Luis Solar Group

Segreene Design and Consulting

S.H. Chen Partners & Associates Civil & Structure Engineering

S.H. Chiang Structural Eng.

Shanghai Tongjian Qianghua Architectural Design Co., Ltd

Shanghai Xian Dai Architectural Design (Group) Co., Ltd

Shen Milsom & Wilkie, Inc. New York, U.S.A., H.K.

Sine & Associates M/Elec Consultants & Engineers

Skidmore, Owings & Merrill LLP. San Francisco CA, U.S.A.

SLA Studio Land. Houston, TX. U.S.A.

Sun Te-Hung Associates

Supertech Consultants International

Suzhou Institute of Architectural Design & Research

SWA Group. San Francisco, CA. U.S.A.

Taiwan Fire Safety Consulting, Ltd.

T. Y. Lin Taiwan Consulting Engineers, Inc.

Tadao ando Architects & Associates. Osaka, Japan

Takano Landscape Planning Co., Ltd.

The Jerde Partnership, International, Inc. Los Angeles, CA. U.S.A.

The Place Makers

Tino Kwan Lighting Consultants. Hong Kong

TOPO Design Group

Wang Sen Yuan Structure Engineers Office

WINDTECH Consultants Pty Ltd. Australia

Weiskopf & Pickworth Structural Engineers

Yuantai Consultant Engineer

ZEB-Technology Pte. Ltd. Singapore

ACKNOWLEDGEMENTS

The majority of the projects included in this new monograph are those we have designed or completed between the years 2000 to 2010 from our two offices in Taipei and Shanghai. The projects mainly focus on China, Taiwan and surrounding regions, and a few are scattered around South Asia, Europe, Africa and United States.

During these 10 years, we have found ourselves more involved in culturally related projects such as museums, cultural centers and performing arts facilities, as well as with projects that have complex programs, such as mixed-use commercial projects, transportation facilities and campus designs.

Any work of architecture is an endeavor of many people. None of the projects in this book would have been realized if not for the efforts and contribution of my colleagues, my clients and our consultants. I would like to first pay tribute to all my partners and co-workers at ARTECH Architects for their extraordinary passion, commitment, endurance and professionalism. To all our clients, I would also like to express my utmost gratitude for their generosity, continuous support and trust towards our pursuit of fine architecture. To our consultants and collaborators, my sincere thanks for your resource, patience and fine cooperation.

My reluctance had long delayed this monograph. Special thanks for the hard work and persistence of the following contributors, without whom this book would not have been possible:

- Poko Chiang for his tireless coordination amongst all parties. He is the key person who has held the whole book together from beginning to end;
- Grace Lin for her commitment and unyielding perfectionism in graphics and texts;
- Doris Chen and Naya Fung for their irreplaceable contribution in design and graphics;
- Yu-Chen Liu and Poko Chiang for Chinese writing;
- Suyi Wun and Judy Lo for taking on the English translation; Grace Lin and Sara Lin for English editing and Joyce Yao for final editing and proof-reading;
- Nina Yu for first-stage coordination which enabled the book to take shape;
- Kate Yang, Andy Chang, Naya Fang and Dan Hwang for all their efforts in composing the cover;
- Special thanks to Dan Hwang and Poppy Lai of EN AVANT, two extremely talented and committed professional designers; through their brilliant work, this book has finally taken shape to a excellent standard;
- Alessina Brooks, Paul Latham and the editorial teams at The Images Publishing Group for their most professional work in publishing this monograph.

Many thanks to my friends Mr. Cui Kai and Prof. Ching-Yue Roan for kindly taking time and energy to write the introduction and foreward for this book.

Special gratitude to my long-time partner Willy Yu, for all his unwavering and patient support so that I can concentrate on my part of the work freely.

My heart-felt gratitude goes to my wonderful family: to my wife Xiang, for her unconditional support and love; and to my beloved children, Joyce, Julian and Adrian. They have grown so much since my first monograph but their continuous love and inspiration brings me unceasing joy.

Lastly, my deepest gratitude goes to my spiritual teacher Dzongsar Jamyang Khyentse Rinpoche, for his unlimited compassion in guiding me every possible way; without him, I would be forever wandering.

Kris Yao

Photography

Chou Yu Hsien / Chyuan Jen Chang / Chen Hsiang Liu / David Chen
Daniel M Shih / Gui Xiang Ke / H.Z.Ma / I-Jong Juan / Jun Jei Liu
Jian Zuo Lai / Jeffrey Cheng / Pay Tsung Pan / Wei Gang Shih